D1709075

BUILDING TALIESIN

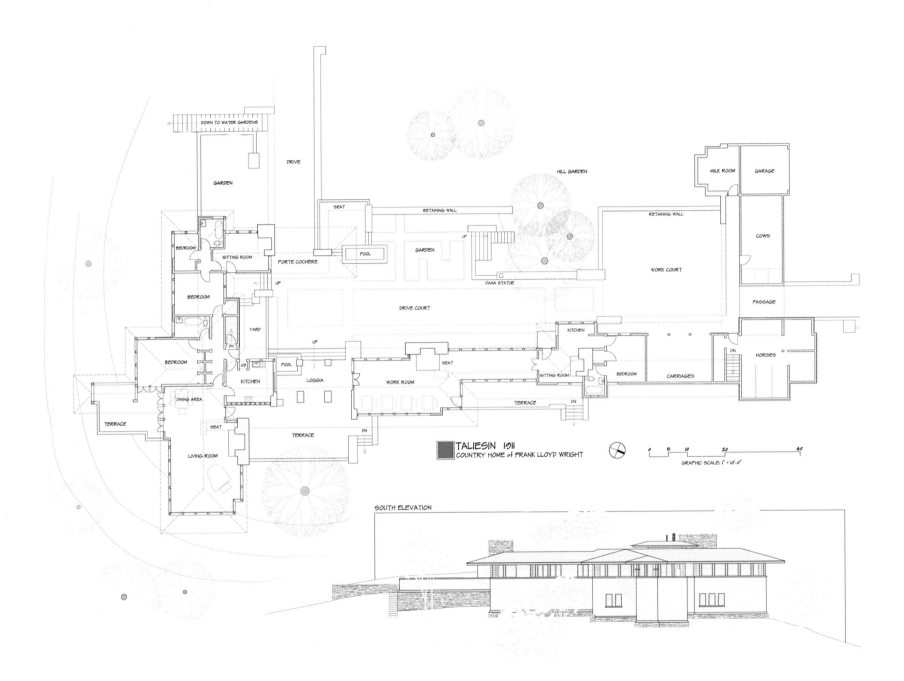

DOWN TO WATER GARDENS

DRIVE

GARDEN

SEAT

MILK ROOM

GARAGE

HILL GARDEN

RETAINING WALL

RETAINING WALL

COWS

BEDROOM

SITTING ROOM

PORTE COCHERE

POOL

GARDEN

WORK COURT

BEDROOM

DANA STATUE

PASSAGE

YARD

DRIVE COURT

KITCHEN

BEDROOM

DN

KITCHEN

HORSES

POOL

LOGGIA

SEAT

SITTING ROOM

BEDROOM

CARRIAGES

DINING AREA

WORK ROOM

TERRACE

TERRACE

SEAT

TERRACE

DN

TALIESIN 1911
COUNTRY HOME of FRANK LLOYD WRIGHT

LIVING ROOM

0 5 10 20 40

GRAPHIC SCALE: 1" = 10'-0"

SOUTH ELEVATION

Rendering by Jim McIntosh

BUILDING TALIESIN
FRANK LLOYD WRIGHT'S HOME OF LOVE AND LOSS

RON McCREA

WISCONSIN HISTORICAL SOCIETY PRESS

Published by the Wisconsin Historical Society Press
Publishers since 1855

wisconsin**history**.org

Photographs identified with WHi or WHS are from the Society's collections; address requests to reproduce these photos to the Visual Materials Archivist at the Wisconsin Historical Society, 816 State Street, Madison, WI 53706.

Front cover: Entrance to Taliesin construction site, 1911. Used by permission, Utah State Historical Society, all rights reserved.
Insets: Frank Lloyd Wright ca. 1906 and Mamah Bouton Borthwick ca. 1914. Photos courtesy the Frank Lloyd Wright Foundation, Scottsdale, AZ.

Back cover: Taliesin embraces its hill crown overlooking Jones Valley. Craig Wilson, Kite Aerial Photography.
Inset: Taliesin entrance plaque, photo © Pedro E. Guerrero.

Printed in the United States of America

Designed by Earl J. Madden, M.F.A.

16 15 14 13 12 1 2 3 4 5

Library of Congress Cataloging-in-Publication Data has been applied for.

♾ The paper used in this publication meets the minimum requirements of the American National Standard for Information Sciences—Permanence of Paper for Printed Library Materials, ANSI Z39.48-1992.

This book is for Elaine

. . . and in memory of Robert LaBrasca (1943–1992), who knew I could.

CONTENTS

PREFACE

Taliesin is a house in three acts.

In Act Three, Frank Lloyd Wright battles back from obscurity, marital strife, and financial reverses in the 1920s to become America's first superstar architect. The artist born two years after the Civil War becomes a TV celebrity in the 1950s. Taliesin in Wisconsin becomes the home of Wright's Taliesin Fellowship of apprentices and is the scene of lordly black-tie musicales.

In the second act—an act of complications—Taliesin is deserted while Wright is in Japan and California, then falls hostage to a jealous, deeply troubled wife. After a second fire, the estate is seized by the Bank of Wisconsin.

This book is about Act One. It begins with the decision of two people to risk everything for love and build a home for it, rises to a time of triumph—then ends suddenly in fire, murder, and Wright's resolve to go on.

R.M.

BUILDING TALIESIN

INTRODUCTION

Fig. 1. It's high summer at Taliesin in a photograph taken about 1913. A young man and Ben Davies, Frank Lloyd Wright's original construction foreman (center), tend the garden bordering the carriage entrance while a young woman gathers flowers and a girl in knee-stockings stands with a horse. The photo was likely taken by a traveling photographer as a souvenir for sale with the oval mat as part of the print. The print is in an album belonging to the farm family. Photograph courtesy of Carla Wright.

TALIESIN I: LOST AND FOUND

In the fall of 1911 Mamah Bouton Borthwick wrote to her mentor, Ellen Key, at Strand, Key's home in Sweden, to answer Key's criticism of her love affair with Frank Lloyd Wright. Wright was a married man of 44 whose wife of 20 years would not grant him a divorce. Borthwick, 42, had divorced Edwin Cheney on August 8 after being married to him for 15 years.

"I have, as you hoped, 'made a choice in harmony with my own soul'—the choice as far as my own life was concerned was made long since—that is absolute separation from Mr. Cheney," she said. "A divorce was obtained last summer and my maiden name is now legally mine.

"Also I have since made 'a choice in harmony with my own soul' and what I believed to be Frank Wright's happiness and am now keeping his house for him. In this very beautiful Hillside, as beautiful in its way as the country about Strand, he has been building a summer house, Taliesin, the combination of site and dwelling quite the most beautiful I have seen anyplace in the world. We are hoping to have some photographs to send you soon.

"Faithful comrade!
A dream in realization ended?
No, a woven, a golden thread in the human pattern
of the precious fabric that is Life: her life, built into the
house of Houses. As far as may
be known—forever!"

Frank Lloyd Wright, 1932

"I believe it is a house founded on Ellen Key's ideal of love. The nearest neighbor half a mile away is Frank's sister [Jane Porter, at Tanyderi] where I visited when I first came here. She has championed our love most loyally, believing it her brother's happiness.

"I have been thus far very busy with the unfinished house and because of the fact that workmen were boarded here in a nearby farmhouse, sometimes as many

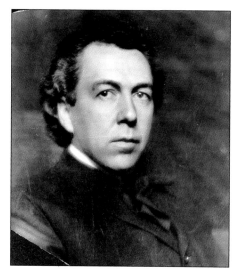 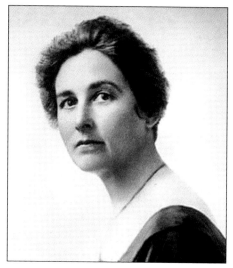

Fig. 2. Frank Lloyd Wright, ca. 1906 Fig. 3. Mamah Bouton Borthwick, ca. 1914

as 36 at a time. Mr. Wright's sister has looked after this all summer but when I came it was turned over to me and I have done very little of your [translation] work in consequence of the building. The house is now, however, practically finished and my time again free.

"Mr. Wright has his studio incorporated into the house and we both will be busy with our own work, with absolutely no outside interests on my part—my children I hope to have at times, but that cannot be just yet."

Mamah's description of their lives and plans in this remarkable letter is the fullest account yet of the early days of Taliesin, Wright's estate at Spring Green, Wisconsin, which observed its 100th anniversary in 2011. The letter is the third of 10 discovered in Key's archive at the Royal Library in Stockholm and brought to the world's attention in 2002.[1]

Mamah apparently did send the photos she promised to Key, because in another letter, written around February 1912, she speaks of sending more. "I enclose two other views of the house," she says. "The interior looks pretty bare, for there are no rugs yet nor many other things which will make it look more home-like."

That description matches photographs in this book. The pictures of the living room and dining areas show "pretty bare" rooms without rugs or much decoration. These and other primitive photos of Taliesin were taken by Taylor A. Woolley.

THE FIRST PHOTOGRAPHER

Woolley, 26, was a draftsman who lived at Taliesin from mid-September 1911 through the spring of 1912 and took pictures the whole time. In Italy the previous year he and Borthwick had become friendly. He had lived with the couple in Fiesole above Florence while working on Wright's two-volume Wasmuth Portfolio. Woolley also took photos in Fiesole. Some of them are included in these pages because Fiesole is where the idea of Taliesin took root.

"I have since made 'a choice in harmony with my own soul' and what I believed to be Frank Wright's happiness and am now keeping his house for him. In this very beautiful Hillside, as beautiful in its way as the country about Strand, he has been building a summer house, Taliesin, the combination of site and dwelling quite the most beautiful I have seen anyplace in the world. We are hoping to have some photographs to send you soon."

—Mamah Bouton Borthwick to Ellen Key, 1911

Woolley's collection of Taliesin photos—the first photos of the first Taliesin— has until now been scattered among three collections in historical societies and libraries in Wisconsin and in Utah, where Woolley was born and spent most of his career. The most important collection, a file of 58 negatives at the Utah State Historical Society that sat unnoticed, possibly for decades, and was not processed until 2002, contains rare views of Taliesin under construction. Additional photo prints from the series by Woolley found their way into the collection of his lifelong

friend, partner in architecture, and brother-in-law, Clifford P. Evans, at the J. Willard Marriott Library at the University of Utah. Evans also was at Taliesin in the fall of 1911 and appears in several Woolley photos. He was 22.

The third portion of Woolley's photographs is contained in an album once owned by a Spring Green couple and acquired on eBay by the Wisconsin Historical Society in 2005 for $28,200 after an intense fund-raising campaign. In a write-up in the *New York Times* the album was hailed as "a Rosetta Stone for the building" but its creator was a mystery. I have discovered that 21 of its 35 images are exact matches to Woolley negatives in Utah, including all three photos that make up the triptych of the living room, the album's signature display. It can now be said with high confidence that Woolley was the photographer.

Woolley's photographs not only match Mamah's words, they match Wright's own recollections of the first Taliesin summer and the craftsmen on the site. In them we see carpenters, stonemasons, and foremen of the sort who Wright remembers by name. We see chalk lines being laid down in a grid on Taliesin's northeast slope to prepare for the vegetable gardens that Wright croons about in his chronicle.

Woolley left Taliesin in the summer of 1912 to be with his ailing mother. In a letter dated July 10, 1912, Wright tells Woolley to "take your time, enjoy yourself" in Utah, and notes: "All well here—the place quite transformed."[2]

Mamah echoes this impression—that Taliesin has been transformed—in a letter to Key dated November 12, 1912. She says: "The place here is very lovely; all summer we had excursion parties come here to see the house and grounds, including Sunday-schools, Normal School classes, etc. I will try to send you some new photographs—you will scarcely recognize them from the others."[3]

Both kinds of photos are represented in this book—the early, rough ones by Woolley ("the others") and the "new photographs," taken in the late summer of 1912 by Clarence Fuermann of Henry Fuermann and Sons, professional photographers from Chicago. Wright needed a polished portrait of Taliesin to illustrate his achievement in the January 1913 *Architectural Record*. A second illustrated article appeared a month later in *Western Architect*. In an introduction, the editors of *Western Architect* confess that photos cannot do Taliesin justice.

"Wonderfully situated on a site commanding every view of one of Southern Wisconsin's most beautiful valleys is Taliesin, the country home of Frank Lloyd Wright, Architect" they say. "Photographs giving an adequate conception of the

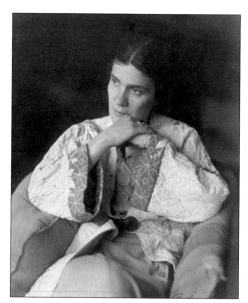

Fig. 4. Olgivanna Lloyd Wright (photographed in 1949 at age 51) was the heroine of Frank Lloyd Wright's late career, helping him through hard times and organizing the Taliesin Fellowship.

layout of the house and grounds with their beautiful surroundings are impossible to procure. Here and there the photographer is able to secure charming little details . . . but the Architect's drawings themselves show more comprehensively the beautiful and artistic arrangement of this estate as planned by Mr. Wright himself."[4]

In February of 2011 a previously unknown collection of 25 photographic proofs of Fuermann's Taliesin set, plus a few other unidentified images, was put up for sale on eBay and acquired by the Wisconsin Historical Society. They became available in time for a selection of them to be included in this book. These beautiful photos, some never published, show Taliesin at its peak, with its gardens, stone steps, and Tea Circle fully formed, its courtyards in bloom, and its vegetable gardens popping with cabbages and other crops, ready for the first harvest.

THE LADY VANISHES

One Fuermann photo shows a horse and two young people under the portecochere, as seen from the hill garden. The next photo presented here, taken two years later by an anonymous photographer from the same perspective, is horrifying. It shows Taliesin in smoking ruins, the porte cochere crashed to the ground. If the two young people in the previous photo were the Cheney children, John and Martha, they are now dead, killed with their mother while having lunch on Saturday, August 15, 1914, during their annual summer visit.

The mass murder and fire claimed seven lives and eventually the life of Julian Carlton, the killer from Chicago. Perversely, it claimed both the life and the identity of the woman for whom Taliesin was built.

Wright in his autobiography is able to remember and recite the names of carpenters, stonemasons, and foremen who worked on the construction site. He is even able to quote them. But he is not able to name the woman who cooked for the crew and was Taliesin's reason for being.

In fact, Wright never names Mamah in *An Autobiography* except for one first-name reference in the first edition and two in the second. He names all his other wives—Catherine Tobin Wright, Miriam Noel Wright, and Olgivanna Lloyd Wright—the last two of whom were also mistresses before they were wives—and even Zona Gale, the Pulitzer Prize–winning dramatist whom he courted but who rejected him.

But references to Mamah are elliptical.

She is "her who, by force of rebellion, as by force of Love, was then implicated with me."

She is "the best of companionship" (though her companionship is omitted from his account of their 1913 trip to Japan).

She is "a kindred spirit" at Taliesin, "a woman who had taken refuge there for life."

In the discussion of her death, she is "she for whom Taliesin had first taken form."

But she is never Mamah Borthwick.

In a coda to the tender account of their sojourn in Tuscany in 1910, Wright exclaims: "Faithful comrade! A dream in realization ended? No, a woven, a golden thread in the human pattern of the precious fabric that is Life: her life, built into the house of Houses. As far as may be known—forever!" He is saying that Mamah's spirit always animated Taliesin and always will. But he cannot utter her name.[5]

It was not always so. Five days after she was killed, Wright names Mamah five times in an open letter to his neighbors. After thanking them for their kindness, he fires a parting shot at married critics: "You wives with your certificates of loving—pray that you may love as much and be loved as well as Mamah Borthwick!"[6]

Immediately after her death, then, she is still a real woman, an individual with a history. But in Wright's 1932 autobiography she is a ghost. She has become, in the words of Bruce Brooks Pfeiffer, "an almost ephemeral, mythical figure, too

close, too precious, to be able to describe. He does not even mention her name."[7]

There are many reasonable explanations as to why Wright did this, but the net result is that in his memoir the first lady of Taliesin has vanished.

CREATIVE TOGETHER

The creative legacy of the original Taliesin was also pushed into obscurity almost immediately after the fire. It was forgotten that during their brief years together Wright and Borthwick were a powerhouse of production.

Between 1911 and 1914 Wright developed a new design vocabulary and his talent flowered in some of his most distinctive works. They started with Taliesin itself and included the Avery Coonley Playhouse, with its famous balloons-and-confetti "kindersymphony" windows; the Francis Little House, whose tawny living room is now installed in the American Wing of the Metropolitan Museum of Art; Midway Gardens, a modernist fantasy of buildings, restaurants, and an outdoor concert garden that occupied a full city block in Chicago.

Wright also opened a second career as a major collector and dealer in Japanese art, taking Mamah to Japan with him in 1913, purchasing thousands of

Frank Lloyd Wright had been lost to a generation, a critic for the Los Angeles Times *observed in 1988, speaking of "the dark ages for Wright designs, which preceded his death in 1959 and spanned the following generation." Tastes in modern design had shifted to Bauhaus and Scandinavian styles.*

artworks, and landing the contract to build the new Imperial Hotel for the Imperial Household in Tokyo. He published *The Japanese Print: An Interpretation* in 1912, while still promoting U.S. sales of his two-volume *Studies and Executed Buildings of Frank Lloyd Wright,* which had taken Europe by storm.

Wright and Borthwick became publishing partners in the effort to spread the gospel of women's liberation and marriage-law reform being promoted by the

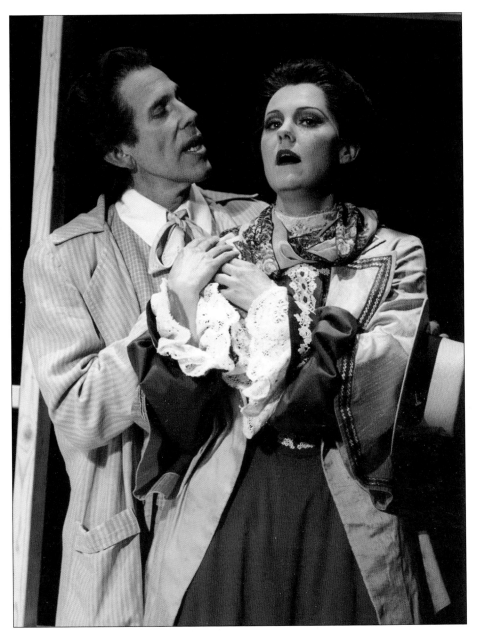

Fig. 5. Robert Orth, appearing in the role of Frank Lloyd Wright, sings a love duet with Brenda Harris, portraying Mamah Borthwick Cheney in the Chicago Opera Theater's 1997 revival of the Daron Hagen opera *Shining Brow.* The opera premiered with the Madison Opera in 1993 and has had other revival performances in Florida, Nevada, and Buffalo, New York.

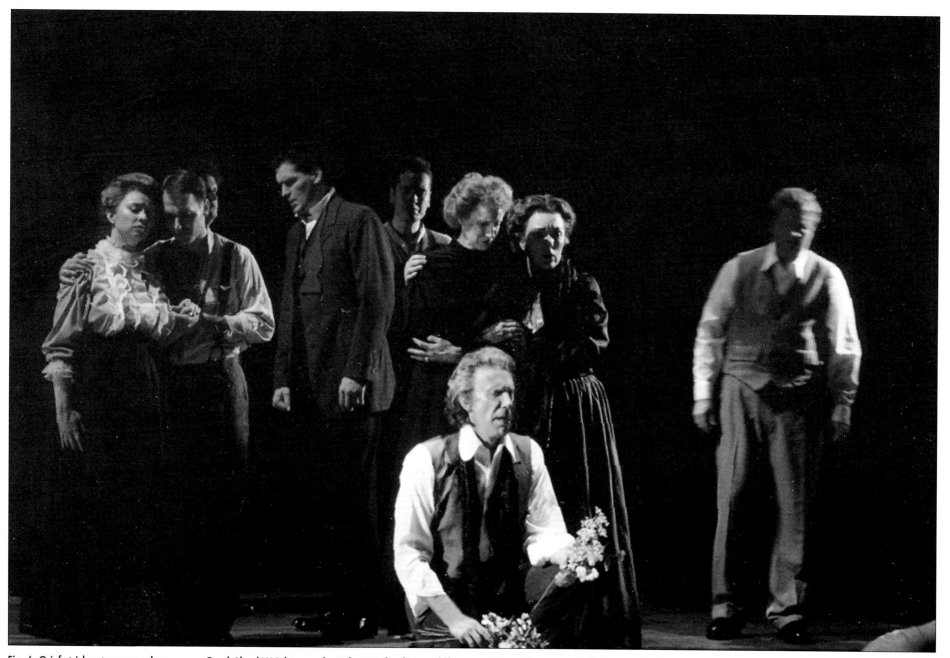

Fig. 6. Grief-stricken townspeople mourn as Frank Lloyd Wright, sung by Robert Orth, places wildfowers on Mamah's grave and pledges to rebuild Taliesin, in a scene from the Chicago Opera Theater's *Shining Brow*. In the actual 1914 event, Wright buried Mamah alone after filling her casket with the flowers from her garden.

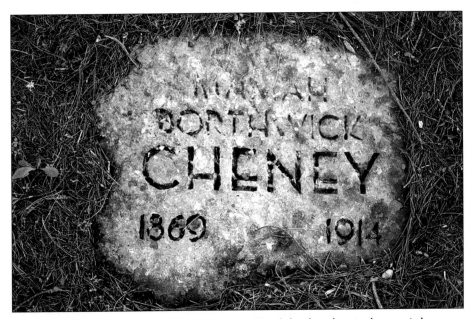

Fig. 7. Mamah Borthwick's grave marker in the Unity Chapel churchyard carries her married name. She stopped calling herself Cheney and reclaimed her maiden name even before she was divorced in August, 1911, before she arrived at Taliesin. She called herself Mamah Bouton Borthwick in all her published translations.

popular Swedish philosopher-activist Ellen Key. With Borthwick working as her official American translator and Wright handling publishing contacts and financing, they published three books through Wright's Chicago publisher, Ralph Fletcher Seymour. Mamah's translation of *The Woman Movement* was issued by Putnam's in New York with an introduction by Havelock Ellis. A final translation, Key's profile of the French peace acvitist Romain Rolland, was published in 1915 in Margaret Anderson's experimental Chicago-based *Little Review,* which Wright had helped get started with a $100 donation.

Anderson published a tribute to the couple in October 1914. It was a piece of poetry that Wright said survived the fire only because he carried it in his pocket. Anderson's preface says: "This fragment, a 'Hymn to Nature,' unknown to us in the published works of Goethe, was found in a little bookshop in Berlin and translated into English by a strong man and a strong woman whose lives and whose creations have served the ideals of all humanity in a way that will gain deeper and deeper appreciation."[8]

TURMOIL AND TRIUMPH

That deeper appreciation was delayed until well after Wright's death. Mamah's memory was first buried under a heap of melodrama and scandal generated by Wright's nine-year liaison and marriage with the volatile Miriam Noel that began in 1915. That bad pairing culminated in a brutal custody fight over Taliesin and an attempt by Miriam to have Wright's new love, Olga (Olgivanna) Lazovich, deported.

By the time the mess was sorted out, the professional cost to Wright had been heavy. Then the Depression hit, and Olgivanna became the undisputed heroine of Taliesin and Wright's career. She pulled them through the hard times resourcefully, persuading her husband to pursue two moneymaking ideas: to write the *Autobiography* and to create a paying school of architecture.

After the founding of the Taliesin Fellowship in 1932 there were new worlds to conquer, a new philosopher-guru to follow (George Gurdjieff), and a new "truth against the world" to proclaim: organic architecture versus the International Style. The eras of Mamah, Japan, and Oak Park were strictly Old Testament.

When Wright died in 1959, Olgivanna concentrated the work and resources of the Frank Lloyd Wright Foundation at Taliesin West in Arizona, where business prospects were better for the foundation's architects, where she had friends and felt at home—and where the house was not haunted. Taliesin East, as the Wisconsin campus was now called, went into 30 years of physical decline.

In a final act, Olgivanna desacralized Taliesin by ordering Wright's remains exhumed from the Unity Chapel churchyard, cremated, and shipped west to be mixed with hers at her death in 1985. Mamah, buried nearby, was given a stone marker reading "Mamah Borthwick CHENEY," emphatically restoring to her the married name she had renounced when she began to live with Frank Lloyd Wright.

A VOICE FROM THE PAST

The recovery of Taliesin's creation story and the revival of interest in Wright and Borthwick had to wait for the death of the last Mrs. Wright. Taliesin under Olgivanna had come to resemble China's Forbidden City under the Dowager Empress in

some ways—insular, wrapped in intrigue, wary of outside scholars. Mamah Borthwick and the first Taliesin were off-limits topics.

After Mrs. Wright's death in 1985, that began to change. Taliesin and its archival treasures became accessible. An early result was the organization of Wright's massive correspondence by Anthony Alofsin into the five-volume *Index to the Taliesin Correspondence* (Garland, 1988). The entire Wright letter archive was copied on microfiche and made available for research at the Getty Museum in Los Angeles. Taliesin archivist Bruce Brooks Pfeiffer issued a stream of original writings and renderings.

Solid biographies and groundbreaking studies followed, including Meryle Secrest's *Frank Lloyd Wright: A Biography* (HarperCollins, 1992), Alofsin's indispensable *Frank Lloyd Wright: The Lost Years, 1910–1923* (Chicago, 1993), Neil Levine's *The Architecture of Frank Lloyd Wright* (Princeton, 1996), Julia Meech's *Frank Lloyd Wright and the Art of Japan* (Japan Society, 2001), and Narciso Menocal's edited Wright Studies volume, *Taliesin I: 1911–1914* (SIU–Carbondale, 1992), which brought together all the known information at the time.

Brendan Gill's skeptical but admiring *Many Masks: A Life of Frank Lloyd Wright* (Putnam's, 1987) established Wright's correct birth year (1867, not 1869) and likely original name (Franklin Lincoln Wright). His dossier on Wright's mother, Anna, whom Wright had painted as a saint, revealed a cruel, controlling side to her personality.

Mamah Borthwick's comeback began with the discovery in the Swedish Royal Library of the letters written by her to Ellen Key between 1910 and 1914. The letters finally gave her a voice of her own. Lena Johannesson, a professor of art history at Linkoping University in Sweden, first revealed the contents in a Nordic women's studies journal in 1994. An English version appeared in 1995, followed by a widely admired article published in 2002 by Wellesley architectural historian Alice T. Friedman.[9] The Key archive also includes a wrenching letter written by Wright in December of 1914, replying to Key's condolences.

BACK IN THE SPOTLIGHT

After scholarship, the second avenue through which the story of the first Taliesin was rediscovered was popular culture. Frank Lloyd Wright had been lost to a generation,

a critic for the *Los Angeles Times* observed in 1988, speaking of "the dark ages for Wright designs, which preceded his death in 1959 and spanned the following generation."[10] Tastes in modern design had shifted to Bauhaus and Scandinavian styles, the writer said—an ironic development, since the mother of Scandinavian modern design was none other than Ellen Key. Her pamphlet *Beauty for All* (1899), expanded and published as *Beauty in the Home* (1913), set off the revolution, but Mamah Borthwick never translated it. It was not available in English until 2008, when the Museum of Modern Art published *Modern Swedish Design: Three Founding Texts.*

It took another shift in tastes—to the glowing copper, fumed oak, matte-green pottery, and stained-glass glories of the American Arts and Crafts Movement—to revive interest in Wright's early decorative objects and Prairie houses. Wright had been a major contributor to the Arts and Crafts campaign for domestic reform and simplicity in design, which peaked between 1890 and 1920. David Hanks's *The Decorative Designs of Frank Lloyd Wright* (Dutton, 1979) opened a roadmap to connoisseurship in the 1980s for star collectors such as Barbra Streisand; action-film producer Joel Silver; and the insatiable Thomas Monaghan, owner of Domino's Pizza and the Detroit Tigers.

Then early Wright designs became big box office, commanding record prices at auction houses and prompting a wave of affordable knock-offs. Suddenly everyone was wearing "balloons-and-confetti" scarves and putting Midway Gardens sprites in their gardens—both products of Frank and Mamah's Taliesin.

Early Wright designs became big box office, commanding record prices at auction houses and prompting a wave of affordable knock-offs. Suddenly, everyone was wearing "balloons-and-confetti" scarves and putting Midway Gardens sprites in their gardens—both products of Frank and Mamah's Taliesin.

The run on Wright designs, which led some Wright homeowners to cannibalize their residences for prized windows, lamps, and pieces of furniture, led to the

creation of the Frank Lloyd Wright Building Conservancy in Chicago in 1989. Wisconsin caught the wave that same year, and Governor Tommy Thompson created the Taliesin Preservation Commission. In return for preservation funds the Fellows agreed to allow a nonprofit group, Taliesin Preservation Inc., to restore the buildings and run public tours. Taliesin tourism got its start.

Stage and film productions came next. The Wright-Borthwick story was dramatized in Daron Hagen's opera *Shining Brow*, written in 1989 and first performed by the Madison Opera in 1993. Their life together was a subject of Jeffrey Hatcher and Eric Simonson's three-act play *Work Song*, which premiered in Milwaukee in 2000. Ken Burns included the story in his 1998 PBS documentary, *The Legacy of Frank Lloyd Wright*.

"The Murders at Taliesin," a cover story I researched and wrote for *The Capital Times* of Madison in 1998, attracted the attention of the E! Entertainment Network's *Mysteries & Scandals* documentary series, which produced an often-repeated Wright segment in 1999. The BBC's Channel 9 used the article for *Frank Lloyd Wright: Murder, Myth and Modernism*, an hour-long documentary that aired in 2005. And William R. Drennan built a book around the article, *Death in a Prairie House: Frank Lloyd Wright and the Taliesin Murders*.[11]

The Wright-Borthwick saga hit the fiction bestseller list in 2007 with the publication of Nancy Horan's novel *Loving Frank*. Horan, an Oak Park native with reporting experience, combined her own research with Mamah's letters, Wright's autobiography, other recent biographies, and her own imagination to produce a sympathetic retelling of the story from Mamah's point of view.[12] So popular has this story been that Taliesin Preservation Inc. in 2010 added a "Loving Frank Tour," which until recently would have been simply unthinkable.

NEWS FROM 1911

In 1992, Anthony Alofsin wrote: "The photographic history of Taliesin I is very short."

In 1997, Kathryn Smith, another Wright authority, said: "Little is known of the details of Wright's daily life with Mamah Borthwick at Taliesin between 1911 and 1914."[13]

Both statements were true when they were written. Neither is true today.

Like Brigadoon, the mythical village that appears once in 100 years, Taliesin I is emerging from the mists.

I expect—and hope—that the new images and information in this book will be eclipsed by even newer discoveries about the first Taliesin. It was Frank Lloyd Wright's most personal creation—his labor of love—and deserves attention. But I am pleased, as a third-generation journalist, to be able to deliver some hundred-year-old scoops.

This book began suddenly in February 2010 when I discovered an Internet reference to a Taylor Woolley photo collection at the Utah State Historical Society that included photos of "Taliesen [sic] I under construction." I ordered the collection and was amazed by what arrived. There was no descriptive information with the images, but Keiran Murphy, Taliesin Preservation Inc.'s knowledgeable historian, helped me fill in the blanks with thirty-seven pages of notes.

Although many Taliesin views were new, I recognized others as being the same as pictures in the anonymous album titled "Taliesin" that the Wisconsin Historical Society had captured on eBay in 2005. After matching Utah negatives to a majority of the album's pictures, I concluded that the photographer for both was Woolley.[14]

I then discovered that Woolley had not been alone when he was present at the creation of Taliesin, but had a Utah friend with him, Clifford P. Evans, them 22, with whom he shared the rest of his professional life. The picture of both of them standing and holding brushes and buckets of wood stain outside Taliesin—two of the "young men in architecture" of whom Wright was so fond—was tucked away in Evans's papers at the University of Utah's Marriott Library. My researcher in Salt Lake City, Butch Kmet, who lives in a 1911 Woolley-designed bungalow, dug out that photo and others as well, helped me document Woolley's illustrious Mormon pioneer family history. (Both the Taylors and Woolleys were eminent founding families. Taylor Woolley himself was not religious but benefted from his legacy.)

Another discovery came closer to home. I had seen Frank Lloyd Wright's 1900 photos of Jones Valley and his aunts' progressive Hillside Home School in the Wisconsin Historical Society's archives. But it took the sharp eye of my wife, Elaine DeSmidt, to discover that three of Wright's winter landscapes fit together into a single valley-wide panorama.

Checking out leads buried in Mamah's letters produced Floyd Dell's previously unnoticed defense of her in the *Chicago Evening Post,* which she sent as a clipping to Ellen Key early in 1912. Dell, editor of the Post's *Friday Literary Review* and leader of Chicago's avant-garde, was incensed at the "hunting and harrying" of Mamah and worried that Wright would be ruined as an artist. There was no copy of Dell's article to be found at any institution in Chicago, but Whitney Harrod, a tenacious journalism graduate student at Northwestern, tracked it down for me at Harvard.

Another Mamah reference, to a visit in 1914 by women's movement leader Charlotte Perkins Gilman, led me to reconstruct a meeting at Taliesin of three important feminists: Borthwick, the voice of Ellen Key in America; Gilman, Key's arch-nemesis on the question of whether all mothers are born to raise children; and Zona Gale, a playwright and leader of the Wisconsin suffragist movement who had recently traveled from Chicago to Wisconsin in the company of Gilman and Margaret Woodrow Wilson, the president's singing daughter.

My biggest thrill was exploring a single photo, the picture of Wright's newly-built puppet theater sitting in the unfinished living room of Taliesin. The only known photo of the theater was taken at Wright's Chicago Art Institute show in 1914, where he labeled it "Marionette Theatre, Made for Llewellyn Wright." The Taliesin picture speaks volumes about the father's conflicted situation—building a lavish gift for his youngest son at the same time he is building a permanent home away from him.

Studying the scenery in Wright's color rendering for the theater, I saw that it depicts a villa with a low-walled terrace and cypress trees and hills in the distance—a memory from Fiesole, which I had visited in 2004. Feeling like the photographer in Antonioi's film *Blow-Up,* I zoomed in. That revealed a tower with a balcony, and in the balcony the figure of a woman leaning over to listen. On the terrace stands a man delivering a speech.

They are without a doubt Romeo and Juliet. Wright, as he builds a hillside refuge for himself and his beloved, has created "a world in little" depicting Shakespeare's classic drama of impossible love. It is a play within a play.

RON McCREA
Madison, Wisconsin, November 15, 2011

Notes

1. Mamah Borthwick to Ellen Key, undated letter. Ellen Key Archive, Royal Library of Sweden, Stockholm. The author is grateful to Nancy Horan for sharing her set.
2. Frank Lloyd Wright to Taylor Woolley, July 10, 1912. Used with permission, Frank Lloyd Wright Foundation, Scottsdale, AZ.
3. Mamah Borthwick to Ellen Key, July 10, 1912. Ellen Key Archive.
4. "Taliesin, the Home of Frank Lloyd Wright and a Study of the Owner," *Western Architect* (February 1913), v. 19, 16. To view Wright's evolving drawings and plans, see Anthony Alofsin, "Taliesin I: A Catalogue of Drawings and Photographs," in Narciso Menocal, ed., *Wright Studies, Volume One: Taliesin 1911–1914* (Carbondale: Southern Illinois University Press. 1992), 98–141.
5. Frank Lloyd Wright, *An Autobiography* (1932), reprinted in *Frank Lloyd Wright: Collected Writings*, v. 2, Bruce Brooks Pfeiffer, ed. (New York: Rizzoli International Publications, 1992), 221. Wright's sole reference to Borthwick by name in this edition is the sentence "Totally—Mamah was gone."
6. *Home News*, Spring Green, Wisconsin, August 20, 1914. For the full text, see p.145.
7. Pfeiffer, introduction to *An Autobiography,* 103
8. "A Hymn to Nature," *The Little Review* (October 1914), v. 1, 30. Wright published this poem in the Spring Green *Home News* on August 20 with his own introduction: "A fragment: A 'Hymn to Nature,' unknown to us in the works of Goethe, we found in a little bookshop in Berlin. Translated by us from the German—together—it comforted us. It is for the strong, and saved from destruction only because I carried it in my pocket. I give it here to those who cared for her." A gold-stamped, color-illustrated edition of 100 copies of Johann Wolfgang Goethe's *Die Natur: Ein Hymnus* was published by the Ernst Ludwig Presse of Darmstadt in 1910, while Wright and Borthwick were in Germany. It is the kind of little luxury Wright would have found hard to resist. Goethe's *Die Natur: Fragment* was first published in 1783.
9. Lena Johannessen, "Ellen Key, Mamah Bouton Borthwick and Frank Lloyd Wright: Notes on the Historiography of Non-Existing History," *NORA/ Nordic Journal of Women Studies* (Scandinavian University Press), No. 2

1995, 126–136; Alice T. Friedman, "Frank Lloyd Wright and Feminism: Mamah Borthwick's Letters to Ellen Key," *Journal of the Society of Architectural Historians* (June 2002), v. 61, No. 2, 140–151.
10. Elizabeth Venant, "The Wright Time for Household Objects: The Great Architect's Creations for Homes Are Now Commanding Respect—and Top Prices," *Los Angeles Times*, December 4, 1988, Calendar, 8.
11. Ron McCrea, "The Murders at Taliesin," *Capital Times*, August 15,1998, 1A. Drennan's book was published in 2007 by the University of Wisconsin Press.
12. Nancy Horan, *Loving Frank* (New York: Ballantine Books, 1977). Another novel, T.C. Boyle's *The Women* (New York: Viking, 2009), offers vivivd portraits of each of Wright's loves in reverse order and with a more ironic tone. Mamah is portrayed as a proselytizing feminist and seductress with a "carefree, rippling laugh that was calculated to freeze any woman to the core and make any man turn his head."
13. Anthony Alofsin's quote is from Alofsin"Taliesin I, 124. Kathryn Smith's quote is from *Frank Lloyd Wright's Taliesin and Taliesin West* (New York: Harry N. Abrams, Inc., 1997), 49. In this book she is the first to publish Taylor Woolley's 1911–1912 photos of the Taliesin dining area and the triptych of the living room (on pp. 54–55). In an e-mail to the author on January 31, 2012, Smith says that she did not see the original prints but "published a copy of a copy."
14. The reference number of the Taylor A. Woolley Collection at the Utah State Historical Society is C-340 and the photos are in Folders 1–4. The society says it has no background information about how and when it acquired the collection, and notes that it would not be unusual for it to have sat for decades before being noticed. The society posted the Woolley Taliesin photos with identification information provided by Peter Goss for the first time on October 10, 2011. The Woolley photo additions to the Clifford P. Evans Collection at the University of Utah Marriott Library are under reference number P0002. The Woolley collection that includes photos from Italy is under P0025. The Wisconsin Historical Society Woolley and Fuermann collections may be accessed by keyword search at www.wisconsinhistory.org/whi/. A combined gallery of Woolley images, showing sources and overlaps, appears in this book on pp. 96–101.

FROM TUSCANY TO TALIESIN

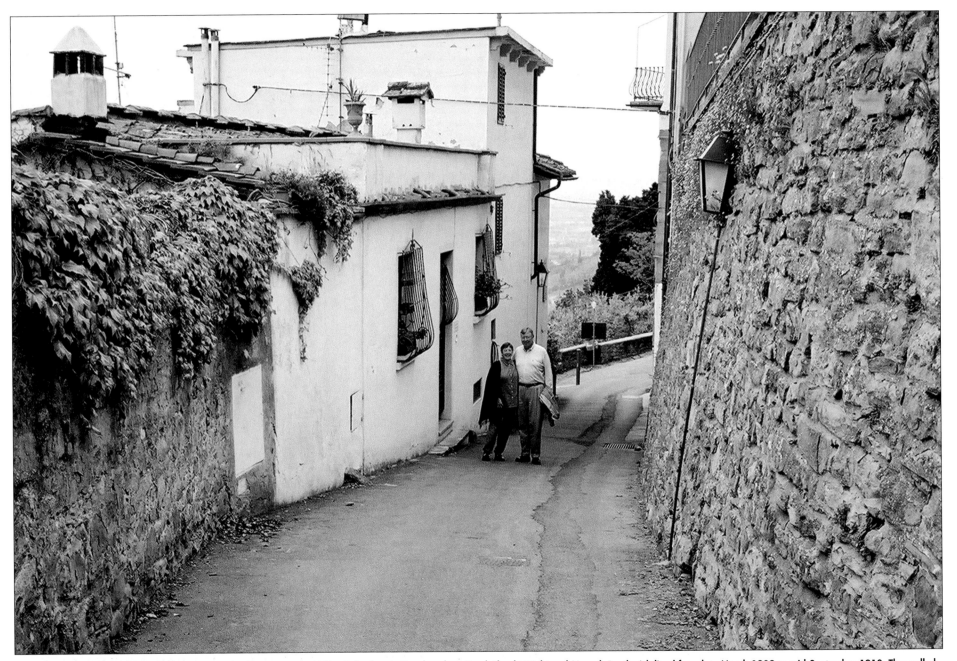

Fig. 8. Elaine DeSmidt and Ron McCrea arrive at the doorway to the Villino Belvedere in Fiesole, where Frank Lloyd Wright and Mamah Borthwick lived from late March 1909 to mid-September 1910. The walled garden at left is part of the residence, which overlooks Florence on the other side.

"How many souls seeking release from real or fancied domestic woes have sheltered in Fiesole!"

—Frank Lloyd Wright, *An Autobigraphy*

By the time Frank Lloyd Wright and Mamah Borthwick reunited in a garden residence overlooking Florence, Italy, in the spring of 1910, they faced a challenge. How would they proceed with their lives?

Each had made a break with their families in the United States the previous fall when they had met in New York and sailed for Europe. Mamah had started the clock on her own divorce in June 1909, when she left for the West and made it clear to Edwin Cheney she was not returning. Wright wrote to Darwin Martin, his client and patron, on September 16 to tell him that he was "deserting my wife and children for one year, in search of a spiritual adventure. You probably will not hear from me again."[1]

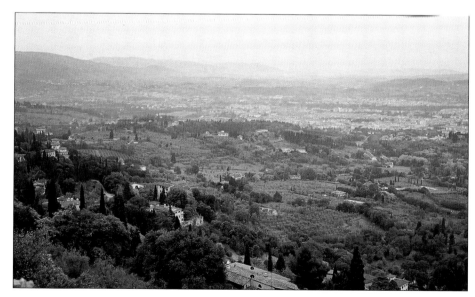

Fig. 9. Wright and Mamah Borthwick enjoyed this view of Florence and the Arno River valley from all levels of the Villino Belvedere. He called their home "this little eyrie on the brow of the mountain above Fiesole—overlooking the pink and white Florence, spreading in the valley of the Arno below." He would later use similar terms to describe Taliesin.

Fig. 10. Bougainvillea cascades from the crannied wall that supports the Villino Belvedere and its garden, above, on the valley-facing side of the house. The photo is taken from the lower Via della Doccia.

Fig. 11. Taylor Woolley took this photograph of the drafting work room of the Villino Belvedere in 1910. A draftsman, possibly Frank Lloyd Wright Jr., is hunched over a drawing at left. The view from the desk beside him is blocked by a potted plant that Woolley may have placed there for effect. The drawings on the wall that they are retracing for the Wasmuth Portfolio are identifiable. From left: Plate XIX, ground plan and site plan, Emma Martin House (Fricke-Martin), Oak Park, Illinois; Plate XXVIII, ground plan and site plan, Francis W. Little House, Peoria, Illinois; Plate XXXI(b) (behind the plant), ground plan, Susan Lawrence Dana House, Springfield, Illinois; Plate XXIII (top), "A Small House With Lots of Room in It," *Ladies Home Journal*, 1901, described in the portfolio as "Typical low-cost suburban dwelling"; Plate LV (bottom), ground plan and site plan, Yahara Boat House, Madison, Wisconsin.

Wright and Borthwick were exposed when a Chicago newspaper reporter found them registered as husband and wife at the Adlon Hotel in Berlin. They traveled to Paris and temporarily parted ways, with Mamah going to Nancy, France, and then Leipzig. There she found work teaching English as a second language.

Although his business was in Berlin, Wright went to Florence. There, in an apartment of the villa Fonte della Ginevra overlooking the Arno River, he was joined by his son Lloyd Wright, 19, and Taylor Woolley, 25, who had come to assist him with the prepress work for a lavish two-volume compendeum of his pioneering architecture. Its title was *Ausgeführte Bauten und Entwürfe von Frank Lloyd Wright (Studies and Executed Buildings by Frank Lloyd Wright).* Its publisher was Ernst Wasmuth, Berlin, and it became known as the Wasmuth Portfolio.[2]

In February 1910, anticipating Borthwick's arrival, Wright moved the studio and living quarters to the two-story Villino Belvedere in the hillside town of Fiesole. The garden residence enjoys a panoramic view of Florence and the Arno River Valley. The entrance is on the upper level, on the Via di Montececeri, which splits off from the Via Verdi below the larger Villa Belvedere next door. A thick door and a brick wall protect the home and garden.

From the Villino Belvedere it is a two-minute walk to the town plaza, where in 1910 one could catch an electric tram for a 30-minute ride down the hill into central Florence. It is also a two-minute walk from the Fiesole main plaza to a beautiful archaeological park set in a natural bowl. Wright could stroll among the remains of a Roman amphitheater, walk a Roman road, climb Etruscan steps, and imagine the pleasures of what once had been a Roman spa with hot and cold baths and lap pools. At this cool and inviting altitude, visitors to the classical retreat enjoy a refreshing view of Tuscan hills framed by cypress trees.

It was in this setting that Wright and Mamah reunited to ponder their future together. Wright's work on the Wasmuth Portolio was well along. He told his mother, "The work of the publication has prospered. It is going to be all I expected and more. There will be twenty-five plates from my own handwork done here beside all the redrawing, retouching, arranging, the editing, etc. . . . There will be one hundred in all. I am depending upon this to give my feet a secure footing when I come back . . . The financial return from it should be considerable."[3]

In February, with Mamah's arrival imminent, he sent his two young draftsmen off to tour Italy. Lloyd continued on to France and sailed for New York on March 12. Woolley returned to Fiesole and lived with Wright and Borthwick until mid-June. Then he departed, carrying with him a gift of dictionaries from her and a letter of recommendation from Wright praising him as "faithful and an effective draughtsman."[4] After that, the couple had the house and garden and Italy to themselves.

Even 20 years later Wright could summon up detailed memories of that time. "Walking together up the road from Firenze to the older town, all along the way the sight and scent of roses, by day. Walking arm in arm, up the same old road at night. Listening to the nightingale in the deep shadows of the moonlit woods . . . trying to hear the songs in the deeps of life: Pilgrimages to reach the small

> *"[Mamah] told her husband one year before she went away with me that she would go with me married or not whenever I could take her."*
> —Frank Lloyd Wright to his mother, July 4, 1910

solid door framed in the solid blank wall in the narrow Via Verdi itself. Entering, closing the medieval door on the world outside to find a wood fire burning in the small grate. Estero in her white apron, smilingly, waiting to surprise Signora and Signore with, ah—this time as usual the incomparable little dinner, the perfect roast fowl, mellow wine, the caramel custard—beyond all roasts or wine or caramels ever made. I remember."[5]

It was an idyllic time in an idyllic setting. Wright told his mother he wished she and her sisters could "take a cottage for three months here in this garden spot of the earth. I would know how to tell you how you could get the most out of it." But as good as life was, both Wright and Borthwick worried about the future. "I have been so troubled and perplexed that I have not known what to write," he said. "It might be one thing one day and another the next."[6]

Borthwick wrote to Ellen Key, her feminist mentor in Sweden, "My perplexity and doubt is great that perhaps that path was not after all the one I should have taken—perhaps it is not mine. Your torch however will also light me to the

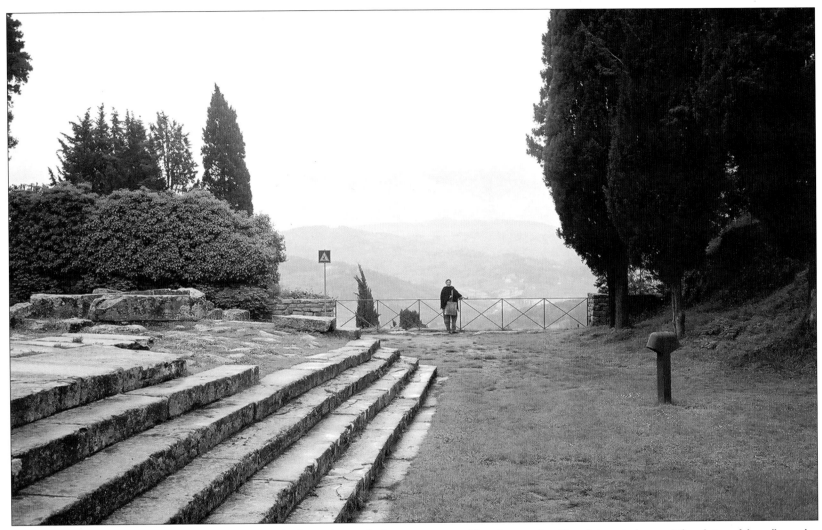

Fig. 12. Steps built by the Etruscans in the fourth century BCE lead up to the site of a former Etruscan, and later Roman, altar. The religious site has a privileged view of the valley and hills beyond. The vista resembles Frank Lloyd Wright's scenic backdrop for the puppet theater he built a year after he left Fiesole.

true path—the path true for myself—if I have mistaken it."[7]

Key's writings gave them a rationale for their relationship. In *Love and Marriage* and *Love and Ethics*, Key argues that the only moral basis of marriage is love—not law, not religious sanction, not family custom; and that marriage based on anything other than love is dangerous to the health of society and children and the progress of the human race. (Key was a dedicated social Darwinist.) Borthwick translated *Love and Ethics* from German with help from Wright, who had a flair with English, during their summer in Italy. It was published in Chicago in 1912 at Wright's expense with both of them listed on the title page as translators.[8]

Fig. 13. Houses are built organically into the side of the hill on the street just above Wright's Villino Belvedere.

NO GOING BACK

At some point in their Tuscan summer, Wright and Borthwick devised a plan to reenter the United States and resume their life together in one year. It worked: In August 1910 they were together on a hillside in Italy, and in August 1911 they were together on a hillside in Wisconsin.

Fig. 14. Taylor Woolley photographed the Villino Belvedere in Fiesole in 1910. He stayed there with Frank Lloyd Wright, Mamah Borthwick Cheney, and Lloyd Wright, and worked in the studio.

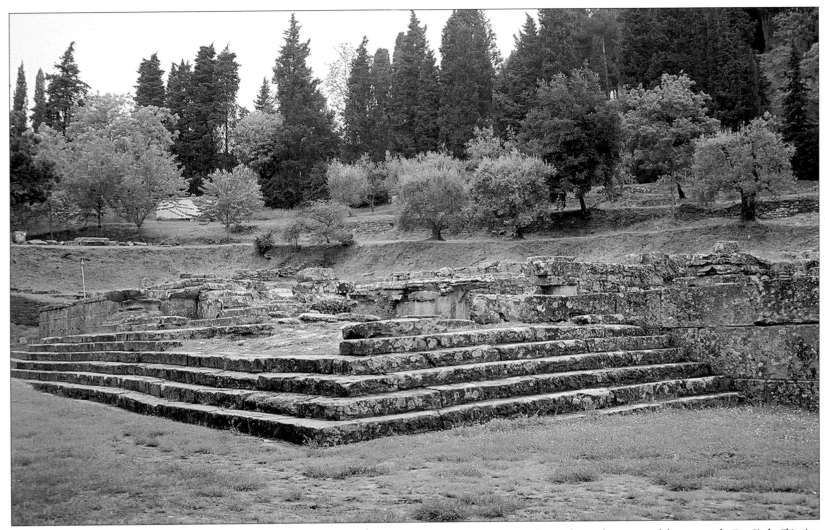

Fig. 15. Etruscan steps, retaining wall, and terraces grown with olive trees resemble the landscaping of the hill garden above Taliesin's forecourt and the steps to the Tea Circle. This site was used in a scene in Franco Zeffirelli's *Tea With Mussolini* (1999), in which Lily Tomlin plays an American archaeologist.

For them to return to Oak Park, Illinois, and resume the status quo ante was out of the question. In Wright's letter to Anna Lloyd Jones Wrignt on July 4, he says he can just imagine their reception: "I am the prodigal whose return is a triumph for the institutions I have outraged. A weak son who, infatuated sexually, has had his passion drained and therewith his courage, and so abandoning the source of his infatuation to whatever fate may hold for her."

For Mamah, life will become "a hard, lonely struggle in the face of a world that writes her down as an outcast to be shunned – or a craven return to another man, his prostitute for a roof and a bed and a chance to lose her life in her children, [so] that something—some shred of self-respect, may clothe her nakedness. While I return to my dear wife and children who all along 'knew I would' and welcomed by my friends with open rejoicing and secret contempt."

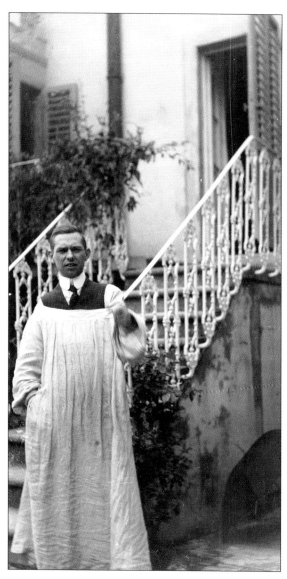

Fig. 16. Taylor Woolley, 25, stands in the garden behind the Villino Belvedere in 1910, wearing his protective smock. The draftsmen used crow-quill pens and India ink made from lampblack in their work. This photo was previously thought to be of Lloyd Wright, but Anthony Alofsin confirms that it is of Woolley.

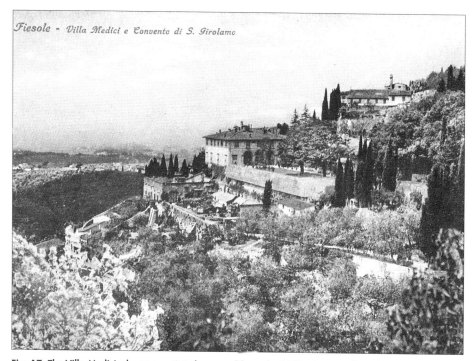

Fig. 17. The Villa Medici, shown in a tinted postcard from the 1920s, interested Frank Lloyd Wright with its terracing and hillside views. It has been called a possible inspiration for the siting and gardens of Taliesin.

Wright finds this idea unbearable. He accuses his family members of making return impossible through their failure to tell the simple truth about the rupture of two marriages. Rather than admit to the press that the breakups were expected and long in coming, he says, they gave credence to the story that Wright had suddenly and deceitfully "eloped with the wife of my friend." He spells out the true story as he sees it:

[Mamah] had left her home forever three months before she went away with me, as her husband knew. You knew and Catherine knew that I was going to take her away with me as soon as I could, as I had declared openly to you both and her husband a year before I did take her. There was no deception that makes the 'runaway' match of the Yellow Journal anywhere.

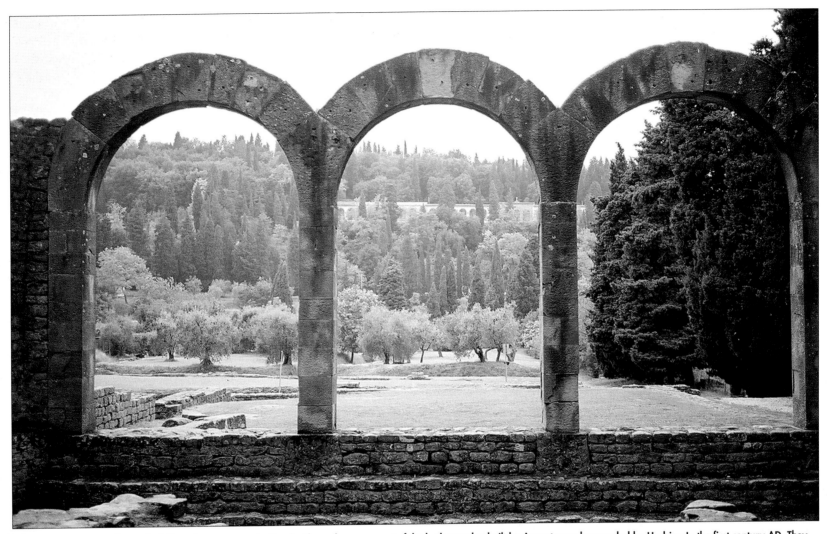

Fig. 18. Roman arches frame the hills and a monastery in Fiesole. The arches were part of the bath complex built by Augustus and expanded by Hadrian In the first century AD. They housed the cold, warm, and hot baths, called the frigidarium, tepidarium, and caldarium. Beyond are long swimming troughs resembling lap pools.

She went with me knowing what you and Catherine knew, that I would in any case have separated from Catherine—though I might have continued under the same roof with her for the sake of the children—even that I told you I was determined not to do.

She told her husband one year before she went away with me that she would go with me married or not whenever I could take her. Marriage was never a condition with her any more than it was with me—except that in order to work I felt this must take place when it might, if it might. It seemed at one time (owing to the requests of her husband solely) as though this were to be made a condition—and so I misunderstood it myself for a time, but this was never her stipulation nor did she ever hide behind it.

I may be the infatuated weakling, she may be the child-woman inviting harm to herself and others—but nevertheless the basis of this whole struggle was the desire for a fuller measure of life and truth at any cost, and as such an act wholly sincere and respectable within, whatever aspect it may have worn without. This by my return I discredit because I seemingly endorse the character made for it publicly by those whom by my returning to them I seem to endorse. This bitter draught seems to me almost more than I can bear . . . I turn from it in disgust.[9]

What is the alternative? Wright drops a broad hint to his mother: He would like to buy land in her Wisconsin valley, next to his sister Jane and her husband Andrew Porter's farm. "I would like to farm it beside him—with that tract of Reider's and Uncle Thomas' farm joined together." He has just described the site of Taliesin.

"But my situation is too discouraging to contemplate such luxury," he adds. "I must earn at least $5,000 every year [$115,000 in 2010 inflation-adjusted dollars] to keep two boys in college and pay household expenses at the rate they have gone in my absence—this with no account of my own needs . . . This doesn't look much like a farm to me."

He says that he has spent money to bring Lloyd to Europe and has just sent money to bring their daughter Catherine, 16, to England to spend two months with Charles and Janet Ashbee, "which will be more to her than a college education, I am sure." The younger children "have their pony still—and what they can have lacked in money or luxuries is beyond my imagination." Wright reports that his wife is spending $275 [$6,353] per month "for household expenses merely," and that he has provided cash totaling $4,500

"I would like to farm it beside him—with that tract of Reider's and Uncle Thomas' farm joined together."

Wright's first mention of the site of Taliesin, next to the Porter farm, written in Italy, July 4, 1910

[$104,000]. "It is a constantly increasing load."[10]

Then he makes a threat: If it comes down to his life or theirs, he will cut the family loose. "The personalities of the children are dear to me—just the same, and I must make the struggle—I can see in no way how I can do otherwise than let this load drop and die to them one and all if I [am] to find the happiness in the life I planned and hope to lead anew."

Wright's threat may have been calculated to mobilize his mother to help him acquire that Wisconsin land. Ten months later, she would. He never made good on his threat.

SISTERLY ASSISTS

The elements of Wright and Borthwick's one-year plan were simple but would demand stealth. Wright, pretending to give up Mamah, would reassemble his architectural practice in Oak Park and Chicago. He would quietly set up a separate income stream to support Catherine and the children. He would quietly build a new home far away from Chicago.

Mamah would stay behind in Europe, out of sight. When the way was clear she would come back through New York, spend time with her children in Canada, divorce her husband, and quietly join Wright at their new home.

Both of them found support from their sisters. Wright's sister Jane (Jennie) Porter named her newborn son Frank on May 29. "Jennie certainly nails

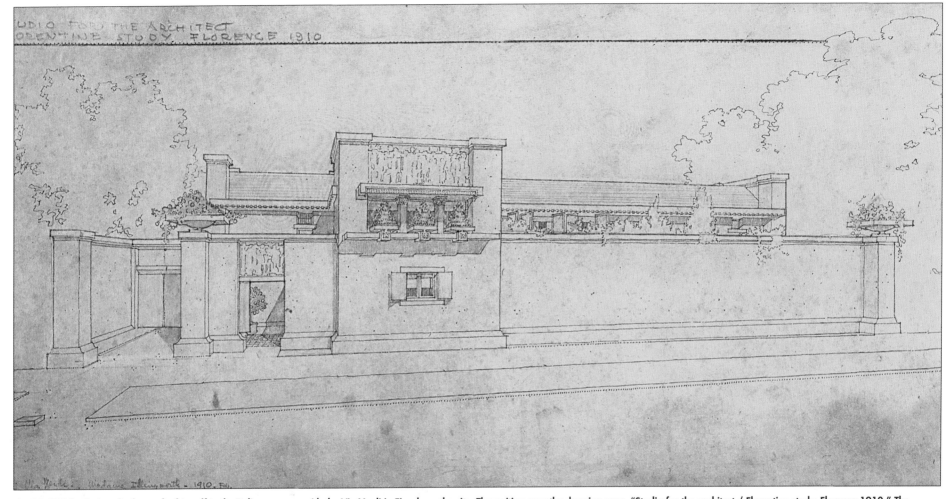

Fig. 19. Wright designed a house for himself in the Italian manner with the Via Verdi in Fiesole as the site. The writing over the drawing says, "Studio for the architect / Florentine study, Florence 1910." The writing below says, "VILLA: Florence Italy—Via Verdi. Madame Illingsworth—1910. Feb." She was the owner of the Villa Belvedere and the Villino next door. Wright's plan has a walled garden on the street side—visitors walk through it to the house in an enclosed entryway that also contains a work space. The home is of two stories and opens to a garden in the rear.

her colors to the mast and such courage to name the child after a brother in disgrace," Wright wrote to his mother. "It was like her, though, and through this perhaps we see Jennie as she really is."[11] When Borthwick arrived at Taliesin, she stayed initially with the Porters at Tanyderi. "She has championed our love most loyally, believing it her brother's happiness," Borthwick wrote of Jane to Ellen Key.[12]

Mamah's sister was Elizabeth V. (Lizzie) Borthwick, a teacher who lived in the Cheney household in Oak Park and looked after Mamah's children. "Only my sister's being there made my absence possible," Mamah wrote to Key. It has recently come to light that Lizzie Borthwick traveled to Europe in the summer of 1910. No doubt she had a serious consultation with her sister about the course ahead. "We do not know when and where the two sisters met," writes

Filippo Fici, the Florentine architect who made the discovery, "but we know that Lizzie left from the port of Rotterdam for New York aboard the ship *Noordam* on August 20."[13]

She would have had just enough time to get back to Oak Park for the opening of the brand-new Washington Irving Elementary School, where she was one of three founding teachers.[14]

HOMECOMING

On October 12, 1910, Catherine Wright wrote Janet Ashbee to say that her husband was home again. "Mr. Wright reached here Saturday evening, Oct. 8th, and he has brought many beautiful things. Everything but his heart, I guess, and that he has left in Germany."

She added, "As near as I can find out he has only separated from her because he wishes to retain the

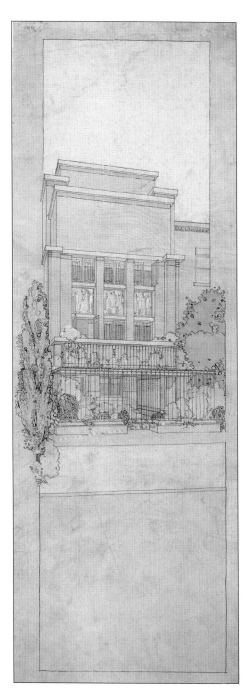

Fig. 20. Frank Lloyd Wright designed a townhouse in 1911 to be built on a narrow lot on Goethe Street, a fashionable address on Chicago's near north side. It could have served as a winter residence and studio for the architect and Mamah Borthwick but was never built. Its features included skylights and a music balcony over the dining area. It has an exterior balcony on the gracious second level, known in Italy as the *piano nobile*.

beauty and ideality of their relationship and feared that by staying with her that he would grow to loathe her."[15]

That was hardly the truth. But if Wright dissembled about Mamah with Catherine, he lied openly to Darwin Martin. "The unfortunate woman in this case is making her way herself," he wrote Martin on November 22. A week later, he told him: "I have left the woman you have in mind to make her future plans as though I were dead."

Anthony Alofsin notes: "Wright was now obliged to lead a double life: a life of denying his love for Mamah Cheney while planning his future around her."[16]

Eight weeks later he was back in Germany, having sailed aboard the *Lusitania* on about January 16, 1911. He needed to resolve issues with Ernst Wasmuth, his publisher, but those issues were settled by February 13. Wright stayed on through the end of March, and no doubt met again with Mamah.

Events leading to the establishment of Taliesin unfolded rapidly after his return. On April 3, he wrote to Darwin Martin requesting money to help his mother purchase property "up country" for "a small house." On April 10, Anna signed the deed to purchase the Reider property he had mentioned in Italy—next to the Porter farm, including a hill with commanding views of the Wisconsin River and the valley of his ancestors. The first plan of Taliesin was in Anna's name. This deflected attention from Wright and protected the property from any legal claim by his wife. Site preparation began in the spring.[17]

Borthwick arrived in New York in June and paid a visit to the office of George Putnam, president of G. Putnam's Sons, which would publish *The Woman Movement*. According to her letters, she then joined her children in Canada for the summer, perhaps with help from Lizzie. Mamah's divorce was made final in Cook County Court on August 5, with Edwin claiming desertion. He remarried a year later, as soon as he could, and sent the children, John and Martha, with Lizzie to stay with Mamah at Taliesin in 1912 while he honeymooned in Europe.[18] His new bride was Elsie Millor, whom Mamah described as Lizzie's "dear friend." Elsie and Edwin later had three children and moved to Missouri.

Mamah Borthwick, her maiden name now officially hers (she had begun to use it in Europe),[19] came to her new home in Wisconsin in August. Wright

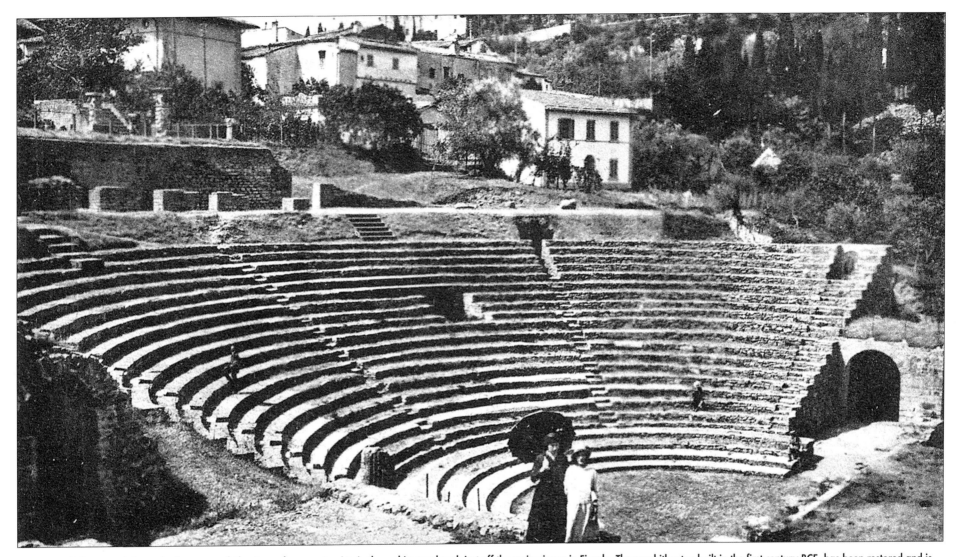

Fig. 21. A 1910 postcard shows the Roman amphitheater and women tourists in the architectural park just off the main piazza in Fiesole. The amphitheater, built in the first century BCE, has been restored and is now used during summer festivals.

called Taylor Woolley back from California on August 31 to work at Taliesin and provide Mamah with a familiar face. Wright divided his time between Taliesin and the remodeling of the Oak Park home and studio. He separated the property into two buildings, one for a home for Catherine and the other for an income property for Catherine. The rental house was advertised in December. By that time, Wright had moved permanently to Taliesin. The one-year plan was complete.

During the summer Wright had drawn plans for a four-story townhouse on

Goethe Street in a fashionable neighborhood on Chicago's near north side. It featured skylights and a music balcony overlooking the entertainment area, much like the one he built for Susan Lawrence Dana in Springfield, Illinois. In her first letter from Wisconsin, Borthwick told Key that Wright "has been building a summer house," suggesting that a winter residence was also being considered. But the Goethe Street townhouse was never built. For the next three years, Taliesin was their home for all seasons.[20]

VILLA TALIESIN

In a letter from Italy to Charles Ashbee, Wright had described his situation lyrically. "I have been very busy here in this little eyrie on the brow of the mountain above Fiesole—overlooking the pink and white Florence, spreading in the valley of the Arno below—the whole fertile bosom of the earth seemingly lying in the drifting mists or shining clear and marvelous in this Italian sunshine—opalescent—iridescent."[21] Wright had discovered *la bella vita*—the beautiful life. Florence and Tuscany, with their lush gardens, good food, musical language, civilized manners, and folkloric as well as historic architecture, had given Wright a new feeling for organic living.

He looked at buildings and made drawings. Marie Sophie (Mascha) von Heiroth, a Russian pianist and translator, and her husband, Alexander (Sasha), an actor and painter, shared the villa Fonte della Ginevra complex in Florence with Wright and the young men. When he moved to Fiesole they visited on Easter Sunday and he showed them drawings of houses inspired by Tuscan Villa traditions. Her grandson, Claes von Heiroth, notes, "He had especially studied Michelozzo's Villa Medici in Fiesole."[22]

That villa has been identified by several architectural authorities as a possible inspiration for Taliesin. Like Taliesin, it is terraced into the side of a hill, with the top garden level above the house and another below. It enjoys commanding views of the Arno River Valley and Florence. It dates from mid-fifteenth century, when Cosimo the Elder hired Michelozzo Michelozzi to design it for his son Giovanni dei Medici. Lorenzo the Magnificent inherited it

in 1469, and the house gained fame as a gathering place for artists, writers, and philosophers.

Architectural writers say the Villa Medici was a departure from the castle-style villas built to defend rural landholders. It was an open and artistic "villa suburbana," enjoying full communion with surrounding nature—gardens, pools of water, breezes, and the changing seasons.[23] Taliesin would be like that.

In his introduction to the Wasmuth Portfolio, Wright shows how far he has come in his appreciation of Italian style. He has been privileged, he says, to be able to study the work of "that splendid group of Florentine sculptors and painters and architects, and the sculptor-painters and painter-sculptors who were also architects." But greater than all these is the organic beauty of Tuscany's "indigenous structures, the more humble buildings everywhere, which are to architecture what folklore is to literature or folk songs are to music."

In these buildings, which do not reflect the religious piety of churches or the "cringing to temporal power" of palaces, one finds "the love of life which quietly and inevitably finds the right way."

Wright continues: "Of this joy in living, there is greater proof in Italy than elsewhere. Buildings, pictures and sculpture seem to be born, like the flowers of the roadside, to sing themselves into being. Approached in the spirit of their conception, they inspire us with the very music of life.

"No really Italian building seems ill at ease in Italy. All are happily content with what ornament and color they carry, as naturally as the rocks and trees and garden slopes which are at one with them. Wherever the cypress rises, like the touch of a magician's wand, it resolves all into a composition harmonious and complete.

"The secret of this ineffable charm . . . lies close to the earth. Like a handful of the moist, sweet earth itself, it is so simple that, to modern minds trained in intellectual gymnastics, it would seem unrelated to great purposes. It is so close that almost universally it is overlooked."[24]

Here, in a few sentences, is the kernel of Wright's manifesto for the natural house. Taliesin would be the first example to come from his hands.[25]

IN WRIGHT'S WORDS
In Exile

In ancient Fiesole, far above the romantic city of Cities in a little cream-white villa on the Via Verdi.

How many souls seeking release from real or fancied domestic woes have sheltered in Fiesole!

I, too, sought shelter there in companionship with her who, by force of rebellion as by way of Love, was then implicated with me.

Walking together up the road from Firenze to the older town, all along the way the sight and scent of roses, by day. Walking arm in arm, up the same old road at night. Listening to the nightingale in the deep shadows of the moonlit woods . . . trying to hear the songs in the deeps of life: Pilgrimages to reach the small solid door framed in the solid blank wall in the narrow Via Verdi itself. Entering, closing the medieval door on the world outside to find a wood fire burning in the small grate. Estero in her white apron, smilingly, waiting to surprise Signora and Signore with, ah—this time as usual the incomparable little dinner, the perfect roast fowl, mellow wine, the caramel custard—beyond all roasts or wine or caramels ever made. I remember.

Or out walking in the high-walled garden that lay alongside the cottage in the Florentine sun or arbored under climbing masses of yellow roses. I see the white cloth on the small stone table near the little fountain, beneath the clusters of yellow roses, set for two. Long walks along the waysides of the hills above, through the poppies, over the hill fields to Vallombrosa.

Back again, hand in hand, miles through the sun and dust of the ancient winding road, an old Italian road, along the stream. How old! And how thoroughly a road.

Together, tired out, sitting on benches in the galleries of Europe, saturated with plastic beauty. Beauty in buildings, beauty in sculpture, beauty in paintings until no "chiesa," however rare, and no further beckoning work of human hands could draw or waylay us any more.

Faithful comrade!

A dream in realization ended?

No, a woven, a golden thread in the human pattern of the precious fabric that is Life: her life built into the house of Houses. So far as may be known—forever!

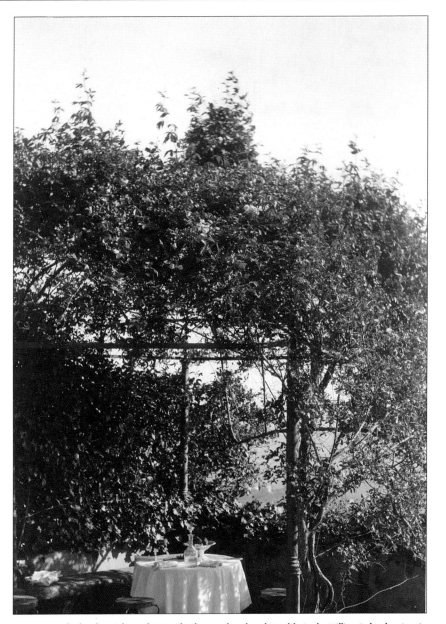

Fig. 22. Frank Lloyd Wright and Mamah Cheney dined at this table in the Villino Belvedere's private garden in 1910. Wright writes of "the white cloth on the small stone table near the little fountain, beneath the clusters of yellow roses, set for two." Photograph by Taylor Woolley.

THE RUSSIANS NEXT DOOR

During the winter of 1909–1910 Frank Lloyd Wright, his 19-year-old son Lloyd, and 25-year-old draftsman Taylor Woolley shared a building in Florence with a Russian family. As Lloyd recalled it, "The villino was divided into two parts opening from a tiny inner court. A charming Russian couple who played chamber music with their friends had one apartment and we enjoyed the cultured company."[26]

The family included Alexander "Sasha" von Heiroth (also spelled Geirot), a painter; his wife, Marie Sophie "Mascha" von Heiroth (formerly Djakoffsky); and their little boy, Algar, who was not yet two. Mascha, beautiful and gifted, spoke six languages, played piano, and sat as a model for several famous artists, according to her grandson Claes von Heiroth, Algar's son.[27] She was married four times; Alexander was her third husband. They later divorced and he went on to act at Stanislawski's Moscow Art Theatre and to appear in early Russian films. One was the 1914 silent production of Pushkin's *Mozart and Salieri* directed by

Viktor Tourjansky, in which he played Wolfgang Amadeus Mozart.[28] The play was later revived by Peter Shaffer as *Amadeus*. Algar grew up to become became Finland's ambassador to Mexico and Israel.

Mascha kept a diary written in French. In 1910 she recorded a visit to the home of Frank Lloyd Wright and Mamah Borthwick, who had invited the whole family, including a nanny, to come up to their new rented home in Fiesole for Easter. Mascha was pleased, because the family was a month away from leaving Italy and it would be a last chance to see old friends and also visit Fiesole, where they had lived and had conceived Algar.

DIARY ENTRY: MARCH 24, 1910

We are in an aviation craze! . . . People are talking of nothing but aviation, which will take place here for the first time. The show will take place on Easter Monday [March 28] at the Campo di Marte. Sasha will go see it; that sort of thing interests him a great deal. I would gladly go too, if someone would only offer a seat in the stands. Otherwise I won't, because it's too expensive, and if there is a huge crowd, I would rather not go.[29]

I'm beginning little by little to say my goodbyes! We are only here for one more month! . . . Sunday we are invited to the home of the architect Wright, who lived near us in the house of the woman who has a husband in Alaska. He has rented the magnificent Villa Belvedere in Fiesole and he invited the entire family

Fig. 24. Marie "Mascha" Djakoffsky von Heiroth (1871–1934), was a Russian translator of several languages who lived near Frank Lloyd Wright and Mamah Cheney in Fiesole in 1910 and kept a diary in French. Her grandson says she played piano and entertained often with her husband, Alexander von Heiroth (also spelled Geirot), a young artist who went on to act in Russian films. Frank Lloyd Wright bought one of his paintings. Mascha sold this portrait, painted in Finland in 1896 by Albert Edelfelt, to the State Hermitage Museum in St. Petersburg, Russia, where it hangs today.

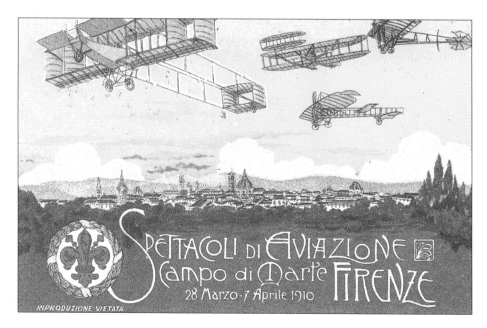

Fig. 23. The 1910 Florence air show was one of the first in Italy. On March 27 Enrico Rougier made the first flight over the city in a Voisin biplane.

there: Sasha, me, Algar, and the maid, as well as the two Halles. Thus it will be a pilgrimage on Easter Sunday and it will probably be our last visit to Fiesole. I would like Algar to see the place where he was conceived two and a half years ago.

DIARY ENTRY: APRIL 1, 1910

Our garden is all white with pear tree blossoms. On the wall behind the house climb the few flowers of the peach tree that our landlord intended to cut down because it does not bear fruit. I, who love

Fig. 25. Mascha von Heiroth kept a diary in French.

it so much for the pretty Japanese pattern that it makes on the wall, did not allow it. I had the double windows taken off to replace them with green shutters the other day, since the nice weather continued. But since yesterday the Tramontana [northern wind] has been blowing, the mountains are once again all white with snow, and we fear that this weather is going to continue.

Last Sunday [March 27] we made our pilgrimage to the Wrights in Fiesole who received us quite well. They live in the charming little Villa Belvedere near our dear old Casa Ricci, with its lovely little garden and its impressive view of Florence. Algar misbehaved without bothering anyone since I brought the maid along with us to take care of him. After lunch, which we ate in a tiny dining room, I accompanied Sasha on Wright's cello,[30] then we looked at his

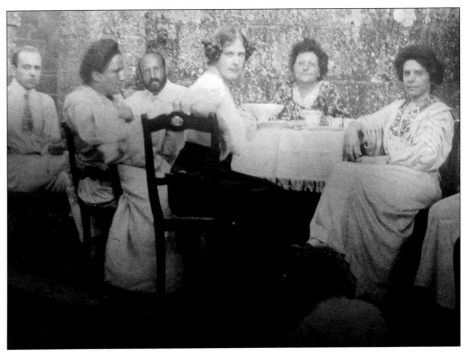

Fig. 26. Alexander (Sasha) Von Heiroth, Gertrude Stein, Leo Stein, Marie (Mascha) Von Heiroth, Sarah Stein, and Harriet Lane Levy socialize at the Villa Bardi in Fiesole in 1908.

extremely interesting drawings of houses, palaces, and churches, after which we went to the piazza.

We stopped a moment at the Casa Ricci where the two elderly ladies Giuseppa and Filomena cried out joyfully on seeing us. Nothing had changed in the little garden. The same romantic clutter ruled as when we were there. No one lives there at present, but Leo and Gertrude Stein come back there for the month of July.[31] So many good memories flashed before my eyes at the sight of this charming little spot. I would have liked to go everywhere I lived in Fiesole—to the Villa Bardi, and toward the lovely pine forest whence the superb road leads to Vincigliata, to Settignano—but time was running out. We had tea one more time on the Hotel Aurora's terrace before taking the tram to the duomo. It was probably the last time I would see Fiesole!!

—*Translation from the French by Jonah Hacker*

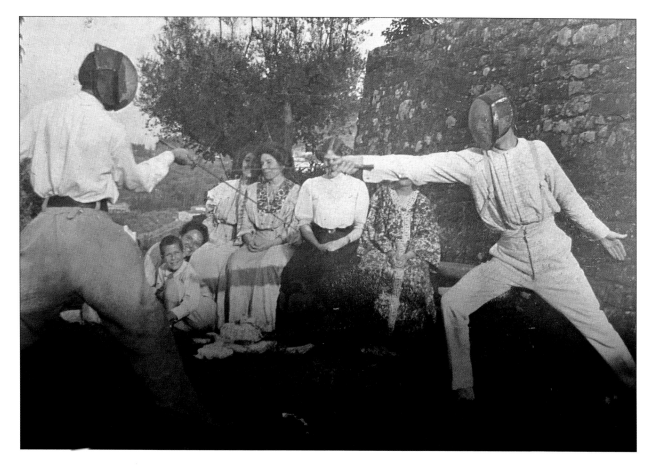

Fig. 27. A fencing demonstration follows luncheon at the Villa Bardi in Fiesole in the summer of 1908. Alexander (Sasha) Von Heiroth, right, fences with Leo Stein, brother of Gertrude Stein. Sasha later had a career as a stage and film actor. Watching them are Allan Stein, 13, son of Michael and Sarah Stein; Gertrude Stein, grinning as she rests her head on the leg of Alice B. Toklas, her new love; Harriet Lane Levy, who traveled to Europe from San Francisco with Toklas but would lose her to Gertrude and return home alone; Maria (Mascha) Von Heiroth; and Sarah Stein, Allan's mother (behind Sasha's sleeve). Pablo Picasso painted a portrait of Allan in 1906. Michael Stein, Allan's father and Gertude's brother, is the likely photographer. Photos from Mascha's albums are courtesy of Claes Von Heiroth.

NOTES

1. Frank Lloyd Wright to Darwin Martin, quoted in Roger Friedland and Harold Zellman, *The Fellowship* (New York: HarperCollins, 2006). The authors credit the SUNY-Buffalo University Archive as their source. I use Borthwick as Mamah's surname because that was her practice in Europe and afterward. Wright mentions Mamah leaving Edwin Cheney in June 1909 in a letter to Anna Lloyd Wright dated July 4, 1910, © Frank Lloyd Wright Foundation, Scottsdale, AZ. This letter was first mentioned by Filippo Fici in "Frank Lloyd Wright in Florence and Fiesole, 1909–1910," *Frank Lloyd Wright Quarterly*, vol. 22 no. 4 (Fall 2011). The author is grateful to Fici for receiving him at his studio and providing helpful information about Florence in 2004 and again in 2011 and 2012. The chronology for this chapter relies in part on Fici's article; the record established by Anthony Alofsin in *Frank Lloyd Wright: The Lost Years, 1910–1922* (Chicago, 1993), 307–309 and Neil Levine in *The Architecture of Frank Lloyd Wright* (Princeton, 1996), Ch. III–IV; and the letters of Mamah Borthwick to Ellen Key, Ellen Key Archive, Royal Library of Sweden. The author visited Fiesole in May, 2004, and the descriptions are direct reporting.

2. An English adaptation of the Wasmuth Portfolio is Frank Lloyd Wright, *Drawings and Plans of Frank Lloyd Wright: The Early Period (1893–1909)* (New York: Dover Publications, Inc., 1983).

3. Frank Lloyd Wright to Anna Lloyd Wright, July 4, 1910.

4. Frank Lloyd Wright Wright to Taylor Woolley, June 16, 1910, Taylor Woolley Manuscript Collection, J. Willard Marriott Library, University of Utah. The information about Lloyd's travels is from Fici, "Frank Lloyd Wright in Florence."

5. Frank Lloyd Wright, *An Autobiography* (1932), reprinted in *Frank Lloyd Wright: Collected Writings*, v. 2, Bruce Brooks Pfeiffer, ed. New York: Rizzoli International, 1992, 220. Wright's spelling of the female servant's name as Estero is questionable. Esther in Italian is Ester.

6. Both quotations are from Frank Lloyd Wright's July 4, 1910, letter to Anna Lloyd Wright.

7. Mamah Borthwick to Ellen Key, undated letter from Pension Gottschalk, Berlin Ellen Key Archive, Royal Library of Sweden.

8. Ellen Key, *Love and Ethics* (Chicago: Ralph Fletcher Seymour Co., 1912).

9. Frank Lloyd Wright to Anna Lloyd Wright.

10. Ibid. The calculations for today's dollars use the U.S. Bureau of Labor Statistics CPI Calculator and other online inflation calculators.

11. Some years later, after a dispute with her brother, Jennie changed her son's name to Franklin, according to Taliesin historian Keiran Murphy. Frank's original name may have been Franklin, according to Brendan Gill, *Many Masks: A Life of Frank Lloyd Wright* (New York: G.P. Putnam's Sons, 1987), 26.

12. Mamah Borthwick to Ellen Key from Taliesin, circa December 1911. Ellen Key Archive.

13. Fici, "Frank Lloyd Wright in Florence."

14. Oak Park, Illinois, city directory, 1911, and Washington Irving Elementary School.

15. Catherine Wright to Janet Ashbee, quoted in Gill, *Many Masks,* 213.

16. Wright's letters to Martin and Alofsin's comment appear in Alofsin, *Frank Lloyd Wright: The Lost Years*, 66–67, and the details of the German trip on 75–76.

17. The land was purchased on April 10 but the purchase was recorded on April 22; Keiran Murphy e-mail to author, June 7, 2011. For a detailed account of the land transactions and evolving plans, see Alofsin, "Taliesin I: A Catalogue of Drawings and Photographs," in *Taliesin 1911–1914, Wright Studies*, vol. 1, Narciso Menocal, ed. (Southern Illinois University Press, 1992), 98–141.

18. Mamah Borthwick to Ellen Key, November 10, 1912. "My sister brought my children here for the summer during Mr. Cheney's absence in Europe for his wedding trip."

19. While still technically Mamah Borthwick Cheney, she signed her name "Mamah Bouton Borthwick" on the guest book at Ellen Key's Strand on June 9, 1911. She also used her maiden name on the title page of *Love and Ethics*, prepared in Italy, and in all of her letters to Ellen Key.

20. "He has been building a summer house, Taliesin," Mamah Borthwick to Ellen Key, undated, circa December, 1911. The description of the Goethe Street plan is from Levine, *The Architecture of Frank Lloyd Wright*, and the detail about the Dana House is from a visit by the author.

21. Alan Crawford, "Ten Letters from Frank Lloyd Wright to Charles Robert Ashbee," *Architectural History*, v. 13 (1970), 67.

22. Claes von Heiroth e-mail from Helsinki, Finland, to Nancy Horan, December 1, 2010. Copied to author with von Heiroth's permission to publish, January 2, 2011. He says his grandmother preferred the German spelling *Mascha* to the Russian *Masha*.

23. Donata Mazzini and Simone Martini, *Villa Medici, Leon Battista Alberti and the Prototype of the Italian Villa* (Florence: Centro Di, 2004), 2. For a siting comparison and assessment of Taliesin and the Villa Medici, see Charles E. Aguar and Berdeana Aguar, *Wrightscapes* (McGraw-Hill, 2002), 152–156.

24. Frank Lloyd Wright, *Studies and Executed Buildings*, A scanned edition of the original portfolio inscribed to Taylor A. Woolley by Wright on the title page is online at the J. Willard Marriott Library at the University of Utah.

25. Levine, *The Architecture of Frank Lloyd Wright*, makes this argument and declares Taliesin "the first natural house." The author is not claiming originality here but seconding Levine's assessment after having visited Tuscany and Taliesin.

26. Lloyd Wright letter to Linn Ann Cowles, quoted in Alofsin, *Frank Lloyd Wright: The Lost Years*, 41.

27. The diary pages and a wealth of helpful family background information come courtesy of Claes von Heiroth, who lives in Helsinki. He was referred to the author by Nancy Horan. He wrote to Horan after his architect wife, Ilona, read *Loving Frank* and suggested that its author might like to know more about Wright's Russian neighbors. His sister in France, Bianca Maria Andersen, retrieved the diary and scanned the entries.

28. "Alexander Geirot," The Internet Movie Database, www.imdb.com.

29. It would be surprising if Wright did not attend. He loved speed, and his 1909 Gilmore House, perched on a rise in Madison, Wisconsin, was dubbed "The Aeroplane House" by fans of the Wright Brothers. He used the term himself. *An Autobiography* (New York: Horizon Press, 1977), 277.

30. Lloyd Wright played the cello. This confirms that there was a cello and a piano in the home.

31. Gertrude Stein writes of Mascha and Sasha: "There were amusing people in Florence. . . . There were the first Russians, von Heiroth and his wife, she who afterwards had four husbands and once pleasantly remarked that she had always been good friends with all her husbands. He was foolish but attractive and told the usual Russian stories;" *The Autobiography of Alice B. Toklas* (New York: Vintage Books, 1990), 55.

CHAPTER 2
"THE BELOVED VALLEY"

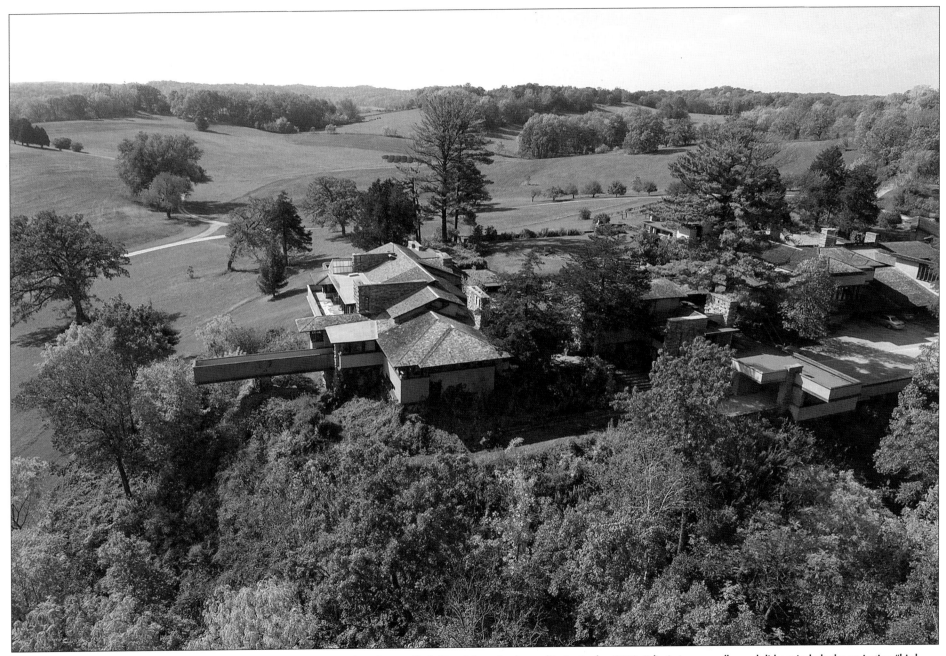

Fig. 28. An aerial photograph taken by Madison kite photographer Craig Wilson shows Taliesin III and the valley beyond in September 2008. Taliesin I was smaller and did not include the projecting "bird walk" that Frank Lloyd Wright added for his third wife, Olgivanna.

"Life, love, and work to be transferred to the beloved Valley."

—Frank Lloyd Wright, *An Autobiography*

When the Jesuit explorer Jacques Marquette canoed down the Lower Wisconsin River in 1673, he saw a scene that is recognizable today. "[It] is very wide; it has a sandy bottom, which forms various shoals that render its navigation very difficult. It is full of islands covered with vines. On the banks one sees fertile land, diversified with woods, prairies and hills."[1]

Frank Lloyd Wright saw the same scene. In his essay "Why I Love Wisconsin" he calls the river "this wide, slow-winding, curving stream in the broad sand bed, where gleaming sandbars make curved breaches and shaded shores to be overhung by masses of great greenery." When Taliesin was built, the river bend was visible from the house.

"I come back from the distant, strange, and beautiful places I used to read about when I was a boy, and wonder about; yes, every time I come back here it is with the feeling there is nothing anywhere better than this is," Wright says. "More dramatic elsewhere, perhaps more strange, more thrilling, more grand, too, but nothing that picks you up in its arms and so gently, almost lovingly, cradles you as do these southwestern Wisconsin hills . . . So 'human' is this countryside in scale in feeling . . . more like Tuscany, perhaps, than any other land, but the Florentines that roamed those hills never saw such wild flowers as we see any spring, if the snow has been plentiful."[2]

Wright had lived in the hills of Tuscany during the spring and summer of 1910, but he had memorized the Wisconsin valley since childhood. As a teenager he had worked on his Uncle James's farm and added the "Lloyd" in his mother's family name to his own.[3] The Lloyd Jones uncles put him to work in the barnyard, but the women of the clan gave him commissions. His first independent commission at age 20 was from his aunts Jane (Jennie) and Ellen (Nell) Lloyd Jones, for the main residence of Hillside Home School in 1887. He called the barnlike structure a product of "amateur me," but made up for it in 1901–1903 by giving the aunts a Prairie Style building, Hillside, that looks modern today.

Fig. 29. *Spring Green, 1912*, an oil-on-canvas painting by George Mann Niedecken, depicts a scene along the Wisconsin River in the vicinity of Taliesin. Pear and apple trees are in the foreground, with the river and a slough below. The ridge across the river shows an exposed rock outcropping of the sort that Wright wanted to imitate with "Shining Brow." The painting was executed during Taliesin's first year, when Niedecken, a Milwaukee furniture builder and designer, was working with Frank Lloyd Wright on the Avery Coonley Playhouse and Gardener's Cottage in Riverside, Illinois.

Jennie and Nell also launched a Wright legend by allowing him to build "Romeo and Juliet" (1896), an unorthodox, sculptural windmill tower. His skeptical uncles protested and scoffed and predicted it would blow down; it outlasted them all, to Wright's permanent satisfaction. In 1907 he built Tanyderi ("Under the Oaks") for his sister Jane Porter, a shingle-style house where Mamah Borthwick stayed as a guest while waiting to move into Taliesin.

For Wright, moving to the Jones Valley in Iowa County, Wisconsin, meant reconnecting himself to his maternal roots and the land where he had discovered nature—both the natural world and human nature. Wright opens his autobiography with a story of himself as a nine-year-old boy, walking through a frosty meadow and up a slope with his uncle John Lloyd Jones. While the uncle walks ahead, the boy scampers off, collecting dried weeds and grasses. When Frank catches up to his uncle to show him his treasures, the uncle reproaches him and points to his straight path, comparing it to Frank's errant zigzag.

The boy was crushed, and the experience made such a deep impression on Wright that he put an abstract rendering of it on the cover of his life story. It was his baptism in adult indifference to the natural world. The valley was his teacher.

DRIFTLESS

Taliesin is a unique creation in a unique landscape. The floodplain, prairies, and hills are part of the trench of a vast prehistoric Wisconsin River. The resulting sandstone and limestone ledges and outcroppings of the valley are hallmarks not just of a primeval riverbed, but of a quirk of nature: the Driftless Area.

"Driftless" refers to the lack of foreign rocks and pulverized soil—drift—that glaciers collect and carry with them during their invasions and leave behind after their retreat. By accident, the Ice Age glaciers missed this area of Wisconsin, making it "famous the world over because it is completely surrounded by glaciated territory," Lawrence Martin says in his *Physical Geography of Wisconsin*. "It preserves a large sample of what the rest of Wisconsin, as well as the northern and eastern United States, were like before the Glacial Period."[4]

This means Taliesin's valley is older than old. Its landforms have been shaped since primeval times only by wind, frost, and thawing. It has a primitive, craggy solemnity.

"I scanned the hills of the region where the rock came cropping out in strata to suggest buildings," Wright says in *An Autobiography*. "How quiet and strong the rock-ledge masses looked with the dark red cedars and white birches, there, above the green slopes. They were all part of the countenance of southern Wisconsin. I wished to be part of my beloved southern Wisconsin and not put my small part of it out of countenance."[5] His home with Mamah would be their private rock-ledge and they would fit in unobtrusively, camouflaged as a part of nature.

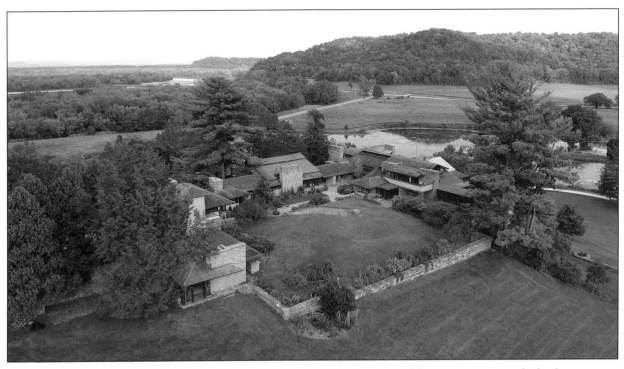

Fig. 30. A Craig Wilson kite photograph looks over Taliesin's hill crown toward the bend of the Wisconsin River. In the far distance at left, the hills of Blue Mound can be seen. Taliesin embraces the hill crown and enjoys a commanding view of the valley.

Or so he hoped.

Wright captured the land in a striking portfolio of landscape photos in the winter and spring of 1900. They were published by his aunts in a promotional brochure for Hillside Home School that was sent to parents of prospective students. Wright's son John remembered that his father developed his own plates in a balcony off his Oak Park studio.

Asian art authority Julia Meech praises Wright's landscape photographs in *Frank Lloyd Wright and the Art of Japan*. "The horizontal format and spare, poetic composition are reminiscent of Japanese ink paintings in the form of handscrolls," she says. Wright was proud of them himself. "In mounting these almost forgotten little views of Hillside for a small Arts and Crafts exhibit I have enjoyed them so much—I did take them myself—that it occurs to me they might give you pleasure too," he wrote to the mother of two former students. "If so, kindly accept them."[6]

FRANK LLOYD WRIGHT'S VALLEY PORTRAITS

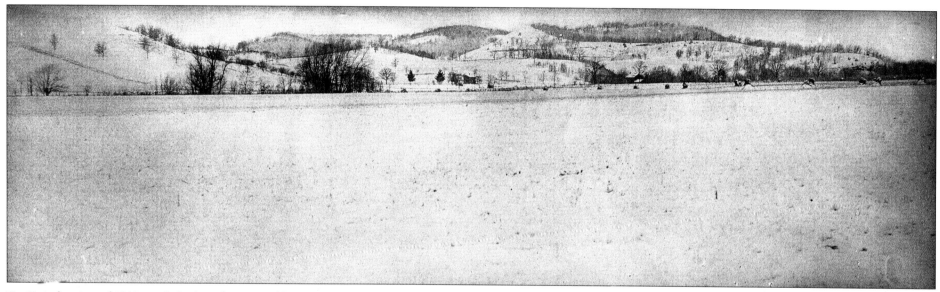

Fig. 31. In the winter of 1900, Frank Lloyd Wright positioned his camera looking northward up Jones Valley, in the direction of the Wisconsin River, from a location near the junction of Highway 23 and County T not far from Unity Chapel. The lefthand view, above, shows the hills where Taliesin would eventually be located. Fig. 31.a shows the valley between the hills. Fig. 31.b shows the hills across the valley, including Bryn Mawr. Knit together, they create a single panorama. (Fig. 31.c). Julia Meech, author of *Frank Lloyd Wright and the Art of Japan*, says of these images: "Wright experimented . . . with Japonesque photographs of the scenery around the Hillside Home School. . . . The horizontal format and the spare, poetic composition are reminiscent of Japanese ink paintings in the form of handscrolls."

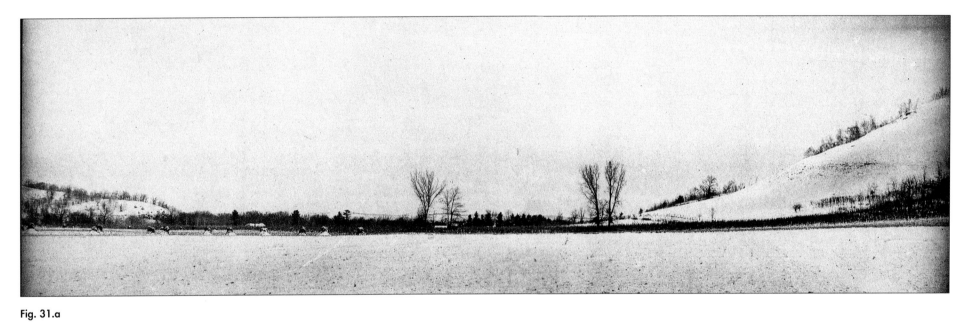

Fig. 31.a

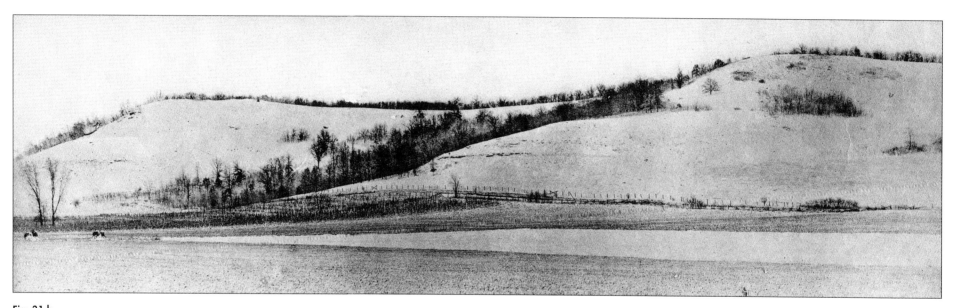

Fig. 31.b

Fig. 31.c. Montage by Roger Daleden of Wisconsin Historical Society Photos

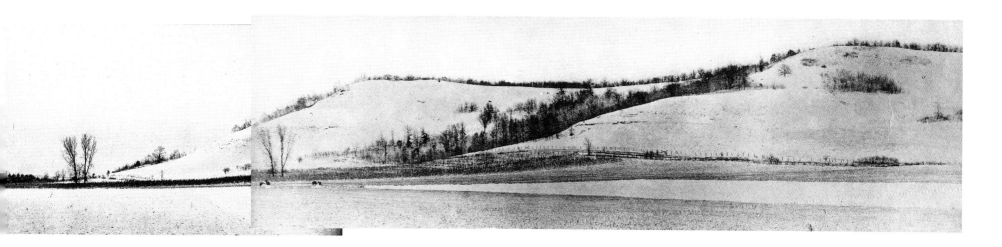

Fig. 32. Whittier Hill (foreground) near Hillside Home School takes on a Chinese brushstroke quality in Wright's photo. Fig. 32.a shows the hill from a closer perspective, at a different angle. John Greenleaf Whittier, a Massachusetts poet, hymnodist, and abolitionist, was admired by Unitarians.

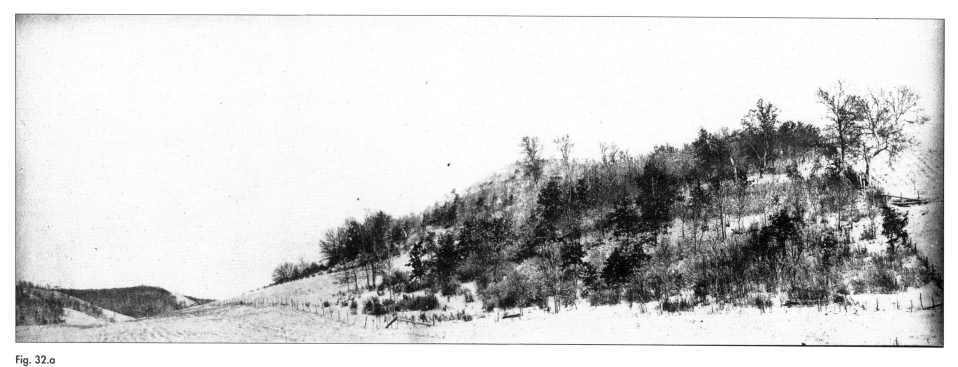

Fig. 32.a

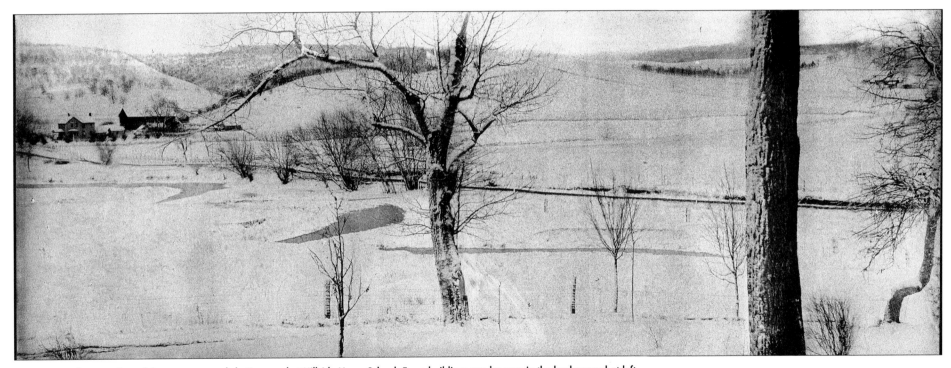

Fig. 33. Trees frame a view of the snow-covered skating pond at Hillside Home School. Farm buildings can be seen in the background at left.

Fig. 34. "Romeo and Juliet" stands at the center of Wright's view of Windmill Hill. The windmill now overlooks the Hillside buildings that Wright designed in 1901. Wright's uncles were convinced the experimental structure would not stand, but the aunts stood by their architect. It was rebuilt in 1990 and remains standing.

Fig. 35. Students and teachers play golf on Thomas Ridge near Hillside Home School in late fall or early spring.

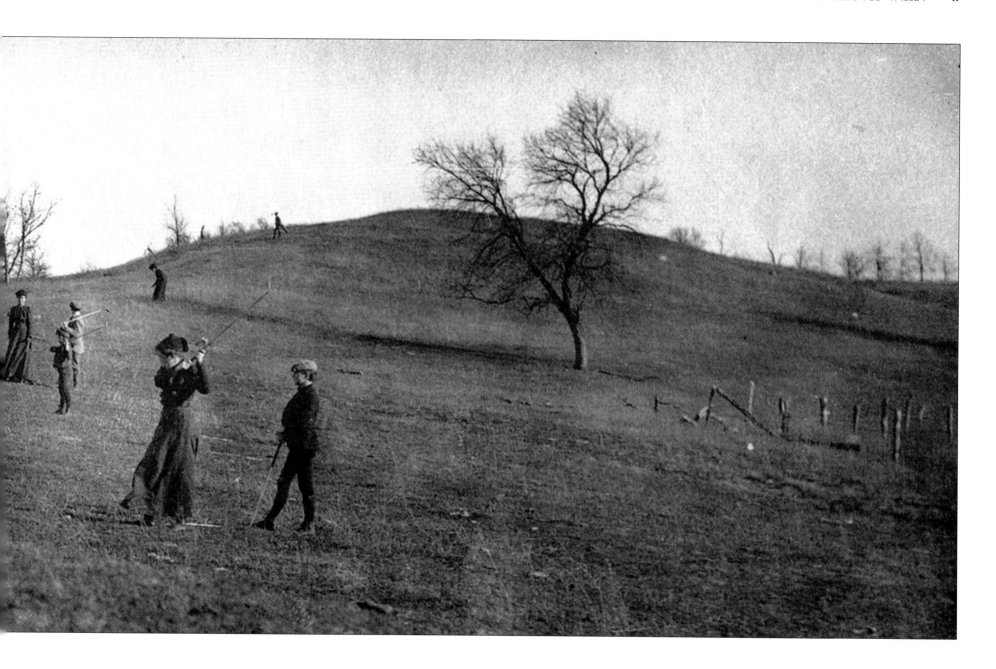

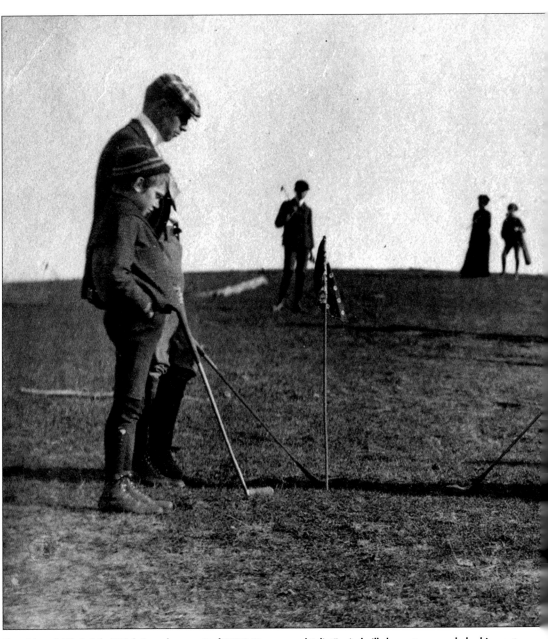

Figs. 36 and 37. At left, Wright's stark portrait of 1896 "Romeo and Juliet" windmill shows two people looking out from the windows of the tower balcony. The tower's design consists of a diamond penetrating an octagon. It is believed that Wright reversed the negative when he printed this photograph, apparently preferring this view. Above, golfers' silhouettes dot the hilltop on Thomas Ridge. In the foreground, a young boy stands within the figure of an older man.

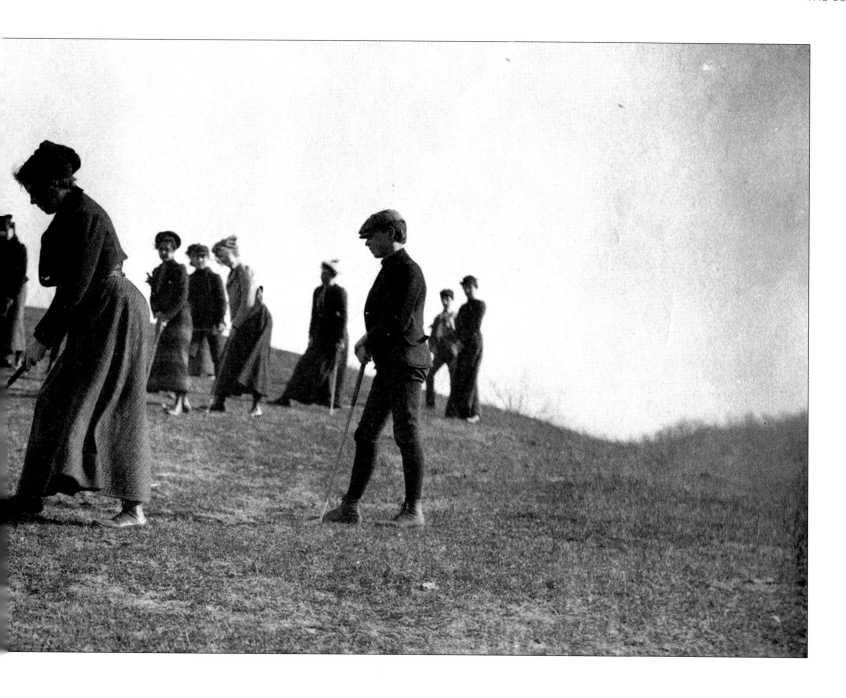

VALLEY OF THE PROGRESSIVES

Frank Lloyd Wright's transfer of his life, work, and love to rural Wisconsin in 1911 brought him not just to a special place in nature—it brought him into a special family culture, at a special moment in Wisconsin history.

He was settling with Mamah among the Lloyd Joneses, his mother's people. Anna (Hannah) was one of the seven children who came by boat from Wales with Richard and Mallie Lloyd Jones in 1844. Three more children were born after they arrived and one died in transit. Five brothers and five sisters lived.

"By the time Frank Lloyd Wright came to spend his summers in the Valley [as a teen] the brothers had filled the entire space around the home farm," a cousin wrote years later. "Although each farm was average for the 19th century, collectively they made a dominating tract. The brothers and sisters continued to act as a unit, sharing labor and amusements and often money and credit."[7]

Wright's sister Maginel remembered the Lloyd Joneses as "larger than life, the women as well as the men. They had a way of towering, in spirit if not in dimension." They were "tall, vigorous, opinionated, lively people . . . high-minded, possibly high-handed too, now and then."[8]

They were not quiet farmers or conventional Christians. In Wales they had defied the British and practiced their unorthodox Unitarian faith. Before they arrived in Spring Green and built Unity Chapel they had briefly attended a Baptist church but were expelled when it got a taste of their heretical views. They regarded the Bible as just one of many paths to God, were skeptics about the divinity of Jesus, and were as likely to quote Ralph Waldo Emerson, Henry David Thoreau, Walt Whitman, or John Ruskin as scripture as they were the Prophets.[9]

Fig. 38. Reverend Jenkin Lloyd Jones, left, stands with Wisconsin governor Robert M. "Fighting Bob" La Follette during the annual La Follette Day celebration at Tower Hill about 1905.

When it came to politics they could be resisters and dissenters, marching under a runic symbol that meant "Truth Against the World." Meryle Secrest suggests that one reason they had to leave Wales was Richard's involvement with a night-riding group called the Maids of Rebecca. These guerrillas put on blackface and women's clothes and burned the hated tollgates where British operators collected fees from farmers taking their produce to market.[10]

It would not be a long stretch from riding with Rebecca's raiders to rallying around a Wisconsin leader whose movement was built around restraining the rate-setting power of the railroads. That leader was Robert Marion La Follette Sr.—"Fighting Bob." His followers called themselves Progressives, and their number included the Lloyd Joneses.

Fig. 39. Jenkin Lloyd Jones preaches from his tree-trunk pulpit at Tower Hill on the Wisconsin River. His woodland camp was a summer meeting place for progressive Wisconsinites and Chicagoans. It also was the site of the annual Tower Hill Congress of state women's organizations.

"The Emerson Pavilion was packed when public assemblies were held. Robert La Follette Sr. spoke in a pavilion many times to groups far too large for the space."

—Jane Wright Porter

When Frank Lloyd Wright and Mamah Bouton Borthwick came to live at Taliesin, Progressivism was at its height in Wisconsin, leading the nation in reform. The Lloyd Joneses formed one of its vital centers. They ran educational assemblies, women's conferences, and La Follette rallies at Tower Hill. They educated new generations of Progressive leaders at Hillside Home School. They served on the Board of Regents of the University of Wisconsin, promoting "the Wisconsin Idea." And they owned and edited the leading Progressive daily newspaper in the state capital.

Fig. 40. Richard Lloyd Jones sits at his publisher's desk at the *Wisconsin State Journal* in Madison. He bought the capital city daily from the father of Thornton Wilder in July 1911 with financial help arranged by "Fighting Bob" La Follette.

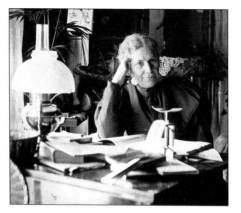

Figs. 41 and 42. Frank Lloyd Wright took these portraits of his aunts, the co-founders of Hillside Home School, in 1898. Jane Lloyd Jones (Aunt Jennie), left, and Ellen Lloyd Jones (Aunt Nell), right, were early progressive educators who organized a coeducational school for children of the big Welsh clan. It soon grew into a boarding school that enrolled many from Chicago.

Jones Valley was a place of natural beauty, full of childhood familiarities for Wright. But it promised to be a stimulating cultural environment. He and his partner each would bring something contribute to the Progressive conversation. Wright was the leading voice of reform in domestic architecture. Borthwick was a translator and publisher of advanced ideas about women's rights and roles. Wright came to believe she would make a good editor of the weekly newspaper.[11]

WHO WERE PROGRESSIVES?

The Progressives were largely members of the educated middle class—what one writer calls "the radical center."[12] They sought to address the ills of a newly industrializing society by finding a middle way between the big-business establishment and the nationalizing socialists. They supported private property, farm and home ownership, and small business but favored public ownership of banks and utilities and wanted the state to serve as the public's referee, regulator, equalizer, and protector.

University of Wisconsin economist Richard T. Ely spoke for many Progressives when he said, "The balance between private and public enterprise is menaced by socialism on the one hand and by plutocracy on the other."[13]

After the Civil War most of the political action in Wisconsin was within the Republican Party—the Party of Lincoln. The Progressives comprised the liberal wing and the conservative Republicans called themselves Stalwarts. The Democratic Party, still tainted as the party of secession, was a weak factor, with less power than the socialists, who had become a rising force in German Milwaukee.[14]

PROGRESSIVE INSTITUTIONS: TOWER HILL

The Republican Party was founded in Ripon, Wisconsin, in 1854 by a group opposing the extension of slavery to the new states of the West. It ran Abraham Lincoln for president in 1860, and after the Civil War the words "Lincoln," "Union," and "Unity" became watchwords for one veteran of the Grand Army of the Republic, Reverend Jenkin Lloyd Jones.

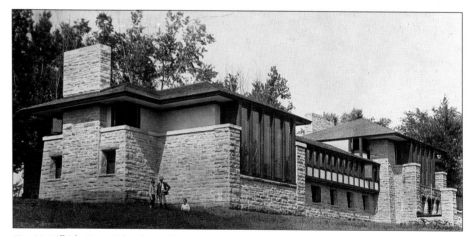

Fig. 43. Hillside Home School, seen here circa 1910, was designed by Frank Lloyd Wright for his aunts in 1901. He designed their first building at age 19.

Fig. 44. Wright did the lettering for the envelope containing a packet of photos he prepared to help advertise his aunts' Hillside Home School in 1900. The three-pronged red figure is the Welsh rune signifying the Lloyd Jones motto, "Truth Against the World."

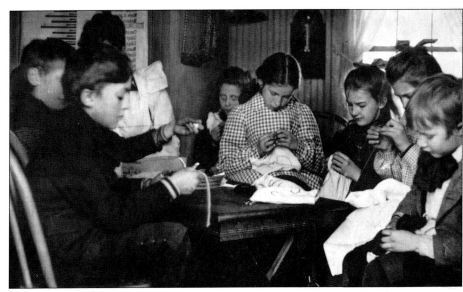

Fig. 45. Wright photographed boys and girls learning to sew. Hillside was one of the first coeducational boarding schools in the country.

"Jenk," the last child of Richard and Mallie to be born in Wales, served as a Union Army artilleryman in the war, fighting in the battles of Vicksburg, Missionary Ridge, Chattanooga, Lookout Mountain, and Atlanta and suffering a broken foot at Missionary Ridge that required him to walk with a cane.[15] He emerged an evangelical pacifist and advocate of reconciliation—of races, of religions, of men and women. His weekly magazine for the Western Unitarian Conference was called *Unity*.

He based himself on Chicago's South Side, building the Abraham Lincoln Center for social services and outreach and founding an interfaith, interracial church called All Souls. Jenk was an ally of Jane Addams and Hull House, where Wright's mother and sister both volunteered, and he created a summer camp near Janesville, Wisconsin, much like Addams's fresh-air camps for city children.[16]

In 1889 he established Tower Hill, a Wisconsin summer campground and conference center that drew campers and speakers from Madison, Chicago, and beyond. Together with Hillside Home School, the pioneering coeducational boarding school run by Ellen and Jane Lloyd Jones, it made Jones Valley a vital center of Progressive discussion and liberal preaching, and a summer staging area for the La Follette political movement.

Jones purchased the 60-acre Tower Hill property, which included a former lead-shot ammunition-making tower over the Wisconsin River, for $1 an acre. The retreat grew to include 25 cottages, the Emerson Pavilion dining and meeting hall, and other structures. The big event was the end-of-season Grove Meeting held the second weekend in August. One of those Chautauquas was in progress in 1914 when Taliesin was destroyed.[17]

In 1906, Jenk invited the Wisconsin Federation of Women's Clubs to use Tower Hill for its annual Women's Congress, and it became an annual event to advance women's rights—another strand of the Progressive movement. One of its two leading organizers was novelist, dramatist, and suffragist Zona Gale.

La Follette Day was also a regular Tower Hill event, held in honor of "Fighting Bob." "The Emerson Pavilion was packed when public assemblies were held," Wright's sister Jane Porter remembered. "Robert La Follette Sr. spoke in the pavilion many times to groups far too large for the space."[18]

PROGRESSIVE INSTITUTIONS: HILLSIDE

When La Follette left for Washington in January 1906 to take his seat in the Senate, he and his wife, Belle Case La Follette, enrolled their three youngest children at Hillside Home School.

The *Dodgeville Chronicle* reported on February 2: "About seventy members of the Hillside School enjoyed a sleigh ride to this city Wednesday and the keys of the city were turned over to them for the day. The hardware and notion stores were the first visited, where they secured all the tin horns in stock and thereafter

their presence in the city was known to every citizen. A visit was made to our new high school, which was very enjoyable to the members of both schools.

"The students and teachers were accompanied by James Lloyd Jones and the principal, Miss Ellen C. Lloyd Jones, Miss Jane Lloyd Jones and Miss Annie Lloyd Wright [Wright's mother]. Among the visiting students were Robert, Philip and Mary La Follette, children of Senator and Mrs. R.M. La Follette."[19]

Robert "Young Bob" La Follette Jr. (1895–1953) went on to take his father's seat in the U.S. Senate and become an architect of the New Deal. He was unseated by Joseph McCarthy in 1946.

Philip F. "Phil" La Follette (1897–1965) went on to become the governor of Wisconsin who bravely led the state through the Depression. He also played a key role in Frank Lloyd Wright's fortunes, serving as his lawyer, negotiator, and financial adviser.[20]

Hillside Home School was initially organized to educate the growing Lloyd Jones brood. The aunts, both leaders in institutions outside Madison, returned to build a residential school on the late patriarch Richard's farmstead. Wright designed the shingle-style building, which he called a product of "amateur me," at age 19. In 1901 he expanded it with a fully modern building. The school, Nell and Jenny said, would operate according to "the principles of Emerson, Herbert

JENKIN'S CREED, 1913

On November 6, 1913, Rev. Jenkin Lloyd Jones celebrated his 31st anniversary as the founder of All Souls Church in Chicago. The Chicago Tribune *printed this statement:*

"During the last thirty-one years I have been a pastor in Chicago. I have stood for that communion of religion that refuses to be rimmed to any 'Christian' name or interpretation. Jew, Buddhist, Mohammedan are eligible for the fellowship of the church I have tried to build.

"I have tried to interpret religion as the reconciling force of society, the bond that holds man to man and man to his duty when all other bonds fail.

"I have stood for religion unrimmed by creeds.

"I have stood for religion that stands for progress, freedom and brotherhood.

"I have, through all these years, stood for the application of religion.

"I have stood for rights of women as an equal partner to men.

"I have stood for the rights of the colored man as eligible to all the privileges of this church and whatever privileges civilization had to give a soul when it is made worthy by effort, sanity, sobriety and purity."

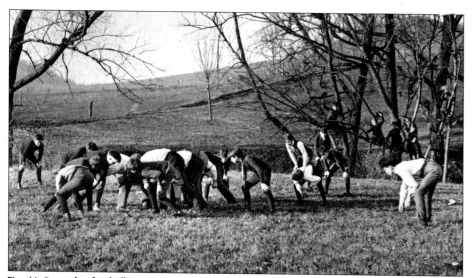

Fig. 46. Boys play football in a Wright photograph taken in autumn.

Spencer, Froebel and other exponents of 'The New Education.'"[21]

It had a strong teacher-to-student ratio and, as it grew to include more urban children from Chicago, was described by the aunts as "a home-farm school, removed from the excitements and distractions of the city."

"Character building is its aim. Its method, so far as possible, is to make the pupil self-regulating. It is the province of the teacher to guide rather than to drive, to help rather than to substitute," they wrote.[22]

Hillside earned such a strong reputation that its graduates were admitted virtually upon application to the University of Wisconsin, the University of Chicago, and Smith and Wellesley colleges.

The La Follette children were not the only stars it produced. Wright's sister Maginel and his sons Lloyd and John became noted artists and architects. Florence Fifer Bohrer, daughter of the Illinois attorney general and later governor, became

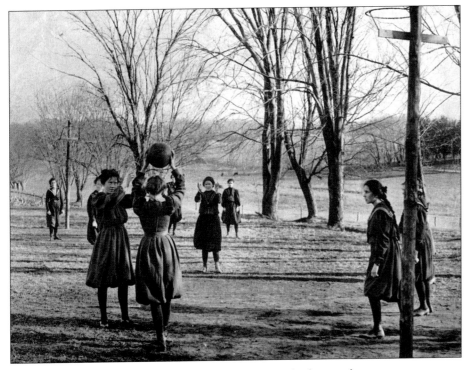

Fig. 47. Girls play basketball at Hillside Home School in a Wright photograph.

the first woman to be elected to the Illinois State Senate.

In a tender memoir about her days at the school—which included having an African American roommate—Bohrer remembered a visit from "Fighting Bob."

"While I was much interested at the time, I do not recall what Mr. La Follette talked about," she wrote. "It was all exciting, and I remember that the Uncles were enthusiastically supporting his candidacy for office. . . . There was much talk of La Follette's courage and independence. He had formulated a reform program and was appealing directly to the people."[23]

REVOLUTION IN MADISON

The summer of 1911—Taliesin's first summer—was the high-water mark of Progressivism in Wisconsin. In Milwaukee, the Social Democrats under Emil Seidel were building on their 1910 electoral sweep, creating the parks, sanitary systems, and other public works that would give them the name "sewer socialists." Victor Berger became the first Socialist ever elected to Congress.

In Madison, Governor Francis McGovern and the Progressive majority, responding to the public's appetite for change and sensing that "the only way to beat the Socialists is to beat them to it," went full steam ahead on an ambitious legislative agenda.[24] When they adjourned on July 15, 1911, they had passed the largest body of legislation ever approved in a single session in Wisconsin: 664 bills. Virtually all became law.[25]

The reforms included the nation's first workmen's compensation program, the first successful progressive income tax, restrictions on child labor and women's labor, a teacher's pension system, a state "public option" life insurance program, the beginnings of a German-style state vocational system, the exemption of cooperatives from antitrust laws, home rule for cities, a "corrupt practices" act placing tight limits on campaign spending, and establishment of the right of citizens to recall elected officials and create laws by referendum.

It was, in the words of a university political scientist at the time, "the most constructive program of popular government and industrial legislation ever presented to any state." The political reforms, he said, would "establish a line of vision as direct as possible between the people and the expression of their will."[26]

Women's will would not be expressed, however: The Legislature approved a bill giving women the right to vote but referred it to a public referendum in 1912 (in which women would have no vote) rather than sending it directly to the governor for his signature. The referendum failed, owing largely to opposition from Milwaukee's brewing companies and the state's barley growers, who smelled Prohibition in the air. Temperance was a powerful theme in both the Progressive and feminist movements, and in the Lloyd Jones family.[27]

As a result of the 1911 session, Frank Lloyd Wright and Mamah Bouton Borthwick would be among the first citizens to pay a progressive income tax; but only he would have the right to vote.

WISCONSIN IDEAS

The University of Wisconsin played a key role in developing the landmark program of the 1911 Legislature, and Lloyd Joneses were among the university's lead-

Fig. 48. Boys and girls are photographed by Frank Lloyd Wright in their classroom. Froebel-type blocks and a globe are in the foreground.

ers. La Follette and his Capitol bill-writing shop, the Legislative Reference Bureau, had crafted a unique working relationship with the University of Wisconsin called "the Wisconsin Idea." The idea was that the university would serve as the state's full partner in policy research, development, and experimentation. It would leave the ivory tower and roll up its sleeves to plan and implement state improvements ranging from railroad property valuation to showing young farmers how to select the best breeds and seeds.

Its motto was, "The boundaries of the University are the boundaries of the state." This meant, said Frederic Howe in 1912, that "the university is a great nerve center, out from which influences radiate into every township in the state. No locality is so obscure that it is not touched by these forces, and no citizen is so poor that he cannot avail himself of some of its offerings."[28]

During this heady time, two uncles of the Lloyd Jones family were named Regents of the university by La Follette's hand-picked successor, Governor James O. Davidson. James Lloyd Jones served on the Board of Regents from 1906 until his death in 1907. Enos Lloyd Jones succeeded him and was still on the board when the 1911 Legislature finished its marathon session.[29]

EDITOR AND PUBLISHER

"Fighting Bob" La Follette wanted "a powerful progressive daily newspaper at Wisconsin's capital—something to complement his recently launched *La Follette's Weekly Magazine*, the medium he selected to advance his political philosophy on a national level."[30] On July 29, 1911, just after the Legislature adjourned, he facilitated the purchase of the daily and Sunday *Wisconsin State Journal* by Richard Lloyd Jones. Richard, 38, was Jenk's son and Wright's cousin.

Wealthy friends of La Follette loaned Jones, who had returned from New York and *Collier's* magazine, $85,000 of the $100,000 he needed to buy the paper from Amos Wilder. Wilder, a former diplomat, was the father of Pulitzer Prize-winning dramatist and novelist Thornton Wilder.[31]

"Between July 1911 and July 1919 the 'virile pen and militant personality' of Richard Lloyd Jones made the *Journal* a powerful voice for the Progressive movement in Madison and around the state," Madison historian David Mollenhoff writes. "In 1912 it carried La Follette's presidential banner. Naturally, Jones pushed La Follette ideals including labor legislation, academic freedom, women's suffrage, and black rights, while decrying child labor, big business, and government corruption."[32]

Jones also made space in the paper for a regular column by Belle Case La Follette,[33] and would endorse Frank Lloyd Wright's design for a downtown hotel in 1912. The *State Journal*'s circulation doubled in the first year Jones owned it. His style was something new in Madison journalism, Mollenhoff notes: "Unlike many journalists who gave both sides of an issue so that readers could draw their own conclusions, Jones *told* his readers what was right and never let them forget it."[34] That also could describe the style of Frank Lloyd Wright.

MAKING ROOM FOR FRANK AND MAMAH

Temperamentally and in most other ways, Wright should have been a natural fit for Jones Valley in 1911. He had been a known quantity there for 30 years, had designed buildings for his aunts and sister, and brought with him an international reputation as a visionary architect with a track record of 100 buildings built and 50 others planned in the previous decade.

He knew the valley; shared the Unitarian regard for Emerson, Whitman, and the other transcendentalists; was intensely musical; had his own Froebel training; and had sent several of his own children to Hillside for schooling. His sister Jane and her husband lived nearby and his mother was a regular visitor. Wright had hired dozens of local laborers and craftsmen to build Taliesin, and claimed in his first interview with the *Dodgeville Chronicle* that he would be employing several draftsmen to handle "a half a million dollars' worth of work now in hand."[35] He had strong ties to Madison, where he spent his teenage years and would design buildings in every decade of his long career. In 1911 a project for a new downtown hotel was on the boards.

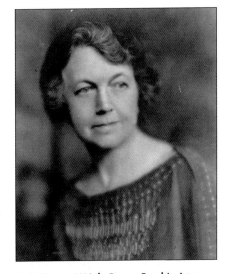

Like the Lloyd Joneses, he had ties to Progressive Chicago. Jenk's friend Jane Addams gave him Hull House as his platform when he delivered his seminal defense of mass-produced building materials, "The Art and Craft of the Machine," in 1901. He knew the movers of the Chicago Renaissance arts revolt, including Margaret Anderson, founder of *The Little Review*; Harriet Monroe, founder of *Poetry*; and Maurice Browne, founder of the Little Theater, who eventually connected him with Aline Barnsdall and a career in Los Angeles.[36] (Carl Sandburg, the poet who became a great Chicago friend, was serving as secretary to the socialist mayor of Milwaukee in 1911.)

Fig. 49. Jane Wright Porter, Frank's sister, taught at Hillside and organized the Lend-a-Hand Club for women. She and Zona Gale led the effort to build a women's clubhouse in 1914. Wright designed Tanyderi for her and her husband Andrew in 1907. The photo is from 1922.

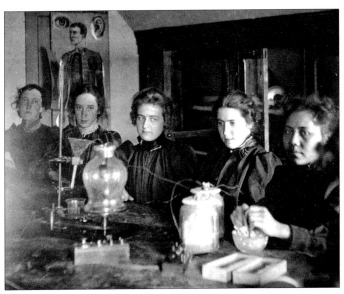

Fig. 50. Wright's photograph of a chemistry class at Hillside shows girls receiving science training and, on the right, a student who could be African American.

Mamah Bouton Borthwick likewise could have been expected to fit into the family culture of the Valley. She was well-educated, with a master's degree from Michigan, and spoke several languages. She had participated in the intellectual life of Oak Park, making presentations—including one on Robert Browning with Catherine Wright—to the Nineteenth-Century Women's Club, which Anna Lloyd Wright had co-founded.

Mamah had been a librarian and had studied with the novelist Robert Herrick at the University of Chicago.[37] Herrick, who lived in a Prairie School building, wrote gritty stories of the city and its business culture's corrupting influence. The central figure of *The Common Lot* (New York: Macmillan, 1905) is a Chicago architect who causes major loss of life by accepting shoddy building materials in return for kickbacks, and escapes conviction.

Frank and Mamah each would bring something unique to enlarge the Valley's Progressive culture. He would bring his ideas on architecture and society, the natural house, and the role of space and freedom in the modern American home. She would publish books and articles on women's liberation and marriage law reform, bringing Ellen Key's controversial Scandinavian ideas to an American audience. They would attract a stream of international visitors.

"While Frank Lloyd Wright set about 'the destruction of the box' that was the Victorian house," a historian of Progressivism notes, "a host of other cultural boxes were tumbling down too. Standing in the ruins, people were free to move and look

around as they never had before."[38] Frank and Mamah would have been in the right place at the right time. If ony they had been married.

THE MARRIAGE QUESTION

Frank, though he had moved out, was still married to Catherine. Mamah was divorced. Their cohabitation under one roof was adultery. Each had also left young children at home, opening them to the accusation of abandonment. (Custody had been settled for Mamah as part of her divorce, but the newspapers ignored it. Wright had arranged an income for his family and some of his children were grown and working for him.)

The Lloyd Joneses were not known to break ranks over divorce. They stood by Frank's mother Anna after she pushed William Carey Wright out of the house and treated his three stepchildren so cruelly that they were also forced to leave.[39] Wright's sister Maginel and his son John were married more than once.

"Divorce is common in my family, maybe because none of us sees marriage as the ultimate institution," said architect Elizabeth Wright Ingraham, John's daughter, in an interview years later. "We are all Unitarians and believe in a kind of freedom of choice. We aren't brought up with a sense of guilt—at least for something like that. There was plenty of guilt if you didn't produce. If you didn't measure up, you'd know it."[40]

Wright and Borthwick, both in middle age, had been hoping that they might live quietly and enjoy their creative collaboration while they waited for Catherine Wright to release Frank to remarry. Wright told the *Dodgeville Chronicle,* "I had hoped, by minding my own business quietly, to protect everybody until the time came when I could set my life in conventional order."[41]

For a while it seemed to go that way. Mamah slipped into the Valley quietly in late summer, staying first with Jane Porter. She got along. She prepared meals for the workmen on-site. The wife of a draftsman sent her a magazine clipping she might like. Taylor Woolley probably gave her photos and kept her company in Wright's absence, along with his friend Clifford Evans.

But the peace was short-lived. When the storm came, it did not come from the village. "Spring Green disapproved of Wright, but it left him alone," says biographer Robert C. Twombly.[42]

The storm came from Chicago, the worst possible place. Worst, because Chicago was the source of a large portion of the enrollment of Hillside Home School. Hillside at that moment was in fragile financial condition after coming out of bankruptcy, and the debate over who should own and manage it had fractured the Lloyd Jones family in the closing months of 1911.

The Taliesin "new romance" story hit the front page in Chicago on Christmas Eve.[43] All the goodwill and support and Progressive solidarity that the Lloyd Jones family might have extended to Frank and Mamah was pushed aside by the terror that their beloved Hillside School might not survive the scandal.

Jenkin Lloyd Jones wrote to his sister Jane: "This is a real calamity."[44]

NOTES

1. Quoted in Lawrence Martin, *The Physical Geography of Wisconsin* (Madison, WI: University of Wisconsin Press, 1965), 187–188.
2. Frank Lloyd Wright, "Why I Love Wisconsin," originally published in *Industrial Wisconsin* magazine in 1930. Reprinted in *Frank Lloyd Wright: Collected Writings*, Vol. 3, edited by Bruce Brooks Pfeiffer (New York: Rizzoli and the Frank Lloyd Wright Foundation, 1993), 134.
3. The 1880 census lists among residents at the James Lloyd Jones farm "Hired hands: John William Kritz, Frank Lloyd Wright." Kritz became the coachman for Hillside. Edna Meudt, *The Rose Jar* (Madison, WI: North Country Press, 1990), 5, 177.
4. *Physical Geography of Wisconsin*, 82.
5. Martin Wright, *An Autobiography*, 224. The story of Romeo and Juliet is on 192–197.
6. Julia Meech, *Frank Lloyd Wright and the At of Japan: The Architect's Other Passion* (New York: Japan Society and Harry N. Abrams, 2001), 37. John's memory of his father's plate processing is noted in Jack Quinan, "Wright the Photographer," in Frank Lloyd Wright's *Fifty Views of Japan: The 1905 Photo Album*, Melanie Birk., ed. (San Francisco: Pomegranate Press, 1996), 74. In an otherwise comprehensive review, Quinan makes no mention of Wright's Hillside and valley photographs.
7. Richard Lloyd Jones, "Cousin Frank," transcript of a speech delivered in Quasqueton, Iowa, October 21, 2006, 2. www.unitychapel.org.
8. Maginel Wright Barney, "The Family in the Valley," excerpted from *The Valley of the God-Almighty Joneses in A Lloyd Jones Retrospective* (Spring Green: Unity Chapel Publications, 1986), 19, 21.
9. Meryle Secrest, *Frank Lloyd Wright* (New York: Alfred Knopf, 1992), 21–24.

10. Ibid., 31–33.
11. Robert L. Sweeney, *Frank Lloyd Wright: An Annotated Bibliography* (Los Angeles: Hennessey & Ingalls, 1978), xxv, n. 26.
12. Michael McGerr, *A Fierce Discontent: The Rise and Fall of the Progressive Movement in America, 1870–1920* (Oxford University Press, 2005), Ch. 2, "The Radical Center," 42. "The progressive middle class offered a radicalism at the center of American society; an ambitious program to halt the friction and conflicts of the industrializing nation."
13. Richard T. Ely, *Studies in the Evolution of Industrial Society* (New York: Macmillan, 1911), 237.
14. John D. Buenker, *The History of Wisconsin Volume IV: The Progressive Era, 1893–1914* (Madison: State Historical Society of Wisconsin, 1998), 517–518.
15. Cathy Tauscher and Peter Hughes, "Jenkin Lloyd Jones" (Unitarian Universalist Historical Society, 1999), 1–9.
16. Ibid.
17. Thomas Graham, "Jenkin Lloyd Jones and Tower Hill," in *A Lloyd Jones Retrospective*, 26–27.
18. Jane Wright Porter, "Tower Hill," 1937 typescript memoir transcribed by Franklin Porter, Jane Lloyd Jones Collection, Wisconsin Historical Society. The Emerson Pavilion was named for Ralph Waldo Emerson.
19. "Hillside News," *Dodgeville Chronicle*, February 2, 1906.
20. "The voice of Philip La Follette is always the voice of reason in Wright's life, although the truth of what he had to say was sometimes more than his client could stomach." Secrest, *Frank Lloyd Wright*, 338.
21. Franklin Wright Porter, "The Hillside Home School," quoting from a statement in a Hillside graduation program in *A Lloyd Jones Retrospective*, 24.
22. Porter, ibid.
23. Florence Fifer Bohrer, "The Unitarian Hillside Home School," *Wisconsin Magazine of History*, Spring 1955, 153.
24. The quote is from Charles McCarthy, chief of the Wisconsin Legislative Reference Bureau, in Buenker, *History of Wisconsin*, 518.
25. "Biggest Grist of Laws Ever Ground Out," *Wisconsin State Journal*, July 15, 1911, 1.
26. Frederic C. Howe, *Wisconsin: An Experiment in Democracy* (New York: Charles Scribner's Sons, 1912), Cornell University Library reprint, 36–37. See also See also Buencker, ch. 12, "The Most Progressive State," 515–568.
27. Julie Hatfield, "Northwest vs. Southeast: Factors Affecting the 1912 Suffrage Vote in Wisconsin" (History Seminar Paper, University of Wisconsin–Eau Claire McIntyre Library digital resource, 2008). On temperance, see McGerr, *Fierce Discontent*, 84–85.
28. Howe, *Wisconsin: An Experiment,* 159.
29. Regent biographies courtesy the Office of the Board of Regents, University of Wisconsin System, Madison, Wisconsin, 2011.
30. David Mollenhoff, *Madison: A History of the Formative Years* (Madison: University of Wisconsin Press, 2003), 284–285.
31. Ibid.
32. Ibid. Whatever support for "black rights" Richard Lloyd Jones professed in Madison vanished when he moved to Tulsa, Oklahoma, in 1919, bought the *Tulsa Democrat*, renamed it the *Tulsa Tribune*, and aligned it with the Ku Klux Klan. On May 23, 1921, the *Tribune* published an incendiary story and editorial that touched off the worst race riot in American history. As many as 300 people were killed. Eight thousand blacks were left homeless, and the African Amercan business district of Greenwood was torched. In the aftermath, Lloyd Jones editorialized that the destruction provided an opportunity for Tulsa to rid itself of future "niggertowns." See Tim Madigan, *The Burning: Massacre, Destruction, and the Tulsa Race Riot of 1921* (New York, St. Martin's Press, 2001), 216. Also see Scott Ellsworth, *Death in a Promised Land: The Tulsa Race Riot of 1921* (Baton Rouge: Louisiana State University Press, 1982).
33. Stuart Levitan, *Madison: The Illustrated Sesquicentennial History*, vol. 1 (Madison: University of Wisconsin Press, 2006), 206.
34. Mollenhoff, Madison, 285.
35. "Wright Case Agitation," *Dodgeville Chronicle*, January 5, 1912, 1.
36. Neil Levine, *The Architecture of Frank Lloyd Wright,* (Princeton, New Jersey: Princeton University Press,1996), 105. Other sources on Wright and the Chicago Renaissance include Sue Ann Prince, *The Old Guard and the Avant-Garde: Modernism in Chicago, 1910–1940* (Chicago: University of Chicago Press, 1990), and Wright's 1918 speech, "Chicago Culture," reprinted in Bruce Brooks Pfeiffer, ed., *Frank Lloyd Wright: Collected Writings*, vol. 1 (New York: Rizzoli, 1992), 154–161.
37. Secrest, *Frank Lloyd Wright*, 193.
38. McGerr, *A Fierce Discontent*, 235.
39. Brendan Gill, *Many Masks: A Life of Frank Lloyd Wright* (New York: Putnam, 1987), 34.
40. "Granddaughter of Architect Is a Talent in Her Own Wright," *San Diego Union-Tribune*, September 30, 1990, F2.
41. "Wright Case Agitation," *Dodgeville Chronicle*.
42. Robert C. Twombly, "Frank Lloyd Wright in Spring Green, 1911–1932," *Wisconsin Magazine of History*, Spring, 1968, 208.
43. "Architect Wright in New Romance With 'Mrs. Cheney,'" *Chicago Tribune*, December 24, 1911.
44. Jenkin Lloyd Jones to Jane Lloyd Jones, December 38, 1911. Jane Lloyd Jones Collection, Wisconsin Historical Society.

CHAPTER 3
BUILDING TALIESIN

THE TAYLOR A. WOOLLEY PHOTOGRAPHS

Frank Lloyd Wright summoned 26-year-old Taylor A. Woolley to Taliesin by tele-gram on August 31, 1911. "Come at regular salary. Wiring money by Western Union today [to] Lloyd at Olmstead [sic] San Diego," the wire said. Woolley was in California, possibly lining up customers for Wright's two-volume Wasmuth Portfolio of drawings. Wright's son Lloyd, with whom Woolley had worked and traveled in Italy, had come west to work at the Olmsted and Olmsted landscape nursery. He was the contact point.

Woolley returned to Chicago, staying at 1636 Monroe Street, about two and one-half miles from Wright's office at Orchestra Hall. A second telegram from Wright arrived at that address on September 12, sent from Spring Green. "OK come along go to Mrs. Roberts for money wire train," it said. Isabel Roberts was Wright's office manager. Woolley was being instructed to pick up his fare and take a train to Taliesin.

The September 12, 1911, telegram and a later one, sent by Wright to Wool-ley in Utah on July 16, 1912, bracket Woolley's time at Taliesin. When he arrived, the basic site preparation and structural work was done, having begun in April. The walls were up and the roofs were on, though the windows of the studio wing were still open to the elements. Taliesin was still very much in the rough—trenches being dug for heating pipes, the courtyard strewn with building materials, the driveway little more than a dirt path. Inside, the drafting studio and main living room were carpentry shops. In Woolley's photos, a dozen workmen line up out-side for a group shot standing in rubble. Woolley poses himself in a photo with his 22-year-old fellow draftsman and Utah companion, Clifford Evans, as they pitch in with brushes and buckets to stain the exterior trim of the studio wing.

Within a few months, Taliesin is much further along. Woolley's photos show the drafting studio operating, the adjoining bunkroom furnished, outbuildings completed, and the southeast slope being laid out in a chalk-line grid for the first spring planting.

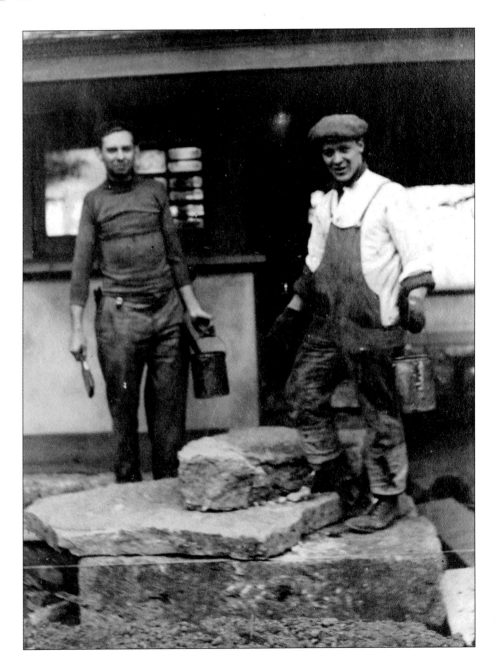

Fig. 51. Taylor Woolley (left) and Clifford Evans pitch in with buckets and stain to finish the exterior trim of Taliesin in the fall of 1911. They are standing in the courtyard in front of the studio. The lower slab that Evans is standing on is still in place. Woolley is 26, Evans 22 in this photograph. They would go on to spend their architectural careers together in Salt Lake City.

Mamah Borthwick has been in residence the whole time. Wright appears to have been living there on and off but moves in permanently before Thanksgiving, by Christmas at the latest. Woolley apparently never photographs them together, and there are no images of either of them in his archives, from either Italy or Wisconsin. There is one image of a woman on horseback who looks the right age to be Mamah, but she is unidentified.

■ ■ ■

As a photographer, Woolley is willing to work to get the right picture. He has a limp from early life, but it does not stop him from climbing to a high vantage point to photograph the garden courtyard. It does not prevent him from walking or riding horseback around Taliesin's acreage to shoot the house from below. He shoots the bend of the snow-laden Wisconsin River from a hilltop, then descends to the riverbank.

Woolley shows a photojournalist's nerve. He moves furniture. He corrals workmen in the courtyard. He groups laborers and draftsmen in front of a fireplace, and poses stonemasons next to the work they have just finished—cementing the plaque in place at the entrance to Taliesin that announces: "Frank Lloyd Wright—Architect." He sometimes creates art—the moody expressionism of Fig. 59, the terrace where Mamah would be killed, is an example. But he is basically creating a record. By doing that, the young Taylor Woolley has added a new chapter to the story of an American landmark.

Fig. 52. Frank Lloyd Wright summons Taylor Woolley back from California in a telegram dated August 31, 1911. He says he will wire funds to his son Lloyd Wright at Lloyd's workplace, the Olmsted and Olmsted landscape gardeners' nursery in San Diego. A second telegram, sent to Chicago on Sept. 12, tells Woolley to pick up money at the office and come to Taliesin.

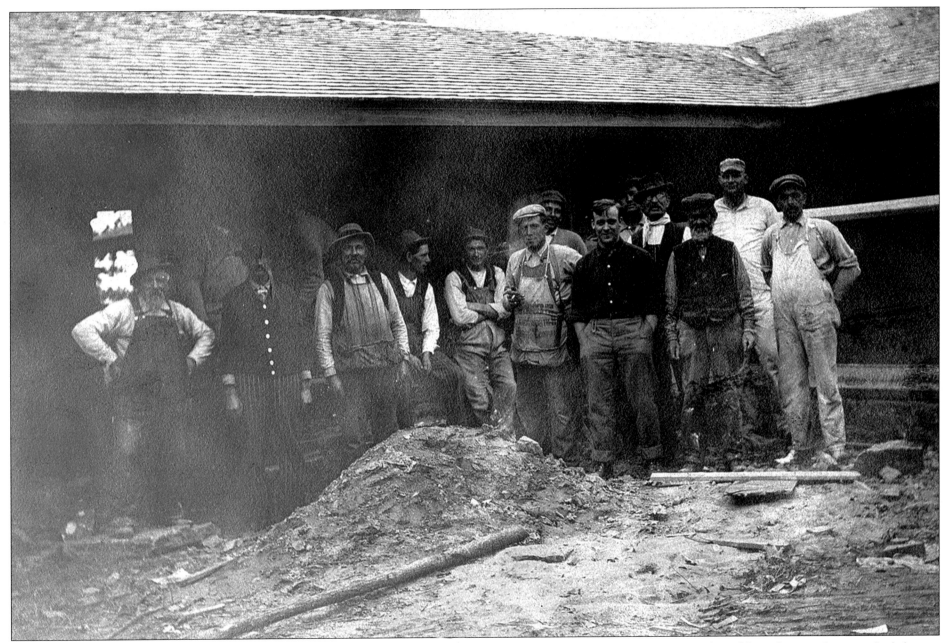

Fig. 53. The Taliesin construction crew poses for a group photo by Taylor Woolley in the forecourt, in front of the breezeway between the residential wing (right) and the studio wing. The man in the dark, buttoned jacket second from left is the carpenter seen holding a board in Fig. 60. Draftsman Clifford Evans, Woolley's partner from Utah, is in the dark shirt and khaki pants in the front row, third from right. Behind him, looking over his left shoulder, is the mustachioed craftsman who appears in Fig. 57.

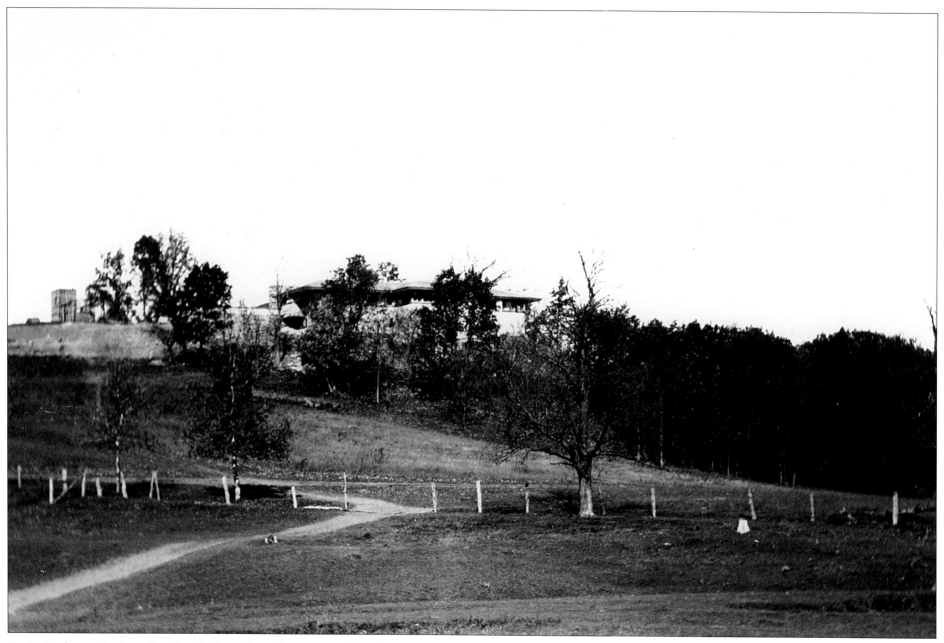

Fig. 54. In what may be the earliest view of Taliesin, the road crosses a neighbor's fence line, turns left, and makes a wide loop around and up the hill. Looking northwest from the base of the hill toward the living quarters of Taliesin, one sees in the background the Belvedere tower under construction, without a roof, in the fall of 1911. Wright has not yet completed the final leg of the carriage path to the house; the lighter soil at top left shows that he has built up this area to create a level area for the drive. This is the first of several photographs Taylor Woolley took from the same position charting the progress of the landscaping.

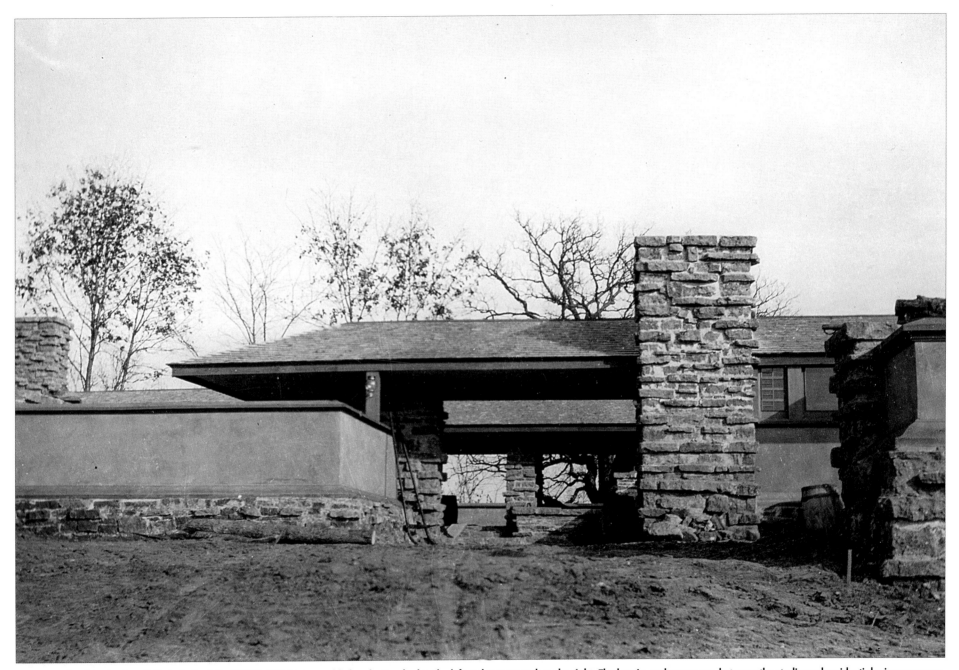

Fig. 55. A dirt drive leads to Taliesin in the fall of 1911. Wright soon added a planting bed to the left and a stone curb to the right. The loggia, or breezeway, between the studio and residential wings appears complete in the distance but is still strewn with barrels and tools.

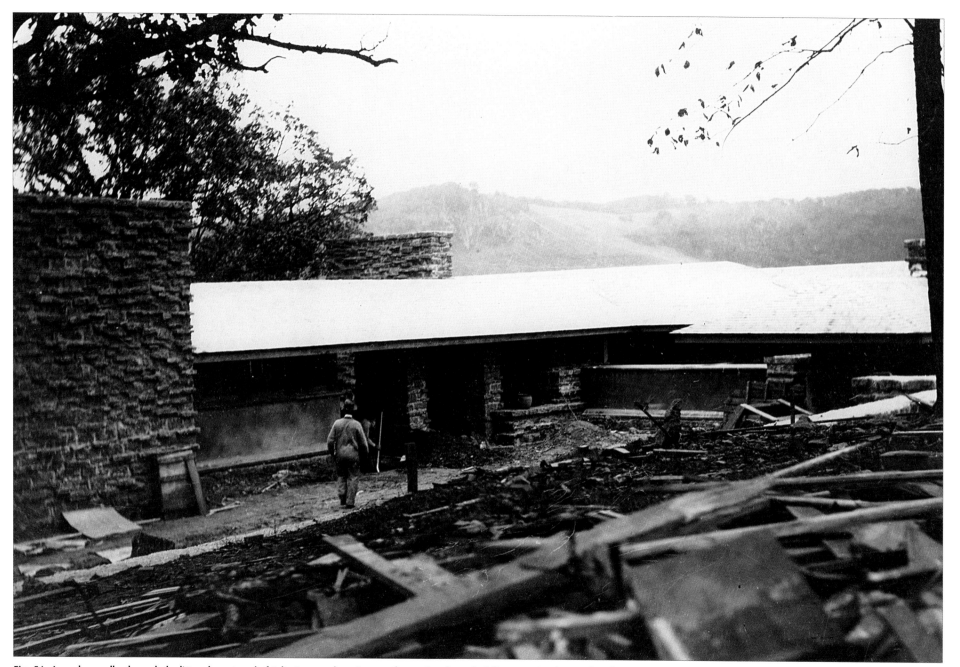

Fig. 56. A worker walks through the littered courtyard of Taliesin, seen here in a northeast view from the hill crown. Another worker digs a trench, probably for steam pipes, in front of the area of the door into the drafting studio.

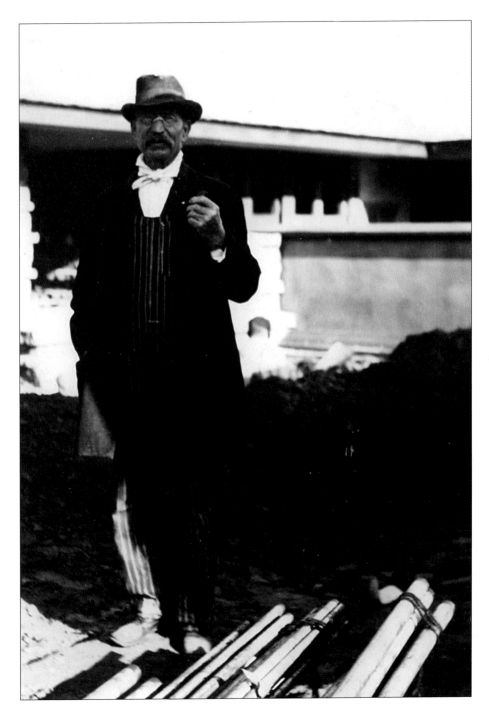
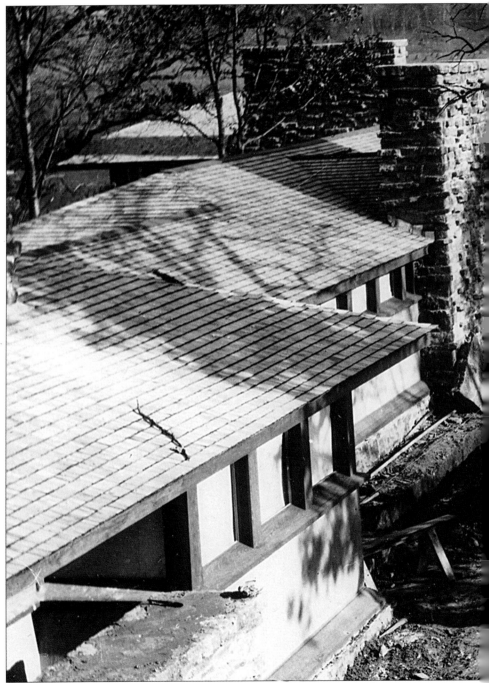

Far left: Fig. 57. A distinguished-looking craftsman stands next to the heating pipes and dirt mound. The windows at his right look in on the kitchen. This man also appears in a group photo in the courtyard, Fig. 53.

Fig. 58. A huge mound of soil fills the Taliesin forecourt in this high view from the agricultural wing. A trench has been dug on the left and a pile of steam-heating pipes can be seen to the left of the oak tree. The window frames are open, waiting to be fitted with glass. The major masonry has been completed, including a portion of the retaining wall for Taliesin's hill crown. At right, a laborer can be seen moving a large slab of stone in front of an oak tree where the Tea Circle will be built.

Fig. 59. An outdoor terrace off the living room is under construction. The wooden floors have not yet been covered with flagstone. The state of construction and the leaves on the trees to the southeast of the terrace suggest that this image was taken within a month of Taylor Woolley's arrival at Taliesin in September 1911. Mamah Borthwick and her children were attacked and killed on this terrace while having lunch on August 15, 1914.

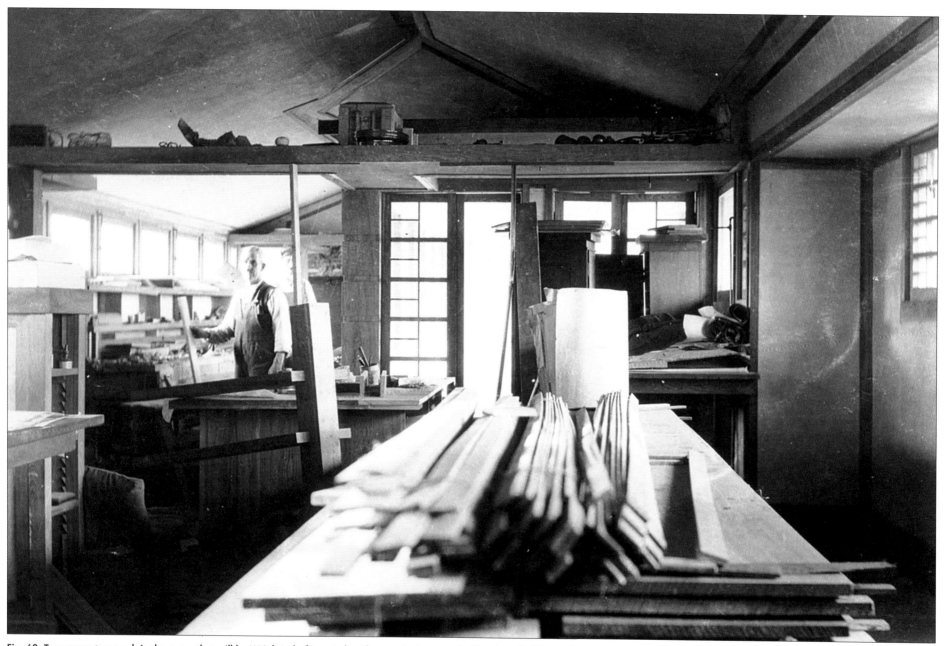

Fig. 60. Two carpenters work in the space that will be Wright's drafting studio. The man in the apron holds a board while another stands behind him. The view looks west from the front office. A table loaded with lath or trim is in the foreground. Drafting tables will eventually occupy this space. A plaster model of Wright's Larkin building (Buffalo, New York, 1902) sits on the crossbeam above. The partial wall separates the drafting area from the sitting room of the workmen's suite, which also includes a bunkroom and bath.

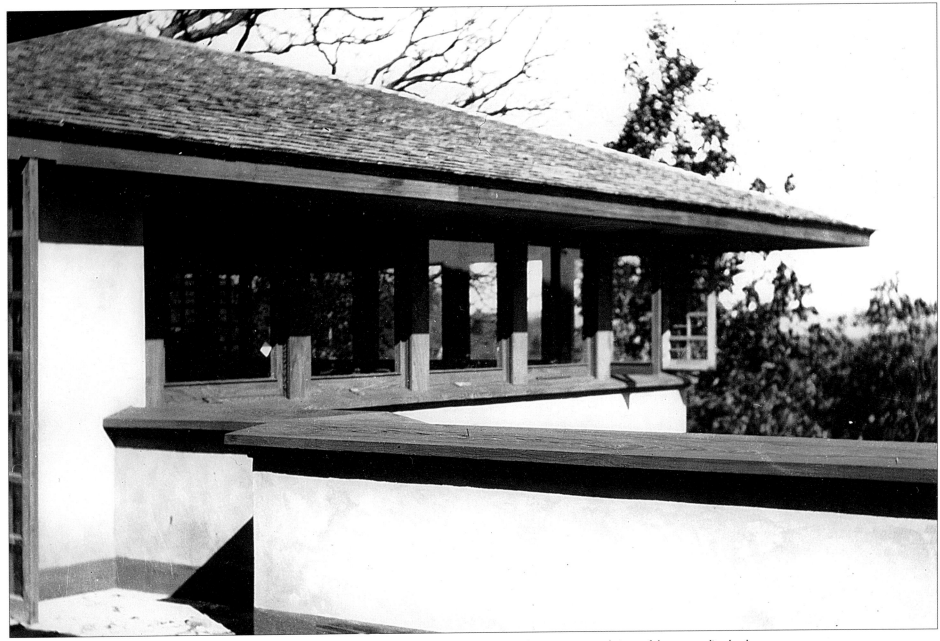

Fig. 61. The living room as seen from the terrace. The flagstone has now been laid. The large plate glass windows take in uninterrupted views of the surrounding landscape.

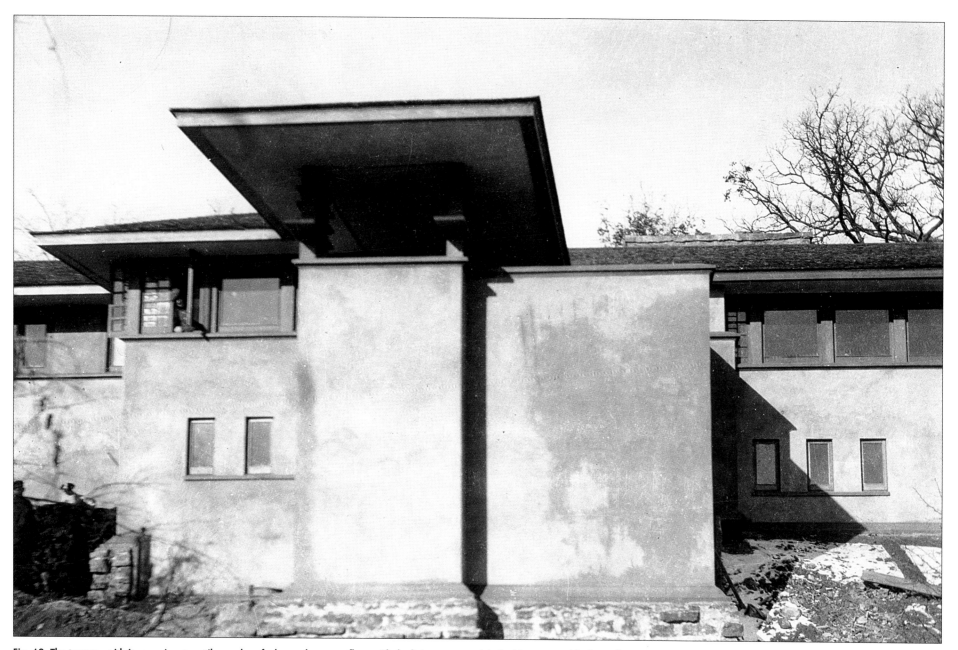

Fig. 62. The terrace, with its prominent cantilevered roof, shares the upper floor with the living room at right in this westward-looking photograph. A workman looks out an open window at left, while another man stands at ground level, left, with a dog, on what appears to be a woodpile.

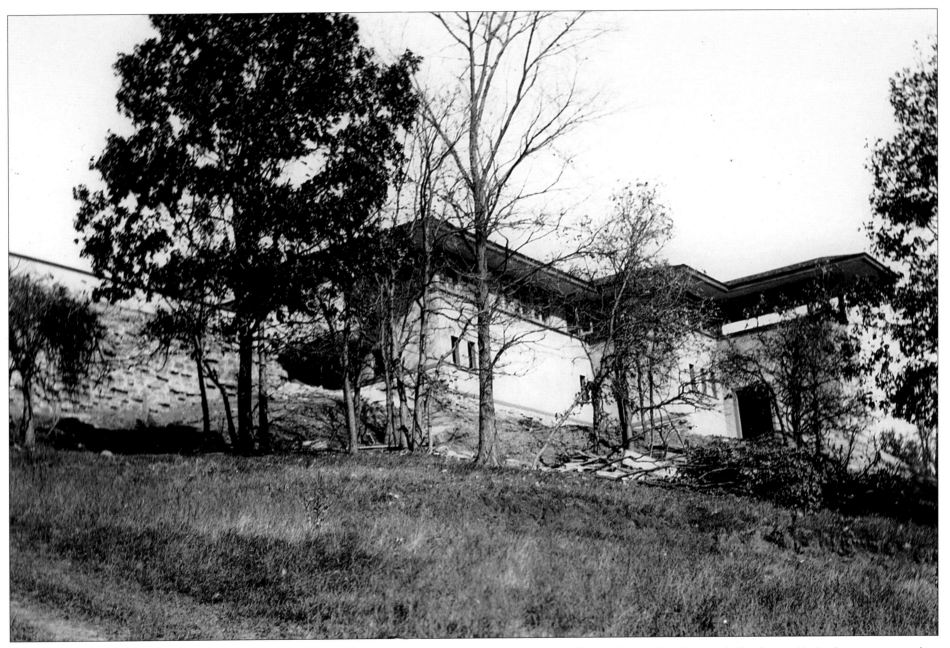

Fig. 63. Taliesin presents a monumental, fortress-like appearance from the approach up the hill. To achieve this, Wright included little in the way of windows on the first floor and had only two terraces on this portion of the structure.

Fig. 64. Looking north/northeast toward the Wisconsin River, this view is taken from the loggia, or breezeway, which separates the studio and residential wings of Taliesin. A corner of the living room and a portion of the chimney are seen at right. The parapet wall may still have been under construction when this photograph was taken, since building materials can be seen.

Figs. 65 and 66. Taliesin's garden muse, "Flower in the Crannied Wall," occupies a place of honor in the forecourt. The sculpture, designed by Wright in collaboration with sculptor Richard Bock, was first done in terra cotta for the Susan Dana House in Springfield, Illinois, in 1902 and was copied in plaster for Taliesin. It depicts a female figure rising from an obelisk of stone, adding a cube to a crystalline structure. The name derives from a Tennyson poem, inscribed on the back, along with a treble clef and staff with two measures of music. The poem goes: "Flower in the crannied wall, / I pluck you out of the crannies. / I hold you here, root and all, in my hand. / Little flower—but if I could understand / What you are, root and all, / I should know what God and man is."

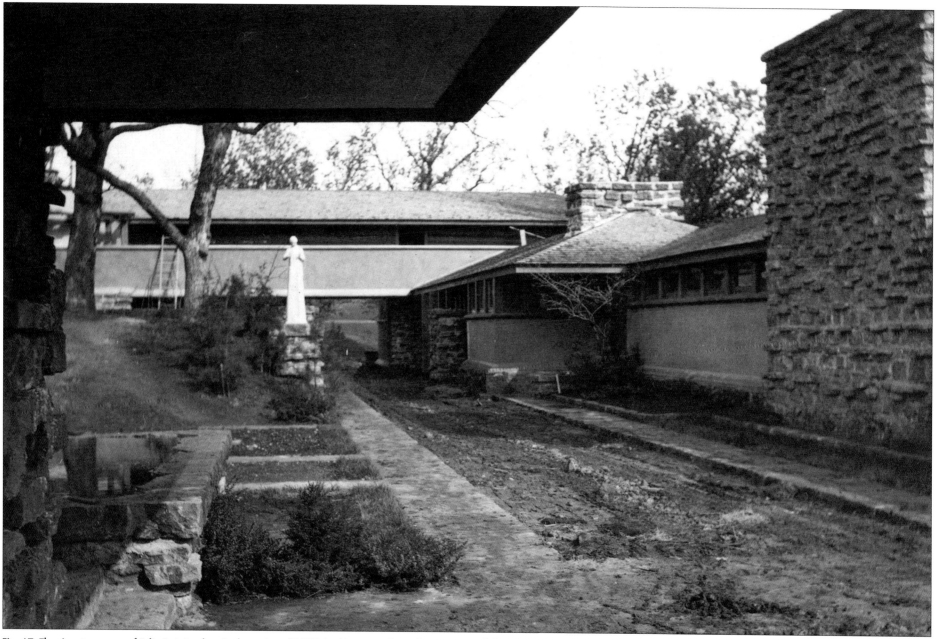

Fig. 67. The signature muse of Taliesin is in place in the spring of 1912. Looking west down the carriage path from beneath the roof of the porte cochere, one sees that Wright has laid out all of the stone paths and curbs, including the garden (with an abstracted "S" shape in flagstones), but has not yet created the stone steps or bench at the Tea Circle (in the mid-ground, left.) A dirt path leads up the hill. Water in the pool, left, shows that the hydraulic ram is working at Taliesin's dam. It was completed in late fall/winter 1911.

 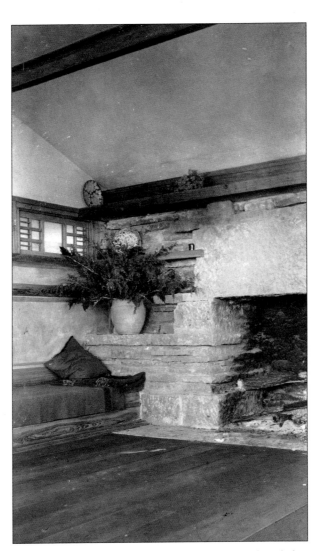

Fig. 68. Three separate images of the living room taken by Taylor Woolley are trimmed and arranged in an album as a triptych. Light has intruded on the third negative. Woolley continues his view of the living room in two more photographs.

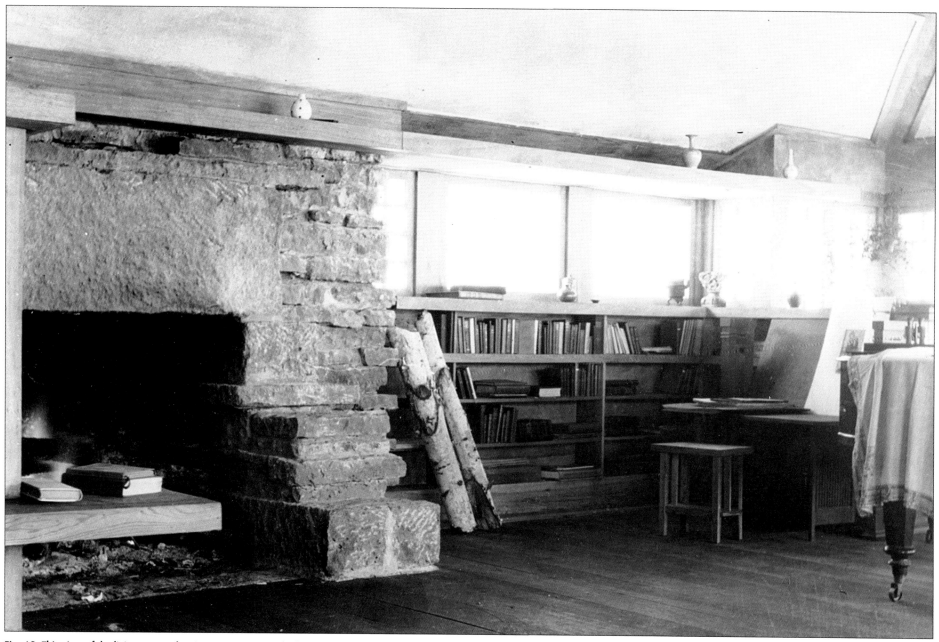

Fig. 69. This view of the living room takes in even more area, looking northwest. The edge of the inglenook is on the left (with two books), followed on the right by the fireplace and built-in bookshelves. There is a Japanese print stand of Wright's design on the north wall, with what appears to be a woodblock print. One of his drafting stools is in front of it. The edge of a draped grand piano is on the extreme right.

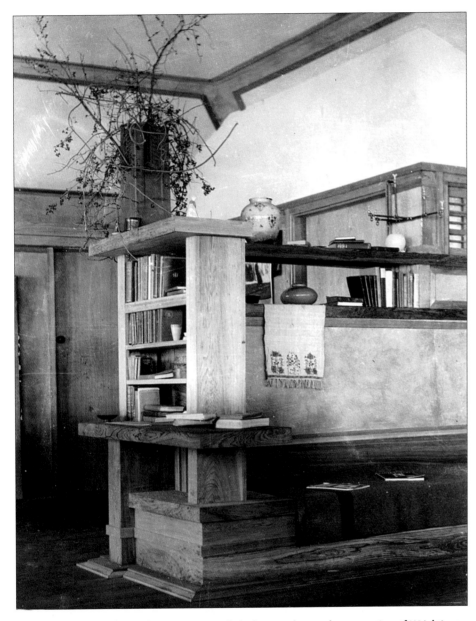

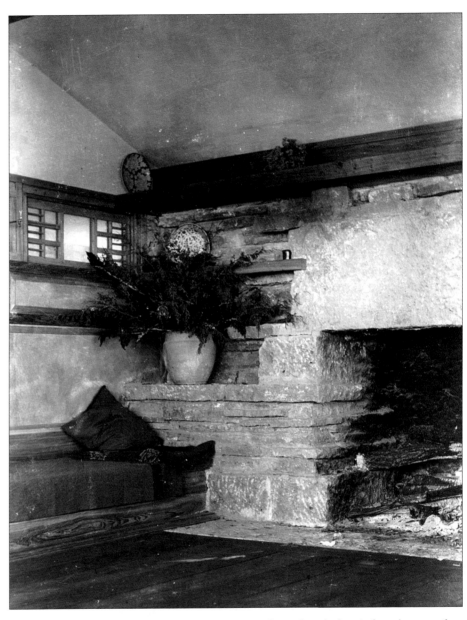

Fig. 70. The left photo of the living room triptych, looking southwest, shows a variety of Wright's decorative objects. A Japanese screen is folded on the far left side. A vase of Wright's design is on the end of the inglenook, while other pots appear to be Asian or European in origin. A sewn fabric is draped over the back of the inglenook. The front door to Taliesin is immediately behind the inglenook, on the right.

Fig. 71. In the center photograph of the living room triptych, windows looking in from the entry of Taliesin can be seen above the inglenook.

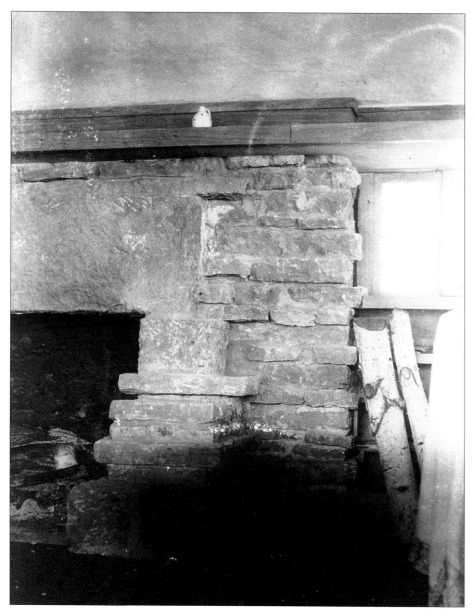

Fig. 72. In the right section of the triptych, Wright's "pop-out" technique of masonry can be seen. This masonry style, created for Taliesin, is meant to evoke the limestone outcroppings of the valley. Wright later used this style in Fallingwater, the Unitarian Meeting House in Madison, and many of his 1950s home designs.

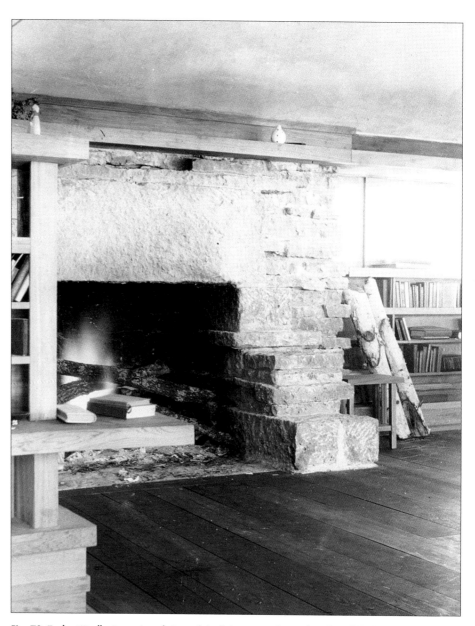

Fig. 73. Taylor Woolley's continued view of the living room shows the edge of the bookcase at the end of the inglenook, left, followed by the fireplace, two birch logs, and built-in bookshelves on the west wall.

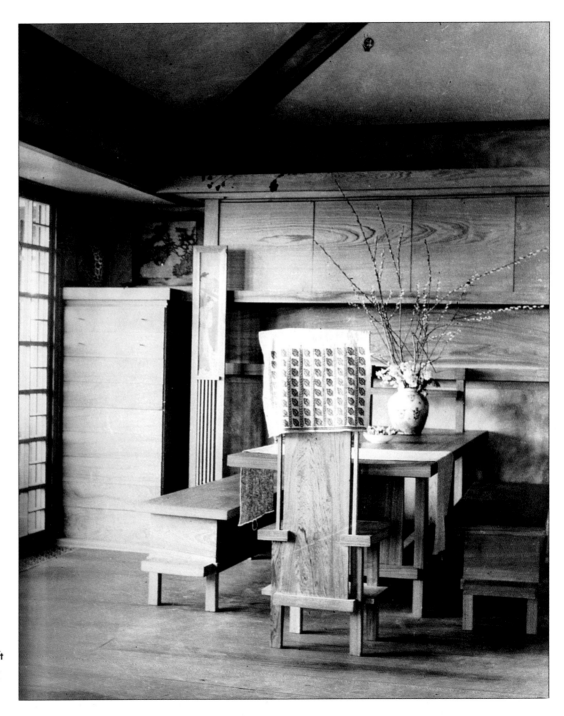

Fig. 74. The dining area occupies an end of the living room, with part of the door to the terrace seen on the left. The pussywillows in the vase indicate this was taken in the spring of 1912. The Japanese woodblock print in the long format stand, to the left of the bench, is the same print seen at an exhibit at the Chicago Art Institute in 1914. Of the furniture seen in this photograph, only one of the benches is known to have survived the 1914 fire.

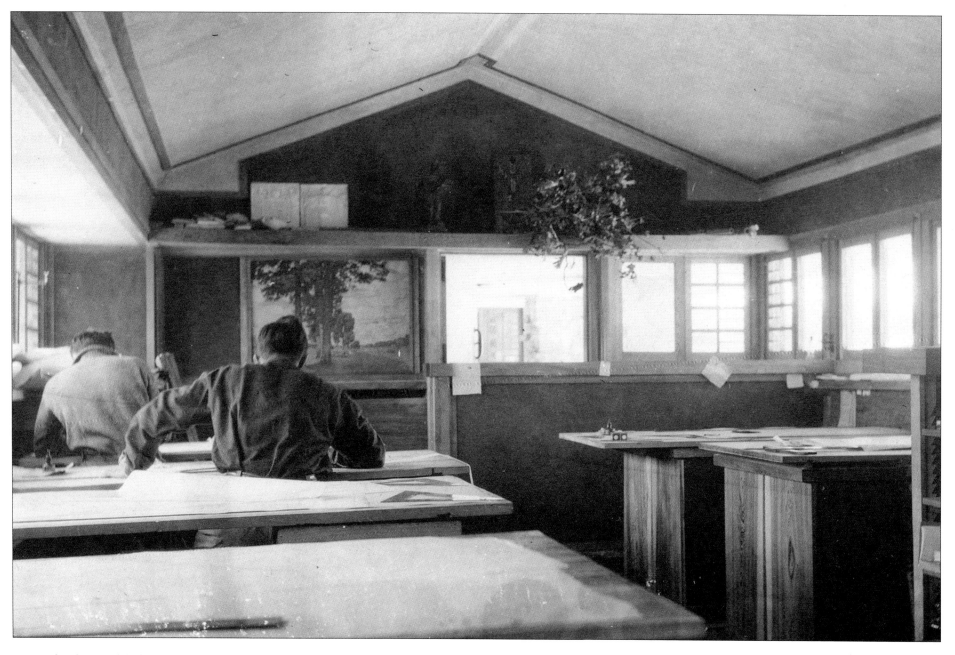

Fig. 75. This photograph looks east into Wright's drafting studio, with five drafting tables, and two draftsmen on the left. This would appear to have been taken in the spring or summer of 1912 because the door on the east wall is open in the background. The landscape painting is of the type done by George Mann Niedecken. The door to the breezeway is to the left of the painting. By the time this photograph was taken, Wright had already made a change to the ceiling, by removing some of the trim at the ridge of the roof (seen by the lighter color on the ceiling).

Fig. 76. The edge of the drafting room's fireplace is on the right, with a built-in decorative wooden detail holding two plaster figures. The bottom of a radiator can be seen at extreme left.

Fig. 77. A third shot of the drafting room shows a plaster model of Wright's Unity Temple in Oak Park, Illinois (1905), sitting on a crossbeam. The room's inglenook is in front of the viewer, supporting a gas lamp. Beyond this is a plaster half-wall.

Fig. 78. Off the drafting room is a bunkroom for the draftsmen, part of a suite that includes a sitting room and kitchen. The wood is tidewater red cypress. The room is decorated with a landscape painting, stems in a vase, a T-square, and books. Illumination is by gas globes. The position of the objects on the built-in cabinet shows that the three photographs in this series were taken at the same time. However, Woolley moved the desk and stools between the photographs, perhaps for composition.

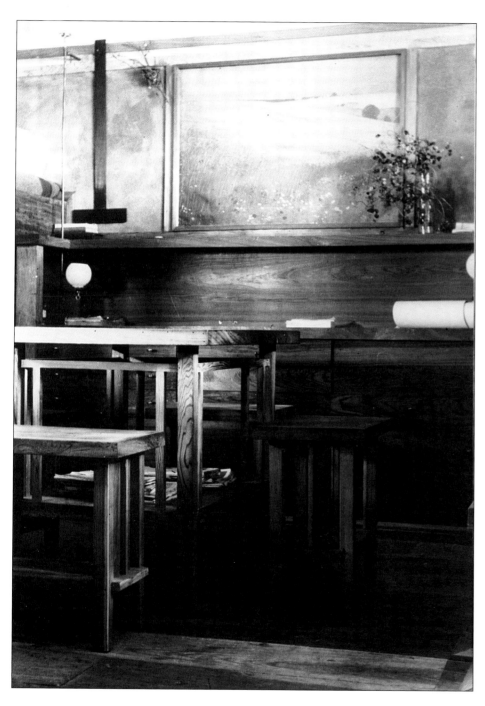

Fig. 79. A view from the right side of the bunkroom shows off the stools and table. Drawers with pulls in the built-in cabinet can be seen through the table at left.

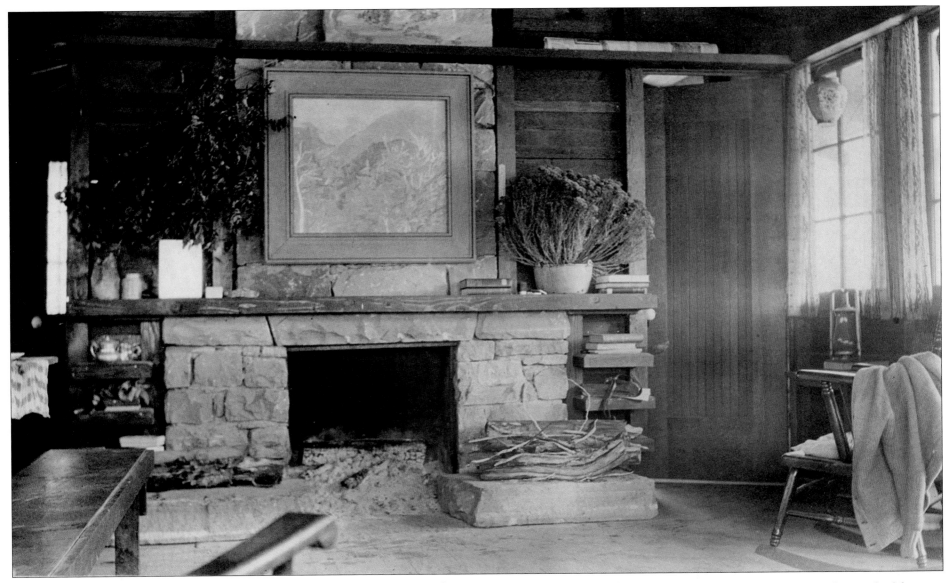

Fig. 80. This living and dining area, included in Tayor Woolley's "Taliesin" album, may be in a guest cottage where Woolley and Clifford Evans stayed during their time at Taliesin. The photographer left no details. A man's cardigan sweater is draped over a chair. The fireplace and its framing are Wrightian, as are the Japanese lanterns, fresh boughs and dried flowers used for decoration. The landscape painting at the very top, depicting a grove of Wisconsin birch trees, appears to be a section of a mural made by George Mann Niedecken for the Adam Mayer House in Milwaukee (1907).

Fig. 81. "Evenings, the men grouped around the open fireplaces, throwing cordwood on them to keep themselves warm as the wind came up through the floorboards," Wright recalled of the first winter at Taliesin. Ten workmen gather in front of the fireplace in the drafting room. Two are smoking pipes while another holds a wooden flute. Clifford Evans sits front and center in a sport coat. The deck above the fireplace still exists in the studio, and the stone mantel is the same today.

Fig. 82. The Belvedere tower, left, and roofline of the Taliesin living quarters, right, are seen in this view looking north. This photograph shows the Belvedere close to its completion in the fall of 1911, with a ladder in front of a roof that Wright called the garage.

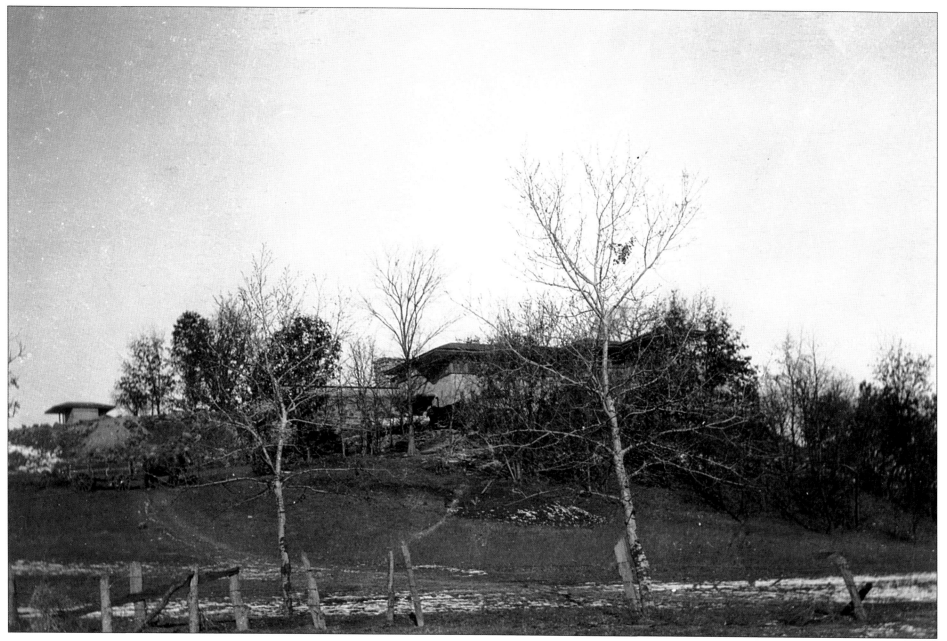

Fig. 83. This is the first in a series of Woolley photosgraphs looking at Taliesin's living quarters from below in late fall 1911. The Belvedere tower in the background appears to have been completed. There is a man seen in this photograph in a trench on the hill, possibly digging in this area, and there are two horses: one on the left, and one in front of the first floor of the building, seen just behind some trees.

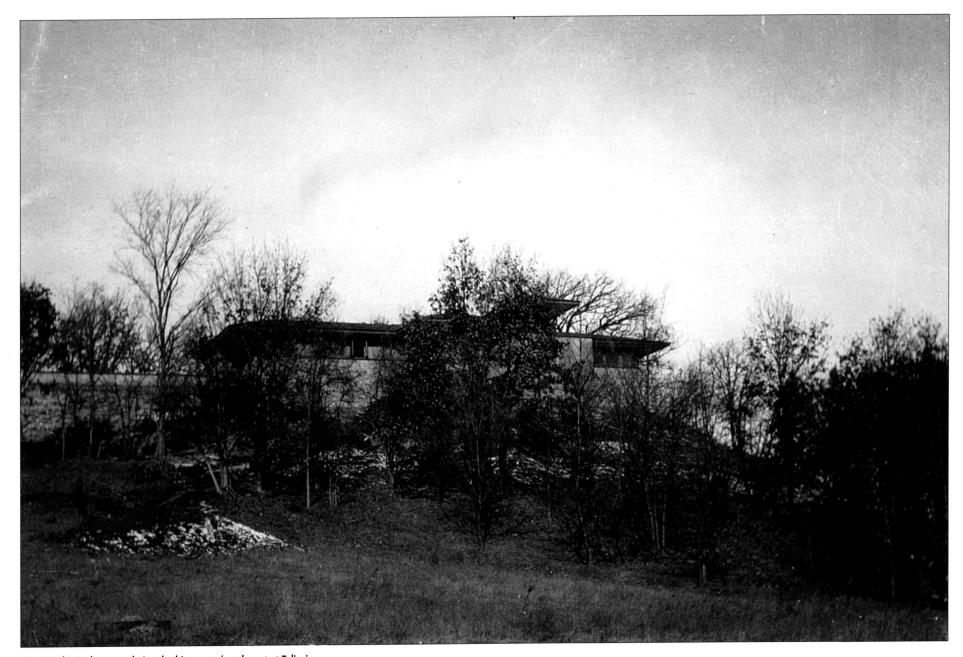

Fig. 84. This is the second view looking west/northwest at Taliesin.

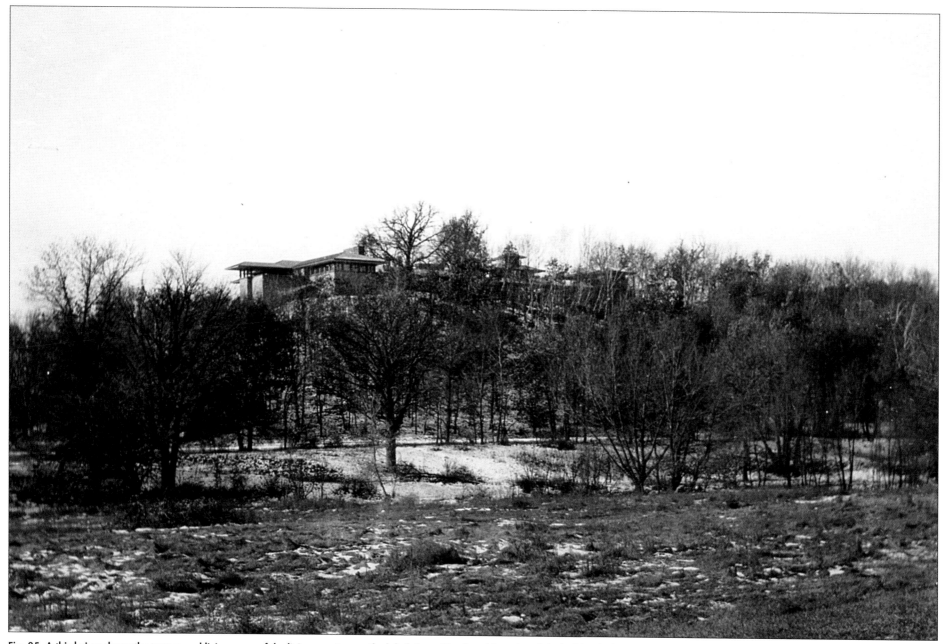

Fig. 85. A third view shows the terrace and living room of the living quarters on the left, followed by the mid-portion of the building hidden behind trees, and ending on the far right at the edge of the hayloft.

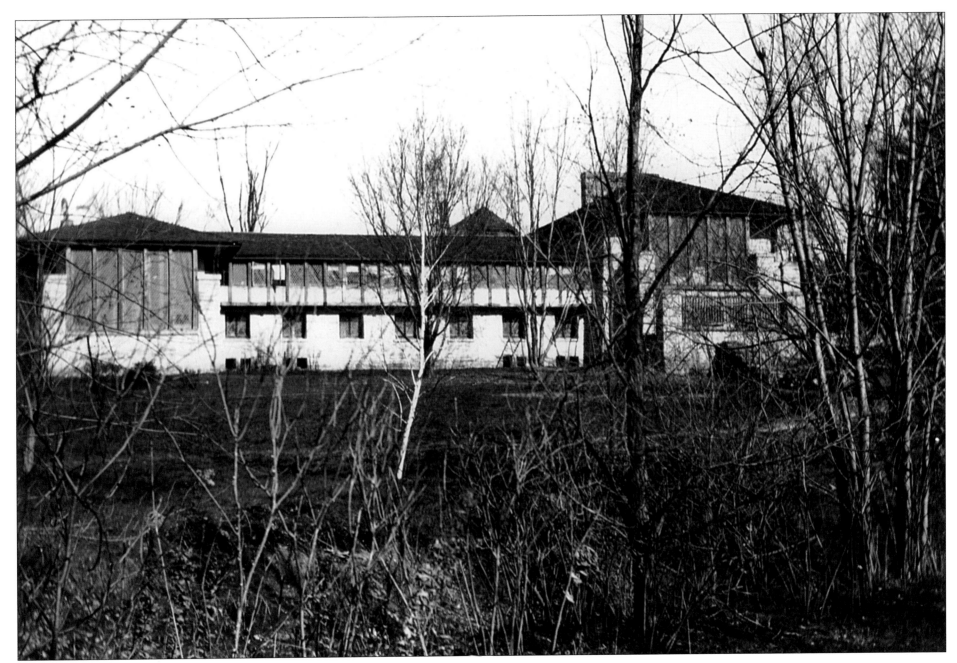

Fig. 86. Taylor Woolley photograph of Hillside Home School. It was designed by Wright in 1901 for his aunts, Jane and Ellen Lloyd Jones.

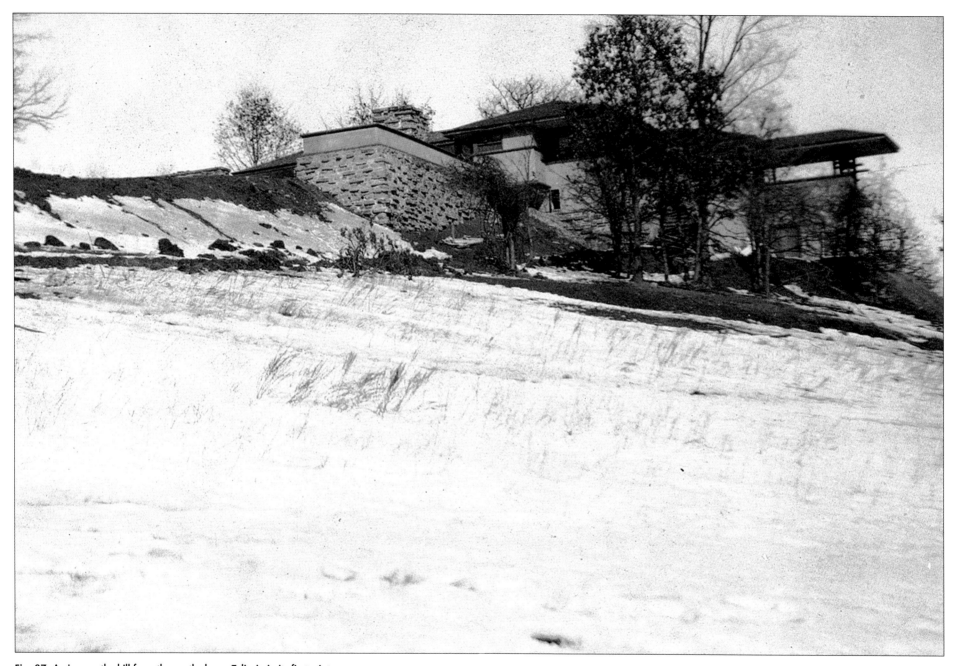

Fig. 87. A view up the hill from the south shows Taliesin in its first winter.

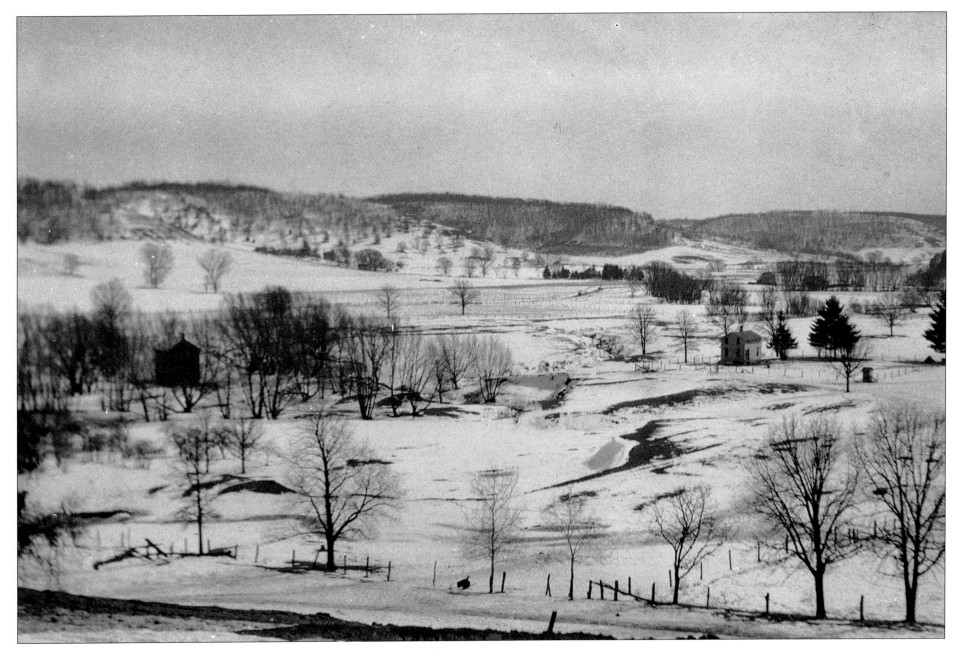

Fig. 88. A vista from Taliesin shows two farmhouses in the valley and the line of hills.

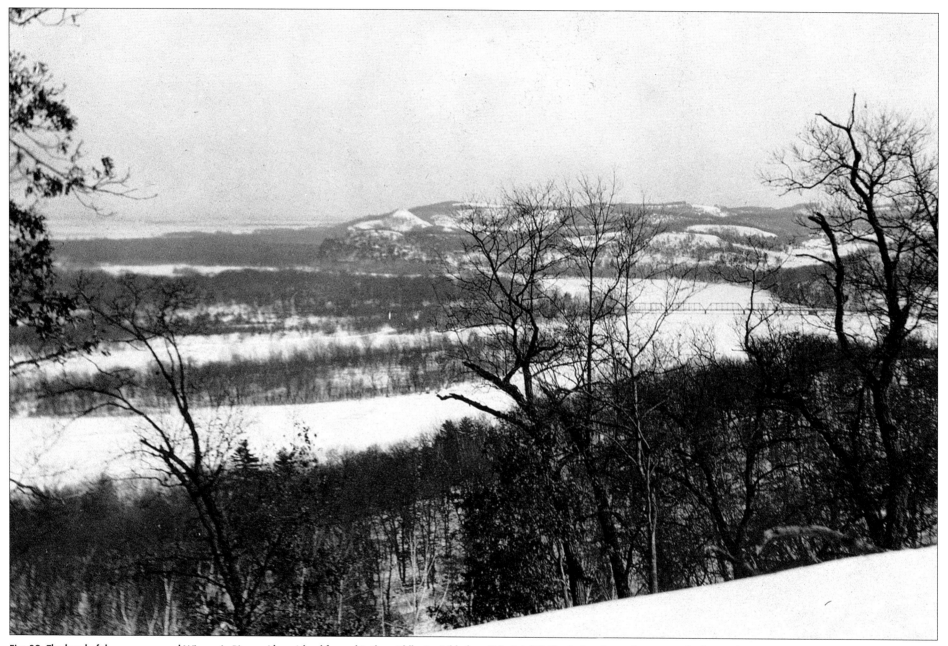

Fig. 89. The bend of the snow-covered Wisconsin River, with an island formed in the middle, is visible from Taliesin's hill. The Spring Green river wagon bridge can be seen between the bare trees. The view of the river from Taliesin has since become largely overgrown.

Fig. 90. The Wisconsin River has an open patch at the shore in this winter view.

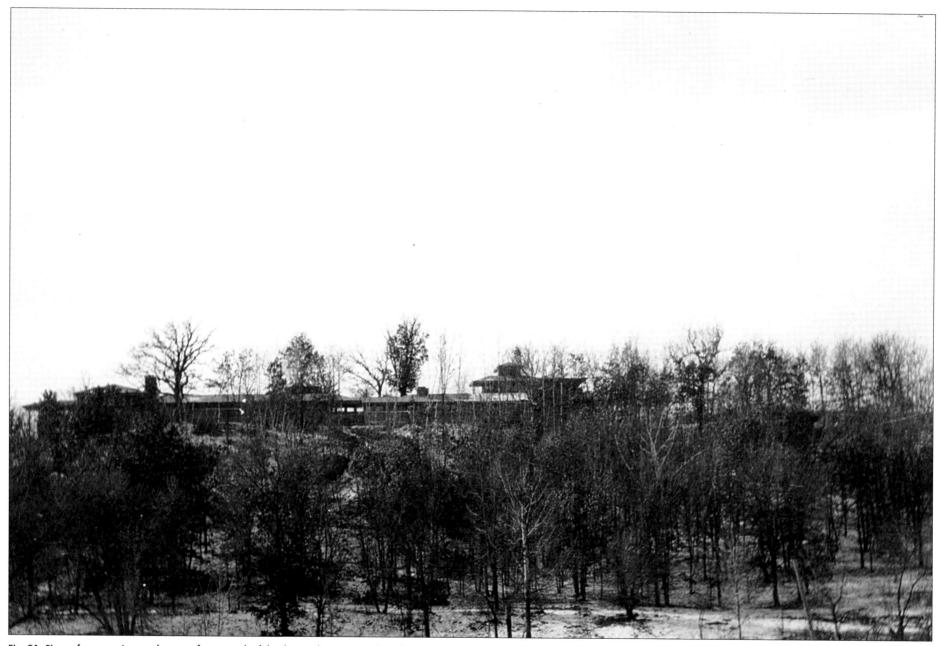

Fig. 91. Signs of construction can be seen, foreground, of the dam at the western edge of a creek that runs through the property, in order to create a waterfall. The winter view looks south, with Taliesin's living room on the left.

Fig. 92. The dammed stream ends in a pond below Taliesin, which is up the hill to the right.

Fig. 93. Water flowing from the dam is rammed up the hill hydraulically to create a water garden and supply the house.

Fig. 94. Water flows over the dam in the foreground, in the winter of 1911-1912. The fence seen in the background marks the northern edge of Wright's property.

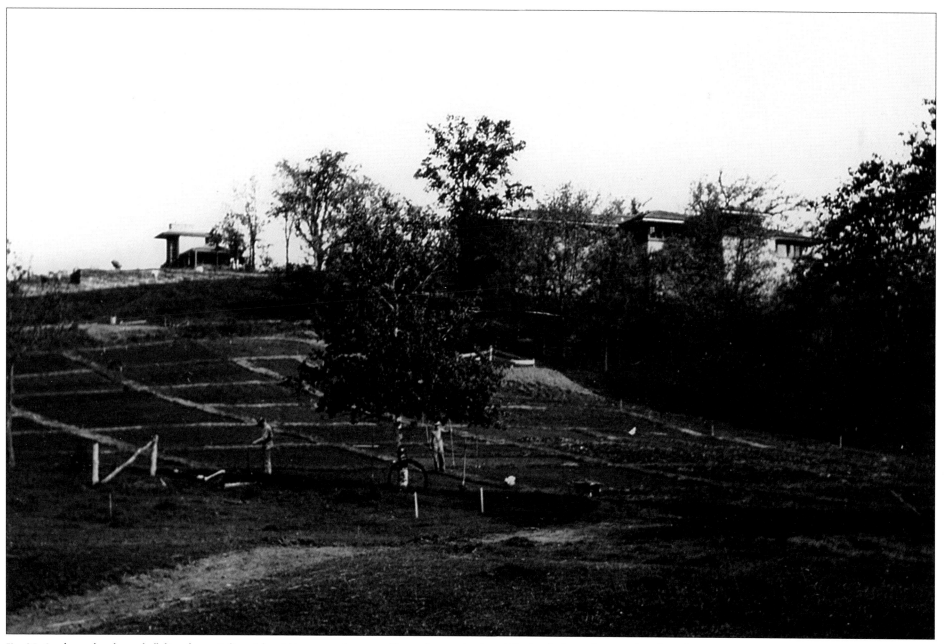

Fig. 95. Gardeners lay down chalk lines for an Italian-style grid to prepare for vegetable gardens on the slope. This view looks northwest at the Taliesin living quarters, during the creation of planting grids on the hill. The foliage, state of the building, and men's clothing suggest that this was taken in the summer of 1912. It is the last photograph Woolley took of this view, which is from the same perspective as Fig. 54.

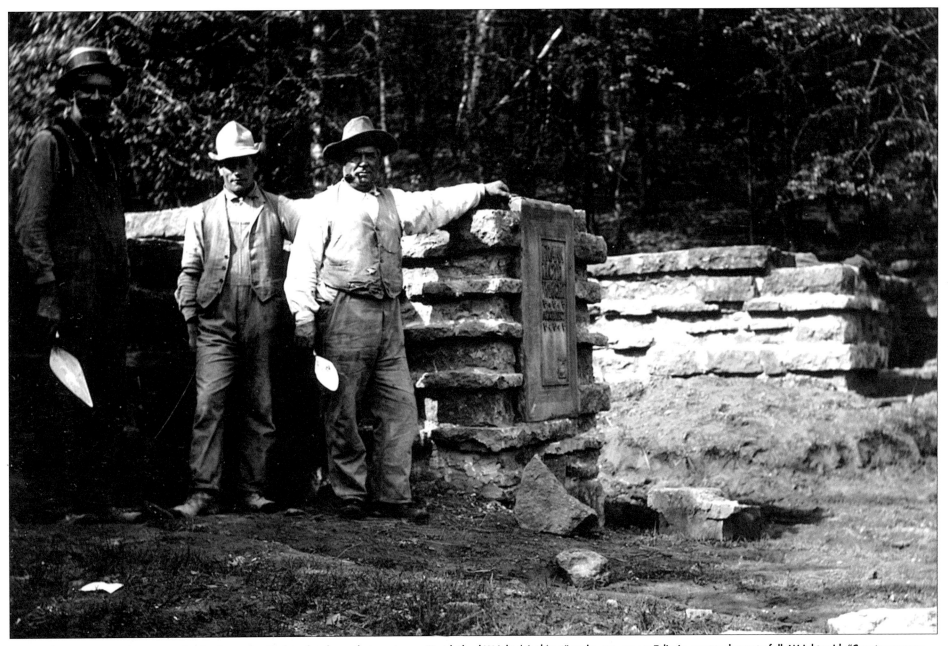

Fig. 96. Three stonemasons pose proudly after cementing in place the plaque that announces "Frank Lloyd Wright / Architect" at the gateway to Taliesin, next to the waterfall. Wright said, "Country masons laid all the stone with the quarry for a pattern and the architect for a teacher. They were soon as interested as sculptors fashioning a sculpture. . . . They were artistic for the first time, many of them, and liked it."

Fig. 97. The limestone plaque, still in place today, was brought from Wright's drafting studio in Oak Park, Illinois, when he left for Taliesin in 1911. A replica was placed at the Oak Park studio by preservationists during its reconstruction. Photograph by Pedro E. Guerrero.

A PUPPET THEATER FOR LLEWELLYN

Robert Llewellyn Wright was the last child of Frank and Catherine Wright, the youngest of six, born five years after his sister Frances and 13 years after his oldest brother, Lloyd.

In the fall of 1911, when his father was gone to build Taliesin, Llewellyn was approaching his eighth birthday, which fell on November 15. This may have been the occasion that prompted his father to build a full-size puppet theater in the unfinished living room of Taliesin.

The richly grained wood, tidewater red cypress, is the same wood used decoratively throughout Taliesin, notably in the dining area. The new theater was crafted from the fabric of Taliesin.

Fig. 98. Llewellyn at age six in 1909

When Wright put the object on display at the Art Institute of Chicago in the spring of 1914, he titled it "Marionette Theatre, Made for Llewellyn Wright." But Llewellyn probably did not play with it at Taliesin. It was apparently shipped to his home in Oak Park, Illinois—in the photos it sits on slats, ready for transfer—and installed there. It is doubtful that the father ever saw it in use. It has since been lost.[1]

In the 1914 photo, curtains hang from either side of the top crossbeam. The photo also shows an ingenious hinged rail at the front of the stage that could be flipped up to reveal footlights. Slots on the floor of the stage, behind the theater curtain, allow scenery to be moved back and forth and changed. The curtain operates on pulleys.

In style the theater has a Prairie feel, a complex of planes and geometric volumes. The carved mottoes on the cabinet, as well as the ornamentation, are also characteristic. But the object also looks Japanese, as though it could be a Shinto shrine. The mottoes are from Richard Hovey's 1896 Camelot play, *Taliesin: A Masque.* Over the stage the motto reads, "To fashion worlds in little, making form as God does with spirit / so God makes use of poets." At either side of the stage,

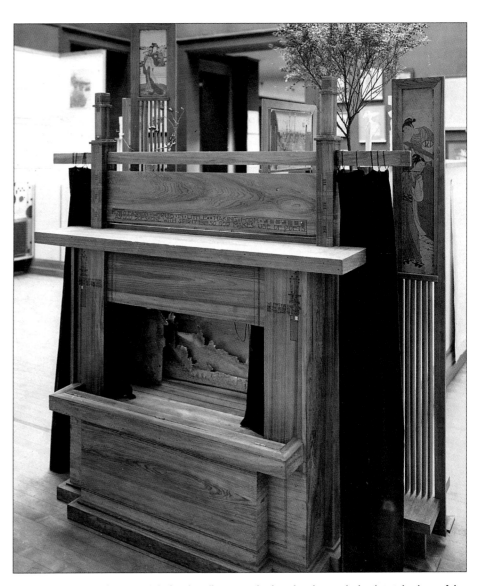

Fig. 99. "Marionette Theatre, Made for Llewellyn" was displayed at the Frank Lloyd Wright show of the Chicago Architectural Club at the Chicago Art Institute from April 9 to May 3, 1914. The stage shows some wear from being used. Other recent Wright designs on view are Japanese print holders, seen at Taliesin, and, in the next room, a "Kindersymphony" window from the Avery Coonley Playhouse.

Fig. 100. For the theater backdrop (detail from rendering) Wright chose an Italian hill scene much like the ones he witnessed the previous year in Tuscany. In the balcony is the figure of a woman and a man stands below, suggesting the famous scene from Shakespeare's *Romeo and Juliet.*

the second motto says, "To fare on, fusing the self that wakes and the self that dreams, we find for choosing the deeds to dare and the laws to keep."[2]

In both Wright's rendering and in close-up photos, the scenery is unmistakably Italian. There is a terrace with a low wall and urns, with cypress trees and hills beyond. It is a memory from Tuscany, where Wright had lived with Mamah Borthwick, Lloyd Wright and Taylor Woolley the previous year. On the left is an Italianate tower with a balcony. In the rendering, there is a woman in the balcony and a man below, suggesting the balcony scene from Shakespeare's *Romeo and Juliet.*

Frank and Mamah may have seen open-air puppet theater shows in the streets of Florence and Fiesole. He may also have seen puppet theater in Japan in his trip there in 1905. In any event, the idea of designing a toy like this must have delighted him. Wright put stages for children's theatrical performances in many of his designs, including the playroom of the Oak Park home; the 1902 Susan Dana House in Springfield, Illinois; and the Avery Coonley Playhouse, which was commissioned in 1911, the same year Taliesin was built. The Coonley building was actually a private, progressive school but took the playhouse name because of the stage. (Wright called it "Kindergarten. Little Play House" in the 1914 program.)

The fact that George Mann Niedecken had worked with Wright on both the Coonley residence and school suggests him as a possible builder of the puppet theater. The Milwaukee craftsman had both the painting and cabinetmaking skills.

Fig. 101. *Catherine Wright and Children,* painted by Frank Lloyd Wright's sister Maginel Wright Barney in 1905, shows Catherine holding a tyke who may be Llewellyn (who was two) and tending her own and neighbor children.

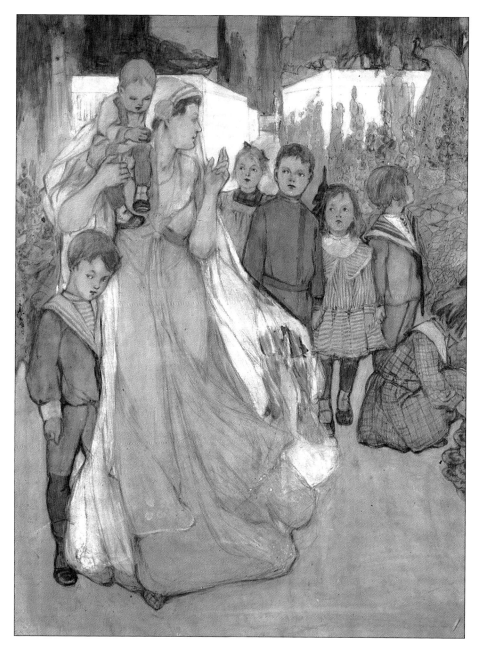

Fig. 102. Frank Lloyd Wright's rendering of the puppet theater for his youngest son is among the papers of Taylor Woolley. An earlier sketch shows a simpler legend over the stage: "To whomsoever this may come designed / for all small boys or girls to mind."

His painting, *Spring Green, 1912,* places him at Taliesin in its early years.

Whether Llewellyn wanted or even liked the lavish puppet theater is an open question. His daughter says he was a quiet boy, not theatrical. When he grew up he called himself Bob and became a government lawyer. Elizabeth Catherine Wright, now an emeritus professor of French living in France, writes:

"I don't recall my father or anyone else ever mentioning such a puppet theater, though of course the large playroom he built for his children is well known . . . I also don't remember my father having any particular interest in theater, though his father did, of course, and one of my cousins did become a famous actress, Anne Baxter."[3]

Elizabeth's brother, Tim Wright, a documentary filmmaker, says that Llewellyn did enjoy theater as an adult and "his relations with his father were certainly the most consistently harmonious of all the children throughout his father's life. But as he wistfully concluded his memoir, 'We never had any real rows or any especially tender moments. He was always kind and affectionate with me . . . [but] the sad truth is that we were friendly strangers'"[4]

On November 15, 1911, Llewellyn wrote to his father at Taliesin: "Dear Father: This is my birthday. I miss you very much. Will you please eat Thanksgiving dinner with us. We are lonesome with out you. We are afraid you are sick I am eight years old. Good bye from your loving son." On the last page he added, "birthday kisses OOOOOOOO," one for each year.[5]

There is no mention of a marionette theater. The gift may have been for a later occasion. But it may also be that when he wrote that letter Llewellyn was too busy playing the puppet for his mother in the Wright family drama to think of toys or thank his father.

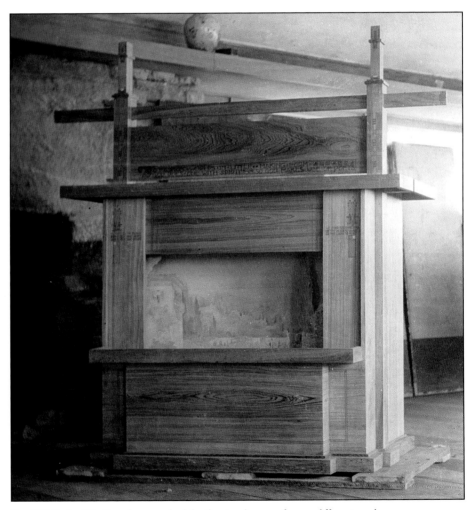

Fig. 103. Taylor Woolley photographed the theater close-up, from a different angle.

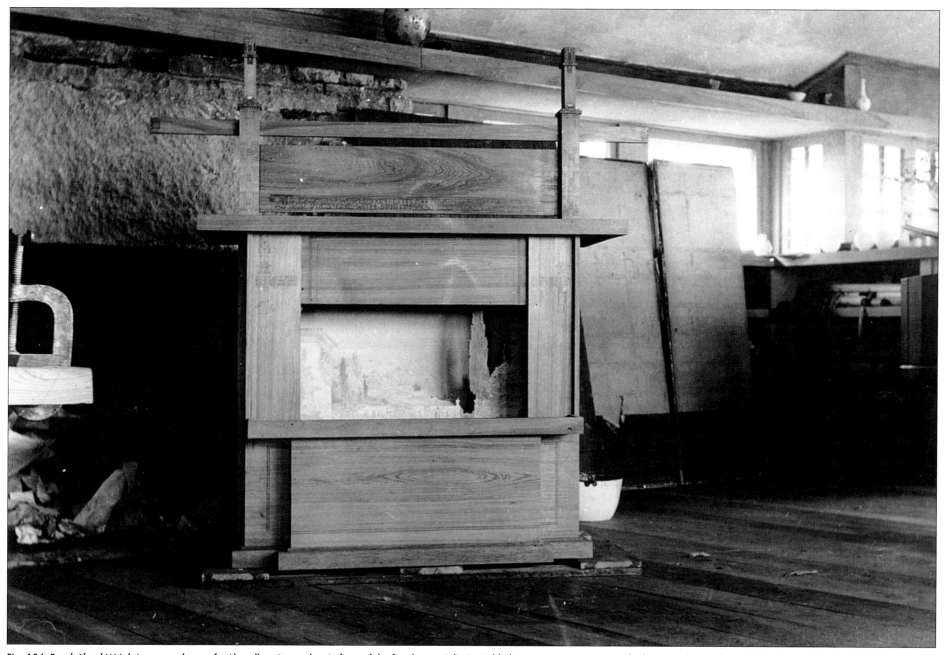

Fig. 104. Frank Lloyd Wright's puppet theater for Llewellyn sits on slats in front of the fireplace at Taliesin. Folded Japanese screens are stacked against the windows and the floors are bare.

WOOLLEY'S TALIESIN PHOTOS: SOURCES

Taylor Woolley's photographs of Taliesin in 1911–1912 are spread among three collections. The main collection is at the Utah State Historical Society in Salt Lake City. It consists of original negatives. A second group of photos is divided between the Taylor Woolley Collection and the Clifford Evans Collection at the J. Willard Marriott Library at the University of Utah, Salt Lake City. Evans, who appears in several photos at Taliesin, was Woolley's lifelong friend and architectural partner. The third group is in an unidentified album titled "Taliesin" (in quotation marks) at the Wisconsin Historical Society in Madison.

There are overlaps among the collections, but each contains unique images. Keiran Murphy, historian at Taliesin Preservation Inc., Wisconsin, has indicated in the following thumbnail galleries which image is to be found where.

The abbreviations are:

USHS: Utah State Historical Society
UUL: University of Utah Library
WHS: Wisconsin Historical Society

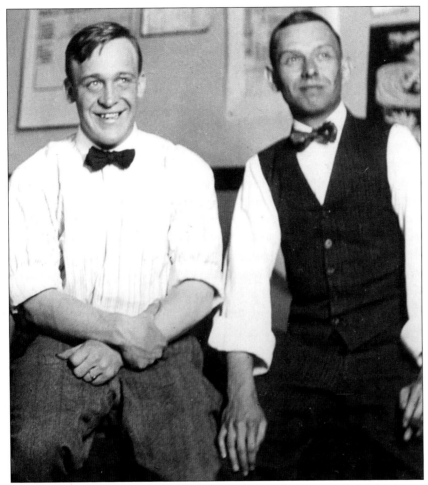

Fig. 105. Clifford Evans, left, and Taylor Woolley, architectural partners, in their Salt Lake City office. The photograh is in the Taylor M. Woolley Collection at the Utah State Historical Society. This photograph has been cropped.

MILLER · WOOLLEY & EVANS ARCHITECTS
SALT LAKE CITY UTAH
McINTYRE BUILDING

Fig. 106. Woolley's firm used Wrightian lettering on its letterhead when it was organized in 1917. Miles Miller, the third partner, left in 1921.

Fig. 107. This Prairie Style bungalow in Salt Lake City was designed by Taylor Woolley just before he left for Taliesin. The building permit listing him as architect was filed on August 18, 1911. Wright cabled him on August 31. A newspaper ad by the developer Kimball & Richards says, "The architectural lines follow what is known as the Frank Lloyd Wright or New American architecture. The chief characteristic is the absence of useless ornamentation and 'ginger-bread' trimmings. Beauty is secured by harmonious arrangement, artistic proportions, and simplicity." The home is being restored by its owner, Butch Kmet.

USHS, WHS

WHS

WHS

WHS

USHS

USHS

USHS

USHS

WHS

USHS, WHS

USHS, WHS

WHS

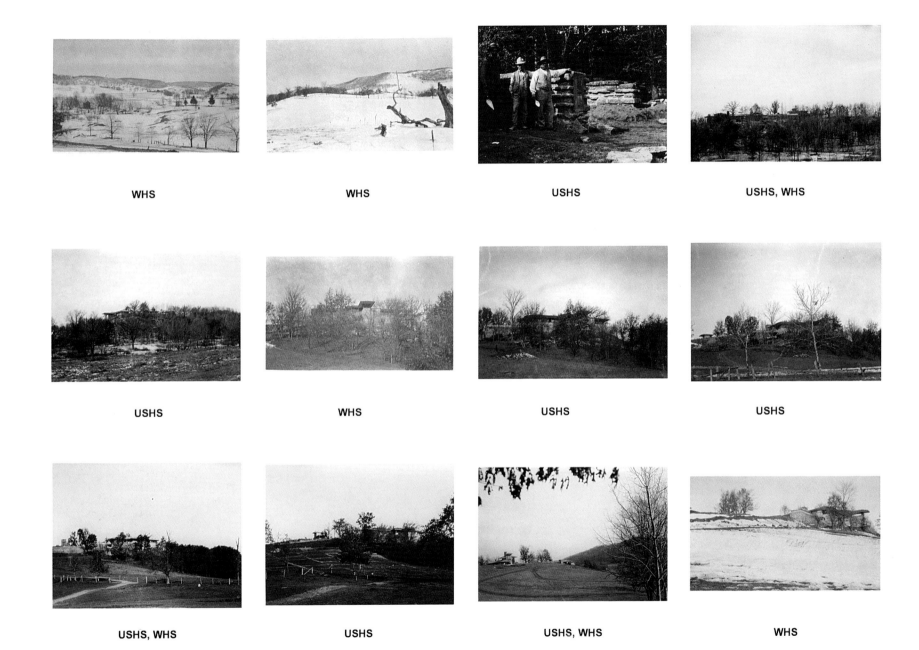

WHS WHS USHS USHS, WHS

USHS WHS USHS USHS

USHS, WHS USHS USHS, WHS WHS

USHS, WHS, UUL

USHS, UUL, WHS

USHS

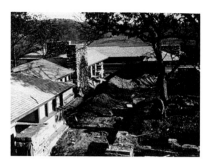

USHS, UUL

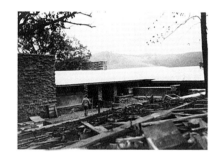

USHS, UUL

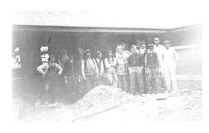

UUL

USHS, UUL

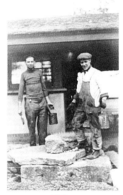

UUL

UUL, WHS

UUL

USHS, WHS, UUL

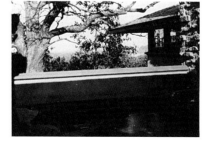

USHS, WHS

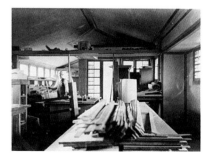

USHS

USHS, WHS

USHS, WHS

USHS

USHS, WHS

USHS

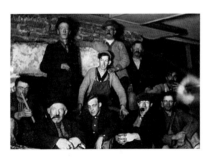

USHS, UUL, WHS

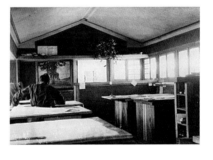

USHS, WHS

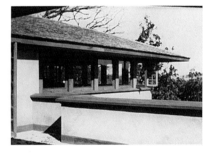

USHS, WHS, UUL

USHS

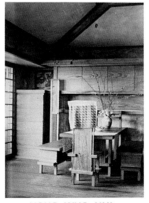

USHS, WHS, UUL

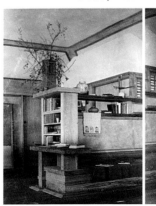

USHS, WHS

USHS, UUL

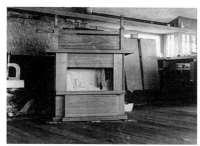

USHS, UUL

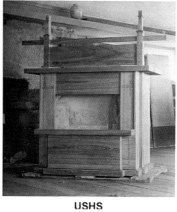

USHS

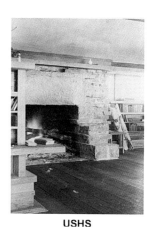

USHS

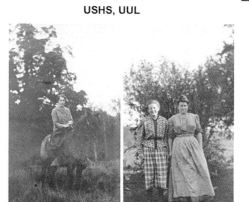

USHS, WHS

WHS

WHS

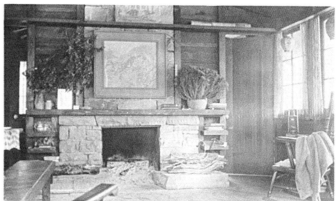

WHS

IN WRIGHT'S WORDS
"I wanted a *natural* house to live in myself"

The following is Frank Lloyd Wright's own account of how he conceived and built Taliesin I. Written beginning in 1926 and published in 1932, this section of An Autobiography *is remarkable for its depth of detail on construction techniques and materials. It is also notable for the Whitman-like gusto with which Wright describes the food that Taliesin would produce. Composed in very lean times, it reads like the dream of a hungry man.*

Taliesin was the name of a Welsh Poet. A druid bard or singer of songs who sang to Wales the glories of Fine Art. Literally the Welsh word means "shining brow." Many legends cling to the name in Wales.

And Richard Hovey's charming masque "Taliesin" had made me acquainted with his image of the historic bard. Since all my relatives had Welsh names for their places, why not mine?

The hill on which Taliesin now stands as a "brow" was one of my favorite places when I was a boy, for pasque flowers grew there in March sun while snow still streaked the hillsides.

"And so I began a 'shining brow' for the hill, the hill rising unbroken above to crown the exuberance of life in all these rural riches."

When you are on its crown you are out in mid-air as though swinging in a plane, as the valley and two others drop away leaving the tree-tops all about you. "Romeo and Juliet" stands in plain view to the southeast, the Hillside Home School just over the ridge.

As "the boy" I had learned the round-plan of the region in every line and feature.

In "elevation" for me now is the modeling of the hills, the weaving and the fabric that clings to them, the look of it all in tender green or covered with snow or in full glow of summer that bursts into the glorious blaze of autumn.

I still feel myself as much a part of it as the trees and birds and bees and

Fig. 108. Frank Lloyd Wright sits at his writing desk in front of a Japanese screen at Taliesin II in 1924. He began to dictate his autobiography in 1926.

red barns, or as the animals are, for that matter.

So, when family-life in Oak Park in that spring of 1909 conspired against the freedom to which I had come to feel every soul entitled and I had no choice would I keep my self-respect, but go out, a voluntary exile, into the uncharted and unknown deprived of legal protection to get my back against the wall and live, if I could, an unconventional life—then I turned to the hill in the Valley as my Grandfather before me had turned to America—as hope and haven—forgetful for the time being of grandfather's "Isaiah." Smiting and punishment.

Architecture, by now, was mine. It had come by actual experience to mean to me something out of the ground of what we call "America," something in league with the stones of the field, in sympathy with "the flower

that fadeth, the grass that withereth," something of the prayerful consideration for the lilies of the field that was my grandmother's. Something natural to the change that was "America" herself.

I knew well by now that no house should ever be *on* any hill or *on* anything. It should be *of* the hill, belonging to it, so hill and home could live together each the happier for the other. That was the way everything found round about it was naturally managed, except when man did something. When he added his mite he became imitative and ugly. Why? Was there no natural house? I had proved, I felt, that there was, and now I, too, wanted a *natural* house to live in myself. I scanned the hills of the region where the rock came cropping out in strata to suggest buildings. How quiet and strong the rock-ledge masses looked with the dark red cedars and white birches, there, above the green slopes. They were all part of the countenance of southern Wisconsin.

I wished to be part of my beloved southern Wisconsin and not put my small part of it out of countenance. Architecture, after all, I have learned, or before all, I should say, is no less a weaving and a fabric than the trees. And as anyone might see, a beech tree is a beech tree. It isn't trying to be an oak. Nor is a pine trying to be a birch although each makes the other more beautiful when seen together

The world has had appropriate buildings before—why not more appropriate buildings now than ever before? There must be some kind of house that would belong to that hill, as trees and the ledges of rock did; as Grandfather and Mother had belonged to it, in their sense of it all.

Yes, there must be a natural house, not natural as caves and log-cabins were natural but native in spirit and making, with all that architecture had meant whenever it was alive in times past. Nothing at all that I had ever seen would do. This country had changed all that into something else. Grandfather and Grandmother were something splendid in themselves that I couldn't imagine in any period. Houses I had ever seen. But there was a house that hill might marry and live happily with ever after. I fully intended to find it. I even saw, for myself, what it might be like and began to build it as the "brow" of the hill.

It was still a very young faith that undertook to build it. But it was

the same faith that plants twigs for orchards, vinesips for vineyards. And small whips that become beneficent shade trees. And it did plant them too, all about!

I saw the hill crown back of the house, itself a mass of apple trees in blossom, the perfume drifting down the valley, later the boughs bending to the ground with the red and white and yellow spheres that make the apple tree no less beautiful than the orange tree. I saw the plum trees, fragrant drifts of snow-white in the spring, and in August loaded with blue and red and yellow plums, scattering over the ground at the shake of a hand. I saw

> "There was a stone quarry on another hill a mile away, where the yellow sand-limestone when uncovered lay in strata like the outcropping ledges in the facades of the hills. . . . The teams of neighboring farmers soon began hauling it over to the hill, doubling the teams to get it to the top. Long cords of this native stone, five hundred or more from first to last, got up there"

the rows on rows of berry bushes, necklaces of pink and green gooseberries hanging to the underside of green branches. Saw thickly pendant clusters of rubies like tassels in the dark leaves of the currant bushes. The rich odor of black currant I remembered and looked forward to in quantity.

Black cherries. White cherries.

The strawberry beds white, scarlet, and green over the covering of clean wheat-straw.

I saw abundant asparagus in rows with a stretch of sumptuous rhubarb that would always be enough. I saw the vineyard on the south slope of the hill, opulent vines loaded with purple, green and yellow grapes, boys and girls coming in with baskets filled to overflowing to set about the room, like flowers. Melons lying thick in the trailing green, on the hill slope. Bees humming over all, storing up honey in the white rows of hives beside the chicken yard.

And the herd that I would have! The gentle Holsteins and a monarch of a bull—a glittering decoration of the fields and meadows as they moved. The sheep grazing the meadows and hills, the bleat of the little white lambs in the spring.

The gleaming sows to turn the waste to solid gold.

I saw the spirited, well-schooled horses, black horses and white mares with glossy coats and splendid strides, being saddled and led to the mounting-block for rides about the place and along the country lanes that I loved—the best of companionship alongside. The sturdy teams ploughing in the fields. The changing colors of the slopes, from seeding time to harvest. I saw the scarlet comb of the rooster and his hundreds of hens—their

"Taliesin was to be a combination of stone and wood as they met in the aspect of the hills around about. The lines of the hills were the lines of the roofs, the slopes of the hills their slopes. The plastered surfaces of light-wood walls, set back into shade behind broad eaves, were like the flat stretches of sand in the river below and the same in color, for that is where the material that covered them came from."

white eggs. The ducks upon the pond. The geese—and swans floating in the shadow of the trees upon the water.

I saw the peacocks Javanese and white on the walls of the courts. And from the vegetable gardens I walked into a deep cavern in the hill—the root-cellar of my grandfather—and saw its wide sand planted with celery, piled with squash and turnips, potatoes, carrots, onions, parsnips, cabbages wrapped and hanging from the roof. Apples, pears, and grapes stored in wooden crates walled the cellar from roof to roof. And cream! All the cream the boy had been denied. Thick—so lifting it in a spoon it would float like an egg on the morning cup of coffee or ride on the scarlet strawberries.

Yes, Taliesin should be a garden and a farm behind a workshop and a home.

I saw it all, and planted it all, and laid the foundation of the herds, flocks, stable, and fowls as I laid the foundation of the house.

All these items of livelihood came back—unproved—from boyhood.

■ ■ ■

And so I began a "shining brow" for the hill, the hill rising unbroken above to crown the exuberance of life in all these rural riches.

There was a stone quarry on another hill a mile away, where the yellow sand-limestone when uncovered lay in strata like the outcropping ledges in the facades of the hills.

The look of it was what I wanted for such masses as would rise from the slopes. The teams of neighboring farmers soon began hauling it over to the hill, doubling the teams to get it to the top. Long cords of this native stone, five hundred or more from first to last, got up there, ready to hand, as Father Larson, the old Norse stonemason working in the quarry beyond blasted and quarried it out in great flakes. The stone went down for pavements of terraces and courts. Stone was sent along the slopes into great walls. Stone stepped up like ledges on to the hill, and flung long arms in any direction that brought the house to the ground. The ground! My Grandfather's ground: It was lovingly felt as part of all this.

Finally it was not so easy to tell where pavements and walls left off and ground began. Especially on the hill-crown, which became a low-walled garden above the surrounding courts, reached by stone steps walled into the slopes. A clump of fine oaks that grew on the hillside stood untouched on one side above the court. A great curved stone-walled seat enclosed the space just beneath them and stone pavement stepped down to a spring or fountain that welled up into a pool at the center of the circle. Each court had its fountain and the winding stream below had a great dam. A thick stone wall thrown across it to make a pond at the very foot of the hill, and raise the water in the Valley to within sight from Taliesin. The water below the falls, thus made, was sent by hydraulic ram up to a big stone reservoir built into the higher hill. Just behind and above the hilltop garden, to come

down again into the fountains and go down to the vegetable gardens on the slopes below the house.

■ ■ ■

Taliesin, of course, was to be an architect's workshop, a dwelling as well for young workers who came to assist. And it was a farm cottage for the farm help. Around a court were to be farm buildings, for Taliesin was to be a complete living unit, genuine in point of comfort and beauty, from pig to proprietor.

The place was to be self-sustaining if not self-sufficient, and within its domain of 200 acres, shelter, food, clothes and even entertainment, within itself. It had to be its own light-plant, fuel yard, transportation and water system.

Taliesin was to be recreation ground for my children and their children, perhaps for many generations more. This modest human program in terms of rural Wisconsin arranged itself around the hilltop in a series of four varied courts leading one into the other, courts together forming a sort of drive along the hillside flanked by low buildings on one side and by flower gardens against the stone walls that retained the hill-crown on the other.

The strata of fundamental stonework reached around and on into the four courts, and made them. Then stone, stratified, went into the lower house walls and on up into the chimneys from the ground itself. This native stone prepared the way for the lighter plastered construction of the upper-wood-walls. Taliesin was to be a combination of stone and wood as they met in the aspect of the hills around about. The lines of the hills were the lines of the roofs, the slopes of the hills their slopes. The plastered surfaces of light-wood walls, set back into shade behind broad eaves, were like the flat stretches of sand in the river below and the same in color, for that is where the material that covered them came from.

The finished wood outside was the color of gray tree trunks, in violet light.

The shingles of the roof surfaces were left to weather, silver-gray like the tree branches spreading below them.

The chimneys of the great stone fireplaces rose heavily through all, wherever there was a gathering place within, and there were many such

places. They showed great rock-faces over deep openings inside. Outside they were strong, quiet, rectangular rock-masses bespeaking strength and comfort within.

■ ■ ■

Country masons laid all the stone with the quarry for a pattern and the architect for a teacher. They learned to lay the walls in the long, thin, flat ledges natural to it, natural edges out. As often as they laid a stone they would stand back to judge the effect. They were soon as interested as sculp-

> **"The furnishings inside were simple and temperate. Thin tan-colored flax rugs covered the floors, later abandoned for the severer simplicity of the stone pavements and wide boards. Doors and windows were hung with modest, brown checkered fabrics. The furniture was 'home-made' of the same good wood as the trim and mostly fitted into the trim."**

tors fashioning a sculpture. One might imagine they were, as they stepped back, head cocked to one side, to get the effect. Having arrived at some conclusion, they would step forward and shove the stone more to their liking, seeming never to tire of this discrimination. They were artistic for the first time, many of them, and liked it. There were many masons from first to last, all good, perhaps Dad Signola, in his youth a Czech, the best of them, until Philip Volk came. He worked away five years at the place as it grew from year to year (for it will never be finished). And with no inharmonious discrepancy, one may see each mason's individuality in his work at Taliesin to this day. I frequently recall the man as I see his work.

At that time, to get this mass of material to the hilltop meant organizing men and horsepower. Trucks came along years later. Main strength and awkwardness directed by commanding intelligence got the better of the law

of gravitation by the ton as sand, stone, gravel, and timber went up into appointed places. Ben Davies was commander of these forces at this time. Ben was a creative cusser. He had to be. To listen to Ben back all of this movement was to take off your hat to a virtuoso. Men have cussed between every word, but Ben split the words, [and] artistically worked an oath in between every syllable. One day Ben with five of his men was moving a big rock that suddenly got away from its edge and fell flat, catching Ben's big toe. I

> **"Inside floors, like the outside floors, were stone-paved or if not were laid with wide, dark-streaked cypress boards. The plaster in the walls was mixed with raw sienna in the box. Went onto the walls 'natural,' drying out tawny gold. Outside, the plastered walls were the same but grayer with cement. But in the constitution of the whole, in the way the walls rose from the plan and the spaces were roofed over, was the chief interest of the whole house. The whole was all supremely natural."**

shuddered for that rock, as, hobbling slowly back and forth, Ben hissed and glared at it, threatening, eyeing, and cussing it. He rose to such heights, plunged to such depths of vengeance, as I had never suspected, even in Ben. No "Marseillaise" or any damnation in the mouth of Mosaic prophet ever exceeded Ben at this high spot in his career. William Blake says exuberance is beauty. It would be profane, perhaps, to say that Ben at this moment was sublime. But he was.

And in Spring Green—the names in the region are mostly simple like Black Earth, Blue Mounds, Lone Rock, Silver Creek, etc.,—I found a carpenter.

William Weston was a natural carpenter. He was a carpenter such as architects like to stand and watch work. I never saw him make a false or unnecessary movement. His hammer, extra-light, with handle fashioned by himself, flashed to the right spot every time, like the rapier of an expert swordsman. He, with his nimble intelligence and swift sure hand, was a gift to any architect.

That William stayed with Taliesin through trials and tribulations the better part of 14 years. America turns up a good mechanic around in country places every so often. Billy was one of them.

■ ■ ■

Winter came. A bitter one. The roof was on, plastering done, windows in, the men working inside. Evenings, the men grouped around the open fireplaces, throwing cordwood into them to keep themselves warm as the wind came up through the floorboards. All came to work from surrounding towns and had to be fed and bedded on the place during the week. Saturday nights they went home with money for the week's work in pocket, or its equivalent in groceries and fixings from the village.

Their reactions were picturesque. There was Johnnie Vaughn, who was, I guess, a genius. I got him because he had gone into some sort of concrete business with another Irishman for partner, and failed. Johnnie said, "We didn't fail sooner because we didn't have more business." I overheard this lank genius [while] he was looking over the carpenters, nagging little Billy Little, who had been foreman of several jobs in the city for me. Said Johnnie, "I built this place here off a shingle." "Huh," said Billy, "that ain't nothin'. I built them places in Oak Park right off'd air." No one ever got even, a little, over the rat-like perspicacity of that little Billy Little. Workmen never have enough drawings or explanations no matter how many they get—but this is the sort of slander an architect needs to get occasionally.

The workmen took the work as a sort of adventure. It was an adventure. In every realm. Especially in the financial realm. I kept working all the while to make the money come. It did. And we kept on inside with plenty of clean soft wood that could be left alone, pretty much, in plain surfaces. The stone, too, strong and protective inside, spoke for itself in certain piers, and walls.

■ ■ ■

Inside floors, like the outside floors, were stone-paved or if not were laid with wide, dark-streaked cypress boards. The plaster in the walls was mixed with raw sienna in the box. Went onto the walls "natural," drying out tawny gold. Outside, the plastered walls were the same but grayer with cement. But in the *constitution* of the whole, in the way the walls rose from the plan and the spaces were roofed over, was the chief interest of the whole house. The whole was all supremely natural. The rooms went up into the roof tent-like, and were banded overhead with marking strips of waxed, soft wood. The house was set so sun came through the openings into every room sometime during the day. Walls opened everywhere to views as the windows swung out above the treetops, the tops of red, white and black oaks and wild cherry trees festooned with wild grapevines. In spring, the perfume of the blossoms came full through the windows, the birds singing there the while, from sunrise to sunset—all but the several white months of winter.

I wanted a home where icicles by invitation might beautify the eaves. So there were no gutters. And when the snow piled deep on the roofs and lay drifted in the courts, icicles came to hand staccato from the eaves. Prismatic crystal in pendants sometimes six feet long glittered between the landscape and the eyes inside. Taliesin in winter was a frosted palace and walled with snow, hung with iridescent fringes, the plate glass of the windows delicately fantastic with frosted arabesques. A thing of winter beauty. But the windows shone bright and warm through it all as the light of the huge fireplaces lit them from the firesides within and streams of wood-smoke from a dozen such places went straight up toward the stars.

■ ■ ■

The furnishings inside were simple and temperate. Thin tan-colored flax rugs covered the floors, later abandoned for the severer simplicity of the stone pavements and wide boards. Doors and windows were hung with modest, brown checkered fabrics. The furniture was "home-made" of the same good wood as the trim and mostly fitted into the trim. I got a compliment on this from old Dan Davis a right and "savin'" Welsh neighbor, who saw we had made it ourselves. "Gosh-dang it, Frank," he said, "Ye're savin' too, ain't ye?" Although Mother Williams, another neighbor, who came to work for me, said "Savin'? He's nothin' of the sort. He could 'ave got it most as cheap ready-made from that Sears and Roebuck . . . I know."

A house of the North. The whole was low, wide, and snug, a broad shelter seeking fellowship with its surroundings. A house that could open to the breezes of summer and become like an open camp if need be. With spring came music on the roofs for there were few dead roof-spaces overhead, and the broad eaves so sheltered the windows that they were safely left open to the sweeping, soft air of the rain. Taliesin was grateful for care. Took what grooming it got with gratitude and repaid it all with interest.

Taliesin's order was such that when all was clean and in place its countenance beamed, wore a happy smile of well-being and welcome for all.

It was intensely human, I believe.

An Autobiography, 222–229. Reprinted with permission of the Frank Lloyd Wright Foundation, all rights reserved.

NOTES

1. Heather Oswald, visual resources and archives manager of the Frank Lloyd Wright Home and Studio Research Center, says the center has a record that "a nephew of Catherine Tobin Wright recalled the theater from his visits. We do have notations that Llewellyn mentioned it as well; however, there is no primary source on this. . . . We have no record of what became of it." Email to author, July 12, 2010.

2. Richard Hovey, "Taliesin: A Masque," in *Poet-Lore, A Monthly Magazine of Letters*, (February, 1896), 71. The author is grateful to Anthony Alofsin for his article "Taliesin: 'To Fashion Worlds in Little," which included Wright's rendering of the puppet theater and the 1914 photo at the Chicago Art Institute. Without these aids, seeing the theater in place at Taliesin would have been a puzzle. See *Wright Studies Volume One: Taliesin 1911–1914*, Narciso Menocal, ed., Carbondale: Southern Illinois University Press (1992), 47–49.

3. Elizabeth Catherine Wright, e-mail to author, September 29, 2010. The letter she refers to is Robert Llewellyn Wright's "Letters to His Children on His Childhood," undated typescript. The Frank Lloyd Wright Home and Studio Research Center has a reference copy. Elizabeth Wright's memoir of her parents and their correspondence, *Dear Bob, Dear Betty: Love and Marriage During the Great Depression*, privately published in 2009, is available at the Taliesin Bookstore.

4. Tim K. Wright, e-mail to author, November 13, 2011.

5. Robert Llewellyn Wright to Frank Lloyd Wright, Frank Lloyd Wright Foundation, Scottsdale, Arizona, used by permission.

CHAPTER 4
LIFE TOGETHER

WRIGHT REVEALS ROMANCE SECRET

Architect Says Year's Test of Love Living Apart Was Agreed Upon.

ISSUES HIS STATEMENT.

Recalls Trip Abroad, Return, Life in "Divided House," and the Bungalow Climax.

Spring Green, Wis., Dec. 30.—[Special.]—Frank Lloyd Wright, the Oak Park architect, today wrote out the story of how he and Mamah Borthwick fell in love and deserted their respective families.

He said he did not know whether Mrs. Wright and Edwin H. Cheney, who was

WRIGHT TALKS: 'I WON'T TALK'

Architect Says His Attorney Will Issue Statements Hereafter.

BUT HE'S "COMING BACK."

Doesn't Know Whether "Family Caucus" Will Result in Explanation.

"CASTLE OF LOVE" MAY BE RAIDED

Soulmate of Frank Lloyd Wright Installed in $30,000 Bungalow

Superintendent of Schools Lampoons Millionaire Architect

SPRING GREEN, Wis., Dec. 2—Sheriff Wm. Pengally and his deputies are considering plans to raid Frank Lloyd Wright's "Castle Love," where he has installed Mr Edwin Cheney, his soulmate in a $30,000 bungalow. The sheriff has conferred with District Attorney J.

TAR AND FEATHERS FOR WRIGHT AND SOULMATE

By United Press.

DODGEVILLE, Wis., Dec. 27.—A blizzard that piled the roads with snow and made travel impossible today prevented an investigation by Sheriff Pengally of the "ideal life" of Frank Lloyd Wright, the Chicago architect, and Mamah Borthwick, the divorced wife of Edwin H. Cheney. Sheriff Pengally says he is not sure what a "spiritual hegira" really is, but if any of the neighbors

CITIZENS AROUSED BY "AFFINITY" PAIR

Sheriff of Iowa County Would Arrest Notorious Elopers.

TAR PARTY TALK IS HEARD

...ng of Architect Wright of Oak ...k, Ill., and Mrs. Cheney to ...ngalow Near Dodgeville Causes ...ignation Among Neighbors.

...dgeville.—Plans for a raid of ...ew $10,000 bungalow at Hill- ...now occupied by Frank Lloyd

ELOPERS GUARDED FROM COLLEGE BOYS

Sheriff Stations Sentries $10,000 "Cave."

TAR PARTY THREATENE

Architect Who Deserts Wife a Six Children to Live With H Charmer in Limestone Grot Enrages Residents of Hillsid

Chicago, Dec. 26.—A guard was t day placed around the $10,000 lime- stone grotto, or artificial cave, of Frank Lloyd Wright, architect, at Hillside Wis. where he is living with

AFFINITIES PLAN ESCAPE

GUARDS STATIONED ABOUT HIS HOME TO WARD OFF ARREST.

Two Farmers, After Conference With Others, Declare Laws Are Violated by Wright.

Spring Green, Wis., Dec. 29.—Formal written complaint, naming Frank Lloyd Wright as an offender against the statutes of Wisconsin, is on the

BARRED DOORS HOLD SOULMADE PRISONER

SPRING GREEN, Wis., Jan. 7.—Frank Lloyd Wright, the Oak Park architect, is jealously guarding one

"THE BUNGALOW" UNDER SEIGE

Wright handed the *Chicago Tribune* the smoking gun.
On Christmas Eve, the *Tribune* led with it:

Spring Green, Wis., Dec. 23— *Let there be no misunderstanding, a Mrs. E. H. Cheney never existed for me and now is no more in fact. But Mamah Borthwick is here and I intend to take care of her.*

—FRANK LLOYD WRIGHT

"The above reply was received by The Tribune last night," the unbylined story continued. "It is in response to a telegram to the eccentric architect that he authorize a denial of the reports that he has again deserted his wife and is living in a bungalow in Spring Green with the divorced wife of E.H. Cheney."[1]

If the account is factual, the *Tribune*'s challenge seemed to make it a moment of truth or dare for Wright. Like a statement in open court, Wright's admission opened the floodgates to a 10-day torrent of sensational reporting, a raucous shivaree for an unmarried couple thrown by a crowd of Chicago reporters.

The "Trial of the Century" involving another celebrity architect—Stanford White of New York, who was shot to death by Philadelphia tycoon Harry K. Thaw for his seduction of 16-year-old Evelyn Nesbit, "the girl in the red velvet swing"— had riveted the nation just three years before. With that in mind, the Chicago press might have hoped to whip up a circulation bonanza like the one the Hearst papers enjoyed—especially if Wright wound up in jail.

The *Tribune* gloated over its scoop. "The spot is ideal for such a romantic liaison as Wright and Mrs. Cheney apparently have planned. Up to a time that a newspaper reporter called on them yesterday they were 'far from the madding crowd,' free from prying eyes or inquisitive ears."

The reporter arrived at the "the bungalow"—which he identified as being in Grant County and in northwest Wisconsin, both wildly off—to find "a man and a woman in the house."

The story continued: "The woman was preparing breakfast. The reporter said he had heard that Mr. Wright and Mrs. Cheney were living in the bungalow. He asked if this were true. Mr. Wright immediately admitted his identity. He was furi-

ous. He paced up and down the big room.

"'I'm Wright,' he said, 'but I won't say a word.'"

"'Is the woman living with you Mrs. Cheney?" he was asked.

"'That's none of your business. I won't say a word.'

"The reporter went away, but an hour later he called up the bungalow on the telephone.

"'I want to talk to Mrs. Cheney,' he said.

"'I am Mrs. Cheney,' a woman's voice replied."

In Chicago, another *Tribune* reporter caught up with Catherine Wright at the office of Sherman Booth, who was serving as attorney for both Frank and his wife. "She would not believe, or at least admit, that her husband had returned to the woman with whom he had fled to Europe two years ago," the report said.

"'Mr. Wright went north on business,' she said. 'He built that bungalow as a home for his mother. If there is any woman there it is his mother.'"

Booth interjected: "I will say that I accompanied Mr. Wright to the Union depot last Thursday night when he departed for Wisconsin. He was alone. There was no woman there, of that I am positive." (True enough. Mamah was already in Wisconsin.)

EMBROIDERING THE NEWS

Next, a reporter came to the Wright home in Oak Park, where he encountered 17-year-old Catherine Wright, who "met all inquiries with the flat statement, 'We

have nothing to say.' When shown a copy of the report exploiting [sic] her father's latest fall from grace she seemed surprised and amused.

"'We have become hardened to the sensational features of this case,' she said, finally, with a smile, 'and we really don't pay much attention one way or another.'"

Catherine—whom reporters would now call "plucky"—said her father was building a home for her aunt Jane Porter at Hillside, and was often away on business. She said she did not know whether he would be home for Christmas. She added: "I rather think Mother will be amused over this occurrence. It really seems funny that this skeleton in the closet should be dragged forth at every opportunity. Just say for Mr. Wright and Mrs. Wright, and all the little Wrights that we don't know anything about this awful story, and that it must be untrue."

> *"Threats of tar and feathers moved the sheriff to take the precaution of placing a guard. . . . The population of Hillside is made up largely of college students, and the sheriff says they are apt to 'bust out any minute.'"*
>
> Syracuse (N.Y.) Herald, December 26, 1911

This last sentence has been cited by biographers as evidence of Wright's heartless disregard of his children's feelings. But melodrama is a hallmark of yellow news writing. The standards of journalism of the day permitted invention and embellishment. One handbook for reporters advised that it was acceptable to make things up, "as long as the imaginative writing is confined to the non-essentials and is done by one who has in him at least the desire to represent the truth."[2]

If young Catherine's quotation is true, it might have been an attempt to stop the story, like her mother's statement that if there was a woman at Hillside it had to be Frank's mother. Wright said he had informed everyone ahead of time of his new living arrangements.

"SPIRITUAL HEGIRA"

The telegram made it all moot. The *Tribune* headlines announced: "Architect Wright in New Romance with 'Mrs. Cheney' / Found at Spring Green, Wis., on Bungalow He Designed for Them Himself. / Woman Changed Her Name / 'Mrs. Cheney Never Existed for Me, I'm Taking Care of Mamah Borthwick,' He Wires. / Old 'Spiritual Hegira' Recalled."

Wright had once used the phrase "spiritual hegira" in a letter to a friend to describe his odyssey to Europe. "Heriga" means an escape to safety. It originally described the Prophet Mohammed's flight from Mecca to Medina in 622 AD to escape his enemies. Now it was a headline writer's toy, used repeatedly to taunt Wright, to suggest that his desire to quit a failed marriage, take up with someone new, and justify it as principled was something outré.

It was there again on Christmas Day, when Wright decided to meet the press. "Spend Christmas Making 'Defense' of 'Spirit Hegira,'" the Tribune's headline said. "Frank Lloyd Wright and His Companion, Mrs. Mamah Borthwick, Interviewed. / 'Law for Ordinary Man' / Oak Park Architect Says He Will Care for Family Even if Own Absence Continues. / Wife May Welcome Return."[3]

"If the first Christmas of the second 'spiritual hegira' of Frank Lloyd Wright and Mrs. E.H. Cheney was not a happy one," the story began, "that fact was not apparent to any caller at the bungalow in which they have placed their household gods, defying society and leaving Mrs. Wright at home just west of Chicago."

The *Tribune* reporter paused to twist the knife: "Apparently Mr. Wright did not feel any regret he was not present in the Oak Park house where his lawful wife and their six children were spending Christmas, and Mamah Borthwick seemed to have forgotten the Christmases of the past which she had spent with her husband and children."

Wright paces back and forth in the living room of "the bungalow which he has built on the great limestone crag which commands a view of the Wisconsin River and miles of the valley." Then he lays it all out.

ON HIS MARRIAGE: Wright says his marriage to Catherine when she was 19 and he was 21 was "a mistake" that became "a tragedy." "Mrs. Wright wanted children, loved children, and understood children. She had her life in them. She

played with children and enjoyed them, but I found my life in my work. . . . In a way my buildings are my children."

ON MAMAH BORTHWICK: Catherine "did not understand my going away. She does not understand it now. She thinks I am infatuated with another woman. That isn't the whole of it. I went away because I found my life confused and my situation discordant. . . . I have been trying to live honestly. I have been living honestly. Mrs. E.H. Cheney never existed for me. She was always Mamah Borthwick to me, an individual separate and distinct, who was not any man's possession."

ON CHILD SUPPORT: "Everything I have done up to this time is at their disposal. I have taken nothing and shall take nothing from them. My earning capacity means a much and is as rightly at their service as ever."

ON LOSING WORK: "It may be that this thing will result in taking my work away from me. . . . An architect comes into intimate contact with his client as does a physician. He consults the wishes of a family about a home. There will be people who will be unwilling to have me in that intimate relation. It will be a waste of something socially precious if this thing robs me of my work. I have struggled to express something real in American architecture. I have something to give. It will be a misfortune if the world decides not to receive what I have to give."

"Two trunks are packed in the main hall and a fast team is standing harnessed in the barn. . . . Wright has a complete spy system. He will be informed the instant that Sheriff Pengally leaves Dodgeville."

Carbondale (Ill.) Free Press, December 29, 1911

ON SELFISHNESS: "If I could have put aside my desire to live my life as I build my buildings—from within outward—I might have been able to stay. But . . . I wanted to be what I had come to feel for some years that I was. I would be honestly myself first and take care of everything else afterward."

ON RULES FOR GENIUSES: "I want to say this: Laws and rules are made for the average. The ordinary man cannot live without rules to guide his conduct. It is

infinitely more difficult to live without rules, but that is what the really honest, sincere, thinking man is compelled to do. And I think when a man has displayed some of his ability to see and feel the higher and better things of life, we ought to go slow in deciding he has acted badly."

TRUTH—AND CONSEQUENCES?

The truth was out. Now, would there be consequences? The press hoped there would be. Starting the day after Christmas, stories began to appear reporting that local citizens were up in arms and law enforcement officials were being pressed to act. There was talk of tar and feathers.[4]

"Neighbors of Frank Lloyd Wright decided this afternoon that if their disapproval was nothing to him they would find more effective means of compelling him to abandon his plan of making his hilltop bungalow a permanent home for himself and Mamah Borthwick, who, until her divorce was Mrs. E.H. Cheney," the *Tribune* reported on December 26. "They appealed to Sheriff W.R. Pengally of Iowa County to help them."

"The citizens who consulted me do not want to take the law into their own hands," Pengally allegedly responded. "I told them I would thwart any attempt at tarring and feathering. I don't believe Wright's neighbors intended to do anything

SPEND CHRISTMAS MAKING 'DEFENSE' OF 'SPIRIT HEGIRA'

Frank Lloyd Wright and His Companion, Mrs. Mamah Borthwick, Interviewed.

"LAW FOR ORDINARY MAN"

Oak Park Architect Says He Will Care for Family Even if Own Absence Continues.

WIFE MAY WELCOME RETURN

of the sort. They want him to leave and they think he can be compelled to go by legal means or else send away this woman he is reported to be living with."[5]

Nevertheless, a United Press story in the *Des Moines News* announced: "Tar and Feathers for Wright and Soulmate."[6]

"TAR PARTY" AT "LIMESTONE GROTTO"

The stories grew more bizarre with distance, as wire services and syndicates carried versions of reportage that first appeared in Chicago papers.

The Syracuse, N.Y., *Herald's* headlines on December 26 said: "Elopers Guarded from College Boys / Sheriff Stations Sentries at $10,000 'Cave.' / Tar Party Threatened / Architect Who Deserts Wife and Six Children to Live With His

> *"Wright has refused all callers the privilege of seeing Mamah and insists upon receiving his visitors in his workshop or study. The mystery suite where the affinities live is closed and barred to the world. There is no window . . .a glimpse of the interior is impossible."*
>
> Fairbanks (Alaska) Citizen, February 12, 1912

Charmer in Limestone Grotto Enrages Residents of Hillside."[7]

The story, datelined Chicago, said: "A guard was today placed around the $10,000 limestone grotto, or cave, of Frank Lloyd Wright, architect, at Hillside, Wis., where he is living with Mamah Borthwick, while his own wife and children wait for him in Oak Park, a fashionable suburb.

"Threats of tar and feathers moved the sheriff to take the precaution of placing a guard. . . . The population of Hillside is made up largely of college students, and the sheriff says they are apt to 'bust out any minute.'

"'The only thing that has prevented a tar party so far,' said Sheriff Brown [sic], 'is the lack of a leader. There has been plenty of talk of such action both here and in Spring Green. But no one seems willing to suggest the actual plans.'"

The next day's *Herald* announced that at 10 a.m., the Iowa County sheriff had

led a posse out of Dodgeville, "determined to raid Frank Lloyd Wright's 'Castle of Love.'"[8] The following day, the *Herald* reported that although "an attempt yesterday to break up the combination was unsuccessful, the arrest of the esthetic architect and his 'art mate' is imminent." But, it still might not happen until "after the 'Love Castle' has been besieged and captured by force of arms."[9]

MAKING UP MAMAH

The silence of Mamah Borthwick was frustrating, so reporters began to fill in the blanks.

"Mrs. Borthwick, in a merry mood, chaffed the reporters, declaring she was sorry for them," said a wire story in the *Racine Daily Journal*. "'It's a pity they have sent all you fellows up here just to watch me,' she allegedly said. "'We are bothering no one and want only to live our lives in peace.'" She then allegedly referred all "questions about soulmating and spiritual love" to Wright, but "declared she would 'stick to him.'"[10]

Another story had Mamah personally keeping tabs on the press corps. "Every movement made by the small army of newspaper correspondents is at once reported to the bungalow by telephone," it said. "The former Mrs. Cheney receives many of the communications and displays the liveliest interest."[11]

Other stories had her locked away. In Fairbanks, Alaska, the news on February 12, 1912 (datelined January 7) was that Wright was holding Mamah in "the inner room of his 'Castle of Spiritual Love.'" The headline was, "Barred Doors Hold Soulmade [sic] Prisoner."[12]

"Wright has refused all callers the privilege of seeing Mamah and insists upon receiving his visitors in his workshop or study," the story said. "The mystery suite where the affinities live is closed and barred to the world. There is no window . . . a glimpse of the interior is impossible."

In a burst of histrionics, the reporter laments: "The real Mamah, the Mamah of Port Huron, the Mamah of 'the good old times in Oak Park,' the Mamah for whom her children are crying and praying, is as much a mystery as the chamber where she spends her hours in solitude or with her twentieth-century champion of marital freedom."

FAST HORSES AT THE READY

As the saga neared its end, readers of the Carbondale *Daily Free Press* in Illinois were told that Frank and Mamah were about to make a run for the border. "The belief grows stronger that plans for flight have been matured at the 'love bug' bungalow. Two trunks are packed in the main hall and a fast team is standing harnessed in the barn. . . .

> *"You understand of course that everything would be condoned by the public if only we were married. But Frank of course cannot marry as he has not been divorced. Neither of us has ever felt, of course, that that had the slightest possible significance in the 'morality' or 'immorality' of our action, but it has all the significance in the newspaper-public consciousness."*
>
> —Mamah Borthwick to Ellen Key, ca. February 1912

"It is believed that Wright and his affinity plan to slip away by the east road from that on which the sheriff approaches and to evade arrest by reaching Illinois before a warrant can be served. Wright has a complete spy system. He will be informed the instant that Sheriff Pengally leaves Dodgeville."[13]

"I REFUSE TO BE THE GOAT"

Fanciful reports like these made Pengally increasingly impatient. On December 29, pestered by reporters, he told the *Tribune*: "There's nothing doing. I haven't seen any complaint and I am not going to monkey with this business until I do."[14] The next day, when pressed again, he fumed, "I refuse to be the goat in this affair."[15]

Wright issued a statement: "We are here to stay. The report that the people of Spring Green are preparing to make a raid on us has no foundation in fact. I have received no notice from any law officer of the county and I do not expect to."[16]

He was right. Nothing happened. The story petered out in ten days and the reporters went home.

A DEFENSE FROM CHICAGO

At the height of the fever, when it appeared that Wright and Borthwick were in danger of arrest, they received a strong and unexpected defense from an important voice in Chicago. Floyd Dell, just 24, had risen to be the editor of the *Chicago Evening Post Friday Literary Review*. But Dell was more than that: he was the leader of the community of artists and writers known as the Chicago Renaissance.

Wright's publisher, Ralph Fletcher Seymour, had just released Mamah Borthwick's first volume of Ellen Key translations, *The Morality of Women*. Dell gave the book his lead review in the *Literary Review* of December 29, taking direct aim at the campaign being waged against the couple.

Dell notes that Key maintains that a legitimate marriage should be defined by love, not law. He quotes her as saying, "This love, legally sanctioned or not, is moral, and where it is lacking on either side a moral ground is furnished for the dissolution of the relationship."

Dell demurs: "In this country the matter of law is more exigent. It is seldom dispensed with except when, on account of our too rigid laws, it is impossible to

ASK SHERIFF'S AID TO OUST WRIGHT

Neighbors of Bungalow Induce Official to Make Inquiry as to Power.

SEEKS LAWYER'S ADVICE.

Architect's Wife Still Insists There Will Be No Action for a Divorce.

[BY A STAFF CORRESPONDENT.]
Spring Green, Wis., Dec. 26.—[Special.]—Neighbors of Frank Lloyd Wright decided this afternoon that if their disapproval was nothing to him they would find more effective means of compelling him to abandon his plan of making his hill top bungalow a permanent home for himself and Mamah Borthwick, who, until her divorce was Mrs. E. H. Cheney. They appealed to Sheriff W. R. Pengally of Iowa county to help them.

The sheriff visited Hillside, within easy view of Wright's living room windows, talked with several citizens, and went back to Dodgeville to consult District Attorney Jesse Smelker.

Sheriff Makes Inquiry.

"I was asked to make an investigation," the sheriff said tonight. "Wright's neighbors have decided he is going ahead with his

secure it. Those who try to realize their ideal under such circumstances must be very strong or very cunning, or else very insignificant, to succeed.

"A case very much to the point is that of the translator of this book, Miss Namah [sic] Borthwick, who, as the result of attempting to put its ideas into practice openly, and thus avoid the soul-corroding poison of secrecy and hypocrisy, is at the present time being hunted and harried by newspapers and officers of the law; while the man who has joined with her in this attempt, a first-rate artist, stands in danger of having a career of great social value brought to ruin. The difference between America and Europe—a difference by no means to our credit—is shown in the vicious fanaticism with which we attack an attempt made obviously in good faith."

Dell concludes, sharply: "Let us not be under the illusion that the ideal of monogamy can be implanted in people's hearts by sheriff's posses."[17]

Mamah, whose first name is misspelled on the title page of the book's early editions in the review, appreciated the article enough to share it with Ellen Key. In an undated letter sent from Taliesin to Sweden with the clipping, she notes: "The reference of Mr. Floyd Dell in the 'Post' is to the unpleasant publicity the 'Yellow Journals' gave to our situation here. They fabricated and published interviews and occurrences which, of course, never took place. The 'officers of the law' was one of these fictions. You fortunately have nothing in Europe like our 'Yellow Journals,' which go to any length to print something they can print as sensational."

She adds: "You understand of course that everything would be condoned by the public if only we were married. But Frank of course cannot marry as he has not been divorced. Neither of us has ever felt, of course, that that had the slightest possible significance in the 'morality' or 'immorality' of our action, but it has all the significance in the newspaper-public consciousness."[18]

"RATHER WITLESS AND MORE OR LESS INCREDIBLE TALES"

One small Wisconsin newspaper cut through the fictions and turned the spotlight on the visiting press. A *Dodgeville Chronicle* headline on January 5, 1912, said: "Public Craving for Sensation Basis for Much Buncombe." Buncombe is another spelling of bunkum. Bunkum is another name for bunk.

The story, likely the work of editor John M. Reese, described the circus that followed the revelation that Wright and Borthwick were living together:

"Since the matter came up, Spring Green, about three miles distant from the Wright habitation, has become the headquarters for a small army of reporters and photographers, and the local telegraph office has taken on an added importance with the stationing there of an extra operator.

"To some of these reporters Wright has accorded interviews, and has through them given out a lengthy statement of the situation from his standpoint. Villagers, while the Wright case is the great subject of conversation, seem inclined to side with Wright in his resentment toward some of the reporters, whose conduct during their enforced isolation and idleness has been of a character to force public sympathy in that direction.

"One reporter, when asked with regard to the matter, stated that the furore with regard to this case was prompted by the prominence of the parties concerned and the desire on the part of the newspapers to gratify the public craving for sensation.

"The tiresome waiting for developments that do not materialize, and the desire to justify their presence here by accomplishment, must be in a measure responsible for the rather witless and more or less incredible tales of local excitement, indignation meetings, hints of violence, and such like matter published in the daily papers, as well as the besieging of county officials with queries and suggestions of actions.

"Particularly Wright has avoided and frustrated the photographers . . . In his protection of himself and grounds from the camera men and reporters Wright has several men employed, and when, by his direction on a recent occasion one of them grappled with a photographer to prevent his getting a focus on Wright, the act was applauded by onlookers, including village officials, and mutters against the 'fresh Chicago guys,' all indicating the state of mind in that locality with regard to this eccentric character."[19]

Fig. 109. Floyd Dell, age 27, in a 1914 portrait by
John Sloan.

"A case very much to the point is that of the translator of this book, Miss Namah [sic] Borthwick, who, as the result of attempting to put its ideas into practice openly, and thus avoid the soul-corroding poison of secrecy and hypocrisy, is at the present time being hunted and harried by newspapers and officers of the law; while the man who has joined with her in this attempt, a first-rate artist, stands in danger of having a career of great social value brought to ruin.

"The difference between America and Europe—a difference by no means to our credit—is shown in the vicious fanaticism with which we attack an attempt made obviously in good faith. . . . Let us not be under the illusion that the ideal of monogamy can be implanted in people's hearts by sheriff's posses."

—FLOYD DELL, Chicago Evening Post Friday Literary Review, December 29, 1911

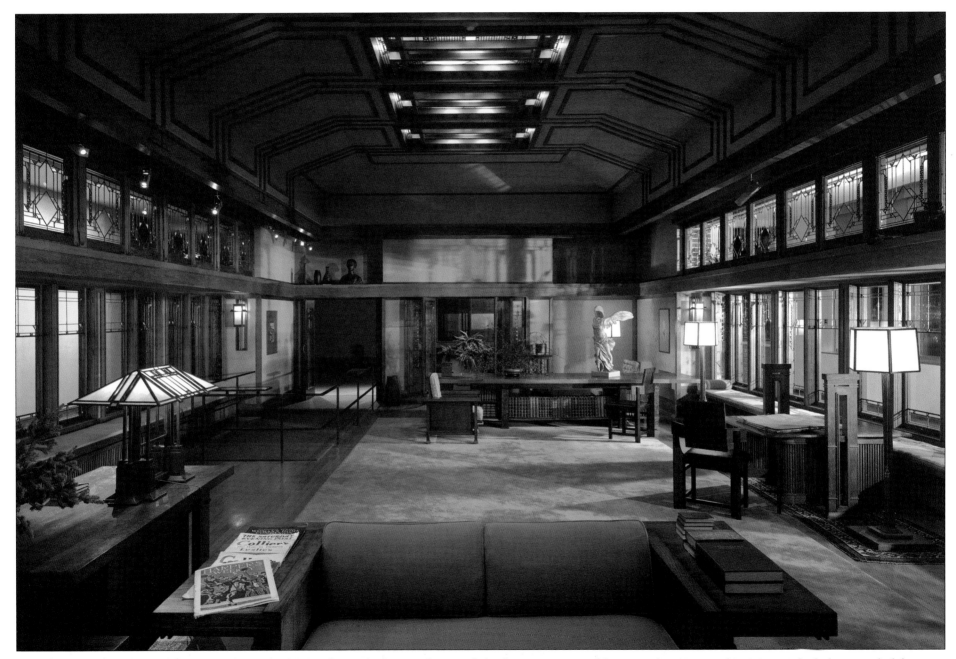

Fg. 110. The living room of Northome, the Minnesota summer home of Francis and Mary Little, is installed in the American Wing of the Metropolitan Museum of Art in New York. The home was built from 1911 to 1914 in a high Prairie style, with extra size and high ceilings in the living room so that Mary Little could hold piano recitals.

WRIGHT AT WORK, 1911–1914

The storm that buffeted Taliesin turned out to be a squall. It blew its way through the valley and was over. Frank Lloyd Wright and Mamah Borthwick scarcely missed a beat before settling into the life they had fought to live.

"We work together," Wright told Francis and Mary Little, his Minnesota clients. Their creative collaboration lasted just three years before Taliesin was destroyed and Mamah was killed. But it was a productive time.

Beginning with Taliesin, Wright produced some of his finest architecture. His masterworks, like Taliesin, were self-contained worlds: the walled Midway Gardens concert garden in Chicago; the enclosed Imperial Hotel plan for Tokyo; and the Coonley Playhouse, a small gem of a progressive school.

He opened a second career as a dealer in Japanese art, quickly rose to the top, and published a classic book on the topic, *The Japanese Print.* His efforts furnished some of America's greatest museums with their collections of Japanese prints.

Mamah Borthwick translated four books by Ellen Key dealing with women's rights, marriage and divorce reform, and female fulfillment. Wright was an active collaborator and underwriter. Together they fought obstacles to publication in Chicago and New York. They traveled together to Manhattan and Tokyo, and received luminaries at Taliesin.

These years, 1911–1914, are included among what Anthony Alofsin calls Wright's "lost years." They may have been lost to history for a time, but they were not lost to Wright and Borthwick. They were years in which the couple, in the prime of life, secured their home and pursued their dreams. Wright spread his wings in Europe and Asia and returned to Chicago trailing clouds of glory.

DAMAGE CONTROL

As the year 1912 opened, the Chicago reporters had gone home, but Wright still had to deal with relatives, parents of Hillside students, and some peevish clients.

The week after New Year's Day, Wright gave the *Dodgeville Chronicle* a written statement that said in part, "It is perhaps only fair to my relatives to say that

they are in no way implicated in my situation here. Their countenance or support has neither been given nor sought."[20] That was not entirely true. He had sought editorial support from his cousin Richard Lloyd Jones, the editor and publisher of the *Wisconsin State Journal.*

Richard refused, saying, "I can't run any story in my paper." He told Wright he did not make any public comment "until I found that the reporters were preparing to interpret your presence here on the basis that you went among your own relatives who would harbor you and befriend you and lend you society at a time when you were isolated from society generally by virtue of your experiment."

At that point, "with the advice of my father, I published a paragraph saying the family was not harboring you in this experiment and that it was not approving of your actions at this time and in that place. I felt it was only just to the Hillside School that its patrons should be reassured in this manner."[21]

One account, which referred to Wright's home as "the Crazy House bungalow," reported Richard as saying that "while Mr. Wright had become a member of the family through marriage, the members of the family do not now recognize him as such."[22]

Wright seethed about this. In a letter to clients Francis and Mary Little, he said, "The animosity of current morality hisses like a snake in my ears. The 'Jones con-

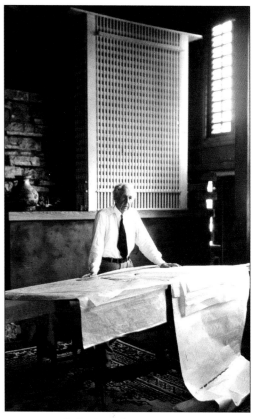

Fig. 111. Frank Lloyd Wright stands at his drafting table in his studio in 1947 in a photo by Pedro Guerrero. The model behind him is the 26-story skyscraper he designed in 1912 for the *San Francisco Call.* It was never built, but Wright always kept the model in view.

science' of which I once stood in awe manifests itself chiefly as fear."[23]

The fear was not entirely unfounded. One father of a 10-year-old boy at the school, A. Cole, owner of Cole Manufacturing Co. in Chicago, a maker of industrial blast ovens, warned Wright: "I am writing Aunt Nell today that unless you can be persuaded to move from Hillside or vicinity at once I will have to take my son out of school. I have talked with others who have children there and I am sure that the parents of all the children there feel exactly as I do about the matter."

Cole said he feared that "the example you are setting to the pupils of the Hillside School will begin to bear fruit when the children the age of my boy are ten or twelve years older."[24]

FAMILY COURT

There were reports that the Lloyd Joneses were gathering to sit in judgment on Wright. The *Waukesha Freeman* reported, "The Wright-Cheney 'spiritual hegira' is to be passed on by as bizarre a tribunal as ever was drawn together to further the ends of justice. Frank Lloyd Wright is to be 'tried' by a court composed of his own relatives."[25]

But if such a family council ever convened, it lacked one key member: Anna Lloyd Jones Wright. Wright's mother held the deed to Taliesin and could have called the sheriff to demand that he evict her son. Anna said nothing and did nothing.

> *"[Mamah Borthwick] has her remunerative work as I have. She is quite able to supply her own needs—and we work together."*
>
> Frank Lloyd Wright to Francis and Mary Little, 1912

In the end, Wright's only concession was to issue a notarized letter for his aunts to distribute. "To check certain mischievous statements intended to injure the Lloyd Jones Sisters' Home School by involving them with me and my situation here in some way, I wish to once more and finally force upon public attention the fact

that my aunts are in no way connected with me socially or financially," he said.

"They are guided now as they have been in the past by their own ideas of right and wrong and depending on their own financial resources for any move they make. It is unfair to them to connect my residence in this county with them or with their school in the slightest degree.

"I am not even a neighbor. There could be no less intercourse between us were I in another world, and so far as any intention or expectation on my part or theirs is concerned, they will remain so."[26]

Some parents might have been placated by this statement (though it was obvious to anyone who visited the school that Taliesin was a neighbor) but the numbers suggest that Hillside did suffer losses. The graduating classes of 1908, 1909, 1910, and 1911 had between 10 and 13 students. In 1912 the number dropped to 5 and stayed there.[27]

SAVING THE NORTHOME COMMISSION

If Wright was cavalier with his aunts, he also was unrepentant when he replied to Francis and Mary Little. "I am only sorry that when they [the newspapers] were through I had seemed to apologize and complain whereas I did neither," he said.

Wright changed his tone, however, when it came to salvaging his commission to build Northome, the Littles' long-delayed summer home on Lake Minnetonka in Minnesota. Wright had designed a house for them in Peoria in 1902 and had borrowed $9,000 from them to go to Europe and purchase the press run of the Wasmuth Portfolio. Now his old admirers were calling him "a selfish piece" and demanding that he "wake up."[28]

Wright begged the Littles to believe that their money would help his Oak Park family. "Of course all I have and may earn is theirs still and will continue to be and there is no real happiness for me unless I can help them," he said. Mamah Borthwick "has her remunerative work as I have. She is quite able to supply her own needs—and we work together."

"I love the woman who has cast her lot with me here not wisely but too well," he admitted, but added in a postscript, "The phaeton awaits mother's advent—this is her home as well as mine and she is expected soon."[29]

Wright's tap-dance worked. The Littles allowed Wright to proceed with Nor-

thome. Wright had begun the design work before he left for Europe in 1909, and this large residence is one of the final great examples of his high Prairie style. Mary Little was an accomplished pianist who had studied with Franz Liszt and wanted to hold recitals, so the living room ceilings are unusually high and the room itself is unusually large.

Northome was completed in 1914. When the house was demolished in 1972 the living room was acquired by the Metropolitan Museum of Art in New York and later installed in its American Wing.[30]

PUBLISHING

Wright and Borthwick churned out books during their years together. He published three and she published four, plus an eight-page article. He was closely involved in her work, collaborating as a co-translator, content adviser, literary agent, and financial underwriter.

While Borthwick's first translations of Ellen Key were being published in Chicago in 1911 and 1912, Wright was pursuing subscriptions for the English version of the Wasmuth Portfolio and its companion photo book, the *Sonderheft.*

"I am to own this work outright," he told Charles Ashbee, "& have bought it because I believe it will be profitable and there is no cleaner way for an architect to find his money than in the sale of his own works in this way."[31]

On the title page of Taylor Woolley's personal copy of the portfolio, Wright wrote, "To patient, long-suffering 'Wooley,' [sic] with grateful appreciation of his devotion to this work—and a hope."[32] He hoped that together they would sell a lot of books. Woolley was in California taking orders for the volumes when Wright summoned him to Taliesin in the fall of 1911. In a letter to Woolley sent on April 22 of that year, he gave him lengthy instructions.

"Libraries, building contractors, and private persons with money and interest in building" would be easier to sell than architects, he counseled. Lesser architects would be better than important ones, because "the more important ones feel compromised to have the work of a living contemporary in their libraries," Wright said, adding wryly, "I can't die to further sales."[33]

The best markets would be in the South and West, he advised. "All public libraries in all small towns in America should be taught the value of a copy. It will

have a more cultured effect than anything else on the shelves."

The volumes were to be carried in specially made cases and "presented in spic and span condition." Sales on credit were approved for "young fellows" because Wright wanted them especially to have it. Woolley would receive $15 per volume (the price was $50) and handle collections. Wright would handle delivery.

Wright closed with a pep talk, saying he was confident Woolley could succeed even though it might be discouraging at first. "Everything of the kind needs pushing and perseverance—and a method of getting at and presenting the thing which has to come with experience," he said.

Fig. 112. Wright published *The Japanese Print* in Chicago on rice paper in a fine edition in 1912.

CAPTIVATING EUROPE

In Europe, the big, two-volume edition of *Ausgeführte Bauten und Entwürfe von Frank Lloyd Wright,* with 100 plates of Wright's best early work, was selling itself. "The leader of what was an essentially provincial movement completely outflanked the conservatives of New York and the East and gained almost instant European endorsement," says architectural historian Alisdair McGregor.

"A young Le Corbusier acquired a copy, and the atelier of Peter Behrens in Berlin is said to have downed tools for an entire day when their copy arrived. (Walter Gropius and Mies van der Rohe were both apprenticed to Behrens at the time.) Wright's work had previously been known outside the United States only from magazine articles such as the 1908 *Architectural Record.* The portfolio would now form a focus of study for the architects of the Bauhaus in Germany and the

De Stijl movement in Holland. The young Austrian modernists Richard Neutra and Rudolph Schindler were lured to the United States in part because of the portfolio's impact."[34]

THE JAPANESE PRINT

In 1912 Wright published *The Japanese Print: An Interpretation*, printed in Chicago by Ralph Fletcher Seymour, his friend in the Fine Arts Building. It was produced on rice paper and contained reproductions of prints from his own collection. Wright was so particular about quality that he had an unsatisfactory first printing destroyed.

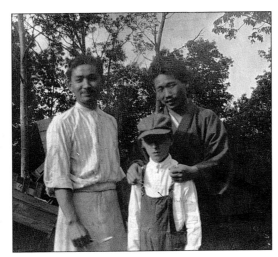

Fig. 113. Japanese men pose with a Wisconsin farm boy, John Davies, at Taliesin in the summer of 1918. At right is Arata Endo, Frank Lloyd Wright's principal Japanese assistant architect in building the Imperial Hotel. The man at left, wearing an apron and holding a cooking spoon, may be Satsu, the house servant who traveled with Wright and Mamah Borthwick to Japan in 1913 but was detained upon return.

Many consider Wright's essay on the Japanese print to be the most important statement of his artistic philosophy. He praises the Japanese artist's ability to evoke the "spell-power" of underlying geometric forms in every woodblock print, to get to the essentials. "The first and supreme principle of Japanese aesthetics consists in stringent simplification by elimination of the insignificant and a consequent emphasis on reality,"[35] he says.

Wright's current struggles with prevailing sexual mores bubble up in *The Japanese Print*. He notes that many prints depict scenes from the Yoshiwara, the pleasure district of old Edo, the name for Tokyo before the modern era. These *ukiyo-e*, or "pictures of the Floating World," feature kabuki actors, sumo wrestlers, samurai, and courtesans, including that rarefied figure, the geisha. She is depicted "with an innocence incomprehensible to us," Wright says, " for Japan at that time—although the family was the unit of her civilization—had not made monopoly of the sex relation the shameless essence of this institution."[36]

DEALING IN ASIAN ART

When Wright returned from his first visit to Japan in 1905 with Catherine, he assembled his treasures and in 1906 put on a precedent-setting show of Hiroshige prints at the Art Institute of Chicago. "They were the first *ukiyo-e* to be shown at that museum and, more remarkably, the world's first Hiroshige retrospective," notes Julia Meech, the authority on Wright and Japanese art.[37] In 1908 he put on an even bigger show.

Now, at Taliesin, he elevated his passion to a second profession. The years 1912 and 1913 saw Wright rise to become a world-class dealer in Japanese art. This new trade surpassed his architecture "in terms of both the attention he devoted to it and the financial gain," Meech says.[38]

In architecture Wright was at a disadvantage, being a solo practitioner and positioning himself as an outsider. But in the world of Japanese print collecting and dealing, "he was very much in the mainstream, a man of his times. He was limited by only his pocketbook, and sometimes not even that," Meech says. "His U.S. clients included all of the big names in the print world." These were "the golden years of print collecting in the United States, and the prints played a pivotal role in introducing Japanese art to the West."[39]

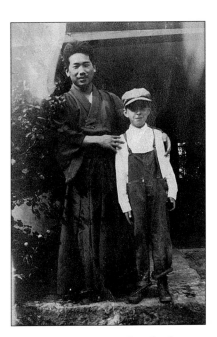

Fig. 114. Arata Endo stands with John Davies in the Taliesin courtyard in 1918. Wright and his staff worked on plans during the summer and returned to Japan in the fall to begin building the Imperial Hotel. These photographs were discovered in a farm family album; the Davies family provided household help at Taliesin.

TRIP TO "THE FLOWERY KINGDOM"

In the summer of 1912 Wright was introduced to two key patrons, the Spaulding brothers of Boston, by his fellow collector Frederick Gookin of Chicago. (He was not an uncritical friend. "Wright would have been shocked to know that the strait-

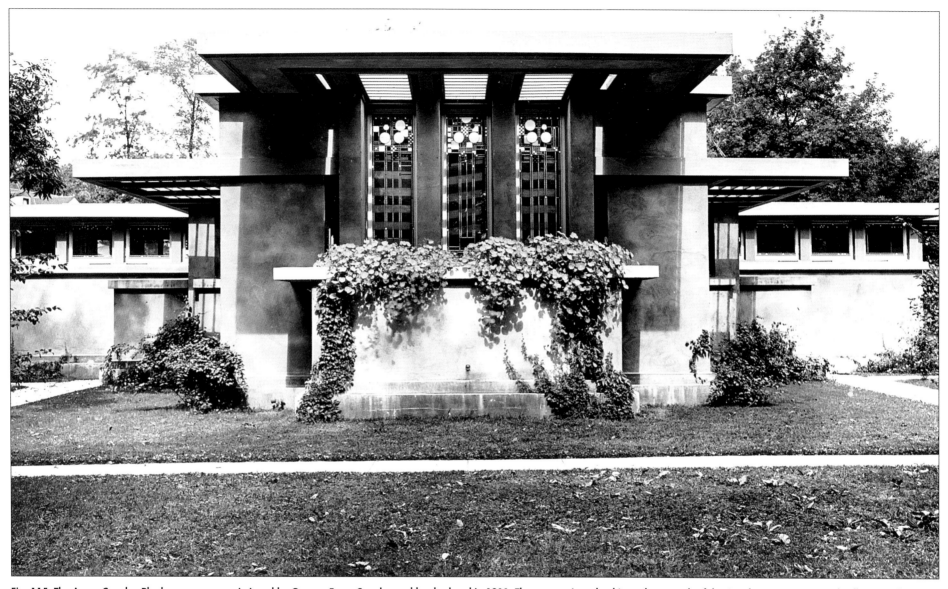

Fig. 115. The Avery Coonley Playhouse was commissioned by Queene Ferry Coonley and her husband in 1911. The progressive school is on the grounds of the Coonley estate in Riverside, Illinois. William Drummond later built a house nearby to house teachers. The three famous windows can be seen in the center.

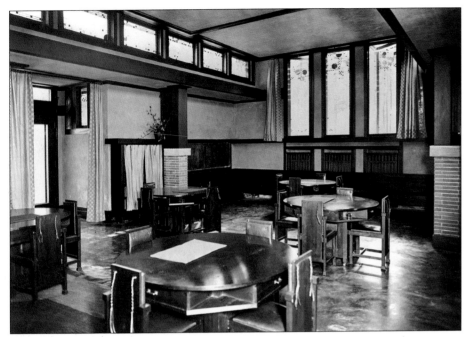

Fig. 116. The "kindersymphony" stained glass windows in primary colors march in a parade around the main classroom of the Coonley Playhouse. The motifs include balloons, flags, and confetti. The triptych is Wright's most famous decorative design. Children were grouped at tables. Wright designed the furniture, which was built by George Niedecken of Milwaukee.

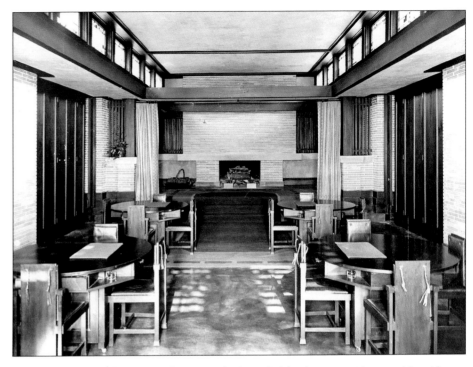

Fig. 117. A stage and fireplace can be seen at the far end of the classroom. Wings on either side contain a kitchen and a craft workshop.

laced Gookin secretly wanted him to be tarred and feathered by the philistines in Spring Green for his adulterous behavior with Borthwick. 'It would be about the best thing that could happen to him,'" Gookin had told his wife.[40])

Impressed by Wright, William and John Spaulding bankrolled him for a major collecting trip to the "Flowery Kingdom" of Japan, as the *Dodgeville Chronicle* quaintly termed it. Wright and Borthwick left Taliesin on January 12, 1913, but missed the boat in Seattle on January 15. They sailed for Yokohama two weeks later.[41] The *Chronicle* said they had with them a Japanese servant named Satsu. He may be the person Borthwick mentions in a letter to Key in July: "I had just returned from Japan when your card came and as our Japanese servant was delayed I have been my own cook since then."[42]

They returned in late spring, and in July, while Mamah was cooking for herself, Wright spent three days with the Spauldings in Boston viewing 1,400 prints he had purchased for them. In the 1943 edition of his autobiography, he added

a colorful account of his hero's welcome by the brothers.[43] The Spaulding prints would form the core of major collections at the Metropolitan Museum in New York and the Museum of Fine Arts in Boston. Wright's own collections, which he continued to build during his years in Japan, would find their way into museums across the country.

ARCHITECTURE

Wright was correct when he told the *Chicago Tribune* interviewer that the scandal over Mamah Borthwick might cost him work. Robert C. Twombly notes that in his three years at Taliesin with Borthwick, Wright "saw only seven designs reach completion for paying customers."[44]

Wright also was correct when he predicted that people would not want him designing their homes. From 1900 to 1910, two-thirds of his work had been resi

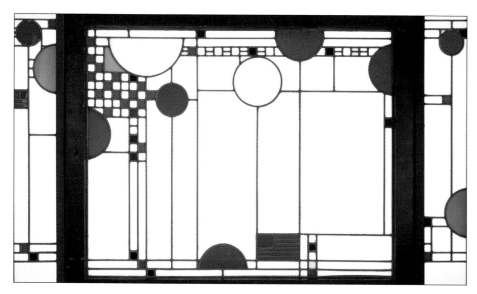

Fig. 118. A clerestory window from the Coonley Playhouse shows one of several patterns Wright used of balloons, confetti, and an American flag. Solid, bright colors and simple geometric forms were something new for Wright after he returned from Europe.

dential. From 1910 to 1914, it was less than half. "By 1914 Wright was as much as commercial as a domestic architect," Twombly says.[45]

But it was great commercial architecture. Wright was aiming high. One of his personal favorites from 1912 was a skyscraper—a 26-story tower designed for the *San Francisco Call* that included communal living quarters for journalists on the top floor. It was never built, but Wright kept the model in his studio.

PRIMARY COLORS: THE COONLEY PLAYHOUSE

Queene Ferry Coonley and Avery Coonley were wealthy Chicagoans. She was the daughter of the owner of the Ferry Seed Co. He also had inherited wealth. But they were unconventional people. Their daughter, Elizabeth Coonley Faulker, tells of her mother coming home from a lecture on the animal cruelty at the Chicago stockyards.

"She said, 'Avery, if you heard the lecture that I heard today, you'd feel just as I do. I just feel that I can never eat meat again. I think we should look into vegetarianism.'

"My father sighed and said, 'My Dear, we're Christian Scientists and women suffragists, you run a progressive school and we live in a Frank Lloyd Wright house. Let's not look into vegetarianism.'"[46]

In one of the few studies ever done of what made a Wright client tick, Lawrence K. Eaton compared two Coonleys, Avery and his younger brother Prentiss. Both had a Rolls-Royce radical as their mother, Lydia Avery Coonley Ward, who knew Booker T. Washington and at whose funeral Jane Addams spoke. But when it came time for them to build houses in suburban Chicago

Fig. 119. Queene Ferry Coonley.

in 1908, Prentiss hired establishment architect Howard Van Doren Shaw to build a traditional Georgian mansion in Lake Forest, while Avery hired Wright to build an unorthodox Prairie-style mansion in Riverside, a new suburb on the Des Plaines River designed by Frederick Law Olmsted and landscaped by Jens Jensen.

Queene Ferry Coonley disliked the typical American schoolroom "with rigid little seats screwed relentlessly into the floor."

Eaton concluded that Queene Coonley was the deciding factor in the choice of Wright. "It was, after all, Mrs. Avery Coonley who first went to Wright after seeing an exhibition of his work at the Chicago Architectural Club," Eaton says.[47] She told Wright they were seeking him out "because it seemed to them they saw in my houses 'the countenance of principle,'" Wright recalled. ("Principle" was a word used in Christian Science, a faith founded by a woman, to refer to a divinity that embraced both male and female.) "This was to me a great and sincere compliment," Wright said. "So I put the best in me into the Coonley house."[48]

Now, in 1911, he had a new opportunity. Queene Coonley's original Cottage School, offered free to children ages four and five, was expanding and

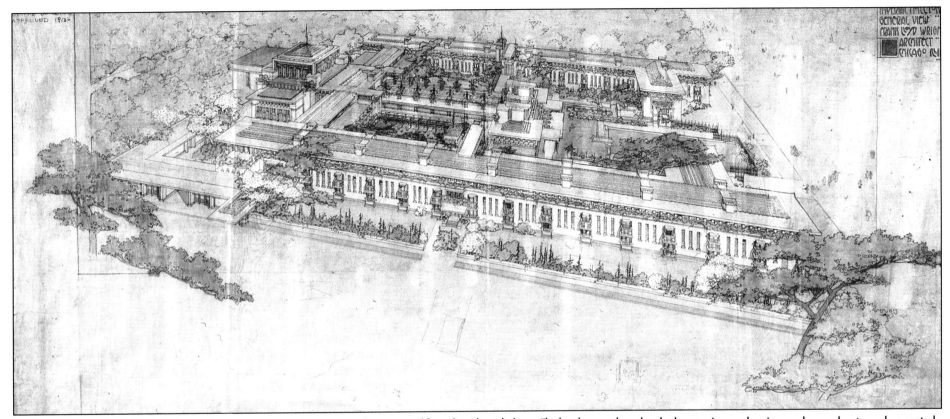

Fig. 120. Frank Lloyd Wright's first plan for the Imperial Hotel in Tokyo shows the compound from the side and above. The hotel was to have low bedroom wings embracing gardens and a stepped-up central building containing the hotel's social and ceremonial functions. The rendering is several feet long and is drawn on panels. It was rendered in 1913 by Taliesin draftsman Emil Brodelle, who was one of the seven murder victims in 1914.

adding grades. Once again Wright and Queene Coonley saw eye to eye. Both believed in Froebel kindergarten methods and John Dewey's dictum that "school is not a preparation for life, it is life." Both of them saw traditional schools as wrong for children of American democracy. She called the typical school "a building consisting of a group of rooms with rigid little seats screwed relentlessly into the floor."

In her school, "a children's community," the idea was "not so much to teach what others had thought or grown-ups had done, but for the children themselves to do something."[49]

Wright's solution was a joyful, churchlike open space with two naves, all banded with brilliant stained-glass clerestory windows portraying a parade of

geometric balloons, American flags, and confetti. The centerpiece at one end of the classroom was a triptych of tall windows of clear glass accented at the top by circles and squares of the same bold colors—red, blue, green, and yellow. Wright called these windows his "kindersymphony," or children's symphony, and they are his most famous decorative design. Viewed from inside the room, they transmit light and color but are too high to distract children.

The classroom had round tables and chairs for little groups of children. One nave had a kitchen. The other nave had a craft shop. "Students were involved in cooking the lunches, making useful objects for the school, and in weaving, printing, and woodwork. When studying literature and history they researched the era,

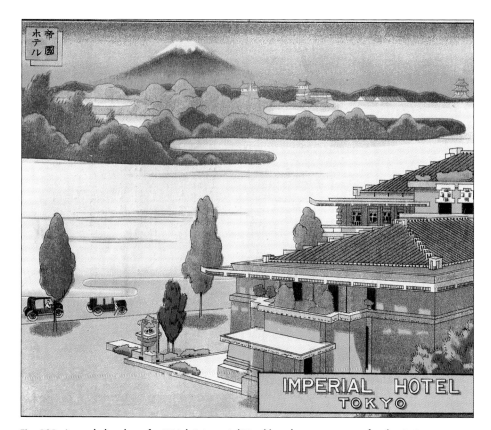

Fig. 121. An early brochure for Wright's Imperial Hotel has the appearance of a classic Japanese print, with off-center perspective and subtle colors. The hotel and Mount Fuji are presented as icons of modern Japan.

THE EMPEROR'S NEW HOTEL

On July 8, 1913, while Wright was off to Boston to show his prints to the Spauldings (he was expected there on July 9), Mamah Borthwick wrote to Ellen Key from Taliesin. "I wanted you to know of our delightful trip to Japan," she said. "Frank is to build the Imperial Hotel in Tokio and a few other things, not the property of the Emperor, so less important. The main object of the trip was, however, Japanese Prints, of which you know Frank is a collector.

"I have a dream of you coming to America, visiting us, and then of our going over to Japan together. Will you realize it, do you think possibly? Frank must go

> *"I have a dream of you coming to America, visiting us, and then of our going over to Japan together. . . . Frank must go again in connection with the hotel, and we expect to have a little house there. . . . Would you consider it?"*
>
> —Mamah Borthwick to Ellen Key, 1913

again in connection with the hotel, so we expect to have a little house there where you would again be our guest, during your stay in Japan. Would you consider it? Of course you would be perfectly independent to make whatever side trips you might wish."[53]

This trip was not to be, for Borthwick or for Key. Mamah would die and Wright would eventually return to Japan to build the hotel accompanied by a new lover. But in 1913, fresh from his travels, which included a stay at the old Imperial Hotel, he drew an elaborate plan for a gracious hotel compound featuring gardens and pools—a new meeting place and clearinghouse for East and West.

Japan had moved its capital from Kyoto to Edo in 1868, a year after Wright was born. The Emperor Meiji declared that its name would be changed from Edo, or "bay-port," to Tokyo, or "Eastern Capital." The move was a sign of Japan's rapid change from a closed feudal dynasty to an outward-looking modern state.

In 1890 the first hotel for Westerners was built, an ornate neo-Renaissance

made costumes, and acted out the subject."[50] Wright placed a stage with a fireplace at the upper end of the main room. That was the reason Wright called the building a "playhouse," even though Coonley fought the name, fearing that critics of progressive education would think it frivolous. "There's a workshop in it, after all," she told Wright. "Why don't you call it a workshop?"[51]

Queene Ferry Coonley remained a lifelong friend and ally to Wright. She turned a blind eye to his love life. Her daughter recalled: "People would say to her, 'I don't know how you can go along with Mr. Wright, with these three wives, one of which he hasn't even married!'

"And mother would say, 'Only *one* at a time.'"[52]

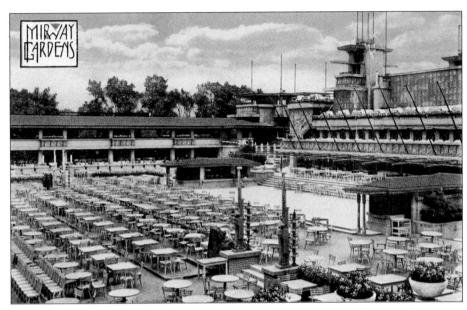

Fig. 122. Table service in the outdoor garden of Midway Gardens was on several tiers. Food was sent from the kitchen by tunnels to service stations, such as those at left and right. A dance area can also be seen.

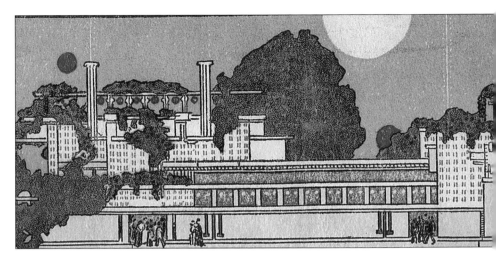

Fig. 123. A promotional pamphlet for Midway Gardens shows the building on Cottage Grove Avenue looking like a fantastic battleship. The Gardens complex was built in just three months in 1914 and opened on June 27. It had two good years before troubles set in.

building designed by a German-trained Japanese architect. With three stories and just 60 guest rooms it soon proved too small for the influx of foreigners, and the Imperial Household turned to Wright. His inside track came from Frederick Gookin, who knew the manager, Hayashi Aisaku, and recommended Wright for the job of architect in the fall of 1911. Another reason Hayashi may have been receptive was that there was a Badger State connection—he had attended the University of Wisconsin.[55]

Wright was in a mood to think big. In 1913 he produced plans for the two biggest projects of his career, the Imperial Hotel and Midway Gardens in Chicago. Both plans gave him the chance to play the uber-artist, orchestrating all the arts and designing every feature of a massive project down to the rugs, china, and crystal. This was not new to him, but the scale of these *Gesamtkunstwerke*, or total works of art, then a European vogue, was vast.

Wright's hotel, which was to have 285 guest rooms, was laid out in a large H intersected by an I. The central section contained the ceremonial and social functions—promenades, theaters, a cabaret, and banquet halls in ascending struc-

tures. The low private bedroom wings of the H embraced the gardens and pond. It would be "a world complete within itself," formal and green in the heart of the bustling city, across from Hibaya Park and within sight of the Imperial Palace. Wright said it was to be a protest against the commercial "office hotel." The Imperial, honoring Japan's love of nature, would be "a system of gardens and sunken

> *"[Geometric] forms could be made into a festival for th eye no less than music made a festival for the ear. I kewe. And all this could be genine building, not mere scene painting."*
>
> —Frank Lloyd Wright on Midway Garden

gardens and terraced gardens—of balconies that are gardens and loggias that are also gardens—and roofs that are gardens—until the whole arrangement becomes an interpenetration of gardens."[56]

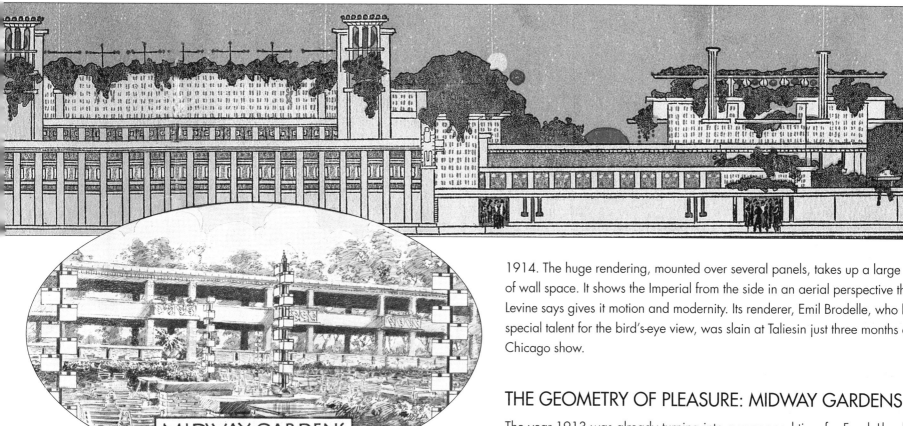

MIDWAY GARDENS
THE MIDWAY AND COTTAGE GROVE AVENUE
OPPOSITE WASHINGTON PARK

1914. The huge rendering, mounted over several panels, takes up a large amount of wall space. It shows the Imperial from the side in an aerial perspective that Neil Levine says gives it motion and modernity. Its renderer, Emil Brodelle, who had a special talent for the bird's-eye view, was slain at Taliesin just three months after the Chicago show.

THE GEOMETRY OF PLEASURE: MIDWAY GARDENS

The year 1913 was already turning into a very good time for Frank Lloyd Wright, with his triumphs in print dealing and the capture of the commitment for the Imperial Hotel. Then, in the fall, he was handed another huge opportunity: a chance to exercise all his skills and show Chicago that he was still the greatest.

A group of developers offered Wright the chance to design an entertainment complex that would occupy a full city block on Chicago's south side. Midway Gardens, located near the Midway Plaisance boulevard that was created for the Columbian Exposition, would be a place to see and be seen in all seasons. It would have a summer concert garden with terraces on three levels and an enclosed winter garden with taverns, restaurants, and dancing. Symphony orchestras and dance bands would offer both popular culture and high culture.

Wright described the "Aladdin" moment when the project's 36-year-old leader, Edward Waller Jr., spun out his proposition.

Wright also pictured the Imperial as an ocean liner, another kind of self-contained world. Part of its virtue was "conservation of space by concentrated conveniences," he said. His hotel rooms would be like staterooms.[57]

But the ocean liner's main virtue was its ability to ride swells—like the swells of an earthquake. Wright's "floating" Imperial would gain fame in 1923 when it survived the greatest natural disaster in Japanese history, the great Kanto earthquake and firestorm of September 1 that left between 100,000 and 110,000 dead.[58]

Wright put great artistry and detail into the preliminary plan he prepared in 1913, which was put on display at his Art Institute show in Chicago in the spring of

The Work of Frank Lloyd Wright, 1911–1914
Program of the Chicago Architectural Club's 27th Annual Exhibition, Art Institute of Chicago, April 9–May 3, 1914

MODELS
306. Office Building, San Francisco
307. Midway Gardens, Cottage Grove Avenue and the Midway, Chicago.
308. Figures Decorating Winter Garden of the Midway Gardens. A. Iannelli, Sculptor.
 The Cube.
 The Sphere.
 The Triangle.
 The Hexagon.
 Sprites.
309. Terminals of Exterior Piers.
310. Little Play House, Riverside, Illinois, for Mr. and Mrs. Avery Coonley.

DRAWINGS
311. Imperial Hotel, Tokio, Japan.
 Ground Plan.
 Sections and Elevations.
 Outline Perspective.
312. Midway Gardens.
 Perspective Study.
 Detail of Garden Furniture.
 Detail of Interior Furniture.
314. Recreation Pavilion, Banff, Alberta, for the Canadian Government.
315. River Forest Tennis Club House.
316. Carnegie Library, Pembroke, Ottawa.
317. Post Office, Ottawa, Canadian Government
318. Double House, Ottawa, Canada.
319. Model Quarter Section.
 Plan.
 General View.
 Detail of Typical Block.

320. Cement Exhibit, New York, for Universal Portland Cement Co.
321. Hotel Madison, Wisconsin.
322. Country Inn, Lake Geneva, Wisconsin.
323. State Bank, Spring Green, Wisconsin.

DWELLINGS
324. Jerome Mendelson, Albany, N.Y.
325. Sherman M. Booth, Glencoe, Illinois.
326. Henry S. Adams, Oak Park, Illinois.
327. Residence at Palm Beach, Florida.
328. Herbert Angster, Lake Bluff, Illinois.
329. Low Cost Suburban Dwelling.
330. Edward Schroeder, Milwaukee, Wisconsin.
331. E. Ebenschade, Milwaukee, Wisconsin.
332. Arthur W. Cutten, Country House, Wheaton, Illinois.
333. Francis W. Little, Summer Home, Minnetonka, Minnesota.
334. Mr. and Mrs. Avery Coonley, Riverside, Illinois,
 Kindergarten.
 Little Play House.
 Detail of Glass.
335. Taliesin, Hillside, Wisconsin.
 Country Studio Home of Frank Lloyd Wright.
 Plan. Elevation. Perspective.
 Photographs.
 Detail of Gates.
336. Taliesin, Workman's Cottage.
337. City House.
 Plan and Perspective.
 A Florentine Study.

PHOTOGRAPHS

DETAILS OF FURNITURE AND GLASS

EDUCATIONAL TOYS
Marionette Theatre, made for Llewellyn Wright.
A Toy Garden Scheme, worked out by Frank Lloyd Wright, Jr.
Child's Building Blocks, worked out by John Lloyd Wright.

WOODEN PRINT STANDS
Three Types. Utilizing Japanese Color Prints for Interior Decoration, after the manner of the statuette.

Fig. 123a. Midway Gardens plate.

"Well, Aladdin and his wonderful lamp fascinated me as a boy, but now I knew the enchanting young Arabian was just a symbol for creative desire, his lamp intended for another one—imagination. I sat listening, myself 'Aladdin.' Young Ed? The genii."[59]

Wright saw another chance to conceive and design an urban gathering place down to its last detail, with the architect commanding an army of artists and artisans. It was also a chance to try out a new design approach that would leave "realism" and historical styles behind and go for something sleek and abstract. He said he was aware of European experiments in abstract painting and sculpture that "excited the esthetic vanguard." But those same experiments insulted "the rank and file." He would try to win over the rank and file with pure geometry, using "my trusty T-square and triangle."

"[Geometric] forms could be made into a festival for the eye no less than music made a festival for the ear," he said. "I knew. And all this could be genuine building, not mere scene painting."[60]

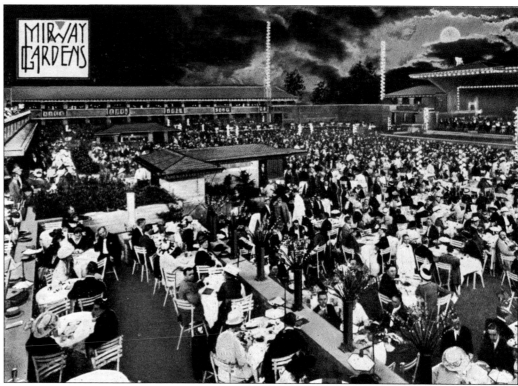

Fig. 124. A colored postcard shows Midway Gardens crowded under a full moon in Chicago in July 1914, soon after its opening. Opposite page: A Midway Gardens plate designed by Frank Lloyd Wright.

The construction schedule was brutal. "Working drawings were to be ready for contract in 30 days and the construction completed 90 days later," John Lloyd Wright recalled. Originally this meant a starting date for drawings of January 1, 1914, and a project completion date of May 1. After some delays, the clock was reset. "From the setting of the foundation in early April to the plastering of the inside walls in late June, Midway Gardens was, indeed, built in three months," says Paul Kruty, author of *Frank Lloyd Wright and Midway Gardens*.[61]

On the eve of the June 27th opening there were still 500 workers on the site, setting up and putting the finishing touches on Wright's "city by the sea" while the newly-formed National Symphony Orchestra of Chicago under conductor Max Bendix struggled to rehearse. "The grind of concrete mixers and the shouts of the gang bosses drowned out the rehearsing orchestra," the *Chicago Tribune* reported.[62]

On opening night, several thousand concertgoers had arrived for the opening and nearly as many had to be turned away. "The odor of wet mortar was strong in the air," a *Tribune* critic noted.[63]

The lucky visitors who made it in on that summer night encountered an enchanting sight: a sea of tables covered in white linen, a stage bathed in light, the terraces illuminated by "electric needles" pointing to the sky, light stalks with cube-shaped lamps, walls decorated with patterned cement blocks, and sculpture all about—decorative "totem poles" and deco-like human figures called sprites and spindles, created by sculptors Richard Bock and Alfonso Iannelli, who used Wright sketches. Some sprites held up the building blocks of architecture: the cube and octagon, the pyramid and sphere. A winged sprite, called the "Queen of the Gardens," thrust a cube aloft.

It was a celebration of architecture—and of the architect, who included in his design a special "architect's box" for himself. It would be nice to think that Mamah

Borthwick joined him in it on opening night, but there is no evidence. Wright remembered it as "as brilliant a social event as Chicago ever knew."

"In a scene unforgettable to all who attended, the architectural scheme and color, form, light, and sound had come alive," he said. "Thousands of beautifully dressed women and tuxedoed men thronged the scene. And this scene came upon the beholders as a magic spell. . . . Chicago marveled, acclaimed, approved. And Chicago came back and did the same marveling again and again and again.

"To many it was Egyptian, Mayan to some, very Japanese to others. But strange to all. It awakened a sense of mystery and romance in the beholder. . . And for the remainder of the season, Chicago, the unregenerate, came to rendezvous with a new beauty."[64]

During the first three weeks, Midway Gardens attendance was "almost frightening," the *Tribune* reported, with 17,000 coming in just one weekend. When the last concert was done on September 7, *Musical America* reported that the first season attendance had totaled more than 200,000.[65]

SUMMING IT UP, SHOWING IT OFF

On March 30, 1914, Wright sent an urgent telegram from Taliesin to his trusty friend Taylor Woolley in Salt Lake City. "Need your help to prepare architectural exhibit open April 9th," it said. "Can you come at once?"[66]

Wright was on deadline; the Chicago Architectural Club's annual exhibition show was opening in just 10 days at the Art Institute and Wright was up to his neck in work on the Midway Gardens. There is no record of a reply from Woolley, and no indication he came. The show went on as scheduled.

Wright, anxious to show Chicago that he was "up and running," was able to put the spotlight on himself at the Art Institute. He got his own dedicated room and put on a show of work not just from the preceding year, which was what all the other architects were doing, but of his total output "since spring of 1911"—since building Taliesin.

Wright's exhibits included not only completed work (Taliesin, Northome, the Coonley Playhouse) but also work in progress (Midway Gardens, not yet open), work yet to be done (the Imperial Hotel), and work that would never be done (the *San Francisco Call* skyscraper and the Goethe Street townhouse). It included an educational toy for one son (Llewellyn's puppet theater) and toys "worked out" by two others, Lloyd ("A Toy Garden Scheme") and John ("Child's Building Blocks." John would later invent Lincoln Logs.) He tossed in everything he could think of.

This created a furious backlash among other architects, some of whom boycotted the show. "It is not putting it too strongly to say that the Chicago Architectural Club sold out to Wright," one architect growled. It was alleged that Wright had paid $500 to the club to make up a deficit, which a spokesman denied.[67]

Wright was defiant. "Let them talk," he said. "Let them say what they will. Let them resurrect all the old scandal of the past three years. What do I care. I have three walls for my work. I'm erecting the Imperial Hotel in Tokyo and I'm doing other big work in the world—both the scandal and what I'm doing artistically will bring in bigger crowds. Let them talk, let them talk."[68]

Fig. 125 . The sign over an exhibit room at the 1914 Chicago Art Institute show says, "Work of Frank Lloyd Wright Exhibits Continued to Work Done Since Spring of 1911." The white model in the right foreground is of Midway Gardens. The dark model in the center is of the Coonley Playhouse. The large rendering on the wall at right is of the Imperial Hotel. Statuettes at upper left are of *The Queen of the Gardens*, left, by Alfonso Iannelli, and a *Contemplative Spindle*, or sprite, right, by Richard Bock, at Midway Gardens. The three types of wooden Japanese print stands can be seen, two of them sitting on the back of the marionette theatre made for Lewellyn Wright (notice curtain at right). A Clarence Fuermann photograph of Taliesin, taken from the roof and showing the tea circle, is in the immediate foreground.

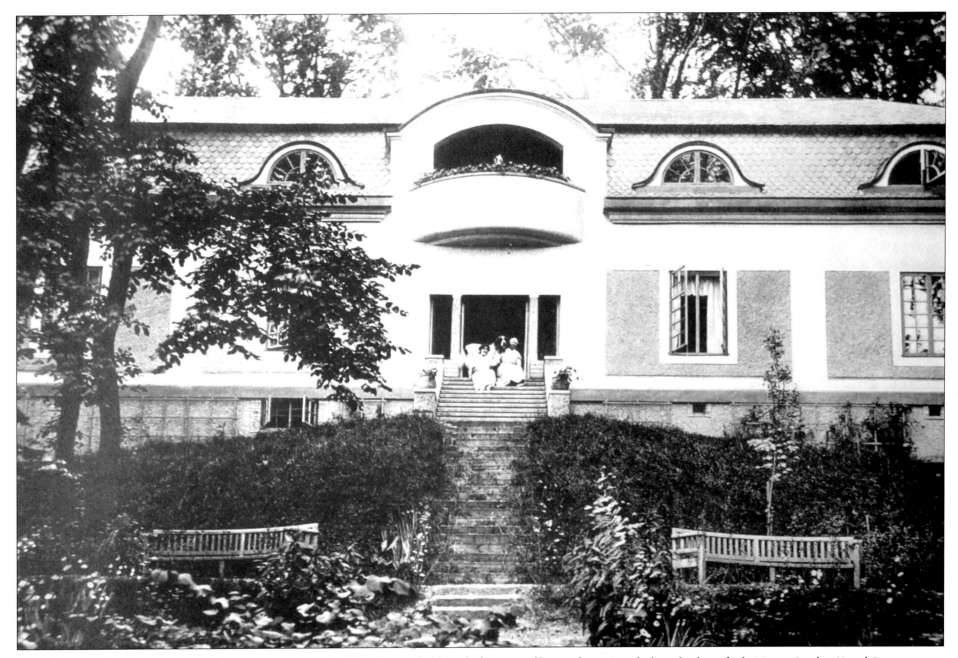

Fig. 126 In a 1911 photo, Ellen Key, right, sits with a younger woman and her St. Bernard Vilda on the front steps of her new home, Strand, above the shore of Lake Vättern, Sweden. Mamah Bouton Borthwick was among the first visitors that year, signing the guest book on June 9. Photograph courtesy of Hedda Jansson.

MAMAH BOUTON BORTHWICK AT WORK, 1911–1914

SECRETS OF THE HIROSHIGE

In the summer of 1992, a curious Swedish art historian visiting Ellen Key's lakeside mansion Strand turned over a picture on a wall and found a key that unlocked most of what is known today about Mamah Bouton Borthwick. The print was "an exquisite woodcut," of the "highest quality," a color landscape by the Japanese master Hiroshige. "The elegance of its frame is quite astonishing," Lena Johannesson reported. "A very thin, stained strip of oak frames the picture, which has been

> *"Frank is sending you a little Hiroshige which we hope you may care to hang in your new house."*
>
> —Mamah Borthwick to Ellen Key

mounted without passe-partout [matting] but is flanked on each side by blind parts in brownish cardboard." She saw that on the back of the picture Ellen Key had written, "A gift from the great American architect Frank Lloyd Wright."[69]

No one in Swedish scholarship had ever made a connection between Wright and Key. They were "two giants," Johannesson said, both philosophers of "ideal living in modern aesthetics." She went to the Royal Library in Stockholm and pored over the Key archive. There she found the missing link: Martha Bouton Borthwick, always called Mamah (MAY-mah). Ten letters written between 1910 and 1914, five of them typewritten, and a handwritten letter from Wright tell the story of Borthwick's dealings with Key and her life with Wright.

The Hiroshige story leaves an impression of the character of all three principals. The print was a gift sent from the couple during their first Christmas together at Taliesin. "Frank is sending you a little Hiroshige which we hope you may care to hang in your new house," Borthwick says. They sent it despite receiving a hurtful criticism of their relationship by Key, which they address in the same letter. Key had told Borthwick she should leave Wright and return to her children and ex-husband.

"I feel as if I had lost a friend," Borthwick quotes Wright as saying.[70]

Wright had the gift framed twice before he was satisfied to send it. It arrived in Sweden with $3 postage due, despite having been prepaid, and Key complained. Wright delayed in sending a money order, so Mamah finally resolved the matter by sending a personal check from her own account.

Key gave the print pride of place. "The Hiroshige print, the joint gift of Mamah and Frank to Ellen Key, will be seen even today as a gesture of attachment and sincerity," Johannesson said.[71]

Wright offered the print out of attachment to Mamah, to support her ambition to be Key's American translator. Mamah sent the gift with love and admiration to Key despite having been slapped down by Key about her relationship with Wright. Key responded to the gift, a rare work of art, by complaining about an extra postal charge.

Fig. 127. The woman on horseback may be Mamah Borthwick. Taylor Woolley took this photo during the time they both were at Taliesin, 1911–1912, and included it in an album titled *"Taliesin."* It is the only portrait of an individual woman. She appears to be the right age—Borthwick was 42. There is no identification.

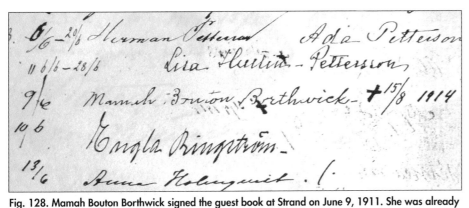

Fig. 128. Mamah Bouton Borthwick signed the guest book at Strand on June 9, 1911. She was already using her maiden name. Ellen Key noted her death on August 15, 1914, and marked it with a cross.

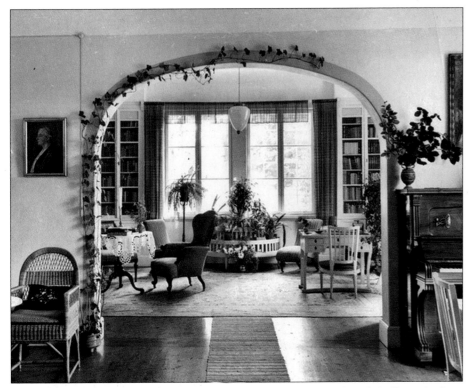

Fig. 129. Ellen Key's sitting rooms at Strand, built in 1910, show her taste for pale walls, minimal curtains, plank floors, woven rugs and runners, green plants, and fresh flowers. Photo courtesy of Hedda Jansson.

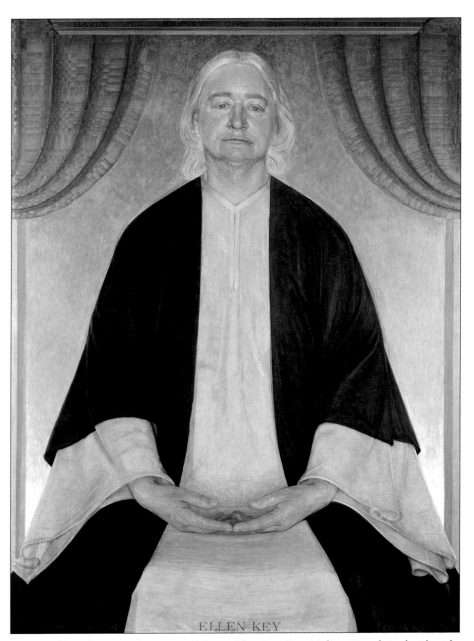

Fig. 130. Ellen Sofia Key at 58 in a portrait by Danish painter Ejnar Nielsen. Mamah Borthwick said, "Can't you persuade him to paint out that most inharmonious curtain draped at each side of the top? The folds are so out of feeling [and] the two blots at each side of the head are ugly."

Fig. 131. Ellen Key's spacious home, Strand, sits above Lake Vättern in central Sweden. Mamah Borthwick Cheney met with her there on June 9, 1911, when it was still new. For Key's 60th birthday in 1909, Swedes from all walks of life contributed money and presented her with an "alternative Nobel Prize" that she used to build Strand. It included four guest rooms reserved for working-class women in need of a vacation. Photograph courtesy of Björn Sjunnesson.

These themes appear again and again in the dealings of Wright and Borthwick with Key during the years 1911–1914. Wright invests himself in Borthwick's work with little or no reward for himself other than building his relationship with Ma-

> *"Only when there is nothing ugly available for sale, when beautiful things are as inexpensive as ugly ones are now, can beauty for everyone be fully realized."*
>
> —Ellen Key, *Beauty in the Home*

mah. Mamah pursues her goal of spreading Key's message—and embodying it in her life—with a joy that overrides repeated insults and discouragements from Key. Key provides Mamah with the inspiration, and them with a reality check.

THE PROPHET

Ellen Sofia Key (1849–1926) was in fact a giant in Scandinavia and Europe when Mamah Borthwick first made contact with her in the spring of 1910. She was a leading public intellectual, writing and advocating for reform in education, women's and children's rights, marriage, divorce, and the conditions of the working class. She was a peace activist and social Darwinist who believed that war was at odds with human evolution. She inclined toward socialism but believed in the individual right to self-development.[72] Her book *The Century of the Child* and her writings on state support of children, including children of single mothers, evolved into basic policies of the Swedish welfare state, today among the most liberal in the world.[73]

> *Key rejects the idea that "while God walked in Paradise and founded marriage, the Devil went about in the wilderness and instituted love"—and sex.*

Her lectures at the Worker's Institute and at student clubs in Stockholm in the 1890s "gained her great fame," says Barbara Miller Lane. "She was by all accounts a bewitching speaker. Her talks—vivid, extemporaneous, presented with a modest (almost shy) demeanor and in a low voice—commanded attention from huge audiences of artists, architects, philosophers, literary figures, politicians, students, and workers."[74] She also presided at a weekly salon of friends at her apartment. Her books and articles were translated into many languages, and royalties from these sales provided her living. She never married or had children. For Key's 60th birthday in 1909, Swedes from all walks of life contributed money and presented her with an "alternative Nobel Prize" that she used to build Strand on a slope above Lake Vättern in central Sweden. There she was able to display the simple, beautiful Swedish style she had advocated in her books *Beauty for All* (1899) and *Beauty in the Home* (1913).

Both were practical guides for women to use in banishing "the most garishly cheap German taste" that she believed prevailed in Swedish homes—"ugly, ostentatious, crowded, dark, and gloomy."[75] She preferred "light-filled rooms,

Fig. 132. Frank Lloyd Wright designed the frame and mounting for this Hiroshige print from his collection that he and Mamah Borthwick sent to Ellen Key in December 1911 as a housewarming gift. The print, *Amusements at Gotenyama* from the series *Famous Places of the Eastern Capital* (1833–1843), shows people picnicking under cherry blossoms at seaside, an appropriate gift for Key's new lakeside home. Photograph courtesy of Björn Sjunnesson.

Fig. 133. Ellen Key's handwritten inscription reads: "Color print (of Hiroshige, the Japanese artist). A gift from the great American architect Frank Loyd [sic] Wright." Photograph courtesy of Björn Sjunnesson.

pearl-gray furniture, plain deal [wide plank] floors, and thin white curtains to let the sunshine in."[76]

Key and Frank Lloyd Wright had ideas in common when it came to design, though Wright and Borthwick probably were not aware of this side of her reputation. Like Wright, Key believed that the properly designed home "could be the source of creative change in both the arts and society," though with the woman driving it as mother, educator, and chief artist.[77] She believed that "a room does not have a soul until someone's soul is revealed in it, unless it shows us that someone remembers and loves, and how this person lives and works every day."[78]

She believed that useful objects in the home should be beautiful. "It is bad taste to imagine that the useful becomes beautiful by concealing its purpose behind decoration," she said. "No household implement can be beautiful which does not convince you, first, of its usefulness, and, second, of a neatness that is in full agreement with its intended use."[79]

> "All the publishers were afraid. You cannot realize how provincial America is when it is a question of a thought in advance of its time."
>
> —Mamah Borthwick to Ellen Key

In a statement that helped set the course for modern Scandinavian design and anticipated both Orrefors and IKEA, she said: "Only when there is nothing ugly available for sale, when beautiful things are as inexpensive as ugly ones are now, can beauty for everyone be fully realized."[80]

Fig. 134. The Ralph Fletcher Seymour edition of *Love and Ethics* carries Frank Lloyd Wright and Mamah Bouton Borthwick's names as co-translators. The Chicago publisher delayed publishing this book because it was too controversial, even though Wright put up the money.

THE DISCIPLE

Mamah Borthwick was, by contrast, a novice in literature, translation, and publishing. She was born June 19, 1869, in Boone, Iowa, to a railroading family that moved to Oak Park, Illinois. She and Key were both of Scottish descent; there is a Borthwick Castle near Edinburgh, and Key was descended from McKays.

Mamah was a well-educated woman, fluent in French and German, with a master's degree in teaching from the University of Michigan and an interest in writing. She had worked as a librarian, married Edwin Cheney, a well-off electrical engineer and business owner, took in her sister's girl as an infant, then had a boy and girl of her own.[81] She participated in suburban women's literary clubs and had once made a joint presentation on Robert Browning with Catherine

Fig. 135. This is a second edition of the rival *Love and Ethics* published by B.W. Huebsch in New York. The first edition came out in 1911, stealing Wright and Borthwick's thunder and the sales of their own translation. They later discovered that Ellen Key had made a separate deal with Huebsch.

> "We went out to New York to see Mr. Huebsch, to insist upon his withdrawing his edition from the market, saying that I had your authorization. He told us that you had sold the rights to Love and Ethics to him, and showed us a check with your endorsement as proof."
>
> —Mamah Borthwick to Ellen Key

Tobin Wright. She could quote poetry from heart, and did so in one of her first letters to Key. She could drive an automobile and use a typewriter. She was modern. She was 20 years Key's junior and romantically linked to a famous architect. That was her résumé.

Fig. 136. Ellen Key's balcony at Strand overlooks Lake Vättern in central Sweden. Photograph courtesy of Björn Sjunnesson.

Fig. 137. Borthwick's translation of *The Morality of Women*, published in 1911 by Seymour, won positive reviews and went into a second printing of 1,000 copies.

Fig. 138. *The Torpedo Under the Ark* had only 28 pages and sold only 39 of 1,000 copies. Ellen Key would not permit Borthwick to expand it with more essays as the Chicago publisher recommended.

words in which, as is Frank also, I am heart and soul interested," she wrote. (She often adopted a Germanic sentence structure when writing to Key.)

Key gave her a chance. In a letter sent to Borthwick in Italy, she said, "I authorize you to commence with *Ibsen and Women;* some essays . . . and *Love and Ethics* in two small volumes as you proposed. And translated from the German. In the meantime you study Swedish and when Putnam has published *Love and Ethics* you are ready to offer him *Essays* translated by you from Swedish. I would be delighted to make you my only authorized translator in your language if you learn mine."[83]

Fig. 139. *The American* rejected Key's writings as not popular enough. The centerpiece of this August 1913 issue is a story about shipwrecked sailors on an island who encounter a tribe of winged women.

FEAR OF PUBLISHING

Wright left Europe in September 1910, returned to Germany in January 1911, and departed again for the States at the end of March. It was then that Borthwick gave him the finished translations for the three small books that he took to his Chicago publisher, Ralph Fletcher Seymour.

"I must confess we had to say many times, 'That passage is better than ours.' But we quite agreed in saying more frequently, 'There we are better than he is.'"

—Mamah Borthwick, on comparing translations with Wright

mour. The books were *Love and Ethics* (62 pp.), listing Borthwick and Wright as co-translators; *The Torpedo Under the Ark: Ibsen and Women* (28 pp.); and *The Morality of Women* (78 pp.). *Morality* was made up of three essays: "The Morality

While living in France, away from Wright during their first months in Europe, Borthwick discovered Key's writings on sexual politics in German editions—either *Love and Marriage* (1903) or its follow-up, *Love and Ethics* (1905). Key rejects the idea that "while God walked in Paradise and founded marriage, the Devil went about in the wilderness and instituted love"—and sex.[82] Key's assurance that moral marriage is based on love alone, not law or church sanction, and that women should be free to fulfill themselves erotically, was an epiphany.

"You cannot know what you have been and are in my life—the embodiment of so many ideals," she wrote to Key, "scarcely formulated until your light burst upon me in the little hotel in Nancy, where I was struggling so hard, against such frightful odds, to live the truth that you alone gave me strength and encouragement to cling to."

Mamah had found a mission: to bring Key's message to American readers. "I am concerned only with an opportunity to be the English mouthpiece for your

Fig. 140. British sexologist and eugenics advocate Havelock Ellis disliked Mamah Borthwick as a translator and told Putnam's he was disappointed *The Woman Movement* was not "more distinguished."

The
Woman Movement

By
Ellen Key
Author of
"The Century of the Child," "Love and Marriage," etc.

Translated by
Mamah Bouton Borthwick, A.M.

With an Introduction by
Havelock Ellis

G. P. Putnam's Sons
New York and London
The Knickerbocker Press
1912

Fig. 141. Putnam's published Borthwick's translation of *The Woman Movement* in New York in 1912 with Havelock Ellis's introduction.

of Women," "The Woman of the Future," and "The Conventional Woman."[84]

Borthwick spent the winter in Berlin, where she taught English classes and ran occasional errands for Key. She writes of taking Key's photo to a printer of visiting cards. The manager, Fraulein Boehm, "delighted me very much, for she too said that I looked like you—although 'not so strong a face,'" Mamah said.

She and Key met face to face on July 9, 1911, at Strand, where Borthwick may have stayed in one of the four guest rooms that Key reserved for working-class women in need of a vacation. During that meeting, she told Key that all the publishers they had contacted had declined the sex books. "Since they had refused the translations, Frank took them to America with him," she recalled having said.

Soon after their meeting Borthwick sailed for New York, where she paid a visit to the Putnam publishing house. George Putnam Jr. was abroad, so she met with a representative. Then she went to Canada, spent time with her children there, divorced Edwin Cheney, and moved into Taliesin in late July or early August.

When she arrived she discovered that *Love and Ethics* had not yet been published. "Mr. Seymour himself, though personally in sympathy with the work, was

also afraid to publish it at first," Borthwick wrote, "although Frank himself put up the money to cover the expenses. It is interesting to note that Mr. Seymour's head proofreader came to him and said, 'Mr. Seymour, I have been with you a good many years but I would rather give up my position than have anything to do with this. I cannot read any more of it!' This he said of *Liebe und Ethik*."

"All the publishers were afraid," Borthwick said. "You cannot realize how provincial America is when it is a question of a thought in advance of its time."[85]

In his 1945 memoir, *Some Came This Way,* Seymour paints himself as braver than he was. He writes that Wright "laid two [sic] manuscripts by Ellen Key on my table for publication on which he had the American rights. These I read with surprise. They appeared to be of a pattern similar in thought to Wright's and dissimilar to the thinking of almost everybody else. They advocated a sensible attitude toward love. I published both of them and to my surprise found that thousands of people were eager to read them. Ellen Key's writings marked a step ahead in the matter of sex morality and were accepted for a time as the last word in that field."[86]

Seymour published *The Morality of Women* late in 1911. It got good reviews from Floyd Dell in the *Chicago Evening Post Friday Literary Review* and from *Current Literature* magazine.[87] The book had sold 1,000 copies and gone into a second 1,000-copy printing by June 12, 1912. But Wright was still taking a net loss, according to a statement that Borthwick sent to Key. The other two books were money-losers. He had ordered 1,000 copies of *Love and Ethics* but only 28 had been sold, and he had ordered 1,000 copies of *Torpedo Under the Ark* but only 39 had been sold.

Fig. 142. Margaret Anderson published Mamah Borthwick's translation of Key's "Romain Rolland" posthumously in *The Little Review*. Her magazine, founded in Chicago with $100 in help from Frank Lloyd Wright, later became famous in New York when it serialized James Joyce's *Ulysses*. This 1930 portrait is by Man Ray.

Key accused Borthwick and Wright of withholding money. Although Wright was in the red, Borthwick sent her a check of her own for $28, $25 for royalties plus the $3 postage due for the Hiroshige. (Borthwick's separate checking account is an indicator of how she and Wright handled money.)

The small sales of the Ibsen book could be explained. The topic was specialized and it was little more than a pamphlet. "People didn't feel they were getting their money's worth, the booksellers tell me," Borthwick said. But *Love and Ethics* was the book Wright and Borthwick had labored over together. It was to have been their debut in print, with Key's thoughts on love and marriage doubling as their manifesto.

Seymour had delayed publication out of fear, and during that delay a rival translation had been published in New York, stealing both their thunder and their sales. The publisher was B.W. Huebsch, the translator Auralis K. Bogutslawsky. It came out in 1911 and went into a second edition in 1912. The London branch of Putnam's also published the Huebsch translation in 1912.

Bogutslawsky seems to have had a scare himself. In a note prefacing the second edition, "A.K.B." distances himself from the content, cautioning: "Ellen Key points the way to these higher values, without demanding that her revolutionary ideas of reform be translated into immediate action. *Conditions are not ripe for the radical changes she suggests. A gradual transformation of moral values must lead the way* to a better future, founded on a higher conception of love" (emphasis added).[88]

NO LOVE, NO ETHICS

The Huebsch publishing house, located in the West Village at 116 W. 13th Street, specialized in cutting-edge books. Huebsch published the first U.S. editions of work by James Joyce and D.H. Lawrence. He published Maxim Gorky's *The Spy*, Karl Liebknecht's *Militarism*, works by sociologist Thorstein Veblen, and Sherwood Anderson's *Winesburg, Ohio*.

"I know nothing of Mr. Huebsch," Borthwick wrote Key after receiving the publisher's announcement. "*Liebe und Ethik* was given to Ralph Fletcher Seymour of Chicago. . . . Mr. Wright has written Mr. Huebsch. Perhaps something can be done about his pirated publication."

Noting that "Fletcher Seymour is publishing *Love and Ethics* as the 'only autho-rized translation,'" Borthwick worried that their edition now would "probably not prove profitable owing to Huebsch's piracy. Every effort will be made, however, to discountenance Huebsch in his undertakings."

Borthwick was sure Seymour's publication of *The Morality of Women* and its good reviews would break the ice for other publishers. "Now that one American publisher has dared to do it and the words have received such extremely favorable attention . . . they are evidently much chagrined," she said. "You can feel

> *"You will be interested, I think, to know how our attempt to do what we believed right has succeeded. I can now say that we have, I believe, the entire respect of the community in which we live. I have never received a glance otherwise, and many kind and thoughtful things have been done for us by the people around here."*
>
> —Mamah Borthwick to Ellen Key, November 1912

assured now that, altho' after the appearance of *Love and Marriage* publishers were still afraid here in America to publish Ellen Key's work, there is no one now, after the appreciations *The Morality of Women* has received, who will be afraid to publish anything from her pen.

"It must be difficult for you to realize how far behind Europe America is," she told Key.

As to the fate of *Love and Ethics*, Borthwick said their publisher, Seymour, had assessed the Huebsch edition and "decided that ours was so much better it would repay publishing."

"I cannot say so unqualifiedly as Mr. Seymour that ours is a better translation," Borthwick said candidly. "Huebsch's is clearer in many places and more concise, but because of its conciseness, perhaps partly, is quite lacking in the richness and poetry of the original, which qualities I think our translation reproduces better. His translation is that of a man—very evidently—who gives a very clear statement of the thought, but as Frank said, 'It is a poetry crusher, while ours shows it is a

TRAVEL NUMBER

THE FRA

EXPONENT OF THE AMERICAN PHILOSOPHY

Vol. XI JUNE, 1913 No. 3

ELLEN KEY

PUBLISHED·MONTHLY·BY·ELBERT·HUBBARD
EAST·AURORA·ERIE·COUNTY·N.Y.
25·CENTS·A·COPY·2·DOLLARS·A·YEAR

translation made with love and appreciation.' However, I must confess we had to say many times, 'That passage is better than ours.' But we quite agreed in saying more frequently, 'There we are better than he is.'

"I think your criticism of our translation may be just."

Having been put on the defensive about their translation by Key but still having no answer from her about how a rival translation got into print, Wright and Borthwick traveled to Manhattan after New Year's Day, 1913, looking for answers. (They likely went there after Wright met in Boston with the Spaulding brothers to arrange his Japanese print-buying trip.[89]) On January 5, on the eve of their departure for Japan, Borthwick told Key what they had discovered.

"We went out to New York to see Mr. Huebsch, to insist upon his withdrawing

> Huebsch's jittery translator warned readers of Key's Love and Ethics, "Conditions are not ripe for the radical changes she suggests."

his edition from the market, saying that I had your authorization," she said. "He told us that you had sold the rights to *Love and Ethics* to him, and showed us a check with your endorsement as proof."

The couple must have been thunderstruck. Key had cut a separate deal, authorized another translation, and accepted money.

Huebsch took pity on them and offered to buy Borthwick and Wright's translation and use it in place of his own. "But his price was so small we felt that even with his in the market we would do better in time to keep it. We consider after a careful comparison of the two that our translation is best."

She summed up: "Now dear lady, no word of yours has been published through me that you did not give me express permission to use and that was not in the hands of the publisher when I was with you in Sweden, months before you wrote me that you wished Putnam's solely to publish your work.

"Forgive me for this long uninteresting letter. I promise not to again, but I had

Fig. 143. Ellen Key and her St. Bernard Vilda (Wild One) pose on the shore of Lake Vättern for the June 1913 cover of *The Fra*, a magazine produced by Elbert and Alice Hubbard at the Roycroft Arts & Craft colony in East Aurora, New York. Inside is an introduction to Key by Alice Hubbard and an essay by Key translated by someone other than Mamah Borthwick. The *Fra*'s design and typography are by Dard Hunter.

to get things straight," Borthwick concluded. "I dare only add one word to hope that many years will bring blessings to you as you have brought blessings to us. I wish you all happiness in many new years. With veneration and love."

There was no hint of rancor.

THE AMERICAN AND THE ATLANTIC

Wright and Borthwick made one more stop in New York, to meet with John S. Phillips, the editor and publisher of *The American* magazine. Key had been pestering Mamah to place her writings there since 1911, but everything Mamah had sent had been rejected.

The *American* of 1913 was not the muckraking *American* that Key might have had in mind, the one that had been created years earlier by Ray Stannard Baker, Lincoln Steffens, and Ida Tarbell, three famous investigative journalists who had left *McClure's* to form their own publication. After Phillips bought *The American* in 1906, he changed it to a women's magazine with soft features and fiction with mild feminist overtones. The issue of June 1913, for example, was dominated by a story of shipwrecked sailors on an island who encounter a tribe of winged women.

Borthwick in 1912 had tried to interest *The American* in condensing two of Key's earlier books, *Thought Pictures* and *Work and Humanity*. "Mr. Phillips' reply was that he found nothing suitable for a popular magazine," she told Key. Before meeting with Phillips in New York she submitted a piece by Key called "A Whitsunday of Rodin—the First Day of Summer, Beltane," supposedly more popular. Wright warned her that most readers of *The American* had never heard of Rodin. "You cannot realize how provincial we Americans are," Mamah told Key.

They met with Phillips in Manhattan. "He said he wants something in which the masses as well as cultivated readers would be interested," Borthwick said. "Most of his readers, for example, have never heard of Maeterlinck or Rodin. I think an article just a trifle spectacular is what Mr. Phillips wants; the masses are not captured otherwise.

"No, I did not give the Rodin article to any newspaper. You authorized me only to send it to the *American*. Of course any of the other magazines (except the

Fig. 144. A portion of a letter sent from Taliesin in 1912 shows Mamah Borthwick's handwriting style. It says, "A draughtsman of Frank's whose wife is a Swedish woman brought us a copy of 'Jul Kvällen' with its photograph of Strand, Ellen Key's article 'Hemma'—and—an unusually lovely likeness of Ellen Key's lovely self. With a heart full of love—Mamah Bouton Borthwick."

strictly popular) would take any of the articles that the *American* returned, had I your instructions to send them elsewhere."

Key was keeping Borthwick on a short leash. She would not give her permission to try other markets or repackage essays as books for anyone but Putnam. Seymour advised Wright and Borthwick that they could sell more of *Torpedo Under the Ark* if they added two or three of Key's "Thought Pictures." "But this permission I have told him repeatedly I feared I could not get from you since you feel bound to Putnam's," Mamah said.

Wright was willing to help. "Frank is much interested in certain combinations as to subjects in which he is especially interested and which treat so marvelously ideas absolutely misunderstood here—Freedom of the Personality, for instance," she said.

Wright previously had sent Key copies of both *The American* and *The Atlantic Monthly* to nudge her toward *The Atlantic*. "The latter . . . is quite our best magazine, and is unquestionably where you belong," Borthwick said. "You wrote me . . . that you were going to send me an article to translate for *The Atlantic,* and I have been continually hoping you would do it," Borthwick wrote Key on November 10, 1912.

Less than a month later, Borthwick learned that an article by Key—translated by someone else—had appeared in *The Atlantic*. "I have not seen your article in the *Atlantic*. I will send for it," Borthwick said. "As I wrote you last winter, the *Atlantic* is our best magazine and the one in which you would have the most intelligent audience." The article, "Motherliness," translated by "Mrs. A.E.B. Fries," appeared in the October 1912 *Atlantic*. A two-part series translated by Fries, "Education for Motherhood," appeared in the July and August issues of 1913.

Once again Key had double-crossed her. Once again, Borthwick maintained a stiff upper lip.

PROBLEMS AT PUTNAM'S

Mamah Borthwick seemed to be the object of what *Washington Post* etiquette columnist Judith Martin once termed the "Kafka Romance Dissolver." One person in a faltering relationship receives a bewildering series of hurts and rejections from the presumed beloved, without any explanation. Martin likens it to the baffling persecution of Joseph K. in *The Trial*.[90]

Lena Johannesson suggests there were two reasons for Key to pull away from Borthwick. One was that she didn't grasp the implications of Mamah's relationship with Wright until after she made commitments to her. "Ellen Key soon realized the nature of Mamah and Frank's relationship and that her own gospel tended to legitimize that liaison," Johannesson says. Key was shocked to find that two people were daring to live according to her precepts in a high-profile way.

"When she furthermore realized that the woman once called Mamah Cheney had abandoned her children out of love for a man, she seemed unwilling to reconcile such a brutal confrontation with her own theories. According to Ellen Key, the choice of free love can never be positive if it is combined with neglect of maternal love. This was her sad condemnation of Mamah and Frank."[91]

The second reason she was pulling away was that she was hearing criticisms of Mamah as a translator. During 1912 Borthwick had taken on her first big job, the translation of Key's book *The Woman Movement* (252 pp.) for Putnam's in New York. Havelock Ellis, the sexologist and eugenicist who wrote the introduction, had a problem with Mamah. In communications with Key, he "draws attention to the fact that Mamah is not looked upon as a brilliant translator," Johannesson says.[92]

"The place here is very lovely; all summer we had excursion parties come here to see the house and grounds, including Sunday-schools, Normal School classes, etc. I will try to send you some new photographs—you will scarcely recognize them from the others."

—Mamah Borthwick to Ellen Key

Ellis complained directly to the publisher, as evidenced by Putnam's letter to Key in January 1913:

"Mrs. Bouton Borthwick worked very hard to make her translation as good as possible, and we feel that it is now in fairly satisfactory form. Frankly, we do not consider, however, that she is really a first class translator," the letter says. "Mr. Havelock Ellis feels particularly disappointed that the English translation could not have been more distinguished."[93]

Putnam's and Key may have tried to derail Borthwick. "Putnam's have written me several times to the effect that they have letters from other translators who write also that they had your expressed desire that they do the translations into English and finally they asked me to prove my statement that you had asked me to write them concerning "Kvinnsrörelsen" [*The Woman Movement*] by sending them the 'alleged' letter," Mamah wrote. "Their attitude has not been particularly pleasant about their other 'alleged' translators."

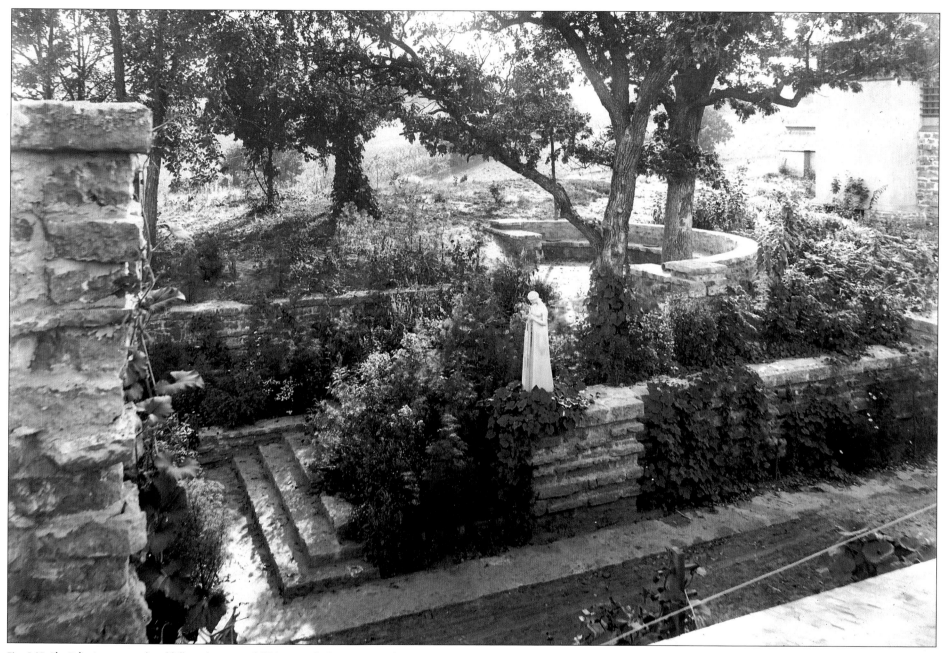

Fig. 145. The Taliesin courtyard and hill garden are at full bloom in the late summer of 1912. The Tea Circle under the oak trees and statue of "The Flower in the Crannied Wall" are prominent in this Clarence Fuermann photograph taken from the roof.

Mamah was so cheerful, dauntless, and determined that in the end she was allowed to proceed. *The Woman Movement* was published by Putnam's in 1912 with her name—and that of Havelock Ellis—on the title page. She heard nothing from Key for six months after sending the very direct letter in January 1913. In July, after she returned from Japan, she received a card from Key that made her "more delighted than I can say." Putnam was going to let her translate a volume of essays by Key and an article on Romain Rolland, one of Europe's leading pacifist and antifascist voices, whose 10-volume serialized novel, *Jean-Christophe*, would win the Nobel Prize for literature in 1915.

The essays never materialized, and Mamah was challenged by Mary Joanna Safford, a Washington-based translator, about her right to translate Key's "Romain Rolland" from the French magazine *La Revue*, where Rolland's own work appeared. Safford maintained that she had exclusive English translation rights to anything in *La Revue*. "There is no intimation that you were authorized to translate this special article," Borthwick quotes Safford in writing to her, "Do you know whether Miss Key informed the editor that she wished the translation to be made by you?"

Borthwick did the translation, which was published by another of Wright's Chicago friends, Margaret Anderson, in *The Little Review*, in 1915. By then Mamah was dead.

Ellen Key took the last letter from Mamah, written on July 20, 1914, and wrote at the top, with an underscore, *"Nu Mördad"*—"now murdered." Below it she drew a cross.

ASSESSING KEY AND BORTHWICK

One must give Ellen Key credit for responding to a novice and entrusting her with her work. Mamah Borthwick had not been published or tested. The texts Key was giving her on marriage and sexuality, unlike her clear writings on home design, were murky and convoluted.

One must give Borthwick credit for being game enough to take them on. To compare passages from the Borthwick and Bogutslawsky translations of *Love and Ethics* produces no clear winner. Without the original Swedish edition in hand, and a knowledge of Swedish, it is hard to know whether either translator could have done any better. Borthwick had gone the extra mile and taught herself to

read and write in Swedish just for Ellen Key.

The Borthwick-Key correspondence is one-sided. One hears only Mamah's voice, though it is usually clear what she is reacting to, and often she quotes Key back to herself. Without the full correspondence available, including letters from Putnam's, it is difficult to judge who is being unfair in each instance. It is difficult to judge whether Wright was really forced to take the three smaller translations to Ralph Fletcher Seymour, his personal publisher, as a last resort, or whether it was his first resort. Putnam's was the logical publisher for *Love and Ethics* since that book was, in part, Key's reply to the wave of criticism that greeted the 1912

> *"Frank's mother has just telephoned me she has a letter so I must run over there. Pardon haste—"*
>
> —Mamah Borthwick to Ellen Key from Taliesin, July, 1913

Putnam edition of *Love and Marriage*. But Putnam's in the United States may have wanted to lie low, as can be judged by the frightened preface of the Huebsch edition.

Wright considered the East Coast a lost cause when it came to advancing new ideas. He believed the future was in the Midwest and West. But that was not the opinion of Europeans like Key, who regarded New York as the only serious place to be published in the United States. In her first letter from Taliesin, in which Mamah says she has learned that a New York house is coming out with an edition of *Love and Ethics*, she tries to make a case for Seymour: "He is very well known in the West at least—particularly for the high-class artistic books which he brings out, in fact devotes himself exclusively to that class of work. I feel sure you would be satisfied that the three or four little things have gone to him. The réclame [the reputation] of his publishing house is of course of a different order from that of Putnam's—so it is not a bad thing to have both?" Key was not persuaded.

No one could have asked for a more dedicated, patient, consistent, cooperative, hardworking and loyal translator than Mamah Borthwick. She was constantly at work, translating many more essays than were published and always asking for more. Key, suspicious, complaining, and controlling, would not give Borthwick

or Wright any freedom to market or repackage her work. Mamah emerges as the soul of charity, never disrespectful but earnest, considerate, and obedient. She is so grateful for the personal liberation Key has helped her find, and so happy with her life, that no abuse by Key can dampen her warmth or temper her high spirits. Taylor Woolley would remember Mamah as "one of the loveliest women I ever knew."[94]

For his part, Frank Lloyd Wright did everything he could to help make Mamah's mission the success she wanted it to be. From her letters one can see he is fully involved. He told Francis and Mary Little, "We work together," and he meant it. Wright and Borthwick are constantly discussing her work. He offers ideas for articles and anthologies, puts his publisher and networks at her disposal, advances his own money, accepts losses, writes letters in Mamah's defense, sends magazines to Sweden for Key's consideration, and accompanies her to her appointments in New York.

He never takes credit for what she does, except for the shared translation credit for *Love and Ethics*. Lena Johannesson believes he took the credit because he paid for the printing. But he paid for all the printing at Seymour. This title page, the product of their time in Italy, was their public declaration of their commitment to each other.

MAMAH AT TALIESIN: NOTES FROM LIFE

Woven among Mamah Borthwick's letters to Ellen Key are enticing glimpses of the life she and Frank Lloyd Wright were living together and insights into their state of mind, their hopes and plans. Soon after arriving in Wisconsin, Borthwick is excited to tell her mentor about the new home he has built for her "in this very beautiful Hillside, as beautiful in its way as the country about Strand." She knows its name—Taliesin—and describes "the combination of site and dwelling" as "quite the most beautiful I have seen anyplace in the world." Frank's sister Jane Porter, her host at Tanyderi while Taliesin was still under construction, "has championed our love most loyally, believing it her brother's happiness."

"I have been thus far very busy with the unfinished house and because of the fact that workmen were boarded here in a nearby farmhouse, sometimes as many as 36 at a time. Mr. Wright's sister has looked after this all summer but when I came it was turned over to me and I have done very little of your work in consequence of the building. The house is now, however, practically finished and my time again free. Mr. Wright has his studio incorporated into the house and we both will be busy with our own work, with absolutely no outside interests on my part."[95]

Responding to Key's quizzing about her children, she says, "My children I hope to have at times, but that cannot be just yet." She says, pointedly, "I believe it is a house founded on Ellen Key's ideal of love."

As progress continues on the house, Borthwick sends two photographs, probably prints made by Taylor Woolley. "The interior looks pretty bare, for there are no rugs yet nor many other things which will make it look more home-like," she says. She mentions that "a draughtsman of Frank's whose wife is a Swedish woman brought us a copy of *Jul Kvällen* [the July issue of *Evening*] with its photograph of Strand, Ellen Key's article "Hemma" ["Home"]—and—an unusually lovely likeness of Ellen Key's lovely self." Draftsman Herbert Fritz's wife, Mary Olava Larson Fritz, was a daughter of Norwegian immigrants. This little act of thoughtfulness shows that Mamah already had made friends.

Her dignified comportment during the press onslaught of December 1911 may have impressed those around her. She tells Key, "Except for the newspapers we have been treated with every possible respect and uniformly courteous consideration."

On November 10, 1912, a year into their life at Taliesin, Mamah sends a happy report. "You will be interested, I think, to know how our attempt to do what we believed right has succeeded. I can now say that we have, I believe, the entire respect of the community in which we live. I have never encountered a glance otherwise and many kind and thoughtful things have been done for us by the people around here.

"I do not go to Chicago, but Frank does and sees his children every week. My sister [Lizzie Borthwick] brought my children here for the summer during Mr. Cheney's absence in Europe for his wedding trip. He married a very lovely young woman, a dear friend of my sister's—and the children are very fond of her and she of them.

"The place here is very lovely; all summer we had excursion parties come here to see the house and grounds, including Sunday-schools, Normal School classes, etc. I will try to send you some new photographs—you will scarcely recognize them from the others."

One also gets a flash of Mamah's experience of her first winter in Wisconsin. "I hope you will have time to write me a word or two—I cherish your letters very dearly," she says. "I have again a long, shut-in winter to read and study your work."

Key must have responded skeptically to the good news and questioned Mamah closely about the children's welfare. In her reply of January 5, 1913, Mamah provides the answers:

"Yes, Mrs. Cheney is lovely with the children. My sister lives there, you know, and no one could have the interest of the children nearer her heart than she has, and she thinks Mrs. Cheney wonderfully wise and lovely with them always. Only my sister's being there made my absence possible. I hope to go to Chicago to see them in a few days. Yes, Frank was here when the children were here last summer and they love him dearly."

By July 8, 1913, Borthwick is looking forward to a new life and a new adventure in Japan. "I have a dream of you coming to America, visiting us, and then of our going over to Japan together," she tells Key. "Will you realize it, do you think possibly? Frank must go again in connection with the hotel, so we expect to have a little house there where you would again be our guest, during your stay in Japan. Would you consider it? Of course you would be perfectly independent to make whatever side trips you might wish."

She adds a telling postscript: "Frank's mother has just telephoned me she has a letter so I must run over there. Pardon haste—With dearest love, Mamah."

"Over there" is probably Hillside Home School, where Anna Lloyd Wright stayed with her sisters Jennie and Nell Lloyd Jones. They have phone service at Taliesin, but the mail is delivered to the school. Although Wright described Taliesin as his mother's home in a 1911 letter to clients, Frank and Mamah have the place to themselves. Anna is on cordial terms with Mamah, giving her a call when there is mail. "Running over there" is probably something Mamah does regularly.

Borthwick's final letter to Key, on July 20, 1914, is personal and newsy. She talks about the weather. "Strand must be lovelier than ever now. You are to be envied its coolness if nothing else. It is nearly 90 Fahr. in the room as I write, with every prospect of reaching 100 very soon. It is of course extremely enervating."

Wright is doing great things. "Frank has been very busy; had a special exhibit of his work in the Art Institute this winter, which attracted a great deal of attention. I am taking the liberty of sending you one of the articles on some Concert Gardens he has just built," the Midway Gardens.

Wright is still supporting Mamah's relationship with Key by sending her presents. "Frank said a few days ago he was going to send you a photograph of me, if you still care to have it. I should be so happy to have a word from you when you can spare me one."

Their social life at Taliesin is one Key might envy but also resent. "Charlotte Perkins Gilman has been here to see us a couple of times recently," Mamah says, naming Key's chief antagonist in American feminist debates,"—an extremely interesting woman of course, with a terrifyingly active brain. Then we have had some other interesting people here lately—editor of The Dial,[96] artists, etc.; but best of all my children come in a day or two to spend the summer with us."

Mamah Borthwick and Frank Lloyd Wright had been through a long ordeal and had survived each trial. They had been scandalized in the U.S. press while in Germany and forced to separate, but they found each other again in Italy. They had been hounded by the Chicago press in Wisconsin but they faced it down. They had been ostracized as creative partners, living together unmarried, but now the world was welcoming them. They were on the verge of vindication.

But it was the summer of 1914. It all would soon be destroyed.

Fig. 146. A bust of Ellen Key sits in a window next to her writing desk at Strand. Photograph courtesy of Björn Sjunnesson.

Fig. 147. Ellen Key and Mamah Borthwick probably sat at this partner desk at Strand in June 1911. The palette shows Key's preference for pale colors, sunlight, and wood. Photograph courtesy of Björn Sjunnesson.

CHARLOTTE AND ZONA AND MAMAH AND FRANK

"Charlotte Perkins Gilman has been here to see us a couple of times recently—an extremely interesting woman of course, with a terrifyingly active brain."

—Mamah Borthwick to Ellen Key, July 20, 1914

Charlotte Perkins Gilman's journey to Taliesin began in mid-June, 1914, when she, Zona Gale, and Rev. Jenkin Lloyd Jones all appeared at the 12th Bienniale of the General Federation of Women's Clubs in Chicago. The conference, which drew an immense crowd of 15,000 clubwomen from the United States and around the world, including 5,000 delegates, took place over seven days starting June 10. Gilman spoke on "The New Art of City Making." Gale chaired the Civics Committee's programs and read a "Friendship Village" story. Jones spoke on peace and temperance.[97]

After the conference Gale and Gilman traveled to Madison, where they appeared with 28-year-old Margaret Woodrow Wilson, the president's daughter, at a five-day "Suffrage School" attended by numerous movement, university, and

"I made up my mind to know Zona Gale better when I got home. . . . I had met her at Taliesin with Charlotte Perkins Gilman."

—Frank Lloyd Wright, *An Autobiography*

political leaders. Wilson's special interest was in building grassroots democratic activity by using public school buildings as social centers, coordinated by appointed "civic secretaries." (The Wisconsin Legislature had passed a law permitting such use as part of its 1911 Progressive agenda.)[98]

On the evening of June 22, Wilson, Gilman, and Gale left Madison for Gale's

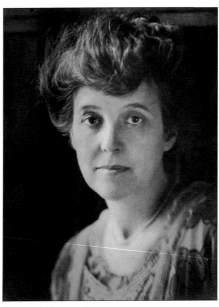
Fig. 148. Zona Gale

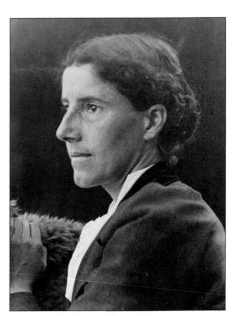
Fig. 149. Charlotte Perkins Gilman

riverside home in Portage. They were accompanied by former Chicago school system architect Dwight Perkins (who had worked with Frank Lloyd Wright in Louis Sullivan's studio) and his wife. They traveled together by car. A local paper reported that they ran into "almost impassable" roads with "water and mud over the hubs" after a heavy rain, and did not reach Portage until almost midnight. The president's daughter traveled without security.[99]

The next evening they put on a program at Portage High School to campaign for Wilson's social centers. Wilson, a singer, also treated the audience to "several songs, including 'The Lass With the Delicate Air.'"[100]

The parties went their separate ways, and Gale and Gilman traveled to Spring Green, where they stopped to visit Jenkin Lloyd Jones's Tower Hill summer colony. Gale recalled an example of Gilman's relentless rationality and truth-telling: "Mr. Jones, with his shock of silver hair and silver beard and ruddy face, came smiling toward us as we sat talking to a little girl. 'See,' I said to the child, 'here comes Santa Claus!' The child's eyes widened and deepened, and Mrs. Gilman touched my arm. When she had my attention, she held me in silence for a moment, and then she said, very low: 'It isn't true.' A memorable moment."[101]

PROMOTING THE WOMEN'S BUILDING

On July 7, the two women appeared on stage at the Spring Green high school auditorium to raise funds for a new Women's Building and Neighborhood Club at the Iowa County fairgrounds. The building was a project of Frank Lloyd Wright's sister Jane Porter, who was interested in finding ways to bring country women together and help them overcome the isolation of rural life. Her Lend-a-Hand Club was another Progressive endeavor; on June 6 she had welcomed the club to Tanyderi, her home on the Taliesin grounds, where "dainty and abundant refreshments were served," girls from Hillside Home School sang and paraded with flags,

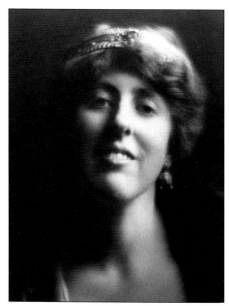

Fig. 150. Margaret Woodrow Wilson, the president's daughter and a noted singer, was 28 when she joined Zona Gale and Charlotte Perkins Gilman for travels in Wisconsin.

and the honored guest was Richland Center neighbor Ada James, the leader of the Women's Suffrage League of Wisconsin.[102] Wright had contributed a design for the Women's Building and pledged to fill its gallery with a display of his newest art treasures from Asia for the building's dedication, which would be on September 2, the opening day of the county fair. Herbert Fritz, Wright's senior draftsman, did the rendering of the building that appeared on the front page of the Home News.[103] Fritz brought his violin to the high school and played solos to open and close the program.

"NOT ONE MOMENT LACKED INTEREST"

"There was only one regret" at the end of the evening, the Home News reported, "and that was that anyone should have missed the opportunity of hearing two such gifted women as Mrs. Gilman and Miss Gale."

Fig. 151. Frank Lloyd Wright's design for a Spring Green Women's Building and Neighborhood Club appeared on the front page of the Home News on July 2, 1914. It was to have a skylighted gallery and a separate children's play and nap area. A different design was finally adopted.

Gilman, who had turned 54 four days earlier, was described as "a lecturer of wide reputation, author, owner and publisher of The Forerunner, a live monthly magazine." She "offered poems and stories which showed her keen understanding of human nature, and she mentioned ways of improving social conditions, emphasizing the idea that human nature need not remain stationary but grow and develop."[104]

Gilman praised the Women's Building, saying it could serve as a respite center for mothers (separate children's play and nap areas were in the design), an art gallery, a hall for lectures and dances, a women's exchange for the display

and sale of homemade items, and a "tea room for automobilists."

"The audience showed sympathetic appreciation of Mrs. Gilman's wit and there was not one moment of her talk that lacked interest," the *Home News* reported.

Zona Gale, 40, read excerpts from an unpublished story. "It was a story that brings us in close sympathy with the life about us and gives us the desire to work

> *Ellen Key maintained that women's work outside the home was "socially pernicious, racially wasteful, and soul-withering," and criticized the women's movement "for setting up male models and male standards of success and fulfillment."*

for the advancement of the community," the reporter wrote. "An unusually earnest and friendly atmosphere pervaded the audience and Miss Gale's enthusiasm gave [everyone] courage to surmount many difficulties and prejudices."[105]

Gale also announced a benefit performance of her new play, *The Neighbors*, in the Hillside Home School gym in late August. Although she lived 50 miles up the Wisconsin River, she was a familiar figure at Hillside and Tower Hill and had accepted a lead role in the Women's Building drive before it was announced on July 2.[106]

VISITING MAMAH BORTHWICK

When exactly did Charlotte Perkins Gilman visit Mamah Borthwick and Frank Lloyd Wright at Taliesin?

Borthwick is not specific, but July 7 was less than two weeks before she wrote to Ellen Key of the "recent" visits. Gilman and Gale might have been houseguests of Jane Porter at nearby Tanyderi.[107] Gale's presence during at least one visit is established by Wright in his *Autobiography* when he discusses his failed attempt to court her in 1923. He says:

"My people all knew Zona. My Mother and my Aunts much admired her. While in Japan I read *Lulu Bett*. Straightaway I made up my mind to know Zona Gale better when I got home; if not, to know the reason why. *I had met her at Taliesin with Charlotte Perkins Gilman.*" (Emphasis added.)[108]

Wright does not mention that Mamah also was in the room. But Mamah was probably the person Gilman most wanted to see. Ellen Key was Gilman's major rival in the feminist debates of the time, and Borthwick was Key's American translator. In the edition of *Love and Ethics* produced by Borthwick, Gilman is called out by name when Key speaks disparagingly of "American feminists of the Charlotte Perkins Gilman type." In the Huebsch translation of the same passage the name does not appear; the word "Americanism" is substituted for the phrase.[109]

THE GILMAN TYPE

What did "American feminists of the Charlotte Perkins Gilman type" believe?

They believed that feminists were no different from men in human essentials, that "female nature" was a social construction. "There is no female mind. The brain is not an organ of sex. Might as well speak of a female liver," Gilman said. "In our steady insistence on proclaiming sex-distinction we have grown to consider most human attributes as masculine attributes, for the simple reason that they were allowed for men and forbidden to women."[110]

They believed that the raising of children should be tasked to people with the best qualifications. "It is not sufficient to be a mother," she said. "An oyster can be a mother."[111]

They believed that women should be free to work in any field. "Doing human work is what develops human character," she said. "The reason that women need the fullest freedom in human development . . . is because women are half the people of the world and the world needs their service as *people*, not only as women."[112]

They believed in the liberating power of association and common effort. "[W]hosoever, man or woman, lives always in a small, dark place, is always guarded, protected, directed and restrained, will become inevitably narrowed and weakened by it," she said. "The woman is narrowed by the home and the man is narrowed by the woman."[113]

These ideas were never far from the surface of Gilman's "terrifyingly active brain." Gale tells of standing with Charlotte "on the platform of a small railway town in Wisconsin. Beautiful red-and-green switch-lights shone out and great engines rushed back and forth.

"'All that,' she said, 'and women have had no part in it. Everything done by

Gilman believed that the raising of children should be tasked to people with the best qualifications.
"It is not sufficient to be a mother," she said. "An oyster can be a mother."

men, working together, while women worked alone within their four walls!'"[114] She was not always in a state of anger. Gale describes Gilman's reaction upon leaving a University of Wisconsin building on Bascom Hill during the summer session. "Emerging on that campus, the summer school students streaming over its green swell in the slanting late afternoon sunlight, bright colored groups under the trees, the university band playing, she said: 'There's heaven. There it is. What more do we mean? People free to come together, and in beauty—*for growth.*'"[115]

"THE TALMUD OF SEXUAL MORALITY"

In contrast to Gilman's audacity and wit, Ellen Key's musings on love, marriage and sexuality seem nearly unreadable. But her focus on the individual woman and her erotic emancipation—the freedom to marry for love and be a lover—drew an audience to compete with Gilman's social vision. "One feminist recalled that even though suffragists regarded Key's views as 'anathema' . . . everybody who used to read Charlotte Perkins Gilman was now reading Key."[116]

Floyd Dell, who profiled both writers in his 1913 *Women as World Builders*, called Key's *Love and Marriage* "the Talmud of sexual morality"—a reference to

Fig. 152. Charlotte Perkins Gilman and Zona Gale both spoke at the 12th Biennial Convention of the General Federation of Women's Clubs in Chicago before coming to Taliesin in the summer of 1914. The conference drew 5,000 delegates and 15,000 club members.

SALVE

TWELFTH
BIENNIAL CONVENTION
OF THE
GENERAL FEDERATION
OF WOMEN'S CLUBS
CHICAGO
1914

both to its wisdom and its impenetrability.

"She lacks logic, and with it order and clearness and precision," Dell says, but "there is a whole universe in *Love and Marriage*; it resembles the universe in its wildness, its tumultuousness, its contradictory quality. Her book, like the universe, is in a state of flux."[117]

> *"There's heaven. There it is. What more do we mean? People free to come together, and in beauty—for growth."*
>
> —Charlotte Perkins Gilman,
> observing the summer scene on the University of Wisconsin's Bascom Hill

Gilman, discussing Mamah Borthwick's translation of *The Woman Movement* in the February 1913 issue of *The Forerunner*, breaks with Key on several big questions, one of which she calls "an unbridgeable chasm."[118] That is Key's conviction that motherhood and raising children is woman's most exalted work.

Borthwick had been jolted in 1911 when Key urged her to leave Wright and return to her children, which she said would be the proper "choice in harmony with your own soul." Mamah had rejected that and told Key that Wright had said, 'I feel as if I had lost a friend.'"[119]

Key also maintained that women's work outside the home was "socially pernicious, racially wasteful, and soul-withering," and criticized feminists "for setting up male models and male standards of success and fulfillment."[120]

But Key had made Borthwick's own professional work—the work of translating and marketing Ellen Key—a hellish assignment. Key had been, among other things, a double dealer, pitting one translator against another and taking money from both.

That is surely why Borthwick made a point of letting Key know in her letter of July 20—the last she would write—that she and Frank Lloyd Wright had welcomed her worst adversary into their living room—more than once—and that they had found Charlotte Gilman "extremely interesting," and possessed of a "terrifyingly active brain."

She might have been teasing her mentor, but it was also her moment of defiance.

NOTES

1. Architect Wright in New Romance With 'Mrs. Cheney,'" *Chicago Tribune*, December 24, 1911.
2. Edwin L. Shuman, *Steps Into Journalism* (1894), quoted in Michael Schudson, *Inventing the News: A Social History of American Newspapers* (New York: Basic Books, 1978), 79.
3. "Spend Christmas Making 'Defense' of 'Spirit Hegira,'" *Chicago Tribune*, December 26, 1911.
4. Painting an outcast with hot tar and spreading feathers over the tar before driving the undesirable person out of town was a vigilante punishment used on rare occasions in American communities as far back as the Revolutionary War. See Lawrence Friedman, *Crime and Punishment in American History* (New York: Basic Books, 1993).
5. "Ask Sheriff's Aid to Oust Wright," *Chicago Tribune*, December 37, 1911.
6. "Tar and Feathers for Wright and Soulmate," *Des Moines Daily News*, December 237, 1911.
7. "Elopers Guarded From College Boys," *Syracuse Herald*, December 26, 1911.
8. "Sheriff to Raid Love Castle," *Syracuse Herald*, December 27, 1911.
9. "Law Vs. Love," *Syracuse Herald*, December 28, 1911.
10. "To Move Love Castle," *Racine Daily Journal*, December 30, 1911.
11. "Affinities Plan Escape," *Washington, Indiana., Democrat*, December 29, 1911.
12. "Barred Doors Hold Soulmade [sic] Prisoner," *Alaska Citizen*, February 12, 1912.
13. "Affinities Plan Escape," *Carbondale Daily Free Press*, December 29, 1911.
14. "Wright Reveals Romance Secret," *Chicago Tribune*, December 30, 1911.
15. Wright Talks: 'I Won't Talk,'" *Chicago Tribune*, January 3, 1912.
16. "Wright in Castle Fearless of Raid," *Chicago Tribune*, December 28, 1911.
17. Floyd Dell, "A New Idealism," *Chicago Evening Post Friday Literary Review*, December 29, 1911.
18. Mamah Borthwick to Ellen Key, late February or early March, 1912, Ellen Key Archive, Royal Library of Sweden.
19. "Wright Case Agitation Develops Temporary News Bureau at Spring Green," *Dodgeville Chronicle*, January 5, 1912.
20. "Wright Case Agitation," *Dodgeville Chronicle*, Janury 5, 1912.
21. Richard Lloyd Jones to Frank Lloyd Wright, December 28, 1911. Frank Lloyd Wright Foundation, Scottsdale, Arizona, used by permission.
22. "Wright is Repudiated—Wife Remains True," *Eau Claire Leader*, December 28, 1911.
23. Frank Lloyd Wright to Francis and Mary Little, January 3, 1912. Frank Lloyd Wright Foundation, Scottsdale, Arizona, used by permission.
24. A. Cole to Frank Lloyd Wright, January 6, 1912. Frank Lloyd Wright Foundation, Scottsdale, Arizona, used by permission.
25. "'Spiritual Hegira' Trial; Relatives of Principal Actor to Pass Upon Situation," *Oshkosh Daily Northwestern*, December 28, 1911.
26. Wright's open letter, February 3, 1912, notarized in Sauk County by Thomas W. King. Jane Lloyd Jones and Ellen C. Lloyd Jones Papers, Wisconsin Historical Society.
27. Numbers from 1915 Hillside brochure via e-mail from Keiran Murphy to author, July 14, 2011.
28. Wright quotes them back to themselves in his letter of January 3. The details of the $9,000 loan are from Anthony Alofsin, *Frank Lloyd Wright: The Lost Years, 1910–1922* (Chicago: University of Chicago Press,1993), 72.
29. Ibid. A phaeton is a type of horse-drawn buggy.
30. For the fate of other salvaged remnants, see "Francis W. Little House II (S. 173)," William Allin Storer, *The Frank Lloyd Wright Companion* (University of Chicago Press, 1993), 174–175.
31. Wright to Ashbee, July 24, 1910. Reprinted in Robert Sweeney, *Frank Lloyd Wright: An Annotated Bibliography* (Los Angeles: Hennessey & Ingalls Inc., 1978), xxii.
32. Frank Lloyd Wright, *Studies and Executed Buildings* (Berlin: Wasmuth, 1910), v. 1, 1, J. Willard Marriott Library, University of Utah.
33. Wright to Woolley, April 22, 1911, Taylor Woolley Manuscript Collection, J. Willard Mariott Library, University of Utah.
34. Alasdair McGregor, *Grand Obsessions: The Life and Work of Walter Burley Griffin and Marion Mahoney Griffin* (Victoria, Australia: Lantern/Penguin Group, 2009), 81–82.
35. Frank Lloyd Wright, *The Japanese Print: An Interpretation* (New York: Horizon Press, 1967), 17, 19.
36. Ibid., 25–27.
37. Julia Meech, *Frank Lloyd Wright and the Art of Japan: The Architect's Other Passion* (New York: Japan Society and Harry N. Abrams, 2001), 40.
38. Ibid., 14.
39. Ibid., 14, 16.
40. Ibid., 72.
41. "Frank Wright Goes to Japan; Departs for Flowery Kingdom on Sunday; Takes 'Soulmate' With Him," *Dodgeville Chronicle*, January 17, 1913.
42. Mamah Borthwick to Ellen Key, July 8, 1913. Ellen Key Archive, Royal Library of Sweden. The newspaper's mention of "Satsu," which might or might not be an accurate rendering of the name, is the only known reference to a Japanese servant at Taliesin.
43. Frank Lloyd Wrght, *An Autobiography* (Barnes & Noble reprint, 1998),

524–530. Wright appears to conflate the 1913 trip with one in 1915–1916, his fifth crossing. Meech has the most authoritative account of Wright's life as a collector and art dealer. *Frank Lloyd Wright and the Art of Japan*, 210–218

44. Robert C. Twombly, *Frank Lloyd Wright: His Life and Architecture* (New York: John Wiley & Sons, 1979), 144–145.
45. Ibid., 157.
46. Theodore Turak, "Mr. Wright and Mrs. Coonley: An Interview with Elizabeth Coonley Faulkner," in Richard Guy Wlson and Sidney K. Robinson, eds., *Modern Architecture in America: Visions and Revisions* (Ames, Iowa: Iowa State University Press, 1991), 157.
47. Larwence K. Eaton, *Two Chicago Architects and Their Clients: Frank Lloyd Wright and Howard Van Doren Shaw* (Cambridge: MIT Press, 1969), 82–85, 220.
48. Turak, "Mr Wright and Mrs. Coonley," 154.
49. Queene Ferry Coonley, "The Educational Responsibility of the Mother," Vassar Quarterly (August, 1921), 239–245.
50. Turak, "Mr Wright and Mrs. Coonley," 150.
51. Ibid., 158.
52. Ibid., 159.
53. Mamah Borthwick to Ellen Key, July 8, 1913. Ellen Key Archive, Swedish Royal Library.
54. Julia Meech, *Frank Lloyd Wright and the Art of Japan*, 80.
55. Ibid., 84.
56. Frank Lloyd Wright, "The New Imperial Hotel, Tokio," *Western Architect*, April 1923, reprinted in Bruce Brooks Pfeiffer, ed., *Frank Lloyd Wright: Collected Writings* (New York: Rizzoli, 1992), v. 1, 177.
57. Ibid.
58. For Wright's account, see "Building Against Doomsday" in *An Autobiography* (New York: Barnes & Noble reprint, 1993), 213–223.
59. Frank Lloyd Wright, *An Autobiography*, 176.
60. Ibid., 180.
61. Paul Kruty, *Frank Lloyd Wright and Midway Gardens* (Urbana: University of Illinois Press, 1998), 28, 32.
62. "Midway Gardens to Be Formally Opened Tonight," *Chicago Tribune*, June 27, 1914.
63. Paul Kruty, *Frank Lloyd Wright and Midway Gardens*, 37.
64. Frank Lloyd Wright, *An Autobiography*, 190–191.
65. Paul Kruty, *Frank Lloyd Wright and Midway Gardens*, 38, 40.
66. Wright to Woolley, March 30, 1914, Taylor A. Woolley Manuscript Collection, J. Willard Marriott Library, University of Utah.
67. Julia Meech, Frank Lloyd Wright and Japan, 110. She cites two newspaper accounts, "Wright Exhibit Stirs Chicago Architects," *Chicago Record Herald*, April 8, 1914, and "Architects Quit Big Exhibit," *Chicago American*, April 9, 1914.
68. Ibid.
69. Lena Johannesson, "Ellen Key, Mamah Bouton Borthwick and Frank Lloyd Wright: Notes on the Historiography of Non-existing History," NORA, the *Nordic Journal of Women's Studies* 3, no .2 (1995), 126–136. For a more comprehensive treatment of the letters, see Alice T. Friedman, "Frank Lloyd Wright and Feminism: Mamah Borthwick's Letters to Ellen Key," *Journal of the Society of Architectural Historians*, v. 61, no. 2, June 2002.
70. Mamah Borthwick to Ellen Key, ca. December 1911. All other quotes and facts, except where otherwise cited, are from Borthwick's letters in the Ellen Key Archive, L 41 A, Swedish Royal Library, Stockholm.
71. Johannesson, Ellen Key, 134. Johannesson argues that Borthwick's work was deliberately slighted by male biographers who treated women as "second-best sources to the lives of great men." However, Borthwick's papers were destroyed in the fire of 1914, her descendants were killed with her, and succeeding Wright wives suppressed any mention of her. Johannesson discovered the only solid evidence of Borthwick's work and then accused biographers of ignoring what only she knew.
72. Thorbjorn Lengborn, "Ellen Key," *Prospects* (Paris: UNESCO, International Bureau of Education, 1993), 23, no. 3/4, 825.
73. Katrin Bennhold, "In Sweden, the Men Can Have It All," *New York Times*, June 9, 2010. Swedes receive 13 months of "generously paid" parental leave, including two months exclusively reserved for fathers.
74. Barbara Miller Lane, "An Introduction to Ellen Key's 'Beauty in the Home,'" in Lucy Creagh, Helena Kaberg, and Barbara Miller Lane, eds., *Modern Swedish Design: Three Founding Texts* (New York: Museum of Modern Art, 2008), 22.
75. Ibid., 25.
76. Mary Blume, "Bathing Sweden in Nordic Light," *International Herald Tribune*, December 30, 1997.
77. Lane, "Introduction," 20, 27.
78. Key, "Beauty in the Home," 35.
79. Ibid., 38.
80. Ibid., 35.
81. Genealogist Karin Corbeil has developed information, supported by obituaries and other sources, that the third child in the Cheney household was Jessie Borthwick Pitkin, Mamah's niece. Her mother, Jessie Octavia Borthwick Pitkin, Mamah's sister, died in childbirth on April 10, 1901. The father, Albert C. Pitkin, gave the baby to Mamah and Edwin Cheney, whose own children were not yet born. (John Cheney was born in 1902, Martha

Cheney in 1905.) Another sister of Mamah, Elizabeth (Lizzie) Borthwick, also resided at the Cheney home and looked after the children. She was listed in the 1910–1911 city directory as a teacher at Washington Irving Elementary School, in the school's first year of operation. Jessie at some point left the Cheney household and moved into the Oak Park home of her wealthy cousin, Carolyn Pitkin McCready. Jessie attended Science Hill School in Shelbyville, Kentucky, an elite finishing school for girls, and the Bouve School of Physical Education in Boston (now the Bouve College of Health Sciences at Northeastern University). She taught physical education at the University of Chicago, then married Roger Higgins, an English instructor at Phillips Academy in Andover, Massachusetts. She was active in music in Andover for more than 50 years, serving as manager and tympanist for the Andover Symphony Orchestra in the 1940s and accompanying vocal and instrumental teachers on the piano. She had two musical sons. Haydn, the older—who remembered growing up with two grand pianos in the living room—became famous as jazz pianist Eddie Higgins, performing in Chicago clubs and international festivals under his stage name. The younger son, Jon Borthwick Higgins, was a renowned singer and an authority on South Indian music at Wesleyan University. Though both are deceased, their recordings are available on Amazon. Sources: Karin (Casey) Corbeil e-mail to author, August 20, 2011. Nancy Horan generously referred the author to Corbeil. "Jessie B. Higgins," *Lawrence Eagle Tribune*, North Andover, Massachusetts, April 4, 1983. "Eddie Higgins, 77; Pianist Created Tapestries of Music," *Boston Globe*, September 27, 2009.

82. Quoted in "'Love and Marriage,'" *New York Times*, March 26, 1911. The deck reads: "Miss Ellen Key maintains that motherhood is not only the destiny, but the highest privilege, of womanhood."

83. Borthwick to Key, January 5, 1913. "Ibsen and Women" was published as *The Torpedo Under the Ark: Ibsen and Women* (Chicago: Ralph Fletcher Seymour, 1912).

84. Ralph Fletcher Seymour, *Some Went This Way: A Forty-Year Pilgrimage Among Artists, Bookmen, and Printers* (Chicago: Ralph Fletcher Seymour, 1945), 114. Seymour says that Wright placed the Ellen Key texts with him upon returning from Germany, at the same time that he gave him "an elaborate American supplement" to his "grand portfolio" to publish, and also a promotional brochure for the Wasmuth Portfolio. The supplement was probably *Frank Lloyd Wright: Chicago*, a variant of the Wasmuth photo supplement known as the *Sonderheft*. (It was labeled "For European Sale Only," but that may have been a ruse to entice U.S. customers.) Since Wright's second trip to Germany concluded at the end of March, Wright's visit to Seymour must have occurred upon his return in April. (Wright attended the world premiere of Richard Strauss's opera *Der Rosenkavalier* on

January 26, 1911, in Dresden. It would be surprising if Borthwick was not with him.)

85. Borthwick to Key, February–March 1912. It is interesting to speculate whether the offended proofreader was responsible for the misprint of Mamah's name as "Namah" on the title page of *The Morality of Women* (Chicago: Ralph Fletcher Seymour, 1911). It was corrected in the second printing. Lena Johannesson sees a different plot behind the typo: "Mamah did not use her real name but a thinly disguised pseudonym, namely 'Namah Bouton Borthwick'." Johannesson, "Ellen Key", 131.

86. Seymour, *Some Went This Way*, 114. Wright actually gave him three books. The third book Seymour does not mention in this recollection is probably *The Torpedo Under the Ark: Ibsen and Women,* which was very brief.

87. Floyd Dell, "A New Idealism," *Chicago Evening Post Friday Literary Review*, December 29, 1911; "Ellen Key's Revaluation of Women's Chastity," *Current Literature* (February 1912), 200–202.

88. Ellen Key, *Love and Ethics* (New York: B.W. Huebsch, 1912), 5.

89. The Spaulding brothers' invitation to Wright was sent on December 31, 1912, and a follow-up note saying they appreciated his visit was sent on January 10, 1913. Julia Meech, *Frank Lloyd Wright and the Art of Japan* (New York: Japan Society and Harry N. Abrams, 2001), 80.

90. Martin says, "There is no possible way for one person to end a romance that the other person thought was going great without causing pain and bewilderment. The chief difference between the Kafka method and those more socially approved ones that come with explanations is that the former engender humiliation as well as pain and bewilderment." Judith Martin, *Miss Manners' Guide to Excruciatingly Correct Behavior* (New York: W.W. Norton, 2005), 350.

91. Lena Johannesson, "Ellen Key," 133.

92. Ibid., 134.

93. Ibid. Johannesson says there are 23 letters from Putnam's to Key between 1911 and 1926 in Key's archive at the Royal Library. Queries from the author to Putnam's about the existence of a file of Mamah Borthwick correspondence received no response.

94. Quoted in Anthony Alofsin, *Frank Lloyd Wright: The Lost Years*, 1910–1922 (Chicago: University of Chicago Press, 1992), 50.

95. Borthwick held fast to this intention. Wisconsin held a statewide referendum on women's right to vote in November 1912. Borthwick took no discernable role in the campaign even though its leader, Ada James, was a regular visitor at Hillside and lived just 20 miles away in Richland Center. The referendum failed.

96. Lucian Clay was the editor of *The Dial* in Chicago at the time. The magazine was a reincarnation of the humanitarian journal originally founded by Ralph

Waldo Emerson and Margaret Fuller.

97. "Club Women Depart to Chicago to Attend Twelfth Biennial," *Racine, Wisconsin, Journal-News*, June 9, 1914. The paper published the full program.

98. "Miss Wilson Urges Civic Secretaries; President's Daughter Gives Address at Madison on Her Special Hobby," *Janesville Daily Gazette*, June 20, 1914.

99. "Mud Delays Miss Wilson; Daughter of President Reaches Portage at Late Hour," *Oshkosh Daily Northwestern*, June 24, 1914.

100. Ibid.

101. Zona Gale, Foreword to Charlotte Perkins Gilman, *The Living of Charlotte Perkins Gilman: An Autobiography* (Madison: University of Wisconsin Press reprint of 1933 edition, 1990), xli.

102. "Lend-a-Hand Club of Hillside," *Spring Green Home News*, June 18, 1914.

103. "The Women's Building and The Neighborhood Club," *Home News*, July 16, 1914. The attribution of the rendering to Fritz is by Anthony Alofsin in *Frank Lloyd Wright: The Lost Years* (University of Chicago Press, 1993), 97. Fritz was one of two survivors of the killing spree that occurred five weeks after the school appearance.

104. "Talented Women Here," *Home News*, July 9, 1914.

105. Ibid.

106. "A Woman's Building for the Inter-County Fair," *Home News*, July 2, 1914.

107. Neither woman appears to have left any account of their visits to Taliesin. The author is grateful to Gilman authorities Cynthia J. Davis and Denise Knight for their efforts to find references to these meetings among Gilman's papers.

108. Frank Lloyd Wright, *An Autobiography*, 1943 edition reprint (New York: Barnes & Noble, 1998), 507. The full title of the novel is *Miss Lulu Bett*. Gale's stage adaptation won the Pulitzer Prize for drama in 1921. Interestingly, Gale set eyes on Olgivanna, the last Mrs. Frank Lloyd Wright, months before Wright did. She saw her perform in New York with the George Gurdjieff dancers on January 27, 1924, and became a convert to Gurdjieff. Wright did not meet Olgivanna until the following November 30, when he found himself seated next to her in a box at the Eighth Street Theatre in Chicago. Roger Friedland and Howard Zellman, *The Fellowship* (New

York: HarperCollins, 2008), 80, 97.

109. The Wright/Borthwick translation, page 47, reads: "The American feminist of the Charlotte Perkins Gilman type looks at all great problems of life from an inferior point of view, when the question of self-maintenance becomes the chief aim of the woman." The Huebsch translation by Auralis K. Bogutslawsky, Page 53, reads, "Americanism views all problems of life from a very low standpoint in regarding the question of self-maintenance as woman's principal aim." Key, *Love and Ethics*.

110. Jone Johnson Lewis, "Charlotte Perkins Gilman Quotes," *About Women's History*, http://womenshistory.about.com/od/quotes/a/c_p_gilman.htm.

111. Cited in Floyd Dell, *Women as World Builders: Studies in Modern Feminism* (Chicago: Forbes & Co., 1913), 28.

112. Charlotte Perkins Gilman, *"On Ellen Key and the Woman Movement,"* in Larry Ceplair, ed., *Charlotte Perkins Gilman: A Nonfiction Reader* (New York: Columbia University Press, 1991), 236–237.

113. Lewis, "Charlotte Perkins Gilman Quotes."

114. Zona Gale, foreword, xxxviii.

115. Ibid., xli–xlii.

116. Cyntha J. Davis, *Charlotte Perkins Gilman: A Biography* (Palo Alto: Stanford University Press, 2010), 116.

117. Dell, *Women as World Builders*, 82.

118. Gilman, *"On Ellen Key,"* 237.

119. Mamah Bouton Borthwick to Ellen Key, late fall 1911, undated letter, Ellen Key Archive, Royal Library of Sweden.

120. Davis, *Charlotte Perkins Gilman*, 315. The "socially pernicious" quote is Key's.

CHAPTER 5
TRANSFORMATIONS

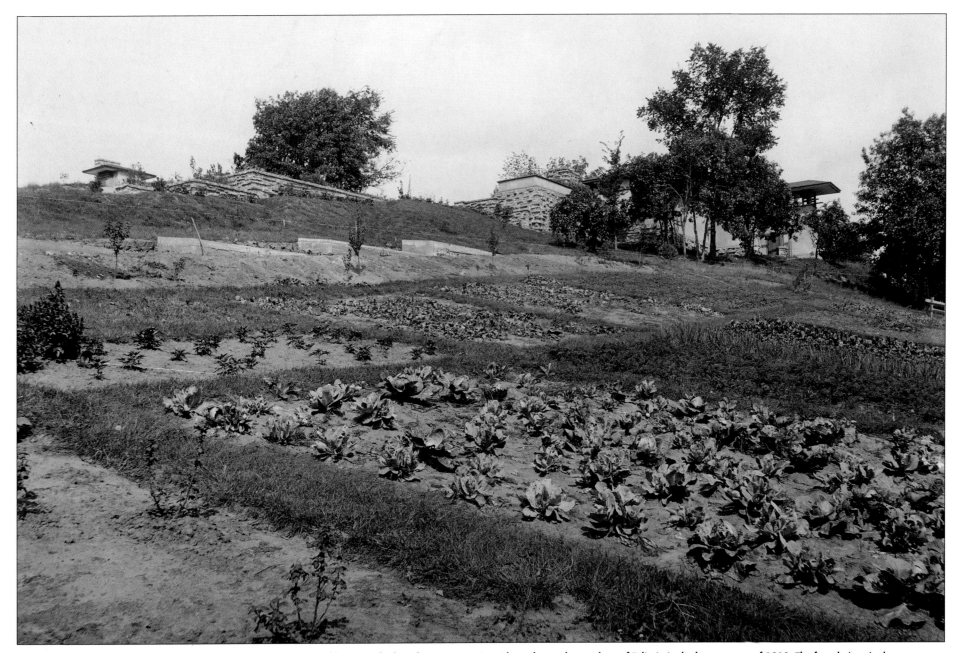

Fig. 153. In a photograph taken by Clarence Fuermann of Chicago, cabbages and other plantings grow in grids on the southwest slope of Taliesin in the late summer of 1912. The foundations in the background may have been the bases for cold frames.

"THE REFUGE FOR AN IDEALIST"

Frank Lloyd Wright's description of the first Taliesin, written 30 years after it was built, defined that building for generations of readers. But there was an outside observer on the ground in the first months. John Reese, editor of the *Dodgeville Chronicle*, visited Taliesin around Christmas 1911 and filed his impressions.

Here one finds not only Wright's vision for Taliesin's development—one that was coming together and soon would take full form—but also a surprising impression of the building's interior light and airiness, a striking contrast to the dark rooms of the Prairie houses.

Although Mamah Borthwick was in residence, there is no mention of her. But it eloquently describes her new home.

"On a natural terrace facing northeast and overlooking the Wisconsin River and the Spring Green river wagon bridge Frank Lloyd Wright has builded [sic] his bungalow," Reese reported. (Wright objected to "bungalow" but Reese said he was using it anyway. The original Taliesin always would be called "the bungalow.")

"The place is reached from the wagon road on the north by a winding drive which mounts the hill and approaches the building from the rear. The house is of one story, consisting of a long, narrow central portion crossed at either end by broader portions, between which, on front and rear, are broad porches.

"Mr. Wright might almost be said to live literally in a glass house, so numerous are the windows in the building, further light being admitted through skylights,

"All well here—place quite transformed."

—Frank Lloyd Wright telegram to Taylor Woolley, July 10, 1912

making the interior practically as light as out-of-doors.

"At one end of the structure are apartments occupied by the head draftsman employed by Wright, while the apartments at the other extremity of the building are occupied by Wright himself.

"The place is beautifully situated and the location is finely adapted to the pur-

Fig. 154. The garden of the forecourt next to the studio, with the breezeway and house beyond, are in bloom, with gourds hanging from a trellis at left. Photograph by Clarence Fuermann.

pose intended; the artist-owner intending to make of it a fruit farm, devoted to the culture of apples, grapes, and bees. His plans for the beautification of the spot are comprehensive, including the damming of a brook which runs through the valley at the base of the terrace, and the creation by this means of an artificial lake or pond of some 18 or 20 acres in extent, which will be stocked with fish and aquatic fowl and plants.

"Shrubbery and flowering plants occupy an important place in Mr. Wright's designs. Indeed, the bungalow itself is built around open-air courts, flower-bordered, and is worked into the hillside and the landscape in an ingenious and interesting manner.

"The whole is eminently the refuge for an idealist, and the artistic bent of the mastery of the place is apparent throughout, in the selection of the place, in the improvements already executed, and in the designs for future arrangement of grounds, buildings, and landscape."[1]

A FRUIT FARM

Wright ordered a lot of fruit for the farm he wanted. In Taliesin's first spring, the great Chicago park and garden planner Jens Jensen made an order on Wright's behalf to a Rochester, New York, nursery that included more than a thousand fruit-bearing trees and bushes.

Jensen's letter to Ellwanger & Barry's Mount Hope Nurseries, dated April 27, 1912, ended with a line typed in red: "Kindly rush this order."[2]

Jerry Minnich, author of the authoritative *Wisconsin Garden Guide*, assessed the order for this book. "Aside from a host of ornamental perennials ordered, which is not unusual for an estate of this size, Jensen ordered 285 apple trees, 300 gooseberry bushes, 150 currant bushes, 200 blackberry bushes, 175 raspberry bushes, and 50 grape vines—a total of 1,160 fruit trees and bushes! (Strangely, no strawberry plants.)

"This is enough to start a midsize commercial orchard. Did Wright intend to support Taliesin through fruit sales? Because, at maturity, these plantings would produce enough fruit to feed several thousand people. I now suspect that the staking shown in some of the photos must have been the laying out of the orchards."[3]

Wright planted orchards and vineyards, but much of Jensen's order did not

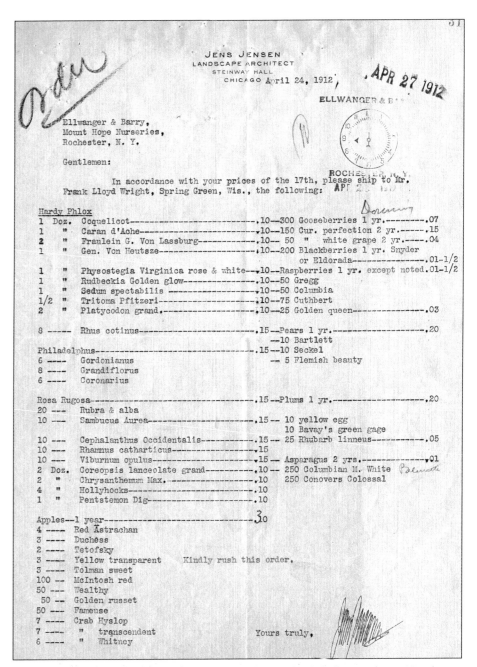

Fig. 155. Jens Jensen sent a nursery order on Frank Lloyd Wright's behalf on April 24, 1912. The order includes more than 1,000 fruit trees and berry bushes.

survive the trip. The shipment was sidelined by a railroad strike and many plants died or arrived damaged. The dispute over what Wright owed the nursery stretched into 1914; there were 23 letters back and forth in 1912 alone.[4]

CONTOURS AND GRIDS

The vegetable and flower gardens of Taliesin flourished in their first season. Clarence Fuermann's 1912 photographs show rows of cabbages in the garden and banks of flowers in the upper courtyard.

In cultivation, Wright departed from the usual straight-line tillage and used both contour and grid tillage, which he had seen in Italy, to productive and artistic effect.

Of these methods, Minnich says: "Contouring is used on slopes to prevent erosion and water runoff. The procedure is actually thousands of years old, and is heavily used in Italy because of the hills, but is far older in China, where rice paddies are built on slopes. The USDA first promoted contour farming in the U.S. in the 1930s.

"Mr. Wright might almost be said to live literally in a glass house, so numerous are the windows in the building, further light being admitted through skylights, making the interior practically as light as out-of-doors."

—John Reese, *Dodgeville Chronicle*, January 5, 1912

"Grid planting is also hundreds of years old. The gardens of the Taj Mahal were designed in a grid pattern (1632). The greatest advantage of grid gardening and orcharding is as an aid to pollination and, thus, fruit production. Sweet corn is also planted in a grid, rather than in long rows, for the same reason. (The bees, moths, and bats get around to more plants when they're in a block instead of a long row.)

"Thus, it is not unreasonable, I think, that Frank Lloyd Wright, designing an orchard and garden on a severe slope at Taliesin, would use both the grid and contour concepts."[5]

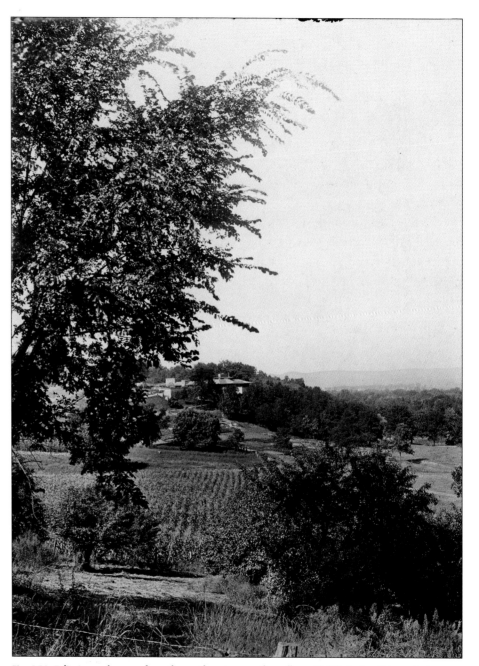

Fig. 156. Taliesin can be seen from the southeast across the valley with hills in the distance in late summer 1912. Photograph by Clarence Fuermann.

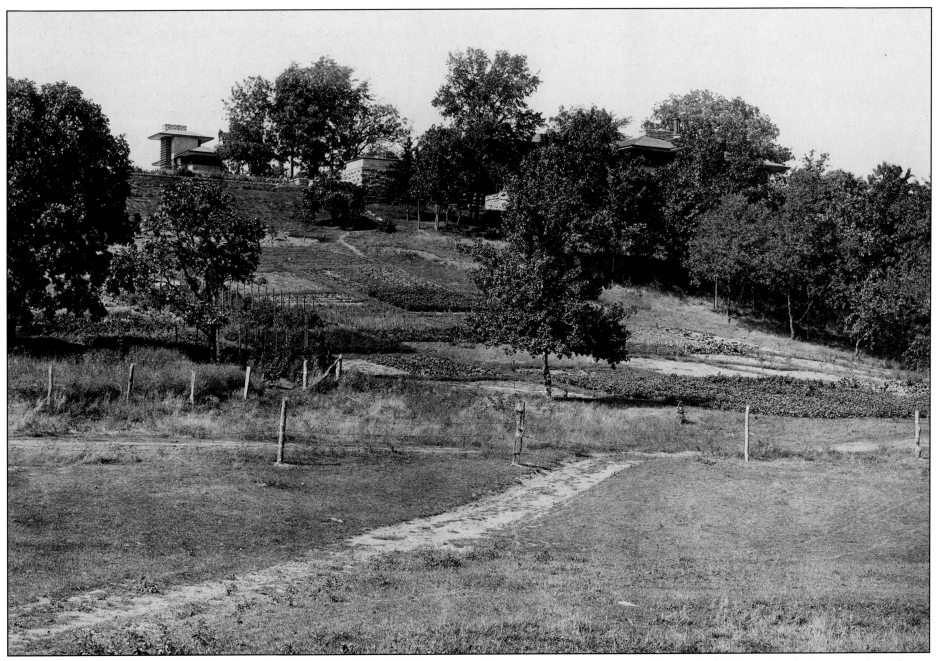

Fig. 157. The southeast slope where men could be seen staking and laying down chalk grids in the spring of 1912 (Fig. 95) is now coming toward harvest. The belvidere and walled entrance to the residence can be seen at the top of the hill. Photograph by Clarence Fuermann.

GATEWAY TO THE VILLA

In the early spring of 1912 Wright dammed the creek running through the property to create both a "water garden" and a spillway at the entrance. Landscape architect Charles Aguar and his wife, Berdeana, in *Wrightscapes*, say that the pond "in 1912 was very small and very oriental in its free form and intricate relationship with the creek, so that it more closely captured the essence of the Japanese water garden than the constructed pond seen today."[6]

Taliesin was "a special kind of oasis, in which the raw and hostile forces of surrounding life had somehow been reorganized into a landscape of blessed peace and plenty."

Both pond and spillway contributed to the experience of entering the Taliesin grounds. "Wright's gateway feature was framed on either side by pillars of striated stone and designed as a unit with the thick stone dam that impounded the creek to form the pond and spillway," the Aguars write. One traveled "under a canopy of trees, passing the water garden on the left and the lower edge of the vegetable and flower gardens to the right, which emulated the Italian grid tillage Wright had admired in Umbria."[7]

It was the first impression visitors would have of Taliesin as a villa.

THE TEA CIRCLE

In 1912 Wright built a retaining wall, stone steps, and a hillside garden on the far side of the courtyard, opposite the roofline of the house and studio. The focal point was a semicircular stone bench on a plaza shaded by tall oaks called the Tea Circle. Its inspiration was both Japanese and Jensenesque; one of the signature features of Jensen's parks was the "council circle." Wright's was more open, more Japanese, with a pool in the center.

The Tea Circle offered a view of the residence and courtyard, or of the garden and hills beyond, depending on where one sat. Neil Levine points out that the hillside circle and its garden were a buffer between the refinement of the courtyard and the untended natural crown of the hill. Built of rough-cut limestone, the Tea Circle offered the Japanese quality of *sabi*, "the appearance of antiquity, age, hoariness rusticity, natural textures," while the garden offered *wabi*, "the sense of quietness, astringency, good taste, and tranquility."[8]

A visitor came away from Taliesin remarking that it was "a special kind of oasis, in which the raw and hostile forces of surrounding life had somehow been reorganized into a landscape of blessed peace and plenty."[9]

THE SCENT OF TALIESIN

Wright's sister Maginel Wright Enright, a well-known illustrator of children's books, came to visit her brother at Taliesin I after she was married. She later recorded her impressions of the house in her memoir *The Valley of the God-Almighty Joneses*.

"Taliesin is full of surprises; full of delights," she writes. "There is no other house on earth quite like it. It has its own smell. Set down in it by magic with my eyes closed I would know I was there by breathing the scent of wood smoke, dried pennyroyal, pearly everlasting, and the faint elusive fragrance that emanates from oriental objets d'art. But it can't really be described."

"The first incarnation was marvelous enough. I was bowled over, and I went home, full of enthusiasm, to tell Pat [her husband] and my friends about it, never dreaming that I would return so soon; sooner than I ever imagined I would, with all the joy gone, and only desolation in its place."[10]

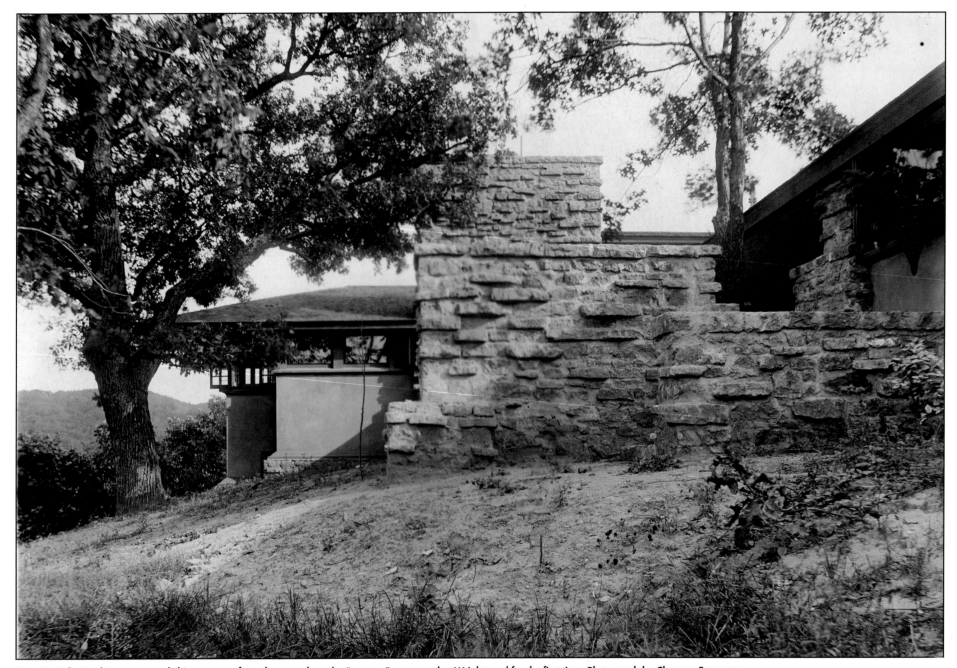

Fig. 158. Taliesin's living room and chimney, seen from the east, show the "pop-out" masonry that Wright used for the first time. Photograph by Clarence Fuermann.

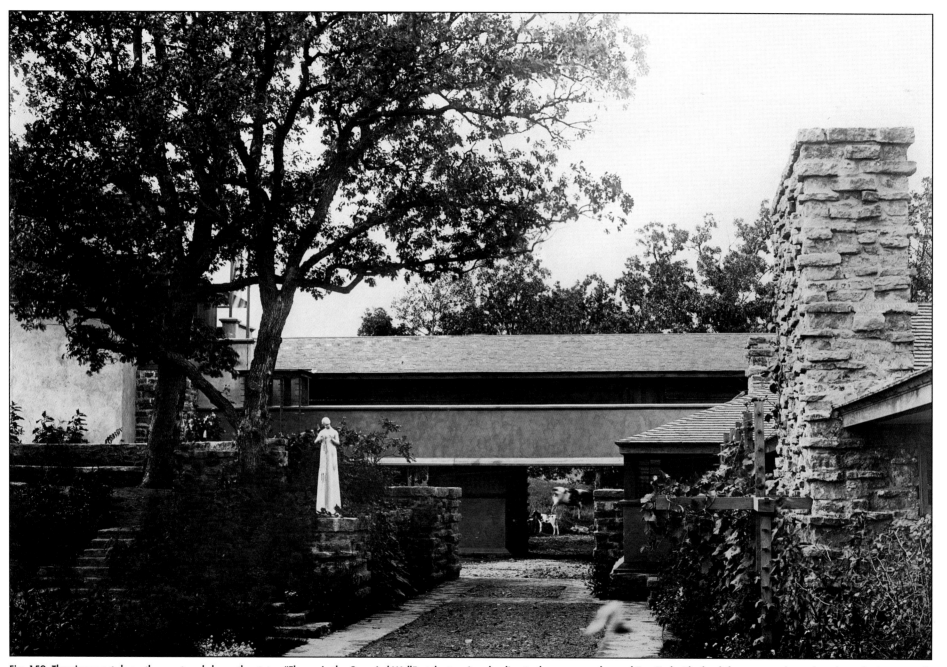

Fig. 159. The view west down the courtyard shows the statue "Flower in the Crannied Wall" at the terminus leading to the upper garden and Tea Circle. The hayloft crosses at the end, and a Holstein cow and calf can be seen through the lower passageway. Photograph by Clarence Fuermann.

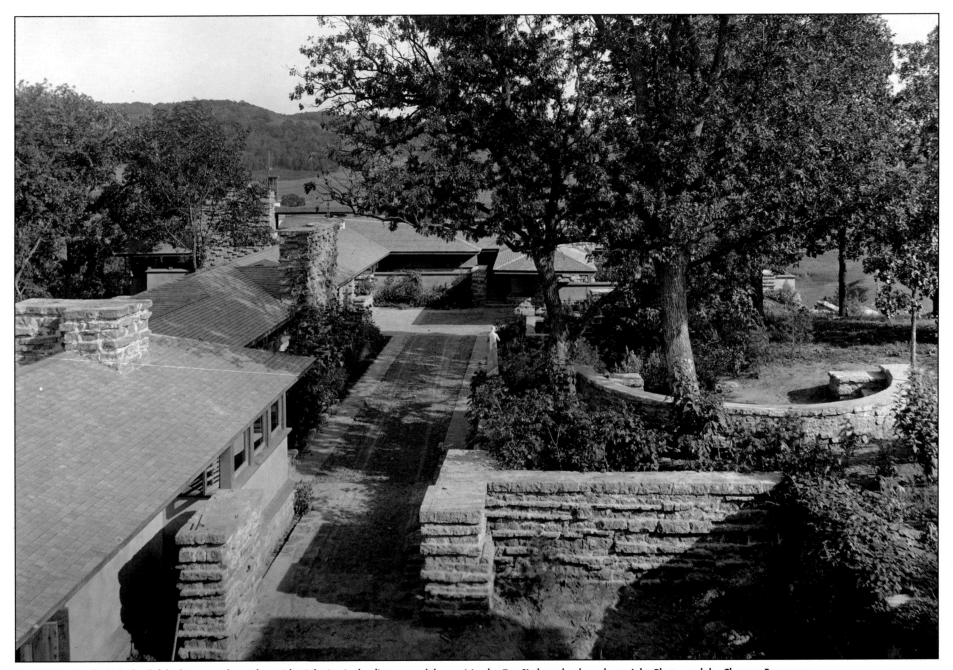

Fig. 160. A view from the hayloft looking east shows the residential wing in the distance and the semicircular Tea Circle under the oaks at right. Photograph by Clarence Fuermann.

Fig. 164. Taliesin is a smoking ruin in the aftermath of the fire and mass murder. The roof of the porte-cochere has crashed to the ground. Frank Lloyd Wright may be standing with arms folded at left, next to a seated woman. If the photo was taken on the day of the fire, Wright may not yet have arrived from Chicago and the couple could be Andrew and Jane Porter. A man sits in the breezeway with a rifle across his lap. A bearded man who could be Jenkin or Enos Lloyd Jones stands at the center, talking with other men.

Fig. 163. A close-up detail of Fig. 162 shows the children more clearly. Martha Cheney was 6 in 1912 and John was 9. They both were killed on August 15, 1914, at ages 8 and 11.

Fig. 162. A view of the courtyard from the Tea Circle shows a pond and, under the porte cochere, two children and a horse. This was taken in the late summer of 1912 when the children of Mamah and Edwin Cheney, John and Martha, were visiting. Photograph by Clarence Fuermann.

Fig. 161. The breezeway, or loggia, separates the residential wing at right from the studio wing at left. The slab in front of the studio is the same one Clifford Evans is standing on in Fig. 51.

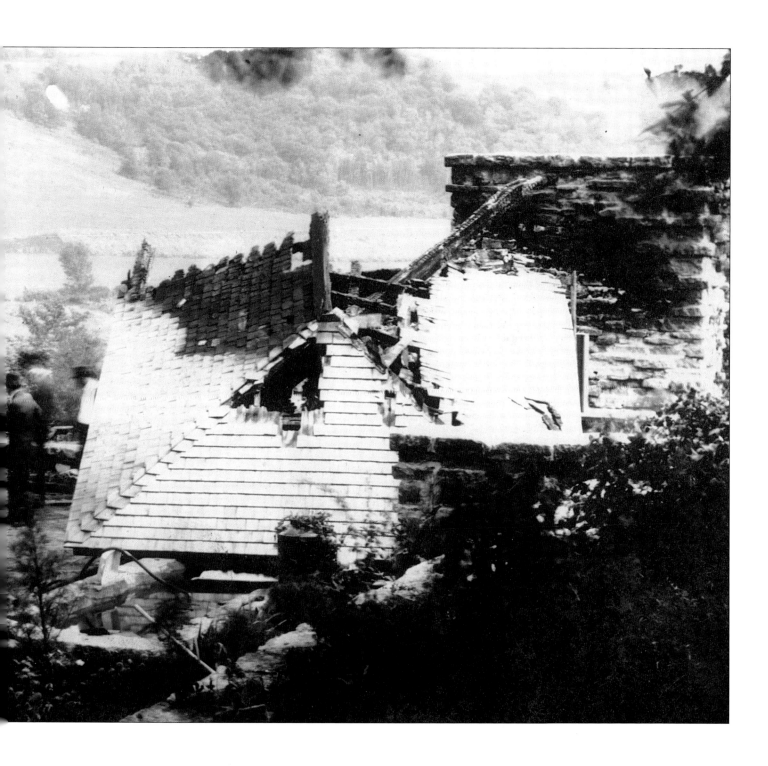

THE DAY OF DESTRUCTION

Saturday, August 15, 1914, should have been a day of national celebration. It was the opening day of the Panama Canal, the largest public works project since the Pyramids. But the opening ceremony in Panama City was subdued, with no ranking dignitaries attending. That was because 10 days earlier the "guns of August" had sounded and Europe was plunging into war.

"The children want to go home. She will not tattle, or tell them what grown-ups say about their mother. It is not that they are different, only rich."

—Edna Meudt, on John and Martha Cheney, 1914

In Jones Valley, Unitarians and Progressives were gathering at Tower Hill for the big end-of-summer event, the 33rd annual Grove Meeting. On Sunday there would be uplifting speeches, lectures, readings, music, and picnics for a large crowd. Rev. Jenkin Lloyd Jones would deliver one of his most popular sermons, "The Gates of the Future Stand Wide Open."

Saturday was a warm day. It was threshing time. Eight-year-old Kristin Kritz rode her mare, Beauty, toward Taliesin, her legs sticking straight out on the horse's "balloon-wide" back. She was going to invite her summer friends, John and Martha Cheney, city kids, to come to her family's farm three miles away to watch the threshers work.[11]

John, 11, and Martha, 8, Mamah Borthwick's children from Oak Park, did not have many playmates, so Kristin's father, John Kritz, who had worked on a Lloyd Jones uncle's farm with Frank Lloyd Wright as a boy and had served as a coachman for Hillside Home School, urged his daughter to make friends. "Are not the children innocent?" he said to any who criticized.

In an eyewitness memoir written as a poem by the adult Edna Meudt, Kristin (her name as a child) says Martha and John did not like Taliesin, and neither did she. The scents and sights that made the house magical to Wright's sister Maginel

made it seem sinister to Kristin. She describes its "strangeness": "Incense; on the floors creamy bears with no insides; birds that talk back; shadowy flowers she never knew; wall-hangings to be put out of her country mind. Windows too high for her seeing out are hung with boughs."

"The children want to go home," she says. "She will not tattle, or tell them what grown-ups say about their mother. It is not that they are different, only rich." This is the only intimate description written of John and Martha Cheney.

As Kristin neared Taliesin, the horse sensed something wrong. Kristin saw a little smoke, then a black plume appear above the buildings. Kristin heard shouts and screams. Terrified, she climbed off Beauty and into a tree where she and Martha had played with dolls. There she sat paralyzed with fear, saying the "Hail Mary" over and over—until she apparently passed out.

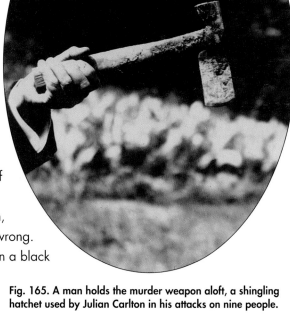

Fig. 165. A man holds the murder weapon aloft, a shingling hatchet used by Julian Carlton in his attacks on nine people.

THE SURPRISE ATTACK

Julian Carlton staged his surprise attack on Taliesin with commando-like tactical planning. He waited until the noon hour, after everyone was seated at opposite ends of the house. He served them lunch. Everyone who could put up a fight was grouped, accounted for, and off guard.[12]

Carlton, a small man of about 31 who came for the summer with his young wife, Gertrude, to serve as chef and maid, attacked the woman and children first. He went after Mamah and the children on the porch off the living room, savagely killing Mamah with one blow to the skull from a long-handled shingling hatchet. He attacked and killed 11-year-old John in his chair. Martha ran, but he caught up with her and bludgeoned her; she died in the courtyard. He splashed the bodies with gasoline and set them afire; afterward only a few charred remains of John were found, not enough to provide a death certificate.

"The first person to reach Mamah Borthwick was Wright's brother-in-law Andrew Porter," says Meryle Secrest. "He found her body ablaze and thought it had been saturated with gasoline. Her corpse was badly burned and her hair almost completely burned off. It was 12:45 p.m."[13]

Fire, an accelerant, and surprise gave Carlton the power of many when he took on the men. He poured gasoline under the door of the dining room at the far end of the residence, where five men and a 13-year-old boy were seated. Draftsman Herbert Fritz, one of two survivors, remembered a bubbly liquid coming under the door. Then the room leapt into flame. Fritz crashed through a window, breaking his arm. He saw Carlton kill Emil Brodelle, the draftsman with the talent for the bird's-eye view.

As the others rushed through the door to escape the flames, Carlton was waiting with his hatchet. He attacked Wright's trusted foreman, William Weston, and

> *"The first person to reach Mamah Borthwick was Wright's brother-in-law Andrew Porter. He found her body ablaze and thought it had been saturated with gasoline. It was 12:45."*
>
> —Meryle Secrest

his 13-year-old-son, Ernest. Ernest died hours later and his father was knocked down but struggled to his feet and escaped. Carlton attacked 65-year-old Thomas Brunker, a laborer from Ridgeway with 10 children, and David Lindblom, 38, a gardener. Both of them survived the day but later died of burns and injuries.

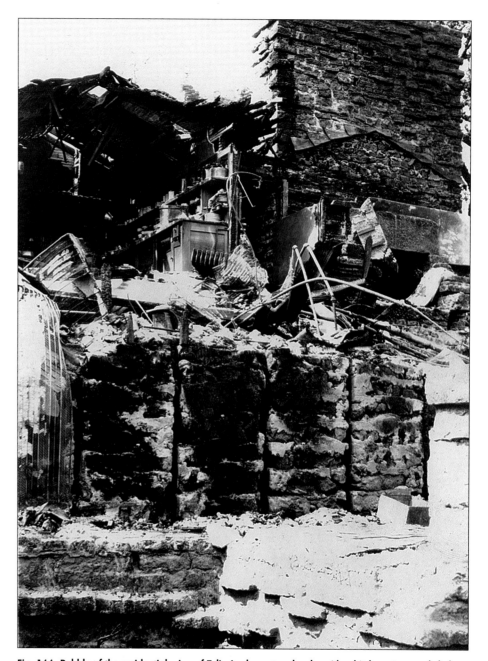

Fig. 166. Rubble of the residential wing of Taliesin shows two levels, with a kitchen stove and shelves holding pots and pans in the upper center. The former living room was at right, and its roofline can be seen against the wide fireplace chimney.

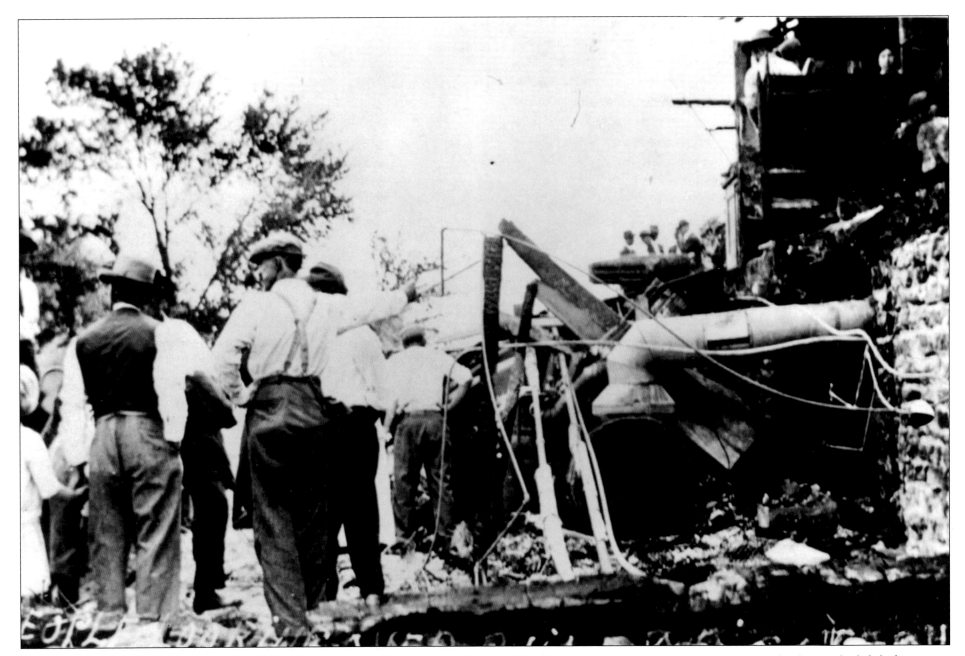

Fig. 167. Men walk through the burned-out residential wing. The man at center with suspenders and a cap is William Weston, who was struck by the attacker but escaped and returned to halt the fire's spread. He lost a 13-year-old son.

Flames quickly spread through the residential wing of the house. Carlton ran to the basement and climbed into the furnace, on the other side of the fireproof wall. He had a small bottle of hydrochloric acid in his shirt pocket—a suicide fallback. He swallowed it when he could stand the heat no longer and was discovered. It did not kill him immediately; he lived for 47 days.

Weston and Lindblom ran for help to a neighboring farm. Weston returned and turned a garden hose on the flames to keep them from spreading to the studio wing. He had lost his son Ernest, his summer companion with whom he had bicycled four miles to work every day. But he saved "the working half" of Taliesin, as Wright gratefully said in his autobiography.

"In thirty minutes the home and all in it had burned to the stonework or to the ground," he said. "The living half of Taliesin—violently swept down in a madman's nightmare of flame and murder. The working half remained. Will Weston saved that."

Dozens, and then hundreds of people came running to put out the fire and search for Carlton. Jenkin Lloyd Jones and some of the men from Tower Hill formed a posse. After Carlton was pulled from the furnace by Sheriff John Williams there was a brief stand-off with angry men who wanted to lynch him. Williams and his deputies got Carlton safely to the Dodgeville jail.

Wright had left Taliesin on Tuesday evening and had spent the days since then putting finishing touches to Midway Gardens with his son John. He had painted

Kristin's parents led her into the courtyard to show everyone that she was safe. She walked past bodies, "covered shapes like statues in Lent fallen over." She walked past Martha.

over murals that he disliked and was creating his own. "Thirty-six hours earlier I had left, leaving all at Taliesin living, friendly, and happy. Now a blow had fallen like a lightning stroke," he wrote.

Kristin's frantic parents found her horse and lifted her out of the tree. They led her into the courtyard to show everyone that she was safe. She walked past bod-

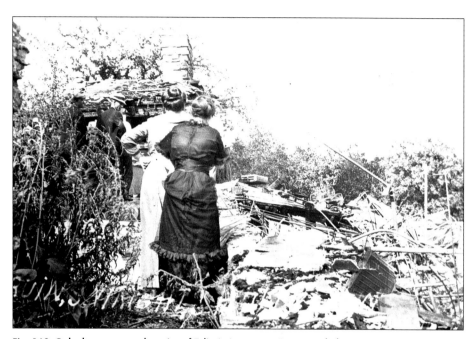

Fig. 168. Onlookers gape at the ruins of Taliesin in a souvenir postcard photo. Two women are in the foreground. Several men can be seen over the elbow of the woman on the left. One of the men wears a hat with a brim.

ies, "covered shapes like statues in Lent fallen over." She walked past Martha.

In the evening Kristin's father took her to meet the train carrying Wright, his son John, and Edwin Cheney. Back at Taliesin, she witnessed a pitiful sight: "One man watching with folded arms while another weeps over rubble, raking with blackened fingers in trickling smoke for bones eleven summers young—his son."

Edna Meudt took a hard view of Wright. In an earlier version of her poem she wrote of Wright watching Cheney "with icicle-eyes." Later she softened her views. Taliesin's casualties were transported to Tanyderi, the Porters' house a quarter mile away. Franklin Porter, who was four at the time, remembered "teams of horses rushing up the road from the school and loud shouts as black clouds of smoke rose from Taliesin."

He wrote: "Those who had been burned fighting the fire were brought over to Tanyderi and laid on improvised beds on the porch, right below the room in which I slept. Mingled with the memory of intense excitement of the fire is that of men moaning in the night with pain, and of a whippoorwill singing during

moments of quiet. For ever after the song of a whippoorwill at night at Tanyderi seems infinitely sad."[14]

Dr. Marcus Bossard and Dr. Frank Nee of Spring Green spent the rest of the day and part of the next tending to the suffering. Bossard's bill was $25, plus $10 for David Lindblom. Wright paid it.[15]

THE CARLTONS

Julian and Gertrude Carlton were from Chicago. Both were African American, although Julian claimed to have come from Barbados. They had been recommended to Wright by John Vogelsang Jr., the caterer of Midway Gardens. The Carltons had been servants in his parents' home on the Near North Side. John Vogelsang

> *"The gardener spoke before he died. It was the black devil Julian. No! Kristin thinks, Not the new cook. Julian makes better desserts than anyone else!"*
>
> —Edna Meudt, "A Summer Day That Changed the World"

Sr. was the owner of Vogelsang's Restaurant, a popular dining spot in the Loop. The family residence was on Astor Place near Lake Michigan, not far from where Wright had wanted to build his Goethe Street townhouse.

The Carltons had arrived at Taliesin in June. Julian Carlton had struck Wright as competent, agreeable, and "well-educated for a member of his class." Wright's sister Jane Porter had found Julian to be "mild-mannered" and could not believe that he had been the killer. It also surprised Kristin. She overheard a bystander say, "The gardener spoke before he died. It was the black devil Julian." "No! Kristin thinks, Not the new cook. Julian makes better desserts than anyone else!"

Despite his geniality Julian Carlton had a volatile, troubled side that grew into agitation and then full-blown paranoia in the days preceding the rampage. His wife, Gertrude, said Carlton wanted to get out of Wisconsin and back to the city. She told authorities that Julian had ordered her to give Wright notice, and told her to say it was because she was lonely. The real reason, it appeared, was that he felt the place closing in on him and that he was being persecuted. He started keeping a butcher knife next to the bed and staying up late at night, watching at the window.

Wright had placed want ads for replacement help in the *Wisconsin State Journal* before he left for Chicago; they ran on Wednesday and Thursday, August 12 and 13. Saturday was to have been the Carltons' last day. They were expected to leave on a train for Chicago after lunchtime. Gertrude was wearing her travel clothes and hat when she was found in a nearby field where she had fled, covered with burrs.

Julian had a score to settle before he left. His antagonist was Emil Brodelle, who was 26, five years younger. On Wednesday Brodelle, the draftsman from Milwaukee, had ordered Carlton to saddle his horse. Carlton refused; he was a house servant, not a farmhand, and Brodelle was not his employer. Brodelle cursed him and called him "a black son-of-a-bitch." Carlton told a doctor in the jail that there had been a second confrontation on Friday morning with Brodelle, and that Brodelle had struck him. The motive was revenge.

But why attack everyone? Why take on nine people at once and burn down Taliesin? Carlton told the doctor that he had planned to escape and had stashed a change of clothes in the woods. If the intent was to destroy all the witnesses and evidence of a crime, then Taliesin and its occupants were collateral damage. It was cunning and well-planned—and completely insane.

Thirty minutes of insanity brought an end to Taliesin in its original vision. It ended the life of Mamah Borthwick, "she for whom Taliesin had first taken form." It was the end of the story of Mamah Borthwick and Frank Lloyd Wright.

IN THE AFTERMATH

Joseph Lins owned a hardware store, a furniture store, and a funeral parlor in Spring Green, a common combination. The ledger for Lins & Hood includes these entries for August, 1914:[16]

Frank Wright

Embalm Mamah Borthwick	12.00
Box and trips	8.00

E.H. Cheney

Casket	50.00
Embalming	10.00
Trip to train	5.00

Tom Brunker

Casket	65.00
Hearse	10.00
Embalming	10.00
Shroud and clothing	4.75
Trip to Ridgeway	5.00

Frank Wright for David Lindblom

Casket	40.00
Embalming	10.00
Hearse	10.00
Shroud	4.00
Preacher	4.00

Edwin Cheney left by train on Sunday, August 16, carrying the remains of his children. As evening approached, Wright cut down Mamah's garden, "the flowers that had grown and bloomed for her," and placed them in a plain pine box. His son John helped him lift the body into it. They closed the lid. The coffin was placed on "our little spring-wagon," the wagon that Wright and Mamah had ridden in together. It was draped with more flowers and hitched to two horses, Darby and Joan.

Fig. 169. Mamah Borthwick's cause of death is listed as "Killed by a negro." Her personal data is attested to by Andrew Porter, Wright's brother-in-law.

Fig. 170. Mamah Borthwick's daughter Martha Cheney, was 8, not 10 as listed. Her cause of death is listed as "Killed by a negro."

"Since Taliesin was first built the faithful little sorrel team had drawn us along the Valley roads and over the hills, in spring, summer, autumn, and winter, almost daily," Wright said. Now, walking beside the wagon, he drove the team to the Unity Chapel churchyard, with John following behind. They were met by two young cousins, Ralph and Orrin Lloyd Jones, who assisted at the gravesite.

> *"I asked them to leave me there alone.*
> *I wanted to fill the grave myself."*
>
> —Frank Lloyd Wright

"Then I asked them to leave me there alone. I wanted to fill the grave myself. The August sun was setting on the familiar range of hills . . . then—darkness. I filled the grave—in darkness—in the dark."

There was no grave marker.

"All I had to show for the struggle for freedom of the past five years that had swept most of my former life away"—Taliesin and Mamah, his home and his love—"had now been swept away. Why mark the spot where desolation ended and began?"

Fig. 171. Ernest Weston, William Weston's 13-year-old son, a gardener, was "murdered by a blow on head and burned," dying after eight hours. He and his father had bicycled together four miles to Taliesin each day during the summer.

Fig. 172. Emil Brodelle, 26, was the main target of Julian Carlton after tangling with him twice. The Milwaukee draftsman, who was engaged to be married, drew the bird's-eye perspectives of the Imperial Hotel and Midway Gardens for Wright.

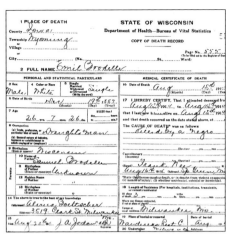

Fig. 173. David Lindblom, 38, was a gardener. He died after suffering for three days from "burns on body and head and blow on skull." Wright paid for the burial expenses of the young Dane and laid him in the Unity Chapel family cemetery.

Fig. 174. Thomas Brunker, the oldest victim, almost 66, was a laborer from nearby Ridgeway. He died three days after suffering "a fracture of skull caused by a hatchet in hands of a negro" and severe leg burns. He left 10 children.

WRIGHT SHOWS UP

Borthwick had no funeral—another sign of Wright's wantonness, some newspapers said—but his workmen did. Wright attended them, and paid the burial expenses for some.[17]

He also showed up for the county fair. The dedication of the Women's Building was scheduled for September 2, opening day. But there was a question: "We

> *"We have been asked many times if Mr. Frank Lloyd Wright will now make an exhibit of his Japanese art products. He says that he will."*
>
> —*Spring Green Home News*, August 27, 1914

have been asked many times if Mr. Frank Lloyd Wright will now make an exhibit of his Japanese art products," as he had promised.

The answer: "He says that he will. He does so gratuitously."

The headline promised visitors "Antiques from Scene of Tragedy." "Frank

Lloyd Wright, the Chicago architect, has consented to place on exhibition his wonderful collection of oriental art products from his bungalow where seven persons were killed recently," the story said.

"This is perhaps the most complete collection of its kind in the United States. There will be models of Japanese temples, rare antique brocades of various periods, samples of antique Chinese pottery, ancient Korean pottery, and various other articles. Mr. Wright has made three [sic] trips to the Orient to procure these articles and the duty on the last consignment was $3,000."[18]

On September 7, a week after the county fair, Wright hosted the annual picnic of Sauk County's rural mail carriers on the Taliesin grounds. "We are told that this was one of the most successful and enjoyable meetings the assembly has held," the *Home News* said.

JENSEN STANDS UP

The nursery that had sent Wright all the fruit trees and bushes in 1911 still had not been paid. Ellwanger & Barry sent a letter to Jens Jensen on August 19 asking him to intervene. They picked the wrong time and the wrong Dane.

Fig. 175. Julian Carlton's death certificate gives his age as 31 and his place of birth as "Alabama?" He said he was from Barbados. The cause of death on October 7, 1914, was "Starvation—suicide following attempt at suicide by hydrochloric acid." Iowa County Sheriff John T. Williams attested to the information.

"I presume you are aware of the fate that met his home a week ago," Jensen replied. "I am surprised that you would send your letter at this time. I don't know of anything more brutal that has happened in the history of America than what happened to Mr. Wright's family Sunday [sic] a week ago, and I would have pity for my worst enemy if he had suffered what Frank Lloyd Wright has had to suffer. . . .

"I shall be glad to take this matter up with him, but you must pardon me when I say that I cannot do it now as he has my sincere sympathy in his great sorrow and economic loss."[19]

WASMUTH PORTFOLIOS DESTROYED

Wright's Japanese prints except for those in the house were spared because he kept them in a vault in the studio wing of Taliesin. Others were stored at his

NEGRO SLAYER SUCCEEDS IN STARVING SELF

Julian Carlton, the negro chef who killed Mrs. Mamah Borthwick and her two children, John and Martha Cheney, Emil Brodelle, Ernest Weston, Thomas Brunker, David Lindblom and seriously injured William Weston and Herbert Fritz and set fire to the Frank Lloyd Wright bungalow at Hillside while the occupants of the building were partaking of their noonday meal, died at the county jail in this city at about one o'clock Wednesday afternoon. The cause of death was from the effects of acid poisoning which the negro drank before being captured in the furnace of the Wright bungalow and from starvation, more particularly the latter. Ever since Carlton has been confined in the jail here he has refused to eat for long periods and again he would eat good meals, but he would keep himself in a weakened condition and he gradually wasted away. When he was first brought to this city he weighed in the neighborhood of 150 pounds but at the time of death it is doubtful if he would weigh more than 90 pounds. A full story of the tragedy has been printed in the Chronicle in former issues.

Carlton, according to Sheriff Williams, several times during the last two weeks, said he killed the Milwaukee draftsman, but did not seem to remember the killing of the other six persons.

The negro has been dying for three days. The sheriff told him so, and asked him to make an ante-mortem statement, but Carlton paid no attention. Persisting in the attempt to get some information, Sheriff Williams asked Carlton whether he killed Brodelle because he was angry with him, whereupon the negro said:

"I guess you solved the question." Carlton also informed the sheriff that he was not married to Gertrude Carlton. He had been living with her for two years in Chicago.

After Carlton had been taken into custody, following the tragedy, he feigned insanity. A preliminary hearing was held before Justice T. H. Arthur and Carlton was bound over to the circuit court without bail.

Last week he was brought before Judge Clementson. He was carried into court by two deputies and laid on a stretcher. He pretended he was unconscious and could not be made to answer questions put to him by the court. Attorney E. C. Fiedler was appointed by the court to defend him and a plea of not guilty was entered. The case was then adjourned until such time as Carlton might be able to stand trial. His condition was such at that time that Judge Clementson urged Carlton to begin eating in order to get sufficient strength to go through the ordeal of a trial.

The body of Carlton was shipped to the medical department of the state university at Madison for dissection yesterday afternoon.

Fig. 176. The *Dodgeville Chronicle* published the only known photo of Julian Carlton on October 9, 1914, after his death October 7.

Chicago office in Orchestra Hall.

But 500 sets of the two-volume English edition of the Wasmuth Portfolio, which he had hoped to sell, were nearly all destroyed by fire and water. He had stored them in the basement of Taliesin's residential wing.

The books "went up in smoke when Taliesin burned," Wright said later. "Some thirty copies only were saved. The pile in the basement smoldered and smoked for three days after the house had burned to the ground."

Dear Ellen Key,
 Beloved Lady,

[letter text, partially legible]

Taliesin, July 20, 1914.
Spring Green, Wisconsin.

Mamah Borthwick
Bouton

Fig. 177. Ellen Key wrote the words "Nu mördad"—"now murdered"—in Swedish on the first page of Mamah Borthwick's last letter to her, dated July 20, 1914. Below it she drew a cross. The signature, which reverses Borthwick's middle and last names, also is in Key's handwriting.

HILLSIDE HOME SCHOOL SUCCUMBS

Hillside Home School announced that it would open for its 28th year of classes on September 23, but for the first time Nell and Jennie Lloyd Jones, the founders, would not be at the helm.

The new principal was Henry T. Mortensen, a teacher at the Francis W. Parker School in Chicago. "The change in leadership means no change in fundamental educational principle," the *Home News* reported.

But it was no good. The horror at Taliesin was the "fatal blow," the "calam-

ity," that Jenkin Lloyd Jones mistakenly thought Frank and Mamah living at Taliesin would be. Hillside Home School shut down the following year.

Wright would later buy it, convert it to a school of architecture, and place the names of Ellen and Jane Lloyd Jones on the cornerstone.

SIGHTSEERS AND SOUVENIRS

An event like the Taliesin mass murder, accompanied by the destruction of a landmark building, would dominate news cycles for weeks today. But there were no news cycles in 1914. People lived harder, less vicarious lives. Community newspapers were not encouraged to dwell on morbid events. The story, which had received national headlines, dropped from sight locally almost immediately.

The burned-out site at "the bungalow" quickly became a curiosity. "Messrs. Williams, Roy Thomas, John Berryman and Misses Nora Berryman and Ward of Dodgeville were guests at the A.D. Richardson home Sunday," said a social note in the *Home News.* "They also took a trip to the bungalow."

Hathaway's dry-goods store in Spring Green advertised "Fair parade and Wright postcards."[20] The postcards, taken by freelance amateurs and local studio photographers as souvenirs, showed the ghastly scene, the murder weapon, and crowds of onlookers viewing the ruin.[21]

"I don't know of anything more brutal that has happened in the history of America than what happened to Mr. Wright's family . . . I would have pity for my worst enemy if he had suffered what Frank Lloyd Wright has had to suffer."

—Jens Jensen, August 24, 1914

THE TREATMENT OF JULIAN CARLTON

Gertrude Carlton, Julian's wife of two years, was held briefly and then put on a train to Chicago. She had $7 in her pocket and was not heard from again.

Fig. 178. Frank Lloyd Wright told Ellen Key in December 1914 that he would deal with the loss of Mamah Borthwick "as the heart of her would have me, and put the soul of her into the forms that take shape under my hands." He wrote the note on his special red-square stationery. Letter is concluded in Fig. 179.

Julian Carlton arrived at the Iowa County Jail in Dodgeville in bad condition. The acid he had swallowed had burned his esophagus and it was hard for him to take nourishment. Even today it would be a challenge for physicians to save a person so injured. One also might assume that a black man accused of multiple killings would receive harsh treatment in a rural jail.

But Julian Carlton received both medical attention and due process from the medical and legal systems of Iowa County. In some ways he was treated like a celebrity.

He was tended to by at least three physicians, including Dr. William Pearce, the head of the county medical society, but he was not hospitalized. His meals were prepared by the wife of Sheriff John T. Williams, whose family lived in the Cornish-style jail attached to the courthouse.

The night after Carlton was arrested he became violently ill in his cell. After being examined by a physician, who pronounced his condition grave, he was arraigned the next day in the hallway. He was charged with the murder of Brodelle—the one killing directly witnessed—and a not-guilty plea was entered.

At his arraignment in court on August 27, testimony was taken and more charges were added, including the slaying of Mamah Borthwick and the others;

arson; and the assaults upon William Weston and Herbert Fritz "with a dangerous weapon, to-wit: a hatchet." Carlton was ordered to appear at the next sitting of the Circuit Court. That would not be until October 1, more than a month away. In the meantime he languished, while curiosity-seeking crowds pressed to get a glimpse of him. Sheriff Williams put an immediate stop to it on August 17, banning anyone from the jail who did not have business.

Ernest Wittwer was four when his father took him to the Dodgeville jail to catch a glimpse of the notorious killer. "He held me up so I could see him through the window," he told an interviewer 84 years later. "I had never seen a black man before. I never felt the same about black people after that."[22]

Judge George Clementson, the circuit-riding jurist from Lancaster, who was known to avoid contact with lawyers even at lunch, eating only with his court reporter Edward Morse, emerged as a man of unusual character. On the morning of October 1 he ordered Carlton examined by two physicians to assess his condition. They said he could appear, but he was carried in on a stretcher and seemed semiconscious. The observers in the jury box were a who's who of local eminences, including both the current and former Iowa County representatives in the State Assembly.

Clementson read the charge against Carlton, then said, "Yesterday I was informed that the defendant had no attorney and had no means to employ one. I appointed Mr. E.C. Fiedler as his attorney in the case."[23] Ernest Fiedler, of Mineral Point, argued that Carlton could not survive a full trial and "it would look better and be creditable to our American court procedure if a short postponement were to be had." He did not have to add: "and nature were allowed to take its course."

William Drennan documents that Judge Clementson had orchestrated this outcome that morning, after he visited Carlton in his cell at the prisoner's request—a highly unusual move. "I was informed that the defendant wanted to speak with me," Clementson said in a statement read into the record. "He did not say anything to me while others were present, but when all had withdrawn, he then talked with me."

The judge continued: "When he thoroughly understood what I was saying to him and I put the question to him whether his plea would be guilty or not guilty and explained how he might be benefited by a certain plea in the case in his now physical condition, he told me that he would plead 'not guilty.' So let that plea be entered."[24]

Clementson must have explained to Carlton that if he pleaded guilty, he would be sent directly to the state's maximum security prison at Waupun, and die there. The alternative was to plead not guilty, remain in the Iowa County Jail, and die in the care of the sheriff's family. As a practical matter it was compassionate counsel. The acid was Carlton's punishment and he had administered it to himself. The jail was his hospice. But the judge had taken matters into his own hands. Carlton was not offered an insanity defense, which was available at the time.

He died in his cell

Fig. 179. Wright's letter (from Fig. 178) concludes.

six days later. The cause of death was listed as starvation. He weighed only 90 pounds and had lingered for 47 days. His remains were shipped without embalming to the University of Wisconsin at Madison, where they were dissected, examined, burned in a cadaver incinerator, and deposited somewhere on the campus grounds.

FRANK LLOYD WRIGHT, SURVIVOR

In the days after the killings and fire, Wright retreated to the draftsmen's parlor and bunkroom in the studio wing. "The following week there was no one on the hill at night but myself and the watchman who sat on the steps to the court with a gun across his knees," he wrote.

"Those nights in the little back room were black, filled with strange, unreasoning terrors. No moon seemed to shine. No stars in the sky. No frog-song from the pond below. Strange, unnatural silence, the smoke still rising from certain portions of the ruin. . . . The gaping hole left by fire in the beautiful hillside was no less empty, charred and ugly in my own life."

Strangest of all, there was no Mamah.

"Strange! Instead of feeling that she whose life had joined mine there at Taliesin was a spirit near, that too was utterly gone. . . . Totally—Mamah was gone. . . . Gone into this blackness of oblivion for several years to come was all sense of her whom I had loved as having really lived at all."

"We lived—richly. She was taken—suddenly ... just as we were beginning to feel that the bitter struggle was giving way to the quiet assurance of peace and the place we coveted together."

—Frank Lloyd Wright to Ellen Key, December 8, 1914

Wright's prodigious instinct for self-preservation had kicked in. He literally could not allow himself to think of her. "I could see forward but I could not see backward," he said. "Until many years after, to turn my thought backward to what had transpired in the life Mamah and I lived together at Taliesin was like trying to see into a dark room in which terror lurked, strange shadows moved, and I would be well to turn away."[25]

Wright's sister Maginel returned from the East. She could see that her brother had been numbed by the trauma, and had "set about directing the restoration of the burned house as automatically as a machine. But then the numbness wore off and the pain came." He developed boils, insomnia, and temporary blindness. He lost weight.

Their therapy was to ride together on horseback. "He wanted to ride, and so we rode by the hour," his sister said, "farther than we would have ridden in a happier time: over Pleasant Ridge, to Blue Mound, and on and on. He would stop the horses on a hill and stare down into the Valley, with its cloud shadows. Then he would talk."[26]

After recovering enough to do his duties—to attend funerals, arrange for the county fair art show, and publish an open

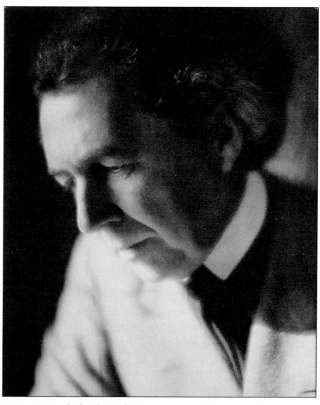

Fig. 180. Frank Lloyd Wright in an early reflective portrait.

letter "To My Neighbors" in the weekly *Home News*—Wright left for Chicago. He kept a small apartment at 25 Cedar Street, in Old Town, and now moved there.

He refused all company, including his mother's. He needed to get away from family, get away from the Valley, get away from the curious. He needed to be invisible. "Strange faces were best, and I walked among them," he said.

He had a basic decision to make—an existential decision. On December 8, he revealed what it was in a letter to Mamah's former life coach, Ellen Key, in Sweden. He told her that, faced with the choice between action and surrender to despair, he had decided to live "as the heart of her would have me" and "put the soul of her into the forms that take shape under my hands." Her life would live in his architecture.

"Your kind words of Mamah are like balm to my heart," Wright replied to Key's letter of condolence.

"There is nothing to say. The lightning struck us—why, no one can say. All that remains is to keep it from sinking me so deep that my usefulness will be gone. Or, rather, to take it as the heart of her would have me and put the soul of her into the forms that take shape under my hands.

"We lived—richly. She was taken—suddenly—without warning or pain to her, I am sure, just as we were beginning to feel that the bitter struggle was giving way to the quiet assurance of peace and the place we coveted *together*.

"I hope that I can see you some time and we can talk of her. You have been a strength and comfort to us both and we have blessed you often.

"With love and regard

"faithfully yours,

"Frank Lloyd Wright"[27]

NOTES

1. "Wright Case Agitation," *Dodgeville Chronicle*, January 5, 1912. The story is unbylined but it was customary for editors of country weeklies to write the main stories.
2. Jens Jensen to Ellwanger & Barry, April 27, 1912. Ellwanger & Barry archive, Department of Rare Books and Special Collections, University of Rochester Library.
3. Jerry Minnich e-mail to author, October 4, 2010.
4. Andrea Reithmayr e-mail to author, May 18, 2011, Rush Rhees Library, University of Rochester.
5. Jerry Minnich e-mail to author, March 22, 2011.
6. Charles E. Aguar and Berdeana Aguar, *Wrightscapes: Frank Lloyd Wright's Landscape Designs* (New York: McGraw-Hill, 2001), 326, n. 286.
7. Ibid., 157.
8. David H. Engel, *Japanese Gardens for Today* (Tuttle, 1959), quoted in Aguar and Aguar, *Wrightscapes*, 160.
9. Robert C. Twombly, *Frank Lloyd Wright: His Life and His Architecture* (New York: John Wiley & Sons, 1979), 389.
10. Maginel Wright (Enright) Barney, *The Valley of the God-Almighty Joneses* (Spring Green, WI: Unity Chapel Publications, 1986), 145.
11. Edna Meudt, "A Summer Day That Changed the World," in *The Rose Jar: The Autobiography of Edna Meudt* (Madison: North Country Press, 1990), 174–178. All the quoted and descriptive material is from this documentary poem. Kristin Kritz changed her first name to Edna after being baptized as an adult, and her last name to Meudt after being married. She is called Kristin here throughout because Edna Meudt tells the story through the young girl who was Kristin.
12. Sources for this narrative include "Awful Crime in Wisconsin Cottage," *Chicago Sunday Tribune*, August 16, 1914; "Negro Murderer of Seven," Spring Green *Weekly Home News*, August 20, 1914; Ron McCrea, "The Murders at Taliesin," *Capital Times*, August 15, 1998 (N.B.: the name Carlton is misspelled Carleton in my account); William Drennan, *Death in a Prairie House: Frank Lloyd Wright and the Taliesin Murders* (Madison: University of Wisconsin Press, 2007); Meryle Secrest, *Frank Lloyd Wright: A Biography* (New York: Alfred A. Knopf, 1992), 216–222; and Frank Lloyd Wright, *An Autobiography*, in Bruce Brooks Pfeiffer, ed., *Frank Lloyd Wright: Collected Writings*, (New York: Rizzoli, 1992), vol. 2, 239–240.
13. Secrest, *Frank Lloyd Wright*, 220.
14. Ibid., 222.
15. Journal of Dr. Marcus Bossard, Marcus Bossard collection of papers, Wisconsin Historical Society. Bossard, after whom the Spring Green library originally was named, published a memoir of his years as a small-town doctor. There is no word in it about the Taliesin mass murder.
16. Reprinted in Frances Nemtin, *Web of Life* (Spring Green, WI: Self-published, 2001), 34.
17. "Hillside Notes," *Home News*, August 27, 1914.
18. "Wright Collection at Fair," *Spring Green Home News*, August 27, 1914. Zona Gale was also curious. "I have seen nowhere reference to the Japanese prints of Mr. Wright's," she wrote to Jane Porter after the fire. "I want so much to know if they were saved, since a part of the studio is safe." Jane Porter scrapbook, Frank Lloyd Foundation Archives, courtesy of Keiran Murphy.
19. Jens Jensen to Ellwanger & Barry, August 24, 1914, Ellwanger & Barry archive, Department of Rare Books and Special Collections, University of Rochester Library.
20. The social note and the ad are from the *Spring Green Home News*, August 27, 1914.
21. A large selection of these cards appears in Randolph C. Henning, *Frank Lloyd Wright's Taliesin: Illustrated by Vintage Postcards* (Madison: University of Wisconsin Press, 2011).
22. Ernest Wittwer Sr. interview with Ron McCrea, 1998.
23. Fiedler's son John became a judge in the same courtroom. His grandson Patrick was a Dane County Circuit Court judge in Madison. retiring in 2011. The author is grateful to attorney William Francis Nelson of Madison for his insights into the court proceeding.
24. Drennan, *Death in a Prairie House*, 147-148.
25. Wright, *An Autobiography*, 240.
26. Barney, *The Valley*, 146.
27. Frank Lloyd Wright to Ellen Key, December 8, 1914. Ellen Key Archives, Royal Library of Sweden.

A Summer Day That Changed the World

BY EDNA MEUDT

All the way down the valley the house where Kristin
is going to visit can be seen. Over hills
from home she knows it well—but last night in her dream
it changed to a quarry where skeletons were found.

The mare, Beauty, sun-bleached, often sun-blind and heavesy,
is dependable and their only riding horse.
Balloon-wide to sit astride her little girl legs
stick out like seal flippers, are wobbly afterward.
It is better than walking three miles to the house
built onto the hill. She thinks about the strangeness:
Incense, on the floors creamy bears with no insides,
birds that talk back, shadowy flowers she never knew,
wall-hangings to be put out of her country mind.
Windows too high for her seeing out are hung with boughs
—They say its name, Taliesin, means Shining Brow.
She does not like the place. But neither do Martha
and John who vacation here a month each summer.
The children want to go home. She will not tattle,
or tell them what grown-ups say about their mother.
It is not that they are different, only rich,
so she wears her nearly best clothes. When told
she should not visit there because of "Goings-on"
her father asked, "Are not the children innocent?"
They seldom had company, and Kristen knew why
she had been invited: When her father was young
he worked for maiden aunts who ran Hillside Home School.
Autumns, winters, springs he drove open-span Morgans
back/forth to town for students farmed from city homes.
The school is closed and scary now. It is summer.
Saturday, our Lady's Assumption in August.
Church again tomorrow. Oxeye daisies suggest
picking for the altar, gophers run a rickrack
across dusty roads. Their pretty valley dozes
that near-noon hour. Beside the buildings grain is stacked

ready for threshing, binders put away in sheds.
Full of happy news and hurry-up she urges
Beauty on with a slap, remembering too late
the collar sore. But joy sustains: She is to ask
the children to her place for watching the thresher work.
Despite coaxing Get-aps! The mare stops, head lifted, nosing air.

Smoke out front? No more than from a stove
at first but soon the whole hill wears a ruffled cap
of smoke. A scream! Others—men voices—children cries—sounds
running together like the wildness of night winds.
She slides to the ground and crawls toward Willow Walk,
Then climbs between the triple trunks of a gnarled one
Where once she and Martha had played house with their dolls.
Smoke coming nearer now—hoarsened voices—Quiet!
Is this still dreaming—bones in the quarry turned black?
Kristin looks at her trembling hands, begins to cry,
prays: "Hail Mary, full of grace! The Lord is with thee . . .
over and over again: "The Lord is with me."
It is bad to be nearly nine and so afraid,
fire on the hill, screaming less, the children quiet—She did not come for
this Thing—whatever it is—
an unknown that is sensed all around the willows,
troubling and as secret as reasons the house is strange.
"The lord is with me . . . The Lord is with me . . . The Lord

They have found Beauty. She hears them calling, "Kristin! Kristeeen!"
The tree holds her up but no answer comes,
father-arms lifting her from darkness she fights, breath-taste
like fresh blood as from running too fast. No more tears.

They climb the stone stairs to tell people she is safe,
cross the court past covered shapes like statues in Lent
fallen over. One that is half under towels,
hair burned and lashes from eyes that beg: Stay with me!
Please don't go! The lips move to form her name: "Kristin—"
She is mute yet sees on the blackboard of her mind
the lie: THAT IS NOT MARTHA—even as she knows
the September-sapphires ring on the swollen hand.

She moves ahead of her father, drawing him on,
aware of other men in sooty, bloody clothes,
their faces sweat-striped masks barely recognizable.

Mother is having a spell. Neighbors rub her wrists,
wipe her face. Kristin can smell the digitalis,
sweat from hot arms around them, the stranger's breath.
Not for such attention to lessen their fears
has she come so far to what is best learned alone—though
foreshadowed when crossing the River in flood,
seeing whirlpools and undertow that take lives,
wild reflections of the sky. At such times her inside-voices
clearly repeated AVES she could not
for heartbeats flipflapping like trout out of water.

More people come to look to judge. Kristin listens:
"The gardener spoke before he died. It was the black
devil Julian." No! Kristin thinks, Not the new cook.
Julian makes better desserts than anyone else!
But who would care? "This was bound to happen!" they say,
and "The wages of sin!" and then "The will of God!"
are like two strings for their beady words. "Be watchful
children," they warn, "Don't go near the walls or ledges."
Don't and Do: "Don't get dirty! Do stay in plain view"
So they play Racetrack, and Trains on the concrete steps
that lead into the cold furnace—all but Kristin
who sits cross-legged to keep her knees from shaking,
and watches a spot under the rubble where smoke
rises as if a teakettle were boiling in there.
This day has erased the dream she tries to recall—but
afterwards remembered when John is not found.
Anxious to leave with her father for the depot
they meet a train that brings two men sharing sorrow;
One whose love-house it was. One whose children they were.
Up those steps again in deep shadows of late dusk,
Changed as summer and the valley, changed as Kristin
Leaving the last sheltered season of innocence.

(O generations!—Whatever it is we are—
never the same after some ruined hill is climbed
and we meet face to face the Thing that makes it Was.)
Reality goes into a created well,
a darkness for those unfamiliar names of sins,
hatchet truth in the hands of a servant gone berserk.
She does relive that longest night after the fire
when a posse tramped the bypaths, their howling hounds
blood-calling WHOO AWHOO AWHAOOO along the creek
and into a stone quarry that opens the caves.
Sickish again hearing them, all the HAIL MARYS
stick between the pages of her tongue and palate
until sleepiness crowds her like the mare against
a barn stall when not in the mood to be ridden.
Then there is Julian, liver-colored and crouched
on all fours in that furnace, and his teeth are like
unbaked ladyfingers. Kristin wakes dry retching,
afraid to move in the big bed upstairs alone,
till she hears whippoorwills and knows she has dreamed.
Into the well goes singed bearskin rugs, gutted rooms
with shapes beneath blankets and smells best forgotten,
parts to be hidden away—some for years and years.
But when nocturnal creatures converse in the woods
and she is thoughtful, snatches return unbidden:
One man watching with folded arms while another
weeps over rubble, raking with blackened fingers
in trickling smoke for bones eleven summers young—
his son—and the scarlet shame burning her back
forever turned away from eyes that begged—
eyes bluer fire than birthstone sapphire.

Fig. 181. Kristin Kritz with her parents, John and Kristine Kritz. Kristin changed her name to Edna as an adult.

Edna Meudt, *The Rose Jar: The Autobiography of Edna Meudt* (Madison: North Country Press, 1990), 174–178. Reprinted with permission.

FRANK LLOYD WRIGHT TO HIS NEIGHBORS

To My Neighbors:

To you who have rallied so bravely and so well to our assistance—to you who have been invariably kind to us all—I would say something to defend a brave and lovely woman from the pestilential touch of stories made by the press for the man in the street, even now, with the loyal fellows lying dead beside her. I cannot bear to leave unsaid things that might brighten memory of her in the mind of anyone. But they must be left unsaid. I am thankful for all who showed her kindness of courtesy, and that means many. No community anywhere could have received the trying circumstances of her life among you in a more high-minded way. I believe at no time has anything been shown her as she moved in your midst but courtesy and sympathy.

This she won for herself by her innate dignity and gentleness of character, but another—perhaps any other—community would have seen her through the eyes of the press that even now insists upon decorating her death with the fact, first and foremost, that she was once another man's wife, "a wife who left her children." That must not be forgotten in this man-made world. A wife still is "property." And yet the well-known fact that another [woman] bears the name and title she once bore [Mrs. Edwin Cheney] had no significance. The birds of prey were loosed upon her in death as well as in life, to feed the Moloch of the heart that maintains itself at the cost of the "man in the street," by preaching to him in vulgar language the Gospel of Mediocrity.

But this noble woman had a soul that belonged to her alone—that valued womanhood above wifehood or motherhood. A woman with a capacity for love and life made real by a higher ideal of truth, a finer courage, a higher, more difficult ideal of the white flame of chastity than was "moral" or expedient and

for which she was compelled to crucify all that society holds sacred and essential—in name.

And finally, out of the mass of lies which forms the article covering this catastrophe in Sunday's Chicago Tribune, is a lie the work of an assassin that in malice belongs with the mad black [killer, Julian Carlton] except that he struck in the heat of madness, and this assassin strikes the living and the dead in cool malice. It leaves me with the same sense of outrage to the dead that the black, cunning face of the negro wears as it comes before me in my dreams. The sting of it is a goad that helps me lift my head again.

In our life together there has been no thought of secrecy except to protect others from the contaminating stories of newspaper scandal; no pretense of a condition that did not exist. We have lived frankly and sincerely as we believed and we have tried to help others to live their lives according to their ideals.

Neither of us expected to relinquish a potent influence on our children's lives for good—nor have we. Our children have lacked the atmosphere of ideal love between father and mother—nothing else that could further their development. How many children have more in the conventional home? Mamah's children

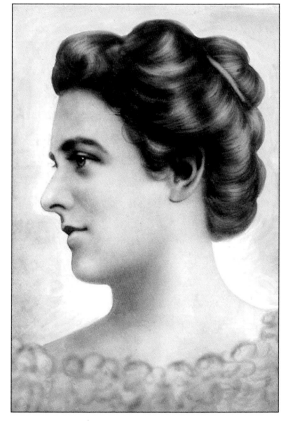

Fig. 182. Mamah Bouton Borthwick, possibly a wedding portrait.

were with her when she died. They have been with her every summer. She felt that she did more for her children in holding high above them the womanhood of their mother than by sacrificing it to them. And in her life, the tragedy was that it became necessary to choose one or the other.

The circumstances of her life before and after we came to live among you have all been falsified and vulgarized—it is no use now to try to set them straight—but there was none of the cheap deception, the evading of consequences, that mark writhings from the obligations of the matrimonial trap.

Nor did Mamah ever intend to devote her life to theories or doctrines. She loved Ellen Key as everyone does who knows her. Only true love is free love—no

> *"This noble woman had a soul that belonged to her alone—that valued womanhood above wifehood or motherhood."*

other kind is or can ever be free. The "freedom" in which we joined was infinitely more difficult than any conformity with customs could have been. Few will venture it. It is not lives lived on this plane that menace the well-being of society. No, they can only serve and ennoble it.

It has sometimes been a source of annoyance to Mamah that one or two friends to whom she occasionally wrote persisted in reading a meaning between her lines that convicted her of an endeavor to seem happy when they thought she ought not to be. I suppose when we live safe in the "heart of the block" we yearn to feel that in another situation than ours—in circumstances we fail to understand—there must be unhappiness, or in circumstances of which we disapprove—an "EXPIATION." This is particularly "Christian."

Mamah and I have had our struggles, our differences, our moments of jealous fear for our ideals of each other—they are not lacking in any close human relationships—but they served only to bind us more closely together. We were more than merely happy even when momentarily miserable. And she was as true as only a woman who loves knows the meaning of the word. Her soul has entered mine and it shall not be lost.

You wives with your certificates of loving—pray that you may love as much and be loved as well as Mamah Borthwick! You mothers and fathers with daughters—be satisfied if what you have invested in them works itself out upon as high a plane as it has done in the life of this lovely woman. She was struck down by a tragedy that hangs by a slender thread of reason over the lives of all, a thread which may snap at any time in any home with consequences as disastrous.

And I would urge upon young and old alike that "Nature knows neither Past nor Future—the Present is her Eternity." Unless we realize that brave truth there will come a bitter time when the thought of how much more potent with love and action that precious "Present" might have been, will desolate our hearts.

She is dead. I have buried her in the little Chapel burying ground of my people—beside the little son of my sister, a beautiful boy of ten, who loved her and whom she loved much—and while the place where she lived with me is a charred and blackened ruin, the little things of our daily life gone, I shall replace it all as nearly as it may be done. I shall set it up again, for the spirit of the mortal that lived in it and loved it—will live in it still. My home will still be there.

FRANK LLOYD WRIGHT

Weekly Home News,
Spring Green, Wisconsin, August 20, 1914

Fig. 183. A luxury limited edition of Goethe's "Hymn to Nature" was published in Darmstadt in 1910. Wright bought a copy of the poem in Berlin that year.

A Hymn to Nature

Frank Lloyd Wright's introduction, August 20, 1914:

" 'A Fragment: A Hymn to Nature,' unknown to us in the works of Goethe, we found in a little bookshop in Berlin. Translated by us from the German—together— it comforted us. It is for the strong and saved from destruction only because I carried it in my pocket. I give it here to those who cared for her."*

Nature!

We are encompassed and enveloped by her, powerless to emerge and powerless to penetrate deeper.

Unbidden and unwarmed she takes us up in the round of her Dance and sweeps along with us, until exhausted we fall from her Arms.

She creates ever new Forms; what is, was never before; what was, comes never again—everything is New and yet ever the Old.

We live in the midst of her and are Strangers to her.

She speaks incessantly with us and never betrays her Secret to us.

We have unceasing Effect upon her and yet have no Power over her.

She appears to have committed everything to Individuality and is indifferent to the Individual.

She builds ever and ever destroys and her Workshop is inaccessible.

She is the very Children—and the Mother—where is she?

* * * * * *

She is the only Artist.

With the simplest Materials she arrives at the most sublime Contrasts.

Without Appearance of Effort she attains most Perfection—the most exact Precision veiled always in exquisite Delicacy.

Each of her Works has its own individual Being—each of her Phenomena the most isolated Conception, yet all is Unity.

She plays a Drama.

Whether or not she sees it herself we do not know and yet she plays it for us who stand in the Corner.

There is an eternal Life, Growth and Motion in her and yet she does not advance.

She changes ever, no Moment is stationary to her.

She has no Conception of Rest and has fixed her Curse upon Inaction.

She is Firm.

Her step is measured, her Exceptions rare, her Laws immutable.

She has reflected and meditated perpetually; not however as Man but as Nature.

She has reserved for herself a specific all-embracing Thought which none may learn from her.

* * * * * *

Mankind is all in her and she in all.

With all she indulges in a friendly Game and rejoices the more one wins from her.

She practices it with many, so occultly that she plays it to the End before they are aware of it.

And most unnatural is Nature.

Whoever does not see her on every side, nowhere sees her rightly.

She loves herself and ever draws herself Eyes and Hearts without number.

She has set herself apart in order to enjoy herself.

Ever she lets new Admirers arise, insatiable, to open her Heart to them.

In Illusion she delights.

Whoever destroys this in himself and others, him she punishes like the most Severe Tyrant.

Whoever follows her confidently—him she presses as a child to her Breast.

Her Children are Countless.

To none is she everywhere niggardly but she has Favorites upon whom she lavishes much and to whom she sacrifices much.

Upon Greatness she has fixed her Protection.

She pours forth her Creations out of Nothingness and tells them not whence they came nor whither they go; they are only to go; the Road she knows.

She has few Motive Impulses—never worn out, always effective, always manifold.

Her Drama is ever New because she ever creates new Spectators.

Life is her most beautiful Invention and Death her Ruse that she may have much Life.

She envelops mankind in Obscurity and spurs him ever toward the Light.

She makes him dependent upon the Earth, inert and heavy; and ever shakes him off again.

She gives Needs because she loves Action.

It is marvelous how she attains all this Movement with so little.

Every need is a blessing, quickly satisfied, as quickly awakened again.

If she gives another Need—then is it a new source of Desire, but soon she comes to Equipoise.

She starts every Moment upon the longest Race and every Moment is at the Goal.

She is Futility itself: but not for us for whom she has made herself of the greatest importance.

She lets every Child correct her, every Simpleton pronounce Judgment upon her; she lets thousands pass callous over her seeing nothing and her Joy is in all and she finds in all her Profit.

We obey her laws even when we most resist them, we work with her even when we wish to work against her.

She turns everything she gives into a Blessing; for she makes it first— indispensable.

She delays that we may long for her, she hastens on that we may not be sated with her.

She has no Speech nor Language; but she creates Tongues and Hearts through which she feels and speaks.

Her Crown is Love.

Only through Love can we approach her.

She creates Gulfs between all Beings and all wish to intertwine.

She has isolated all that she may draw all together.

With a few Draughts from the Beaker of Love she compensates a Life full of Toil.

She is Everything.

She rewards herself and punishes herself, rejoices and torments herself.

She is harsh and gentle, lovely and terrible, powerless and omnipotent.

Everything is ever present in her.

Past and Future she knows not—The Present is her Eternity.

She is generous.

I glorify with all her Works.

She is wise and calm.

One drags no Explanation from her by Force, wrests no gift from her which she does not freely give.

She is cunning but for a good purpose and it is best not to observe her Craft.

She is complete and yet ever incomplete; so as she goes on she can ever go on.

To Everyone she appears in especial Form.

She conceals herself behind a thousand Names and Terms and yet is always the same.

She has placed me here; she will lead me hence;—

I confide myself to her.

She may do with me what she will: she will not despise her Work.

I speak not of her. No, what is true and what is false; She herself has spoken all;

All the Fault is hers; hers is all the Glory.

*By Johann Wolfgang von Goethe, translated by Mamah Borthwick and Frank Lloyd Wright. *Spring Green Weekly Home News*, August 20, 1914. An introduction to the same text published by Margaret Anderson in *The Little Review*, vol. 1, October 1914, 30, says it was "translated into English by a strong man and a strong woman whose lives and whose creations have served the ideals of all humanity in a way that will gain deeper and deeper appreciation."

And so, the story of Taliesin II begins...

**WRIGHT LOVE BUNGALOW
AT HILLSIDE IS REBUILT**

DODGEVILLE. Wis., Nov. 17.—
Frank Lloyd Wright's bungalow at
Hillside is about rebuilt and will soon
be completed. The new building is
similar to the one destroyed by the
fire which was started by the negro
chef, Carlton last summer; the only
difference is that the structure is larg-
er. An addition will be used for apart-
ments for Mr. Wright's mother. It
will fully equal, if not surpass, the
beauty of the old building.

Racine Journal-News, November 17, 1914

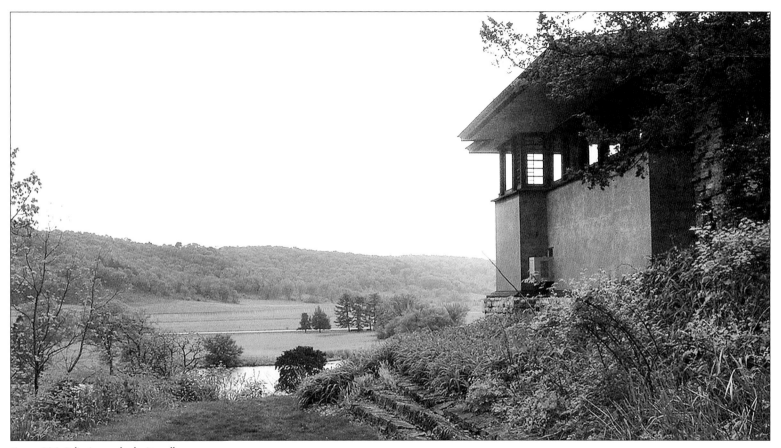

Figure 184. Taliesin overlooks its valley

BUILDING TALIESIN

Many thanks

On February 11, 2010, I was searching the Internet for a link to the Taylor Woolley photos of Frank Lloyd Wright's home in Italy when an unfamiliar site appeared: a collection of Woolley photos at the Utah State Historical Society that purported to include images of "Taliesen [sic] I under construction." I asked David Rogers, a family friend in Salt Lake City, to take a personal look. He called back excitedly to describe the construction scenes. That was the beginning of this book.

Since my life's work had been in newsrooms, I approached my quest for the lost Taliesin as a lead reporter and assigning editor. David was my first recruit. With the power of the Internet my investigative team grew to include a world-wide web of contributors across the United States and in Italy, France, Sweden, Finland, Russia, and Japan. I had read and written about Wright for some time and understood what I needed to find. My luck was that everywhere I turned I found people willing to go to extra lengths to help when they learned that the topic was Frank Lloyd Wright.

The first thing to find about the Woolley Taliesin photos in Utah was what was in them. What were we seeing? The Utah historical society at the time could supply no information. But Keiran Murphy, the meticulous, keen-eyed historian of Taliesin Preservation, Inc., in Spring Green, Wisconsin, was able to identify each one and locate them in time, sometimes using clues as subtle as a vase of pussy willows.

Nancy Horan, author of the best-selling novel Loving Frank, emerged as a great friend of this book. She shared her legible set of Borthwick letters—the other key primary source, which I mined for detail, chronology and leads. She also connected me with Claes Von Heiroth, the grandson of Mascha Von Heiroth. Mascha was the "Russian next door" who spent Easter Sunday 1910 with Wright and Borthwick in Fiesole and wrote about it in her diary.

Von Heiroth, who lives in Helsinki, asked his sister in France, Bianca Maria Andersen, to scan Mascha's diary pages, which were handwritten in French. My friend Clare Mather, a professor of French at St. Olaf College, led me to Jonah Hacker, a graduating senior from Madison, who bicycled over to pick up the pages and did an excellent translation. From the state of Washington (Horan's

Fig. 185. Elaine DeSmidt and Ron McCrea at Taliesin. Photograph by Mark Hertzberg.

home) to Finland, France, Minnesota, and Madison—with a side trip to St. Petersburg, Russia, to pick up Mascha's portrait at the Hermitage—it was world cyber-tour that yielded one small, charming, exclusive story.

Andrea Reithmayr, a librarian at the Rush Rhees Library at the University of Rochester, saw a letter telling me there were no files there for landscaper Jens Jensen, who had submitted a plant order to a Rochester nursery for Wright in 1912. But she knew better, and produced a sheaf of correspondence that included Jensen's scalding letter upbraiding the nursery for pestering Wright for money just days after the 1914 Taliesin murders.

Björn Sjunnesson, a Stockholm architect whom I had contacted after seeing his photo of Strand, Ellen Key's home, on the Internet, made a special auto trip back to Lake Vättern in central Sweden to photograph the Hiroshige print that was Frank Lloyd Wright and Mamah Borthwick's Christmas housewarming present in to Key in 1911. This print, selected by Wright and in a custom frame of his design, has never appeared before.

Other key finds made by Butch Kmet of Salt Lake City and Whitney Harrod of Northwestern University are described in the introduction. The investigative team approach proved its worth again and again.

PICTURES AND POSTCARDS

This book contains more than 200 illustrations, and only a small number will be familiar to followers of Wright literature. The vast majority are original.

Claes Von Heiroth contributed two rare, fascinating, and previously unpublished photos of his grandparents spending an alfresco afternoon in Fiesole with Gertrude Stein, Alice B. Toklas, and the Stein family.

Elizabeth Catherine Wright, the architect's granddaughter now living in France, contributed the charming photo of her father, Robert Llewellyn, at age six. She and her brother Tim Wright both offered thoughts about the puppet theater Wright made for their father in 1911 in Taliesin's raw living room.

Carla Wright (no relation) shared her farm family album photo of gardeners at Taliesin in 1913, including Ben Davis, the construction foreman whom Wright called the "Michelangelo" of cussers. She also contributed her pictures of a Wisconsin farm boy posing with Japanese visitors.

Patrick Mahoney contributed his postcard, freshly purchased on eBay, of gawkers viewing Taliesin's ruins. Brian Spencer contributed his scarce 1914 Midway Gardens brochure. Colleen Flanigan of the Chicago Opera Theater put me in touch with Dan Rest, who dug out his 1997 production photos of *Shining Brow.* Filippo Ficl found the original poster of the 1910 Florence air show.

Jim McIntosh of Lopez Island, Washington, a regular participant in the Frank Lloyd Wright Building Conservancy web chat group, provided his clean color rendering of the architectural plan and elevation of Taliesin I.

Craig Wilson took stunning aerial photos of Taliesin from a radio-controlled kite. My wife, Elaine DeSmidt, spied the links among three of Frank Lloyd Wright's photos of Jones Valley in 1900. Digital specialist Roger Daleiden knitted together the panorama. Pedro Guerrero, Frank Lloyd Wright's personal photographer, provided his well-known images of the plaque at Taliesin's entrance and Wright in his drafting studio.

At libraries and archives, Doug Misner, Gregory M. Waltz and Heidi Orchard of the Utah State Historical Society gave me great assistance and permission to use the key collection of Woolley images. Archivists Margo Stipe and Oskar Munoz of the Frank Lloyd Wright Foundation provided everything I asked from Taliesin West, knowledgeably and promptly. Lisa Marine and Andy Kraushaar of the Wisconsin Historical Society Archives assisted with my visits and extensive image requests. Lorraine Crouse of the University of Utah's Marriott Library fielded my numerous long-distance transactions and on-site visits from Butch Kmet.

Other custodians of visual materials who helped were Mel Buchanan of the Milwaukee Art Museum; Heather Oswald of the Frank Lloyd Wright Home and Studio; Andrea Waala of the Museum of Wisconsin Art; Susan Augustine of the Ryerson and Burnham Libraries at the Art Institute of Chicago; Olga Novoseltseva of the State Hermitage Museum in St. Petersburg, Russia; Rebecca Fawcett of the Hood Museum of Art at Dartmouth; Debra Gust of the Curt Teich Postcard Archives at the Lake County Discovery Museum; and the staffs of the Swedish National Museum of Fine Arts and the Swedish Royal Library.

No picture can substitute for visits to Taliesin itself. The Senior Fellows welcomed me there and showed me hospitality in the great tradition. I thank especially Minerva Montooth, Frances Nemtin, Effi Casey, Susan Jacobs Lockhart, Cornelia Brierly, and Victor Sidy, dean of the Frank Lloyd Wright School of Architecture. On the preservation side, Taliesin Preservation Inc., president Carol McChesney Johnson gave this book early and enthusiastic support. facilities manager Jim Erickson and preservation program coordinator Sidney Robinson, who know Taliesin's DNA intimately, were generous with their time and insights.

PRODUCTION VALUES

Having found a wealth of new materials, I put a priority on getting them into print quickly. I stepped out of my writing and assigning role and drew on my experience in news production to bring this book as close to being press-ready as I could make it. That meant assembling another crew.

I was lucky to retain Earl J. Madden as the designer. His creativity, magic, and appreciation of the materials are visible on every page. What is invisible is his calm, professionalism, and patience. Thanks to Michael Kienitz for introducing us.

For a general editor I called on my wise friend and former "green eyeshade" colleague on the news desks of the *Boston Globe* and *Washington Post*, Richard M. Weintraub. Rick asked the kinds of questions that rattle assumptions and send an author off to dig and rewrite. I was once his best man; now he is mine. Keiran Murphy was chief fact-checker. Barbara Walsh was the invaluable editor for Parallel Press.

Several people read portions of the manuscript. They were Dave Wagner, my mentor in politics and history; former *Newsweek* correspondent Martin (Mick) Andersen; Michael J. Dorgan of the *San Jose Mercury News*; Cynthia J. Davis, the biographer of Charlotte Perkins Gilman; Barbara Miller Lane of Bryn Mawr College, an expert on Ellen Key; Florence architect Filippo Fici; D. Ben DeSmidt of Carthage College, our family classicist; and Nancy Horan.

Laura Gottlieb came out of retirement to prepare the index. Richard W. Young of Quarles & Brady in Chicago guided me through the legal vagaries.

Other friends who provided assists and advice were Bob Allister, Jeff Ballowe, Bill and Amy Dixon, Dan Harrison, Richard and Reed Howard, Moria and Edward Krueger, Narciso Menocal, Jerry Minnich, Judy Schwaemle, Ben Sidran, Joel Skornicka, Susan Steingass and William Francis Nelson, Zane Williams, and Dave Zweifel.

WAYS AND MEANS

This volume is largely self-financed, something that would not have been possible before the digital age reduced the need for personal travel, accelerated research to warp speed, and made book design a cottage industry.

The Evjue Foundation, created by the founding editor of *The Capital Times*, a defender and promoter of Wright during his lifetime, provided a grant. Several individuals also contributed, including one gift made in memory of Robert B. Graves, a tall figure at Taliesin who spent his last years restoring Wright's 1957 Wyoming Valley School.

I had two benefactors in the 1980s who prepared the way for this study by underwriting my research at the Wisconsin Academy of Sciences, Arts, and Letters. The late Marshall D. Erdman, who built with Wright, and Yuzaburo Mogi, chairman of Kikkoman Foods, were the memorable gentlemen.

This year marks the 100th anniversary of the publication of *The Wisconsin Idea*, Charles McCarthy's distillation of the Progressive practices that gave Wisconsin its reputation as a laboratory of democracy. Key among these was the working partnership of the University of Wisconsin with the state to advance its prosperity and quality of life. I am grateful to Elisabeth R. Owens of the UW–Madison Libriaries' Parallel Press, and Kathy Borkowski, director of the Wisconsin Historical Society Press, my publisher, for making *Building Taliesin* a beneficiary of this noble legacy.

LIFE SAVERS AND GIVERS

In 2006 I had a major health crisis that was resolved with emergency surgery and an organ transplant. I would not have lived to write this book had it not been for the skills of the medical staffs of Madison's Meriter Hospital and the University of Wisconsin Hospital Transplant Unit. I would like to thank Dr. Kevin McAllister, Dr. Stuart Knechtle, Dr. Alexandru Musat, Dr. Amish Raval, and Dr. Josh Mesrich. Also, Dr. Alan Kalker, Dr. Tony DeGiovanni, Dr. Robert Olson, Michael Gerst, blood donors, nursing staff, and the family of my anonymous organ donor, whose gift keeps me writing.

I was supported through this by my family, friends, and colleagues at *The Capital Times*, who I thank again, in particular Jacob Stockinger, who is always good therapy. I thank Bob McCrea for his brotherly care and prayers, Christine, Jason and Jennifer McCrea, Benjamin DeSmidt, and Brad, Lesley and Holly Johnson.

Elaine Harris DeSmidt donates her heart to me every day. The experience of her love enabled me to understand this story. This book is for her.

Fig. 186. Clifford Evans (left) doffs his hat and takes a bow as his architectural partner, former Taliesin photographer Taylor A. Woolley (right) shares a dockside toast in Salt Lake City with two unidentified friends. Clifford Evans Collection, Special Collections Deptartment, J. Willard Marriott Library, University of Utah.

ILLUSTRATION CREDITS

Page ii. Taliesin I plan and elevation by Jim McIntosh
Fig. 1. Courtesy of Carla Wright
Figs. 2–4. © Frank Lloyd Wright Foundation, Scottsdale, Arizona
Fig. 5, 6. © Dan Rest
Fig. 7. Courtesy of Anne Biebel, Cornerstone Preservation
Figs. 8–10. Photographs by author
Fig. 11. Special Collections Department, J. Willard Marriott Library, University of Utah
Figs. 12, 13. Photographs by author
Fig. 14. Special Collections Department, J. Willard Marriott Library, University of Utah
Fig. 15. Photograph by author
Fig. 16. Special Collections Department, J. Willard Marriott Library, University of Utah
Fig. 17. Author's collection
Fig. 18. Photograph by author
Figs. 19, 20. © Frank Lloyd Wright Foundation, Scottsdale, Arizona
Fig. 21. Author's collection
Fig. 22. Special Collections Department, J. Willard Marriott Library, University of Utah
Fig. 23. Author's collection
Fig. 24. The State Hermitage Museum, St. Petersburg, Russia. Photograph © The State Hermitage Museum/photograph by Vladimir Terebenin Leonard Kheifets, Yuri Molodkovets
Figs. 25–27. Courtesy of Claes Von Heiroth, all rights reserved
Fig. 28. Craig Wilson, Kite Aerial Photography
Fig. 29. *Spring Green*, George Mann Niedecken, oil on canvas, 1912, Jody and Dick Golsman Collection, Museum of Wisconsin Art
Fig. 30. Craig Wilson, Kite Aerial Photography
Fig. 31. Wisconsin Historical Society (WHI–25569)
Fig. 31.a. Wisconsin Historical Society (WHI–25568)
Fig. 31.b. Wisconsin Historical Society (WHI–25566)
Fig. 31.c. Montage by Roger Daleiden
Fig. 32. Wisconsin Historical Society (WHI–25567)
Fig. 32.a. Wisconsin Historical Society (WHI–25571)
Fig. 33. Wisconsin Historical Society (WHI–25570)
Fig. 34. Wisconsin Historical Society (WHI–25565)
Fig. 35. Wisconsin Historical Society (WHI–25559)
Fig. 36. Wisconsin Historical Society (WHI–25564)
Fig. 37. Wisconsin Historical Society (WHI–25558)
Fig. 38. Wisconsin Historical Society (WHI–85168)
Fig. 39. Wisconsin Historical Society (WHI–30463)
Fig. 40. Wisconsin Historical Society (WHI–3879)
Fig. 41. Wisconsin Historical Society (WHI–4010)
Fig. 42. Wisconsin Historical Society (WHI–4009)
Fig. 43. Wisconsin Historical Society (WHI–10204)
Fig. 44. Wisconsin Historical Society (WHI–33372)
Fig. 45. Wisconsin Historical Society (WHI–40006)
Fig. 46. Wisconsin Historical Society (WHI–25560)
Fig. 47. Wisconsin Historical Society (WHI–4008)
Fig. 48. Wisconsin Historical Society (WHI–25548)
Fig. 49. © Frank Lloyd Wright Foundation, Scottsdale, Arizona
Fig. 50. Wisconsin Historical Society (WHI–25556)

Figs. 51–53. Special Collections Department, J. Willard Marriott Library, University of Utah
Figs. 54–64. Used by permission, Utah State Historical Society, all rights reserved
Fig. 65. Special Collections Department, J. Willard Marriott Library, University of Utah
Fig. 66. Wisconsin Historical Society (WHI–29066)
Fig. 67. Special Collections Department, J. Willard Marriott Library, University of Utah
Fig. 68. Wisconsin Historical Society (WHI–29071)
Figs. 69–79. Used by permission, Utah State Historical Society, all rights reserved
Fig. 80. Wisconsin Historical Society (WHI–290777)
Figs. 81–86. Used by permission, Utah State Historical Society, all rights reserved
Fig. 87. Wisconsin Historical Society (WHI–29058)
Fig. 88. Wisconsin Historical Society (WHI–29048)
Fig. 89. Wisconsin Historical Society (WHI–29051)
Fig. 90. Wisconsin Historical Society (WHI–28951)
Fig. 91. Wisconsin Historical Society (WHI–29056)
Fig. 92. Wisconsin Historical Society (WHI–29054)
Fig. 93. Wisconsin Historical Society (WHI–29053)
Figs. 94–96. Used by permission, Utah State Historical Society, all rights reserved
Fig. 97. © Pedro E. Guerrero
Fig. 98. Courtesy of Elizabeth Catherine Wright
Fig. 99. Collection of Frank Lloyd Wright Preservation Trust
Fig. 100. Special Collections Department, J. Willard Marriott Library, University of Utah
Fig. 101. Maginel Wright Barney, artist. Catherine Wright and Children, ca. 1905, pastel on paper, 29.625 x 22.187 in. (in frame), Collection of Frank Lloyd Wright Preservation Trust, Gift of Thomas and Mary Wright, 1976.07. Photographer: Philip Mrozinaki
Fig. 102. Special Collections Department, J. Willard Marriott Library, University of Utah
Figs. 103–105. Used by permission, Utah State Historical Society, all rights reserved
Fig. 106. Author's collection
Fig. 107. Courtesy of Butch Kmet
Pages 109–113: Combined thumbnails of Taylor A. Woolley photographs courtesy of Utah State Historical Society, Wisconsin Historical Society, and J. Willard Marriott Library Department of Special Collections, University of Utah
Fig. 108. Wisconsin Historical Society (WHI–23788)
Fig. 109. Floyd Dell in 1914, Hood Museum of Art, Dartmouth College, Hanover, New Hampshire; gift of John Sloan Dickey, Class of 1929
Fig. 110. Wright, Frank Lloyd (1867–1959) © ARS, NY. Living room from the Little House, Wayazata, Minnesota. 1912–1915. H. 13 ft. 8 in. (4.17m), L. 46 ft. (14m). W. 28 ft. (8.53m). Purchase, Emily Crane Chadbourne Bequest, 1972 (1972.60.1). The Metropolitan Museum of Art, New York, NY, U.S.A. Image copyright © The Metropolitan Museum of Art/Art Resource, NY.
Fig. 111. © Pedro E. Guerrero
Fig. 112. © Frank Lloyd Wright Foundation, Scottsdale, Arizona
Figs. 113, 114. Courtesy of Carla Wright
Figs. 115–117. © Frank Lloyd Wright Foundation, Scottsdale, Arizona
Fig. 118. Frank Lloyd Wright, American, 1867–1959, Avery Coonley Playhouse: Triptych Window, 1912, Clear and colored glass in oak frames. Art Institute of Chicago
Fig. 119. *New York Times* obituary photograph
Fig. 120. © Frank Lloyd Wright Foundation, Scottsdale, Arizona
Fig. 121. Author's collection
Fig. 122. Lake County (Illinois) Discovery Museum, Curt Teich Postcard Archive
Fig. 123. From the collection of Brian Spencer / Architect
Fig. 123.a. Frank Lloyd Wright (American, 1867–1959), Plate from Midway Gardens (Chicago),

1913, Porcelain, 7 5/8 in. (19.37 cm.), Milwaukee Art Museum, Gift of George Talbot, Madison, WI M1978.259, Photograph credit John R. Glembla
Fig. 124. Lake County (Illinois) Discovery Museum, Curt Teich Postcard Archive
Fig. 125. © Frank Lloyd Wright Foundation, Scottsdale, Arizona
Fig.126. Courtesy of Hedda Jansson, Strand
Fig. 127. Wisconsin Historical Society (WHI–29074)
Figs. 128, 129. Courtesy of Hedda Jansson, Strand
Fig. 130. Einar Nielsen, Ellen Key, © Nationalmuseum, Stockholm, Sweden
Fig. 131–133. Courtesy of Björn Sjunnesson
Fig. 134, 135. Author's collection
Fig. 136. Courtesy of Björn Sjunnesson
Figs. 137–141. Author's collection
Fig. 142. Beinecke Rare Book and Manuscript Library, Yale University
Fig. 143. Author's collection
Fig. 144. Ellen Key Archive, Royal Library of Sweden, Stockholm
Fig. 145. Wisconsin Historical Society (WHI–25065)
Figs. 146, 147. Courtesy of Björn Sjunnesson
Fig. 148. Wisconsin Historical Society (WHI–72185)
Fig: 149: Library of Congress, negative No. LC USZ 62 90042
Fig. 150: Library of Congress, negative No. LC USZ 62 106490
Fig. 151. *Home News*, Spring Green, Wisconsin
Fig. 152. General Federation of Women's Clubs, Washington, D.C.
Fig. 153. Wisconsin Historical Society (WHI–83126)
Fig. 154. Wisconsin Historical Society (WHI–83017)
Fig. 155. Department of Rare Books and Collections, University of Rochester
Fig. 156. Wisconsin Historical Society (WHI–83018)
Fig. 157. Wisconsin Historical Society (WHI–83114)
Fig. 158. Wisconsin Historical Society (WHI–83119)
Fig. 159. Wisconsin Historical Society (WHI–83010)
Fig. 160. Wisconsin Historical Society (WHI–35055)
Fig. 161. Wisconsin Historical Society (WHI–83113)
Figs. 162, 163. Wisconsin Historical Society (WHI–83123)
Fig. 164. Wisconsin Historical Society (WHI–55871)
Fig. 165. Wisconsin Historical Society (WHI–55872)
Fig. 166. Wisconsin Historical Society (WHI–55870)
Fig. 167. © Frank Lloyd Wright Foundation, Scottsdale, Arizona
Fig. 168. Courtesy of Patrick Mahoney
Figs. 169–175. Office of the Iowa County Clerk, Dodgeville, Wisconsin
Fig. 176. *Dodgeville Chronicle*, Dodgeville, Wisconsin
Figs. 177–179. Ellen Key Archive, Royal Library of Sweden
Fig. 180. © Frank Lloyd Wright Foundation, Scottsdale, Arizona
Fig. 181. From Edna Meudt, The Rose Jar (Madison: North Country Press, 1990), reprinted with permission
Fig. 182. Courtesy of the Frank Lloyd Wright Foundation, Scottsdale, Arizona
Fig. 183. Author's collection
Fig. 184. Author's collection
Fig. 185. Author's collection. Photograph by Mark Hertzberg
Fig. 186. Special Collections Department, J. Willard Marriott Library, University of Utah

ABOUT THE AUTHOR

Ron McCrea is a prize-winning journalist and former Alicia Patterson Fellow who worked on the news desks of *New York Newsday,* the *San Jose Mercury News,* the *Washington Post,* the *Washington Star,* the *Boston Globe,* and *The Capital Times* in Madison, Wisconsin, where he served for a decade as city editor and also, previously, as editor of the *Madison Press Connection.* He appears in the E! Entertainment Network's documentary *Mysteries and Scandals: Frank Lloyd Wright* and the BBC's *Frank Lloyd Wright: Murder, Myth and Modernism,* and wrote the script for "The Making of Monona Terrace: Frank Lloyd Wright's Last Public Building," which took finalist honors at the New York Film Festival. He serves on the board of directors of AIA Wisconsin/The Wisconsin Society of Architects, as a professional affiliate member and was the communications director for Wisconsin governor Tony Earl. He holds degrees from Albion College and the Fletcher School of Law and Diplomacy at Tufts University and lives in Madison.

INDEX

Page numbers in italics refer to illustrations